U0031319

Gods of Taiwan

● A Collector's Account

台灣的神像：一名美國文物收藏家研究紀事　Neal Donnelly 唐能理 著

版權屬於尼爾‧唐能理，2006 年
Copyright 2006 by Neal Donnelly

版權所有，在無作者的書面允許下，本書不能以任何形式包括機械性或電子式方法進行任何內容的侵權複製行為，包括不得以拷貝、錄製任何其他形式的資料儲存方式。
All rights reserved. No part of this publication may be reproduced or transmitted in any form by any means, electronic or mechanical, including photocopying, recording or any other information storage or retrieval system without permission in writing from the author.

本書的影像由唐能理先生，在史密森尼機構的台灣文物計畫支持下進行，並得到中華民國行政院文建會的贊助。所有的照片由台灣文物計畫之中，史密森尼機構的唐那‧賀柏特先生主要提供，其餘由史密森尼機構的李東先生、凱特‧厄爾、約翰‧史丁那所提供。
十王圖的圖像為史密森尼機構的藏品（圖 12 、 81 、 83 、 84 、 110 、 114 ），版權所有。
Images for this book were provided to Mr. Donnelly under the auspices of the Smithsonian Taiwan Heritage Project, with support from the Council for Cultural Affairs, Executive Yuan, Taiwan, Republic of China. All photographs provided by the Taiwan Heritage Project were taken by Donald Hurlburt (Smithsonian Institution), Michel D. Lee (Smithsonian Institution), Kate Earle (Smithsonian Institution), John Steiner (Smithsonian Institution)
Finally, images of the Ten Kings Scrolls (figures 12, 81, 83, 84, 110, 114) in the Smithsonian collections are all © Smithsonian Institution.

攝影 Photographs by：
凱西‧莊 Casey Chuang：Figure 18.
尼爾‧唐能理 Neal Donnelly：Figures 2, 26, 27, 72, 92, 113, 115.
凱特‧厄爾 Kate Earle / 史密森尼博物館 Smithsonian Insitution：Figures 22, 33, 49, 82, 101.
唐那‧賀柏特 Donald Hurlburt / 史密森尼博物館 Smithsonian Insitution：Figures 1, 3 — 7, 9 — 11, 13 — 17, 19 — 21, 24, 29, 30, 32, 34 — 38, 40 — 48, 50, 52 — 69, 71, 73 — 80, 85 — 91, 93 — 100, 102 — 104, 109, 111, 112, 116 — 123, 125, 126, 129, 130.
麥克‧李東 Michel D. Lee / 史密森尼博物館 Smithsonian Institution：Figures 23, 25, 51, 70, 108, 124, 127, 128, 130.
史密森尼博物館 Smithsonian Institution：Figures 12, 81, 83, 84, 110, 114.
約翰‧史坦納 John Steiner / 史密森尼博物館 Smithsonian Institution：Figures 105 — 107.

台灣台北藝術家出版社發行 Forthcoming: Taipei, Artist Publishing Co.,

 贊助 Sponsor: The Council for Cultural Affairs, Executive Yuan, Taiwan, R.O.C.

Gods of Taiwan

● A Collector's Account

台灣的神像：一名美國文物收藏家研究紀事　**Neal Donnelly** 唐能理　著

藝術家
Artist Publishing Co.

CONTENTS

INTRODUCTION

Statues of deities, such as those described and illustrated in this volume, are commonly used in public temples and private altars on Taiwan. Those of us who live in the Washington, D.C. area are fortunate in having nearby the private collection of Taiwanese religious artworks and artifacts assembled by Neal and Joan Donnelly, including the deity figures whose stories he recounts in this book.

Mr. and Mrs. Donnelly previously donated to the Smithsonian their unique sets of "Hell Scrolls" (two sets of ten scrolls each), the subject of a book published in 1990 by Artist Press (Taipei), and of a very popular traveling exhibition which we organized that same year. The exhibition, *A Journey through Chinese Hell: Hell Scrolls of Taiwan*, opened at the Smithsonian's National Museum of Natural History and later traveled to many venues around the United States, delighting and educating diverse audiences at venues including the Chinese Cultural Center (San Francisco), the Bowers Museum (Santa Ana, California), and the Quincy Art Center (Quincy, Illinois), until it closed at the University of Hawaii (Manoa) Art Gallery in March 1997. The catalog of the collection (Donnelly 1990) is a fine introduction to the artworks as well as the other-worldly subject-matter of the ten courts of the afterlife as depicted there.

Since that time, the Smithsonian's Asian Cultural History Program, within the Anthropology Department of the National Museum of Natural History, has expanded its research and public outreach activities involving the cultural history of Taiwan, especially with the founding (in February 2004) of the Smithsonian's Taiwan Heritage Project, thanks to a dedicated group of Taiwanese Americans, including many members of the Taiwanese American Association, Greater Washington Chapter (TAA-GWC). These dedicated supporters, and also the Taiwan Economic and Cultural Representative Office in the U.S.A. (TECRO), have recently helped the Smithsonian bring a range of Taiwanese lectures, performances, and events to Washington. These have ranged from a popular "Taiwan Heritage Festival" of dances and craft demonstrations (dough sculpture, grass weaving, paper cutting), to scientific lectures such as that by Dr. Ko Chi-sheng on the physical anthropology as well as historic material culture and artistic records about Chinese foot-binding, based on his own collection in Tu-Cheng City, Taipei. During Taiwanese-American Friendship week in May 2005, the Taipei Physical Education Dance Troupe attracted enthusiastic crowds to the Museum, to view an innovative demonstration of acrobatics and folk dances from many of Taiwan's multicultural traditions including those of the island's indigenous inhabitants, East Asian folk dance traditions, martial arts, and other forms.

As important as all these new public activities of the Museum have been, our audience also realizes that the "behind-the-scenes" study of collections is equally important. Moving beyond the study of the Smithsonian's own collections, the Asian Cultural History Program has been developing research databases on private collections relevant to our heritage programs. From the outset of the Taiwan Heritage Project, one of our stated goals for this research database was to include photography and documentation of Mr. and Mrs. Donnelly's collection of Taiwanese deity figures, including all those described in this book and many other lesser or duplicative examples not included here.

The Donnelly collection, which forms the basis of this book, is unmatched by any museum collection; and as this book attests, it forms a significant source of information on Taiwan's cultural heritage and religious life. Mr. Donnelly acquired these deity carvings between 1969 and 1981, while stationed on Taiwan as an American Foreign Service officer. Mr. Donnelly's collection of Taiwanese folk deity statues is probably the largest of its kind in the United States, and among the largest in the world. Its presentation within this volume is especially important for the English-speaking audience, because most publications on this subject are in Chinese and inaccessible to many scholars and to the interested public.

Both the collection and the presentation of it here are unique in that Mr. Donnelly, who was director of the

United States Information Service (USIS) in Taipei, extensively interviewed the carvers and those who used the statues. These records of the provenance of each item, and the information told to the collector in each case, form an invaluable first-hand record summarized here for the first time in Mr. Donnelly's book. The collector has researched each of the deities through interviews with worshippers and priests on Taiwan during the years he was stationed there. Donnelly's account is built up around a collection of material objects (informed by the collector's experience of events and places where the objects were used, and his subsequent library research). As such, it is unlike ethnographic accounts by non-collectors; in that respect, certainly the publications of Keith Stevens, pre-eminent British collector of such deity figures (and author of the Foreword to Mr. Donnelly's book) come to mind (especially Stevens 1997). There are also other accounts by foreign visitors who became fascinated with the subject matter yet do not have access to such a collection. The intriguing book *Wine for the Gods*, co-authored by the Australian Suzanne Coutanceau with Henry Wei Yi-min (Wei and Coutanceau 1976), for example, is a very readable and informed sojourn through a year of seasonal festivals on Taiwan, with additional accounts of omens, fortune-telling, and more. Yet, Mr. Donnelly's method is more grounded in material culture studies and more like systematic ethnography in its method and its contribution to historical studies.

Jordan and Overmeyer (1986: esp. 1-15) have described and critically examined the results of such methods in relation to their own field studies of Chinese sectarianism on Taiwan. Such important methods of study in the field, including long conversations with worshippers, wood-carvers, etc., have created "texts" of a kind that historians can rarely obtain directly. Yet these texts are also inevitably informed by the questioner's attempts to develop the conversations and interview data in particular directions, or toward his or her developing interpretations. The results set these deity figures within a particular context, but it is a real and data-rich context that will undoubtedly reward still further interpretation and study. One can only speculate on how much greater value the world's storehouses of religious objects in museums or craft galleries would have, if only similar efforts to those of Mr. Donnelly had been made prior to or during their collection in the field.

The importance of these deity figures, and the organization of public and private worship dedicated to them, have been increasingly recognized in recent scholarship (for example, in the bibliography below, books by Allan and Cohen 1979, Adler 1990, Feuchtwang 1992, Dean 1993, Shahar and Weller 1996, Jones 1999, Davidson and Reed 1998). Other important English-language sources of information on Taiwan's folk religious traditions derive from missionary literature, often focusing on syncretic and other effects of polytheistic traditions on the conversion of Christians or on forms of Taiwanese Christianity (e.g. Gates 1979, especially bibliography p. 247-256). Several papers in the recent collections edited by Clart and Jones (2003) and by Katz and Rubinstein (2003) emphasize the importance of local religious practice in recent transformations and reconfigurations of Taiwanese identity. Other recent studies (such as Sutton 2003 on exorcistic performers) focus more on the performance traditions associated with worship rather than on the sculptures or material objects; still others provide valuable, detailed ethnographic examination of religious practice in particular localities on Taiwan (e.g. Jordan 1972, Harrell 1974, Seaman 1974, Baity 1975). To all these approaches, Mr. Donnelly's book offers new data with a useful and complementary focus.

Certainly we all owe Mr. Donnelly a debt of gratitude for sharing this information with us, introducing an important religious artwork or craft tradition to the public, and providing this very visually appealing window on current issues of Taiwanese and Chinese identity. Taiwanese and Taiwanese-Americans who have helped to support this publication recognize the important role that these deities play in Chinese and Taiwanese culture – as an inspirational religious pantheon of course, but also as elements of current popular culture now found in films, advertising, videogames, and other modern-day reinterpretations. I do not know whether Mr. Donnelly's

skills in journalism and diplomacy preceded or derived from his stint as the USIS director on Taiwan. In any case, those skills shine through in this book's clarity of writing and in the respectful appreciation he gives to the opinions of all the (often irreconcilable) sources whom he interviews.

Recognizing that the author has already written his Acknowledgements, I want only to add a note of acknowledgement from the Smithsonian as well. In addition to thanking Mr. and Mrs. Donnelly for sharing their collection with us and with the public, we thank the many supporters of our Taiwan Heritage Project (including members of the Taiwanese Association of American), the Taipei Economic and Cultural Representative Office in the U.S.A. (TECRO), and also Taiwan's Council for Cultural Affairs, Executive Yuan which assisted with the Smithsonian's costs of photographing the collection for our research database as well as this publication. Among Smithsonian staff, special thanks are due also to Michel D. Lee (李東), Taiwan Heritage Project coordinator, to photographer Donald Hurlbert who, with the help of Michel D. Lee and Kate Earle, photographed most of the collection, and to copy editor Diane Della-Loggia.

Washington, D.C., USA. December 2005
Paul Michael Taylor
Director, Asian Cultural History Program
Smithsonian Institution

Bibliography

Adler, Joseph Alan
2002 *Chinese Religions*. London: Routledge.

Allan, Sarah, and Alvin P. Cohen, editors
1979 *Legend, Lore, and Religion in China: Essays in Honor of Wolfram Eberhard on His Seventieth Birthday*. San Francisco: Chinese Materials Center.

Baity, Philip Chesley
1975 *Religion in a Chinese Town*. Taipei: Chinese Association for Folklore.

Clart, Philip, and Charles Brewer Jones, editors
2003 *Religion in Modern Taiwan: Tradition and Innovation in a Changing Society*. Honolulu: University of Hawai'i Press.

Davison, Gary Marvin, and Barbara E. Reed
1998 *Culture and Customs of Taiwan*. Westport: Greenwood Press.

Dean, Kenneth
1993 *Taoist Ritual and Popular Cults of Southeast China*. Princeton, N.J.: Princeton University Press.

Donnelly, Neal.
1990 *A Journey through Chinese Hell: Hell Scrolls of Taiwan*. Taipei: Artist Publishing Company.

Feuchtwang, Stephan
1992 *The Imperial Metaphor: Popular Religion in China*. London: Routledge.

Gates, Alan Frederick
1979 *Christianity and Animism in Taiwan*. San Francisco: Chinese Materials Center.

Harrell, Clyde Stevan
1974 *Belief and Unbelief in a Taiwan Village*. New Haven: Human Relations Area Files.

Jones, Charles Brewer
1999 *Buddhism in Taiwan: Religion and the State, 1660-1990*. Honolulu: University of Hawai'i Press.

Jordan, David K.
1972 *Gods, Ghosts, and Ancestors: The Folk Religion of a Taiwanese Village*. Berkeley: University of California Press.

Jordan, David K., and Daniel L. Overmyer
1986 *The Flying Phoenix: Aspects of Chinese Sectarianism in Taiwan*. Princeton: Princeton University Press.

Katz, Paul R., and Murray A. Rubinstein, editors
2003 *Religion and the Formation of Taiwanese Identities*. New York: Palgrave Macmillan.

Seaman, Gary
1974 *Temple Organization in a Chinese Village*. Taipei: Chinese Association for Folklore.

Shahar, Meir, and Robert P. Weller, editors
1996 *Unruly Gods: Divinity and Society in China*. Honolulu: University of Hawaii Press.

Stevens, Keith
1997 *Chinese Gods: The Unseen World of Spirits and Demons*. London: Collins &Brown.

Sutton, Donald S.
2003 *Steps of Perfection: Exorcistic Performers and Chinese Religion in Twentieth- Century Taiwan*. Cambridge: Harvard University Asia Center.

Wei, Henry Yi-min ["Henry Wei Yi-min"] and Coutanceau, Suzanne
1976 *Wine for the Gods: An Account of the Religious Traditions and Beliefs of Taiwan*. Taipei: Ch'eng Wen Publishing Company.

《台灣的神像》序

　　在台灣，神像一般都放在公共廟宇與私人神壇裡，本書所描寫的神像亦是如此。對於居住在華府地區的我們來說，能夠就近觀賞由尼爾‧唐能理和瓊安‧唐能理所收藏的台灣宗教藝品，實屬幸運，而其中一些神像的故事便是本書的主題。

　　唐能理夫婦曾將兩套各十卷的〈地獄十殿圖〉捐贈給史密森尼博物館，這些卷軸曾在1990年成為藝術家出版社印行的《中國地獄之旅》一書的主角，並在同年我們舉辦的展覽中巡迴展演，獲得熱烈迴響。「中國地獄之旅：台灣的〈地獄十殿圖〉」展（A Journey Through Chinese Hell: Hell Scrolls of Taiwan）從史密森尼博物館的國立自然歷史博物館（National Museum of Natural History）出發，之後陸續巡迴至美國各地，為不同的觀眾提供觀賞與教育素材，包括舊金山的華僑文教服務中心（Chinese Cultural Center），加州聖塔安那市寶爾博物館（Bowers Museum），以及伊利諾州昆西市藝術中心（Quincy Art Center），最後於1997年3月在夏威夷州立大學曼歐亞分校美術館畫下句點。這次展覽的收藏目錄（唐能理 1990）既呈現出展覽中地獄十殿的陰間主題，也是其藝術品的介紹。

　　自那時起，史密森尼博物館國立自然歷史博物館人類學部門便擴充了原有的「亞洲文化史計畫」中與台灣文化史有關的研究範疇和外部公共活動，而多虧華府地區全美台灣同鄉會（TAA-GWC）許多台美人士的奔走，史密森尼博物館在2004年2月更制定了「台灣文物計畫」，致力於台灣文物的保存。近來，這些熱心的支持者與駐美台北經濟文化代表處（TECRO）也協助史密森尼博物館在華盛頓開辦了一系列的演講、表演和活動，包括「台灣文物節」中廣受歡迎的舞蹈和技藝（如麵塑、草編、剪紙）及各項科學演講，如柯吉生博士（Ko Chi-sheng）論體質人類學的演講，以及他以自己在台北土城的收藏為主題發表的纏足史料文化和藝術紀錄演講。在2005年5月的「台美友好週」期間，台北體育舞蹈團也為博物館吸引了大批人潮前來觀賞以台灣原住民、東亞民族舞蹈、武術和其他形式的多元文化傳統為根基的特技和民俗舞蹈的創新表現。

　　和這些新近的公共活動同樣重要的是，我們的觀眾也瞭解到，收藏品背後的研究工夫同樣不可忽視。除了對史密森尼博物館本身的藏品進行研究外，「亞洲文化史計畫」也正以和此文物計畫相關的私人收藏品為對象，逐步建立起研究資料庫。在「台灣文物計畫」進行之初，我們的常設目標之一，即是為唐能理夫婦的台灣神像收藏建立攝影和文件研究資料庫，包括本書所提及的所有資料，以及它未提及的其他較不為人知、或系出同源的例子。

　　做為本書主題的唐能理收藏品，其規模是其他收藏機構難以望其項背的。正如本書所言，它是台灣文化和宗教文物的一個重要資訊來源。唐能理先生在1969年至1981年任美國駐

台外貿人員期間，陸續收集了這些神像，對美國本地或甚至全世界而言，他的台灣神像收藏也許都是最可觀的；而對英語讀者來說，本書的出版尤其顯得重要，因為大多數相關主題的出版品都是以中文寫成，對許多英語學者和有興趣的大眾來說都難以親近。

　　唐能理的收藏和本書的出版都十分難得，因為現任台北美國新聞處（USIS）處長的唐能理先生在書中訪問了許多雕刻師和使用神像的人。每座神像的出處紀錄，以及唐能理獲得的口頭陳述，構成了本書珍貴無比的第一手資料。在駐台期間，唐能理以採訪信徒和廟祝的方式對每座神像進行研究，他的敘述以自身的經驗和史料研究出發，圍繞著他所收藏的物件進行。因為如此，本書有別於其他由非收藏家所撰述的民族誌紀錄，而和著名的英國神像收藏家（同時也是本書〈前言〉的作者）史蒂文生（Keith Stevens）的著作相似（特別是史蒂文生 1997 年的作品）。其他也有著迷於同樣主題但苦無門路接觸此類收藏的外國遊客撰述；另外，來自澳洲的考坦絲（Suzanne Coutanceau）和 魏益民（Henry Wei Yi-min）合著的精采著作《獻神酒》（Wine for the Gods）（Wei and Coutanceau 1976），對台灣一年四季的各種慶典，以及卜卦、算命等習俗皆有描述，為可讀性與知識性均高的著作。然而唐能理先生的著作較近於物質文化研究，在方法和歷史陳述上則較接近民族誌的系統論述。

　　喬登和歐維梅爾（Jordan and Overmeyer）在 1986 年的著作（特別是 1 至 15 頁）中，曾將這些方法與自己對中國宗教在台灣的地域研究串聯起來，詳加描述與檢驗。這些重要的研究——包括與信徒和木刻師等人之間的長談——都為歷史學者提供了難得一見的「基礎文本」，只是不可避免地，這些文本內的對話和訪談也受發問者的個人意圖所引導，受其個人解釋所影響。然而，雖然它們將神像置於特定的脈絡下解釋，但這個脈絡是真實而充滿資訊的，對日後的解釋與研究無疑仍深具價值。在唐能理先生的著作出版之前，從未有人在開始收藏之初或收藏途中即對世界各地的博物館或工藝美術館內的宗教收藏品進行如此富啟發性的研究。

　　近年來，這些神像和公開與私人的膜拜機構的重要性逐漸受到認可（如 Allan and Cohan 1979、Adler 1990、Feuchtwang 1992、Dean 1993、Schahar and Weller 1996、Jones 1999、Davidson and Reed 1998）。其他論及台灣民俗宗教傳統的重要英語資料主要來自傳教史料，其內容多半以多神信仰的傳統對基督徒的信仰變更或台灣基督教之形式的影響為主（例如 Gates 1979，特別是 247 至 256 頁的書目）。在克拉特和瓊斯（Clart and Jones 2003）以及凱茲和魯賓斯坦（Katz and Rubinstein 2003）所編的文集中的幾篇文章，則將重心特別放在近年來地方宗教習俗的轉變和台灣身分認同的重新定位上。其他的最新研究（例如 Sutton 2003 年論驅魔師的文章）

也著重於驅魔傳統與膜拜的關係，對雕刻或實質物件著墨不多。有些著作則詳盡提供了台灣各地宗教習俗的民族誌檢驗（如 Jordan 1972、Harrell 1974、Seaman 1974、Baity 1975）。對這些研究來說，唐能理先生的著作為它們提供了實用的補充資訊。

誠然，對於唐能理先生所提供的資訊，我們都需致上感謝之意。他將重要的宗教藝品或工藝傳統介紹給大眾，為我們提供了賞心悅目的窗景，使我們得以接觸今日台灣和中國身分認同的議題。協助此書出版的台灣人和台美人都明白這些神祇在中國和台灣文化裡的重要性，它們無疑是萬神之靈，而也是電影、廣告、電動玩具和其他當代流行文化之再詮釋的元素。我不清楚唐能理先生在報導文體和外交上的技巧是否來自於他任美國駐台新聞處（USIS）處長的經歷，但無論如何，他的技巧都清楚呈現在本書條理分明的寫作中，以及他對每位訪談對象經常南轅北轍的意見所給予的尊重與賞識裡。

有鑒於本書作者已在書中對各方人士表示感謝，我謹在此代替史密森尼博物館向以下諸位致謝。除了感謝唐能理夫婦的不吝分享外，我們也要感謝「台灣文物計畫」的許多支持者（包括全美台灣同鄉會的成員），駐美台北經濟文化代表處（TECRO），以及台灣文化建設委員會，它曾為史密森尼博物館提供財務協助，使我們的研究資料庫和本書的拍攝工作能順利進行。至於史密森尼博物館的工作人員，我們要特別向「台灣文物計畫」的協調人李東先生，在李東和厄爾（Kate Earle）協助下負責本書大部分拍攝工作的攝影師賀柏特（Donald Hurlbert），以及編審羅吉爾（Diane Della Loggia）等人，表示感謝。

美國華盛頓特區
2005 年 12 月
保羅‧麥克‧泰勒
史密森尼博物館「亞洲文化史計畫」主持人

FOREWORD

A number of books have been written about religious beliefs and altar images, but very few have offered a text illustrated solely from the author's own collection. Although the result of his research is the subject of this book, sensibly, the author has left the reader to evaluate the material.

Neal and I have "competed" down the years with our individual collections. Our goals were similar, but the fundamental difference laid in our fields of acquisition. Neal limited himself to Taiwan, whereas I, who spent many years in Southeast Asia and Hong Kong, found that my interest spread across the whole of China and Chinese communities worldwide.

When I set out to research Chinese iconography, I was amazed by the apparent lack of interest in or knowledge of deities by many Chinese, who assured me that gods were infinite, so there was little point in my trying to identify and categorize them. It took me some time to realize that the only people who could help me in my study were temple staff, god carvers, and the devotees themselves. I am sure the same was true for Neal.

Since I was first shown Neal's collection, I was intrigued by its form, mainly because it revealed a fascinating picture of the iconography carried by immigrants to Taiwan, primarily from Fuchien province but also from Kuangtung. Taiwanese religious beliefs, being a mélange of Fuchienese, Cantonese, Hakka, Chauchou, and Chekiang cultures, have led to descendants of differing linguistic groups and societies to accept a melding of religious cults and rituals.

The Chinese are extremely pragmatic people, and when something, including a god's statue, does not work, it is discarded. Neal and I are the benefactors of such pragmatism. Our images range from comparatively newly carved to battered old insect-ridden images, weathered by decades of sitting in sweltering heat and heavy condensation in households and temples. Each could tell a story.

I am often asked two questions: "How did you acquire your statues?" And, "why did the Chinese dispose of them?" My own images came mainly from two sources: purchases from antique dealers and gifts from former missionaries. As part of their commitment to Christianity, converts were required to dispose of their ancestral tablets and household images. Some missionaries brought home the discards as souvenirs. In such cases, I was able to verify their origins, which was crucial in my search for identifying features to clarify unique provincial or linguistic groupings. Most, but not all, antique dealers were of little use in this endeavor as they normally bought their wares in job lots and knew or cared little of their origin or identity.

The disposal of images that have lost effectiveness tends to follow a usual pattern and is more common for those on household altars than for temple statues. The spirit of a deity believed to be no longer resident in a temple statue could be requested to revisit the image. A ritual to rededicate the image will be performed, after which efficacy usually returns. A ceremony welcoming back the spirit of the deity will then be held on an auspicious day. However, when a family decides they can no longer trust that the spirit usually resident in their statue is still present - commonly by a failure of the spirit to provide satisfactory results to problems raised by devotees - they first obtain confirmation from a ritual master called to verify that the spirit had or had not departed. If not, the statue can be taken to a temple where the same deity is resident. After a ritual, including passing the image through incense smoke rising from the pot before the main altar and possibly sacrificing a cockerel, the statue would be returned to the household altar. If after a few months the image appears to be ineffective still, it would be taken to a god carver to fashion a duplicate. The original would be

left with the carver to dispose of, usually by burning.

As a point of interest, many carvers have assured me that cost is crucial to the subject. Without exception, they claim to be able to carve the most superb images, heavily decorated or completely covered in gold leaf, if the customer can afford it. But the majority of household deities are standard images, carved in a production line, as will be described by Neal. As such, statues are relatively inexpensive; it is not too great a burden to replace an image every five to fifteen years should the need arise.

To highlight the above, let me mention an incident in the life cycle of a few images. Many years ago, I was taking a tour with some twenty fellow members of the Hong Kong Branch of the Royal Asiatic Society around Taiwanese temples, and we stopped in Lukang to visit a row of god carver shops. To my surprise, there were about ten old images, some in very good condition, standing on the pavement alongside the shop front. One of the tour members asked if they were for sale. "Take what you want" was the shop owner's reply. We left with a few lucky people clutching a deity on the airplane back to Hong Kong. Months later, I returned to Lukang and called on the same carver to see if he had any more unwanted images. His reply this time was disappointing, for he realized then that there was a market for such statues among foreign tourists. "No Chinese in his right mind," he said, "would dream of buying a secondhand image for his altar, for he would never know to what extent it had been 'occupied' by demons." I asked him where the rejects had come from. He said that they were brought to his shop after losing efficacy. Devotees did not wish to retain them and, not knowing how to dispose of what had been sanctified, left them in his shop. Despite his fear of these rejects, he kept them for they were once sacred. Eventually, he decided to dispose of them by leaving them outside where, if demonic forces had possessed them, they would not be able to harm him.

In folk religion temples in Southeast Asia, in Singapore especially, there are a number of temples with a side altar reserved for donated household deities brought there by young moderns faced with the problem of unwanted statues. Although not themselves religious, they hesitate to casually discard deities elderly relatives had spent their lives revering.

Neal and I have followed similar routes during our services in Asia with our fascination in and rapport with Chinese temple life, religious rituals, and most of all, the stories related by temple staff and devotees, some of whom were kind enough to invite us into their homes to admire their household deities.

Many of Neal's experiences and research are recorded here for our delight.

by **Keith Stevens**

前言

　　世面上有許多介紹宗教信仰和祭壇神像的書，但很少有一本書是以圖文專門介紹作者的私人收藏。雖然作者的收藏成果最終形成了這本書，不過顯然他也願意讓讀者來品評他的研究內涵。

　　本書作者唐能理和我多年來一直在私人收藏上「互相較勁」。我們的目標很相近，但由於地域性的不同，所以斬獲也不同。唐先生把他的範圍侷限在台灣，我則由於在東南亞和香港居住多年，感興趣的範圍已遍布整個中國，廣達全球華人地區。

　　不過當我準備要研究中國的神像時，我很驚訝相當多的中國人對神明所知不多，甚至擺明不感興趣，他們總是跟我說神明多如繁星，要辨別各個神明並做分類，只會落得徒勞無功。我白白耗費了許多工夫，才明白只有幾種人能幫我進行研究，那就是廟方的人員、神像的雕刻者，以及信徒。我相信唐先生也和我有同樣的狀況。

　　既然我有幸先看到唐先生的收藏品，就有必要介紹整體的概況，這些神像最讓人感到有趣的是它們是從中國分靈到台灣的，大多來自福建省，也有從廣東來的。台灣的宗教信仰透過來自福建、廣東、客家、潮州和浙江等的文化，經過世代的融合，而發展出不同方言的族群和社區，有著「在地化」的宗教流派和儀式。

　　中國人是非常務實的民族，當某樣東西（包括神像在內）失去功用的時候，就會把它丟棄。唐先生和我都是在這種實用主義下的受惠者。我們的收藏品有剛雕刻好的，也有毀壞遭蟲蛀的；有數十年在戶外被風吹日曬的，也有在廟宇或房舍中壓箱多年的。每一尊像都訴說著一個故事。

　　我經常被問到兩個問題：你是如何得到你的雕像的？還有，為什麼中國人要把它們丟掉？我的雕像主要是從兩個方式獲得：一是向古物商購買，還有些是前任的傳教士送給我的。有些人改信基督教以後，就必須把他們的祖先牌位和家中的神像丟掉，於是有些傳教士就把這些被丟掉的神像帶回去當紀念品。在這種情況下，通常就能夠了解神像的來歷，這對分辨不同省分或不同方言地區的製作特色十分重要，而在這方面，大部分的古物商（但不是全部）都無法幫上忙，因為他們通常只管進貨，對雕像的來歷或身分卻一無所知，或不感興趣。

　　那些被視為不靈的神像通常會循一個模式拋棄，這種模式尤以家中的神壇最常見。而當人們相信廟中的神像不再具有神靈時，可以採取再度請神的方式。這時會舉行請神的儀式，然後神靈通常就會回來了。廟方會選擇一個黃道吉日請神明回來。不過，當一個家庭認為他們所信奉的神像不再具有神靈時——通常是因為家中的祭拜者向神明祈求後沒有得到滿意的結果，或是遭致某些麻煩——他們會先請法師來確認神靈是否已經離開了。如果還在，這尊雕像就會被帶到有相同神像，但是有神靈的廟裡。然後再透過一個儀式，像是把雕像跨過插著香火的香爐上，或是殺一隻公雞作為牲禮，這樣神像就可再回到家中的神壇上了。如果經

過了好幾個月，這尊神像還是不靈時，就會被帶到雕刻神像的師傅那兒，用一尊新的雕像來取代。至於原來那一尊就交由雕刻師傅處理，通常是被燒掉。

我很好奇的與許多雕刻師傅談過，他們都會向我強調花費的成本與製作品質有極大的關聯。他們無一例外地宣稱能雕出最頂級的雕像，只要顧客能負擔得起，他們就能製作出金碧輝煌或是全身布滿金箔的雕像。不過大多數家庭裡的神像則是很標準化、生產線的製作規格，就像唐先生在書中的描述。這種情形的雕像通常價格也不貴，如果每五年到十五年要換一尊新的或是添購新的雕像，也不會是太大的負擔。

關於某些神像的生命周期，我想到還有一件很有意思的事。多年以前，我帶著皇家亞洲學會香港分會的二十來位會員遊歷台灣的廟宇，當我們造訪鹿港一整排神像雕刻店時，我很驚訝地發現有大約十尊舊的神像就沿著店舖前面的人行道擺著，有些看起來狀況還很好。有位會員就問那些是否待售，結果商店的老闆說：「你想要就儘管拿。」於是有幾位好福氣的會員便捧了一尊神像搭機回香港。幾個月之後，我回到鹿港再度造訪那家店面，想看看還有沒有棄置的神像。但是這次老闆的回答讓我很失望，因為他發現那種神像對外來觀光客是有市場的。他還說：「腦袋正常的中國人，是不會想要買一尊二手神像擺在家中神壇上的，因為他們沒法知道那尊神像是否曾被什麼樣的邪靈侵占過。」我問他這些被拋棄的神像是從哪兒來的，他說是因為人們覺得神像不靈了，就拿到他的店裡來。原先敬拜的人不想留下神像，但又因為曾經敬拜過所以不知如何處置，便送到他的店裡。收下這些被人棄絕的神像固然會令他不安，但他想到那些畢竟是被人們敬拜過的，便留了下來。最後，他決定把它們棄置在戶外，那麼就算它們曾經被惡靈侵犯了，也傷害不了他。

在東南亞的民間信仰廟宇，尤其是新加坡，常會看到一些廟的旁邊有一個神壇，裡頭擺的是一些家庭裡不要的雕像。年輕的世代往往非虔誠教徒，但看到家中那些以前的長者常年虔誠祭拜的神像也不敢隨便亂丟，便帶來此放置。

唐先生和我在亞洲任公職的期間都有類似的情形，我們都著迷於中國的廟宇、宗教儀式，尤其喜歡聽廟方人員和信徒講述種種故事，有些朋友還很熱情地招待我們到他們家中作客，並敬拜他們所信奉的神明。

我們以喜悅的心情將唐先生豐富的經驗與研究在此呈獻給您。

凱斯・史蒂文生

AUTHOR'S NOTE

The statues in this collection were purchased between 1969 and 1981. The newest was carved sometime around the end of the Japanese Occupation, the oldest in the mid-nineteenth century.

In the eleven years I lived on Taiwan (1966-1972 and again 1975-1981), I collected over 200 statues of various gods and other religious artifacts. Today, they adorn the walls of my home in Chevy Chase, Maryland, just north of Washington, D.C. It is impossible to enter any room in my house without thinking of Taiwan. For our many Taiwanese friends who visit us often, the statues are silent reminders of home.

One such visitor, Hwang Chun P'ing, President of the local Taiwanese Association of America, urged me to exhibit some of them for the 2003 Taiwanese-American Heritage Week. Naturally, I agreed.

The exhibition was held the weekend of May 17 at Twin Oaks and was co-sponsored by the Friends of Twin Oaks. Twin Oaks, the former home of telephone inventor Alexander Graham Bell, is a magnificent house surrounded by 18 wooded acres set in the middle of one of Washington's most prestigious neighborhoods. Before America's diplomatic derecognition of Taiwan, it was the residence of the Republic of China's Ambassador. It is now under the control of the Taipei Economic and Cultural Representative Office and is used for cultural and other events.

The exhibition was held, and it was a success. At the opening ceremony, I spoke about the ins and outs of collecting religious artifacts, especially statues. During the days of the exhibit, I stayed in the hall to answer questions about the display. The interest in the statues surprised me. Washington is an international city, so naturally there were many Europeans and other international residents, as well as Americans who came for the exhibit and to enjoy the other Heritage Week events, which included a Nan Kuan Opera performance and a Taiwan food bazaar. But it was the Taiwanese - for whom the sight of so many familiar statues evoked strong emotional memories - who seemed to appreciate the exhibit most.

For each statue, I wrote a two or three paragraph identification. Many, including Mr. Hwang, urged me to write a book expanding on the identifications, including material about religious practices on Taiwan. At first, I was reluctant, fearing that interest would be slight and others on Taiwan could do a better job. But as more and more Taiwanese pushed for such a project, I relented. This book is the result of their prodding.

There are over 300 main gods and numerous attendant deities worshiped on Taiwan. No book could possibly cover the subject adequately. Only a specialized encyclopedia could do the job. Although I cannot produce an encyclopedia, I can write about my collection. I make no pretense at comprehensiveness. For one thing, my collection is not complete. For another, religious practices and legends associated with individual gods vary from one community to another, so some of what I write may seem at odds with what one or another individual may hold to be the case. I can only record what I have learned from talking to temple staffs and worshipers and what I have researched in books or read in the daily press.

Since my collecting covered the years 1969 to 1981, much about Taiwan's cultural and social environment of that period as it relates to my adventures in acquiring religious artifacts will be included. Since the

1970s, Taiwan has undergone not only an economic transformation but also a benign cultural revolution.

Because of the industrial and technological progress, cities have expanded, incorporating surrounding villages. Factories and bedroom communities encroached on agricultural areas to the detriment of rural land and life. Transportation and communication have homogenized much of the culture and blurred the distinction between city and village.

Giant cement statues have risen all over the island; *paipais* (a general term covering a variety of religious rites and celebrations) have become more extravagant; and automation has crept into worship patterns with machines vending divination slips. Visits can be made to mother temples in Fuchien and other provinces, an unthinkable journey during the years I lived on Taiwan. Importation of god statues from China, again unthinkable before, has further hastened the decline of the local carving industry.

With the new wealth came bigger and more influential temples. When I lived on Taiwan, temples were used as venues for election speeches, and temple committee members could influence matters locally. Some large temples now attempt to exercise political influence nationally and in at least one case, became involved in the 2000 United States presidential election.

For some of the young readers, much of what I have described may seem foreign, but what has not changed is the central role of religion, temples, and gods in the lives of ordinary citizens.

With a few exceptions, I have used the Wade-Giles Romanization system throughout. Chinese characters are included in the appendix. Chinese is a tonal language. For each monosyllable, there may be a number of meanings. It will be useful for the reader to keep in mind the following frequently used words: *Szu* means a Buddhist temple. Other temples use *miao* and *kung*. *Kung*, when referring to a person, means duke. *Wang* means king. For Chinese personal names, the familyname is given first, followed by the given name.

著者序

這些收藏的雕像購於 1969 ～ 1981 年。

年代最久的雕像刻於十九世紀中葉，最新的則爲日本占領時的末期。

在我居住台灣的 11 年期間（1966-1972, 及 1975-1981），我收藏了兩百多尊各種神明的雕像以及一些宗教藝品。現在它們正布置在我位於美國華盛頓特區北方，馬里蘭州雀威雀斯鎮（Chevy Chase）家中的牆面上。走進這棟屋子的任何一個房間，都不可能不想起台灣。對一些常來此造訪的台灣朋友來說，這些雕像也沉靜的牽引他們思鄉之情。

其中一位朋友，也就是擔任華府地區全美台灣同鄉會的會長黃俊平（Hwang Chun P'ing）先生希望我提供部分收藏於「2003 年台美文物週」上展出，自然我就同意了。

這項展覽由雙橡園之友（Friends of Twin Oaks）共同主辦，於 5 月 17 日的週末在雙橡園（Twin Oaks）展出。雙橡園位在華盛頓最雅致的地區之中，此處原本是電話的發明人貝爾（Alexander Graham Bell）的宅邸，建築十分宏偉，四周有蒼鬱的林木，占地達 18 英畝。在中美斷交之前，這裡曾是中華民國駐美大使的使館，2005 年起成爲台北經濟文化代表處的辦事處，以處理文化及其他事務爲主。

這次展出十分成功。在開幕儀式上，我提到了收藏這些宗教藝品，尤其是神像的緣由和過程。在展覽的那幾天，我都待在大廳解說與展品相關的問題。大家對神像的高度興致讓我感到十分驚訝。華盛頓是個國際大城，自然地這裡也住著許多來自歐洲或其他各國的人士，所以這次文物週除了美國人以外也吸引不少國際人士前來觀展或欣賞各項活動，其中有南管歌仔戲演出、台灣美食展等等。不過對本地的台灣人來說，他們看到那麼多熟悉的神像赫然在目，頓時勾起了強烈的過往情懷，也流露出對這項展覽深摯的謝意。

對於每一座展出的神像，我都寫了兩、三段的說明文。黃會長以及許多觀展的朋友看到後，便鼓勵我把說明文再多擴充資料，添加介紹台灣的宗教儀式和活動來集結成書。起初我十分抗拒，我擔心對此題材感興趣的人不多，同時也覺得這個主題由其他台灣的人士來寫應會做得更好。不過由於有越來越多的台灣人頻頻相勸，我只好順從，這本書正是在他們督促下的成果。

台灣地區信仰的主要神祇就超過了三百多種，另外還有難以計數的隨侍神明。要把這個主題完整無遺的撰述在一本書上，是不可能的事，除非是以編專門性百科全書的方式才有辦

法做得完善。不過雖然我不能創製一部百科全書，但我可以寫我的收藏。我未曾妄想使本書成為廣博而詳盡的專書，原因之一是我的收藏並不齊全；另一個原因是宗教儀式和各個神明的傳說故事往往在不同的群眾中有不同的說法和做法，所以在讀本書時，有時會看到同一神明的描述偶或有所差距。我只能盡可能地記下我與廟方的工作人員、信徒的訪談所得，以及對書籍、報章資料的研究心得。

由於我所收藏的時期涵蓋了 1969 至 1981 年，因此當時的台灣文化與社會環境也就與我所能獲得的宗教藝品有相當的連帶關係。自 1970 年代開始，台灣在經濟上有了大幅的轉變，同時在文化層面上也有良好的革新。

因著工業和科技的進步，城市向外開拓，延伸到周遭的鄉鎮。單純的農耕地被工廠和小型社區侵入，改變了鄉村的地貌和生活型態。交通運輸的便捷，使得城鄉的差異減少，也使各地區原有的文化特質逐漸被模糊了。

在這座島嶼上到處立起了巨大的水泥雕像，「拜拜」這種宗教儀式變得越來越奢華；甚至連自動化設備也潛入崇拜的形式中，像是利用自動販賣機來送出占卜的籤條等等。進香之路有時會遠到中國大陸的福建或其他省分的祖廟，這對當時住在台灣的我來說真是難以想像的旅程。同樣令人不解的是，信徒將神像從中國一一迎回台灣，導致本地的雕刻業迅速衰退。

隨著社會繁榮，有些廟宇逐漸壯大並具相當的影響力。我住在台灣的期間，看到廟宇被用來做為選舉演講時宣誓的場所，而廟方的委員往往對地方事務產生影響。有些大型的廟宇甚至試圖影響國家的政治，包括涉足美國 2000 年的總統大選。

對一些年輕的讀者來說，或許會對我所敘述的內容感到有些陌生，不過始終不變的是那些宗教上的主角、廟宇，以及神明在一般民眾生活上的意義。

本書除了少數的例外，我大多採用了韋傑式（Wade-Giles）羅馬拼音，其中文字彙則包含在書末的附錄中。中文是種音調的語言，每一個單音節的字都往往代表幾種不同的意義。書中有幾個常見的字，讀者不妨先記起來：「寺」表示一座佛教的廟宇，有的廟宇也用「廟」或「宮」來稱呼。「公」指的是人物，意思是君主。「王」是指帝王。至於中國人的名字，則是姓氏在前，名在其後。

ACKNOWLEDGMENTS

I am obliged to two members of the Washington chapter of the Taiwanese Association of America for their support of this project. Hwang Chun P'ing first suggested a book on my collection and later helped with the calligraphy. Robert Yi Hsiung Lai read the manuscript and offered several useful suggestions.

Former Taiwan Representative in Washington, Ch'en Chien Jen, and his wife, Yolanda Ho, were primarily responsible for the success of an exhibition of my statues at Twin Oaks. That exhibition was the launching pad for this publication.

Lawrence Chin Yi Wei advised on the translation of poems and inscriptions, and Tsao Yi Ying helped with the appendix. Wang Hsu Ping, a master woodcarver in Taipei from whom I purchased many statues, gave freely of his time explaining carving techniques and giving clues to identification.

Jerry Chin Tun Lai, a colleague and friend for three decades, deserves a special word of thanks for accompanying me on countless visits to Taiwan temples and interpreting religious ceremonies and customs. I am grateful for his careful reading and blue-penciling corrections of this manuscript. Patricia Ayers, a colleague from my Taiwan years, also read the manuscript with an editor's critical eye.

Thanks go to Dr. Paul Michael Taylor, Director of the Asian Cultural History Program, Smithsonian Institution, and his staff, especially Michel Dong Lee, for their advice and assistance in guiding this book to final publication. Smithsonian editor, Diane Della-Loggia, advised on style, and Smithsonian intern, Tiffany Ann Pei Liu, was an invaluable aid.

More than anyone, I owe a deep debt to Keith Stevens, an acknowledged authority on Chinese temple statues. He read, re-read, and commented on every chapter. His invisible hand is present on every page.

Finally, thanks go to my wife, Joan, whose proofreading smoothed the English prose.

誌謝

在此我要向兩位全美台灣同鄉會華聖頓分會的會員誌謝，一位是黃俊平先生（Hwang Chun P'ing），他建議我將個人的收藏研究出版成書，並協助撰寫書法；另一位則是賴義雄先生（Robert Yi Hsiung Lai）幫我校對稿子並提出許多很好的建言。

我的雕像收藏得以在雙橡園順利而成功地展出，最大功臣是台灣前駐美代表程建人先生及他的妻子何友蘭女士。由於那次展覽，才有這本書的出版。

魏欽一先生（Lawrence Chin Yi Wei）對本書的詩詞和銘文翻譯提供了許多建議，曹逸盈小姐（Tsao Yi Ying）協助書末的附錄。我的許多雕像都是購自台北的木刻大師王許炳先生（Wang Hsu Ping），他總是毫不吝惜的向我解說雕刻技術並教我辨識的訣竅。

我要特別感謝的是我三十年的同事兼好友秦湯來先生（Jerry Chin Tun Lai），他陪我走遍了台灣各地的廟宇，並向我解說宗教儀式和習俗。我也很感激他幫我校閱這份文稿。派翠西亞·艾爾（Patricia Ayers）是我在台灣工作時的多年同事，也以專業的編輯眼光為我校對本書。

另外也要謝謝史密森尼博物館亞洲文化歷史專案小組的總指導保羅·麥克·泰勒教授（Paul Michael Taylor）以及他的組員，尤其是麥克·唐·李東（Michel Dong Lee），由於他們提供許多寶貴的意見及多方協助，使得本書得以出版。史密森尼博物館的編輯黛安·黛拉—羅吉爾（Diane Della-Loggia）也對書本的風格提出建言，還有博物館的安佩琉小姐（Tiffany Ann Pei Liu）都給我很多幫助。

在所有人當中，我要致最大謝意的是公認的中國寺廟雕像權威——凱斯·史蒂文生（Keith Stevens），他一遍又一遍的閱讀、評論每一個章節，這本書的每一頁都有他無形的指導。

最後，還要謝謝我的妻子瓊安（Joan）為我潤飾英文的詞句。

THE PANTHEON

A visit to a Taiwanese temple often leaves foreigners with the impression that religion in Taiwan is in a chaotic state. Buddhas share a common altar with Taoist and animistic statues. Two temples dedicated to the same god can have a completely different mix of accompanying statues and attendant gods. Popular deities at times are relegated to a corner niche while a local deified spirit is the center of worship. Up to 100 statues are sometimes crowded into small temples.

In the decade of the 1970s, there were between 7,000 and 8,000 temples on Taiwan. This number did not include "home altars," where neighbors may worship a reportedly efficacious statue. Nor did it include the several thousand miniature field temples to the Earth God, nor the thousands of shrines to hungry ghosts, euphemistically called "good brothers," dotting the landscape where the spirits of orphan souls reside, nor "god niches" in business establishments.

World history seems to be nothing but a recitation of religious antagonism and conflicts. China is no exception. Yellow Turbans, White Lotus, Taiping Zealots, Righteous Fists (Boxer Rebellion), and the suppression of religions by the People's Republic of China punctuate over 5,000 years of its history. Taiwan is an exception. In spite of a virtual saturation of gods, Taiwanese society is surprisingly free of religious parochialism.

Religion in Taiwan bears a strong local stamp. Custom and worship vary to some degree from village to village or from city district to city district. Nevertheless, despite the apparent confusion, there is order and even logic to Taiwanese folk worship.

The worship of animistic spirits, ancestors, legendary personages, Taoist immortals, Confucian sages, and traditional Buddhist saints, which at various times have been popular or even dominant in China, all survive on Taiwan. Seemingly nothing from China's long religious past has been discarded. Animistic gods that remain important include the Jade Emperor (personification of Heaven), Tu Ti Kung (the Earth God), San Shan Kuo Wang (the Three Mountain Kings worshiped by the Hakka), and the Sun God and Moon Goddess.

Prominent deified spirits of sages or heroes are Confucius, Lao Tzu, Kuan Kung, and Cheng Ch'eng Kung, better known in the west as Koxinga, the Ming patriot who in the seventeenth century drove the Dutch from their Taiwan stronghold. Modern heroes recognized as gods on Taiwan include: General Li Kuang Ch'ien, who died in 1949 in the battle of Kinmen and whose statue in full military uniform is enshrined as the main god in a small temple in Chin Ning *Hsiang*, Kinmen;[1] former president Chiang K'ai-shek, who is deified as Jen Te Chen Chun, a title (learned through divination) that was conferred by the Jade Emperor[2] (a photo of him in plain military dress and seated on a simple chair can be seen in the colored pages of Tung Fan Yuan's book on folk beliefs);[3] and Morikawa Seijiro, a virtuous Japanese police officer. His image (fig. 92) is carved wearing a blue uniform and sitting on a bench with his ceremonial sword held upright between his legs with both hands.[4]

Mythical figures still revered are, among others, P'an Ku (the creator of the universe) and Sun Wu

K'ung (Monkey, the hero of one of the most famous tales in Chinese literature).

Animals and even inanimate objects are not neglected in the Chinese pantheon. General Horse, General Ox, and Lord Tiger, three of the most popular, while never enshrined as main gods, appear in numerous temples. Important deified objects include Tsao Chun (Stove God), the Door Gods, and the god of the moat. The Stove God (Kitchen God) is by far the most worshiped, as his paper effigy appears over the household stove. The god of the moat, better known as the City God, is the most important administrative deity in each good-sized municipality.

Deified inanimate objects at times are given prominence over established gods. An extreme example is the temple to Lord Stone in Shih Lin, a northern suburb of Taipei. Aborigines inhabited the area until the arrival of Changchou immigrants in the middle of the eighteenth century. At the foot of a small hill is a gigantic rock that aborigines worshiped as a god. After the original inhabitants were relocated, Changchou people carried on worship to such an obviously sacred stone. In time, a Chinese-style temple was built, and a statue of a god in military dress was carved. Sharing worship in the temple, but in subordinate positions to Lord Stone, are the Buddhist Kuan Yin, the Taoist Lu Tung Pin, and the animistic Tu Ti Kung.

Worship of objects, while not the rule in Taiwan, is far from uncommon. Workmen attempting to remove a large rock while building a highway in Taichung *Hsien* (county) encountered opposition from villagers who believed the rock was the resting place of a young girl who had drowned close by. They feared disturbing the stone would anger her spirit and cause trouble for nearby residents.[5] The Taitung authorities ran into similar opposition from villagers when they attempted to remove a boulder obstructing a stream's flow. Thirty villagers from Wen Ch'uan Ts'un in Pei Nan *Hsiang* protested, claiming the rock was a god that, in the past, had prevented flooding.[6] Spirits are also believed to inhabit a number of banyan trees in southern Taiwan.

With the exception of those who are exclusively Buddhists, most temple goers would agree that the Jade Emperor (Yu Huang Ta Ti) is supreme. A few even go as far as including Jesus and Mohammed as the Jade Emperor's subordinates. I visited a small Taipei temple where carved statues of Mohammed and Jesus rested on a side altar. Sometime later, they were spotted and photographed by Keith Stevens who discovered them in a Taipei antique store where they were for sale. Apparently, the statues were either unpopular additions or perhaps not efficacious. As far as I know, this was the only attempt to place Moslem and Christian deities in the pantheon in such a graphic way.

Although supreme, the Jade Emperor is not necessarily the most important god for the ordinary person. The Kitchen God is likely to loom far larger in the worship pattern, for he is ever-present in the nerve center of the household. From his position over or near the stove, he is able to monitor gossip and learn the affairs of family members. Prior to each New Year, he returns to Heaven where he reports directly to the Jade Emperor on individual conduct. Unlike the Christian Supreme Being, the Jade Emperor is neither omniscient nor omnipresent. Thus, just as a peasant would not dare to make an appeal directly to a mandarin but would seek a well-connected intermediary, few approach the Jade Emperor with their problems. They are more likely to address their petitions to lesser, more local gods.

Although lacking a well-defined hierarchy, there is some order to the Chinese pantheon. Gods fall naturally into such groups as patron, subordinate, attendant, and spouse gods. For example, Confucius and Wen Ch'ang are considered patrons for the educated elite, Matsu for seafarers, Pao Sheng Ta Ti for medical doctors, and Shen Nung Ta Ti for herbal doctors.

Merchants, being one of the dominant classes in Taiwanese society, have two patrons: Kuan Kung and Tu Ti Kung. The story is told that while Kuan Kung, a famous general during the Three Kingdoms

Period, was detained by Ts'ao Ts'ao, he kept a careful record of his expenses and repaid them upon release. For this reason, merchants credit him with establishing the accounting system and consider him their special patron.

In addition to being one of the businessmen's patrons, Tu Ti Kung has responsibility for land as well and is regarded by many farmers and urban householders as the first resident of their plot of land. So in a way, he is an ancestral figure. The Taiwanese, in describing his ubiquitous presence, say, "at the head and foot of each paddy field, there can be found a Tu Ti Kung temple." In the countryside, tiny brick structures, most no bigger than large dollhouses, serve as his temples. They guard unspecified, yet clearly understood territory. In the city, his temples are invariably larger than their rural counterparts. If a community fails to prosper, the faithful will blame Tu Ti Kung, and his temple will be neglected and fall into disrepair. Beyond a doubt, Tu Ti Kung temples are the most numerous in Taiwan. But many of the miniature variety, statueless and unattended, are not counted in the overall total of Taiwan temples.

Many of the Taiwanese gods are classed as subordinate gods. For example, Chu Sheng Niang Niang (prayed to by expectant mothers) has twelve subordinate baby amahs to assist her. The City God, the chief administrative god for a municipality, has a number of subordinates. Wen P'an Kuan and Wu P'an Kuan help him judge civil and martial affairs. General Hsieh and General Fan, better known as the Seventh and Eighth Lords, are his intelligence agents who roam the *yang* world (human realm) reporting on the behavior of its inhabitants. Additionally, it is also their duty to arrest the souls of the dead and bring them before the City God for preliminary judgment.

Cow-head and Horse-face are also on hand in City God temples to assist him in carrying out his judicial responsibilities. Some believe that if a *yang* world official mistakenly punishes innocent people while overlooking the sins of the guilty, the City God will ensure that these mistakes are corrected in the *yin* world (spirit realm).

Although somewhat illogical, Matsu is attended by two of the most famous soldiers in Chinese mythology: Ch'ien Li Yen and Shun Feng Erh (Thousand Mile Eyes and Efficacious Ears). The matchup of these two fanciful generals with Matsu, a pious girl who lived in the tenth century, does not seem to concern the Taiwanese in the least. Tu Ti Kung has only one subordinate: Hu Yeh (Lord Tiger). Commensurate with his low status, Lord Tiger rests on the floor beneath Tu Ti Kung's altar.

In addition to subordinate gods, there are attendants and servants who are the custodians of weapons, seals, or other symbols of office. Important female goddesses have *shih nu*s (waiting ladies). Kuan Yin has two special attendants who are known either as Shan Ts'ai and Liang Nu (Good Boy and Good Girl) or Chin T'ung and Yu Nu (Golden Boy and Jade Girl).

If a deity has a better than average record of granting petitions, the faithful will carve a spouse to keep the god company. This is true even for Tu Ti Kung, whose wife has a reputation as a shrew and is known to hold the common man in contempt. A particularly efficacious god may be awarded not only a spouse, but several concubines as well. Usually, their statues are placed beside the main god. However, if the temple is a large and important one, a separate altar will be reserved in their honor.

A prosperous temple will have several *fen shen*s, smaller replicas of the main god. When the god leaves the temple to make a yearly inspection or to join in another deity's birthday celebration, one of the *fen shen*s will make the journey in a sedan chair, because the main statue never leaves the temple. Some temples also have several smaller images that are lent out to the faithful seeking the god's intercession or to fulfill a vow.[7]

Sprinkled around on various altars may be a number of smaller statues that appear to have no

connection with the temple or the main god. There are a number of reasons for the presence of these "visiting deities." If, for example, there is a large regional group living in the area, a small representation of their god may be placed on one of the altars. Statues from destroyed or damaged temples can be given refuge in an alien temple. The personal statue of a shaman or some other religious practitioner who has left the profession may also be placed in a neighborhood temple. And lastly, many smaller statues are family gods that have been placed temporarily in a temple to be close to the beneficial influence of a powerful main god, thus increasing or rejuvenating the statue's power. This recharging of spiritual batteries is one of the most common reasons for the presence of these "visiting deities."

Gods on Taiwan are considered either *wen* (civil) or *wu* (military). Buddhas are *wen*, while many Taoist and animistic ones are *wu*. *Wu* gods sometimes have a number of *tangkis* (spirit mediums) who, according to some, are chosen by a god or goddess against their will. When possessed by the patron deity, they may speak in strange tongues, travel to the netherworld, or flagellate themselves with no apparent physical repercussion. It is not uncommon, especially in southern Taiwan, to see men and women slicing their tongues, piercing cheeks with needles, sleeping on beds of nails, climbing ladders with rungs of sword blades, or flailing themselves with spiked weapons. One needs a strong stomach to be a spectator at such religious ceremonies.

1. "Commander Li Kuang Ch'ien Dies a Hero," *Central Daily News*, October 25, 1979.
2. "Honor for the President," *Independence Evening News*, April 1, 1976.
3. Tung, *Understanding Taiwan's Folk Beliefs*, colored photo section preceding page one.
4. Stevens, *Chinese Gods*, p. 165.
5. *Taiwan Daily News*, February 20, 1976.
6. *Taiwan Daily News*, August 28, 1976.
7. Wolf, *Religion and Ritual in Chinese Society*, p. 52.

CARVING 雕刻

When settlers first moved to Taiwan from Fuchien, they brought statues from hometown temples with them. Later, master carvers followed. The first shops were in Makung, port city of the Pescadores. As Taiwan grew and temple construction increased, more and more carvers moved to Taiwan proper and set up shops in main cities. This trend continued up to modern times, interrupted only by wars or political upheavals that prevented free traffic across the Taiwan Strait.

For example, Lin You Ti's grandfather was a master carver in Fuchow. In 1977, *Independence Evening News* interviewed Lin. He said that his father followed in his grandfather's footsteps and that he continued the profession from his shop on Ti Hua Street in Taipei.[8]

Every large Taiwanese city has a number of wood carving shops, usually clustered around a major temple. There are three such areas in Taipei, the most important of which is within the shadow of the Lung Shan Temple, the second oldest and best known of all Taipei temples.

At the time of the interview, Lin said there were seventeen shops in Taipei and at least sixty throughout Taiwan that specialized in carving god statues. This number, down from a previous high, was declining, a fact echoed by Wang I Chuan, a woodcarver from Chilung who told the *China Daily News* in 1977 that although previously there were ten shops in Chilung, only four were still in business. It is not lack of religious fervor, but competition from cheap copies, which pose the threat to carvers, according to Wang. He predicted that because of mass-produced statues, "difficult times are coming."

Although Wang lamented the trend, he felt that mass-produced statues could not replace those fashioned by skilled carvers. He and his sons are "all believers," he was quoted as saying, and without belief, a statue not only cannot be properly done, but it would be disrespectful to the god as well.[9]

Competition comes from shops like Ch'iao Chen Hsuan in Taipei's Lung Shan District where wooden statues are turned out in an assembly line. Young boys and girls, who specialize in just one step in the carving or decorating processes, are employed to mass-produce the most popular gods for the domestic and export markets. A machine begins the initial work. Four blocks of wood are fitted facing four spinning blades which, following the contours of a model, cut the blocks simultaneously. In a few minutes, four rough carvings are ready to be passed along the line for more detailed work.

Lin lamented the fact that carving was "falling into the shade," because few young people are willing to take up a profession with a long training period and relatively low pay. In a 1976 *Echo* magazine article, Ju Ming, one of Taiwan's premier sculptors, described the hardships suffered by young apprentices. Born into a poor family in Miaoli, he was apprenticed to a carver of temple statues. "We apprentices were provided with only a few rudimentary materials and implements and had to shift for ourselves when it came to room, board, and miscellaneous expenses," he said recalling the early years of learning his craft.[10]

In 1977, when Lin was interviewed, delicately carved statues fetched only modest prices. A five-inch

Kuan Yin, for example, cost only 800 Taiwan dollars (US $20.00); a nine-inch one cost 1,000 dollars; and a one-foot, three-inch statue might sell for only 2,000 or 3,000 Taiwan dollars.

Lin's apprentices are involved in what he calls a "cooperative creation." The master does the delicate carving; an apprentice smoothes it by sanding or with grinding powder; detail is added; glue and gold leaf are applied; and color is added to hair, chairs, prayer beads, swords, or other hand-held instruments.

Traditionalists such as Wang hold that such "cooperative creations" cannot be considered works of art. Because of the uniformity of appearance, they lack the slight distinctive traces of the carvers' skills and are merely produced for the sake of profit. Purists claim a master carver need never use a model. A buyer merely names the god desired, and a carver, drawing on years of experience, will fashion a unique piece that by any definition can be truly considered "art."

Much of what Lin You Ti and Wang I Chuan covered was discussed in a chat I had with a Wan Hua woodcarver months prior to their newspaper interviews. With his permission, I took notes of his assessment of the wood carving profession. The following are excerpts:

Question: When did you begin carving statues?
Answer: At age twenty.

Question: Are there special schools for carvers?
Answer: Not to my knowledge.

Question: What model do you use when carving a statue?
Answer: Sometimes a customer will ask me to go to a certain temple and copy the god in question, or I may make a suggestion that the customer accepts. But in general, I just imitate the convention based on legends of existing statues. It is a fact that some carvers fashion styles out of their own head and even invent names for the gods.

Question: Before beginning a statue, is there a religious rite performed?
Answer: There should be a *K'ai Fu* (beginning to chop) ceremony where the wood is placed on a table, and meat and wine are offered and incense lit. Certain prayers are said, and the designated spirit is requested to observe the process. This ceremony is neglected unless specifically requested by the customer.

Question: Why do some statues have a hole in the back and some do not?
Answer: There should always be a hole for the insertion of an insect or some other indication of life, but if the customer does not specify this, it is usually ignored.

Question: Do carvers ever put their name and date of carving on statues?
Answer: Some do, some do not.

In the decade of the 1970s, an appreciation of things considered "old Taiwan" emerged. A spirit of pride in what was indigenous to the island blossomed. Aboriginal culture and artifacts were discovered; people began protesting the mass destruction of traditional houses; old furniture, especially canopied beds that were previously discarded as impractical, fetched hundreds of dollars as foreigners started snapping them

up; and religious artifacts, especially statues, became popular collectors' items.

In late 1976, Ho Cheng Kuang, the publisher of *Artist Magazine*, visited my house to inspect a set of "Hell scrolls" that I had collected. He was interested because his father painted religious scrolls for a living. Judging from the calligraphy, he identified the scrolls (figs. 12, 81, 83, and 84) as his father's work. An article in the December issue of his publication noted the interest of a foreign diplomat in local religious artifacts and carried photos of all the scrolls and some of the statues from my collection of deities.

In October 1978, over a hundred god statues were exhibited at Taipei's Kuang Hua Market on Pa Te Road. Several collectors lent statues for display, including familiar gods one might find on family altars, such as Sakyamuni, T'u Ti Kung, Kuan Kung, Matsu, and Kuan Yin. Also included were statues that more commonly belong on main and side altars of temples, such as Jade Girl and Golden Boy, Kuei Hsing, Niao Mu, and even carved statues of the Door Gods. *United Daily News*, in its coverage of the exhibit, noted an unfortunate byproduct of the collecting craze: unscrupulous craftsmen were beginning to fashion fake antique god statues.[11] Such bogus artifacts can readily be sold to tourists, but serious collectors can easily spot a fake.

Most statues are carved from camphor wood, because it is plentiful on Taiwan, soft enough to carve easily, and resistant to insects. Because its aroma diminishes with age, a strong odor is a sure clue that the carving was newly fashioned. Unfortunately, exact dating of antiques is not nearly as easy as spotting a fake. In addition to faking antiques, this interest in Taiwanese artifacts gave rise to another unsavory crime: the theft of god statues from unguarded temple altars, especially temples in rural areas. No reputable collector would buy a statue known to have been stolen.

The statues I collected were mainly from two sources: woodcarvers and antique stores. Families who sense their personal gods are no longer *ling* (efficacious) may ask a woodcarver to fashion another and have a Taoist priest "open its eyes." Temples undergoing renovation have been known to replace all statues, leaving the old ones for the craftsman to dispose of. The sale of these statues that are no longer *ling* makes sense to the practical-minded carvers who are, after all, businessmen. For example, I bought Eighteen Lohan from a woodcarver in Chiayi who made a new set for a recently renovated temple. However, the pious would never sell a temple or family statue. For the fervent, a spent statue should be properly burned lest it be desecrated. Family gods of those who convert to Christianity or those who abandon religion often find their way into the antique market.

The first stage in carving a statue, naturally, is the selection of wood. Because of its natural beauty, sandalwood, according to Liu Wen San, is the ideal wood for carving. However, for all the reasons cited above, camphor is most commonly used. When delicately carved, sandalwood's texture enhances the statue's beauty. Its rare fragrance is understood as a discernible manifestation of the god's energy. Statues are sometimes carved from cherry and boxwood.

Once a new god is carved, it is necessary to hire a Taoist priest to "open the eyes" and infuse a spirit into the wooden statue. To be done properly, an elaborate rite should be performed in a solemn and reverent manner. The procedure was outlined in an article in the July 8, 1978 edition of *Taiwan Daily News*. First, an auspicious spot facing south in relative wilderness should be selected: a requirement that poses an obvious hurdle in crowded Taiwan cities. All necessary articles for the service should be collected and in place before 4:00 in the morning. These include a statue of a god local to the area, a Taoist sword, a mirror, and a white chicken.

The priest, chanting prayers and charms, invites the Taoist patriarchs and the spirit army of the five directions to attend. He will then burn a memorial to the Jade Emperor while waving the sword and mirror

→Figure 1
Kuan Yin with a hole carved in the back for the insertion of an insect or a precious item such as jade.
Height 19cm.

在觀音像的背後鑿洞，好塞進昆蟲或珍石，比如玉。神像高19公分。

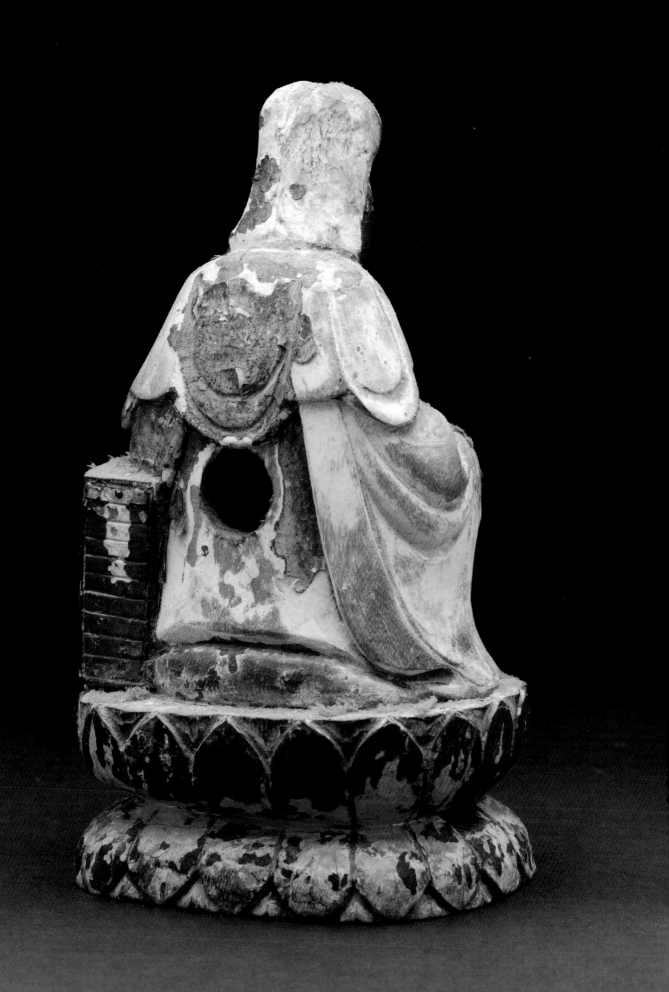

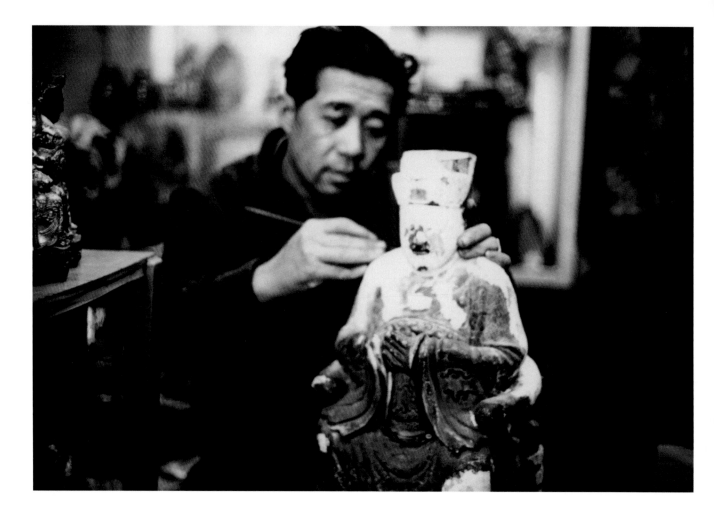

Figure 2
Master carver Wang Hsu Ping repairing
a damaged statue.

彫刻大師王許炳修復神像一景。

about. The chicken will be killed and with its blood, the priest dots the statue's eyes with a brush pen. The statue will be placed in a small sedan chair, and a large quantity of spirit money will be burned, entreating the god to inhabit the statue. To indicate life, a bee or other insect will be inserted in a small hole in the statue's back (fig. 1).[12]

In practice, such an elaborate ritual is seldom followed. I attended an "open eyes" ceremony performed on a Wanhua sidewalk in front of a woodcarver's shop. It was conducted at noon and took about fifteen minutes.

Tu Ti Kung, Kuan Kung, Matsu, and other popular gods are readily recognizable. Pose and clothing are more or less standard. Other, less familiar deities, especially those worshiped by one locality, clan, or ethnic subgroup, are not so easily identifiable. They pose a problem, not only for scholars or collectors, but also for the faithful who pray or petition before an altar crammed with a number of statues.

There is not an abundance of information in English or Chinese on religion that helps one identify less popular gods. English books written by anthropologists sometimes commented on religious practices, the importance of temple worship, and mentioned a few of the familiar deities, but a discussion of iconography is scant.

As for Chinese language books, there are a few written on the subject. With the exception of Academia Sinica, the study of local culture was neither a government nor academic priority at the time I was collecting statues. Academia Sinica commissioned an artisan to carve several dozen deities for research purposes, and Dr. Li Yi Yuan kindly allowed me to photograph them. This was immensely helpful.

Woodcarvers were my most important source of information. I got to know several quite well and

often would drop by their shops to chat about their craft. They acknowledged the difficulty of positive identification and freely admitted that they often were as perplexed as anyone when faced with an unfamiliar god. They did, however, offer the following few hints:

Buddhas are almost never seen on a throne but are usually standing or sitting in a serene pose on a lotus, rock, or bench. One exception is Chi Kung, who is known for his fondness for alcoholic spirits. He is often depicted unshaven and wearing a wine-induced grin. While the lotus position is the most common, Buddhist deities are sometimes carved with one leg tucked under the other in a restful pose. They usually wear loose fitting yellow or gold garments with little or no ornamentation. With the exception of Ti Tsang Wang, Mulien, and a few others who wear the multipointed crown, and Chi Kung, who sports a Nehru-style cap, most Buddhist divinities are bareheaded.

A peaceful expression, gentle sloping eyebrows, and elongated ear lobes, indicating wisdom, are all characteristic of the Buddhist face. Buddhist deities sometimes hold gourds but, more often than not, will be seen clutching prayer beads. The many-armed Kuan Yin holds numerous different objects.

Taoist gods or immortals also generally are not carved sitting on thrones but rather resting on a rock or bench. They wear colorful vestments or plain clothes decorated with mystical symbols: the *pa kua* (eight trigrams) or *t'ai chi* (*yin* and *yang* symbol). On their heads will be topknots, and blank or severe expressions grace their faces. Taoist gods often hold gourds filled with medicine or wave a magic whisk.

If a god is seated with legs spread wide apart on an impressive throne and wears military or court clothing complete with a dragon embroidered on the front and an official wide belt, you are probably looking at one of a number of folk gods, such as Wang Yeh, around whom a local cult has arisen. These gods number in the hundreds on Taiwan and, owing to the similarity of carving, are often difficult to identify positively.

Eyebrows give a clear indication of the character of such gods. Upward slanting eyebrows, for example, reveal a severe and uncompromising nature. Folk gods come in many facial hues. Attendants and subordinate gods can have blue, green, or other colored faces. There are many exceptions, such as Kuan Kung, who has a red face, and Lord Yin Yang, whose face is half white and half black. Ch'ing Shui Tsu Shih Kung, Pao Kung, and a few of the many Wang Yeh have black faces. If a god is efficacious, incense will be burned to it constantly by the faithful seeking favors. No matter what the original color, the face of such a statue will be blackened eventually by smoke.

Folk gods of emperor rank, city gods, kings of Hell, and a few others hold an order board with both hands extended in front of the chest. Warriors naturally clutch weapons; judges and scholars hold pens; while servants carry a variety of objects. Main gods look straight ahead; subordinates and attendants stand with heads inclined toward the main god.

The above are useful guidelines but not hard and fast rules. A god's image, nature, and story can change from locality to locality.

8. "Carving God Statues," *Independence Evening News*, April 13, 1977.
9. "Decline in God Carving Industry," *China Daily News*, June 2, 1977.
10. Huang, "Ju Ming, Wood Carver," *Echo*, Vol. V, No. 9, p. 15.
11. "God Statues Exhibition,"*United Daily News*, October 2, 1978.
12. "Carving Today," *Taiwan Daily News*, July 8, 1978.

DIVINATION

占卜

Divination is central to temple worship. Gods are petitioned for guidance, favors, causes of, and remedies for family or community tragedies.

Among the more popular ways of seeking a deity's help or approval is spirit writing. The celestial communication is accomplished by an entranced *tangki* who, under a god's command, writes characters in a box or small sand pit with a divining rod-shaped instrument. A variation is for two men to hold a tiny sedan chair over a table until a god occupies it. When the god is seated, the chair becomes unbearably heavy, and the men, struggling to control it, sway back and forth over a table, unconsciously tracing out a message from the possessing deity.[13]

I witnessed such a phenomenon during a fire-walking session at Hui Chi Kung on Chih Shan Yen, Shihlin, a temple dedicated jointly to K'ai Chang Sheng Wang and Wen Ch'ang Ta Ti. At the direction of a *fa shih* (Taoist priest), about a dozen men, some shouldering bamboo poles supporting large sedan chairs and some cradling a single deity, crossed the smoldering embers at a brisk trot. As the last man completed the short journey, the duo carrying the lead palanquin began gyrating in an uncontrollable pattern, crashing into spectators circling the fire pit. The lead bearer fell to his knees and began scribbling in the dirt with the left support pole. The *fa shih* interpreted the writing and announced that K'ai Chang Sheng Wang was angry because the procession had crossed early, before he himself was ready. He ordered the group to walk again. Obediently, they lined up and repeated the walk.

A more elaborate way to divine a god's pleasure or to learn why misfortune had befallen a family or community is to hire a *tangki* known to be easily entranced. In such a state, he or she can descend into the *yin* world to obtain heavenly advice or discover the reason for the present trouble.

By far the most popular way to communicate with gods or spirits is through divination blocks, called *poe* in Taiwanese. Because of their crescent shape, they are often called "moonblocks" in English. Some credit Chou Kung, the first ruler of the Chou Dynasty, with designing this divination method[14] called *p'u kua*. In ancient times, an oyster shell split lengthwise was used.[15] Later, split buffalo horns and bamboo roots replaced the shells. Today, wooden blocks are most common. No matter what material is used, one side of the crescent shape must be rounded and one side flat. The flat side represents the *yin*, and the round side the *yang*.[16]

If asking a simple question requiring a yes or no answer only, the petitioner, after making appropriate obeisance with incense sticks, cradles the blocks and gently tosses them on the floor in front of a god. If both fall flat side down, it is a "negative *poe*" and no reply is forthcoming. If both fall on the round side and wobble before coming to a rest, it is the "laughing *poe*," amusing the god. If one falls flat and one round, it is the "sacred *poe*," and the answer is in the affirmative.[17] In this position, the *yin* and the *yang* are in balance, a positive sign.

A typical example of such a yes or no question would be to ascertain if the god was satisfied with food

Figure 3
Fortune box with sticks that correspond
to individual fortune slips.
Height 44cm (sticks).

籤桶裡有籤條，各自對應著不同的籤
詩。全高44公分。

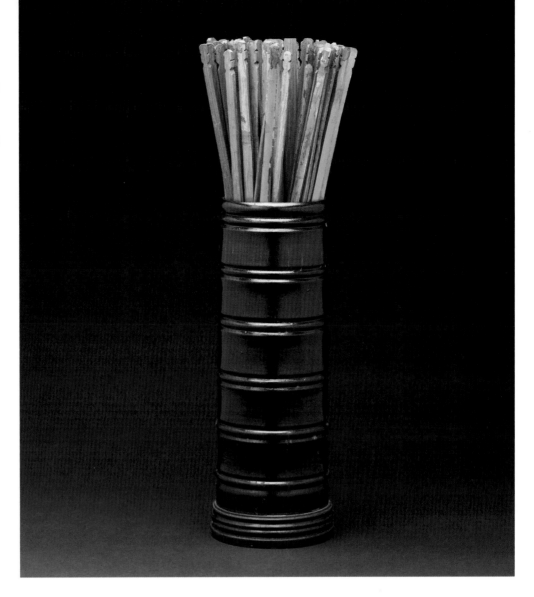

offered in sacrifice. Other questions regarding family or business matters can also be answered quickly
and inexpensively in this way. The *p'u kua* method is adaptable and can be employed in weightier matters.
The choosing of temple committee members or any number of questions regarding temple or community
activities can be put to a god for resolution. In such cases, an involved sequence of "moonblock" tossings,
requiring a number of successive positive answers, is necessary before a course of action can be determined.

If a simple yes or no will not satisfy, the petitioner will use the "moonblocks" in conjunction with
fortune slips. Fortune slips numbering either sixty or one hundred are available in every temple of
moderate size. The slips containing an enigmatic poem, which if interpreted correctly, suggests a proper
course of action, will either be in pigeonhole boxes or hanging from pegs on the wall. To determine which
fortune applies, a petitioner will shake a box or tube containing bamboo sticks with numbers or symbols
corresponding to the slips. After a gentle shaking, one stick will pop up higher than the rest. The petitioner
places the stick on the altar and tosses the "moonblocks" to determine if the selection is appropriate. If the
"moonblocks" indicate a negative answer, the box must be shaken again. The procedure is repeated until
the blocks fall one flat and one round.

Pictured here are: a fortune box with sixty sticks (fig. 3), a woodblock (fig. 5) from which fortune slips
were pressed, and a pair of "moonblocks" (fig. 4). The woodblock is one of a complete set that I bought from
an antique dealer. Together with a Chinese teacher, I translated all sixty of the fortune slips made from this
set. The first six are represented here. As is the case with Western horoscopes, the poems are open to

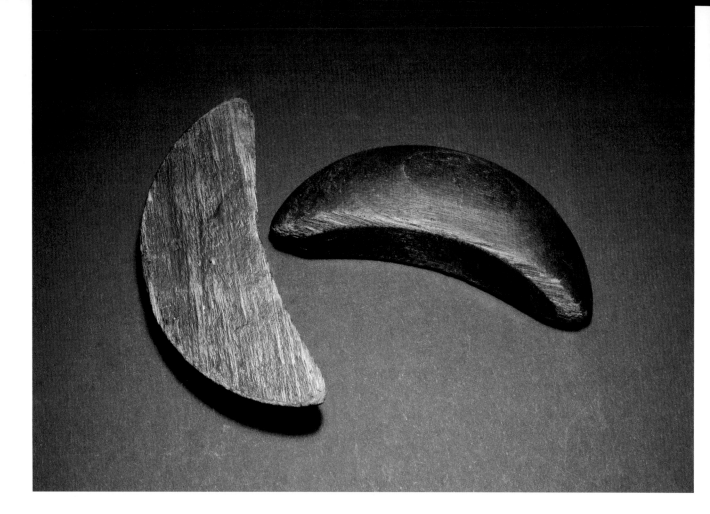

interpretation. The wording for five of the six here are more or less straightforward but number four is ambiguous. I sought help from a number of Taiwanese, including priests and teachers, but none were able to explain satisfactorily the meaning in Chinese or give a better English translation.

The woodblocks (fig. 5) are from the Fu Jen Kung in Ta Ch'i, Taoyuan. They are obviously old, for countless inking and rubbing has worn down the characters. I was unable to ascertain how such a complete set ended up on an antique dealer's shelf, but my guess is that they were discarded because either a new set was carved or the temple switched to commercial printing, and someone associated with the temple sold them for personal profit.

I wanted a pair of "moonblocks" to accompany the woodblocks and fortune sticks. I turned to Wang Hsu Ping, a good friend from whom I had purchased old statues in the past. I asked if he had an old pair in his shop that I could buy. He offered to sell me a new set. But I insisted on used ones. "Take these," he said, handing me a new pair. "Go around the corner to the Lung Shan Temple. Place them on the offering table and just pick up an old pair about the same size." I handed over his price, thanked him for his sensible suggestion, and took them to the temple. I asked an official-looking man who seemed to be in charge if I could exchange new for old. He told me to go ahead and take my pick. My pick was the most worn-looking pair (fig. 4) that undoubtedly had been dropped in petition on the stone floor of Taiwan's most famous temple thousands upon thousands of times.

Figure 4
Poe ("moonblocks"), thrown to indicate the correctness of the stick chosen. These *poe* are from Taipei's Lung Shan Temple.
Length 8cm.

跋杯（擲筊）的用意在於顯示所抽到的籤是否為神明指示的籤。圖中的筊來自龍山寺。長8公分。

13. Jordan, *Gods, Ghosts, and Ancestors*, p. 66.
14. Wolf, *Religion and Ritual in Chinese Society*, p. 217.
15. Dore, *Researches into Chinese Superstition*, Vol. V, p. 353.
16. Wolf, *Religion and Ritual in Chinese Society*, p. 313.
17. Jordan, *Gods, Ghosts, and Ancestors*, p. 60.

Figure 5
Fortune slips woodblock and the English translation. Size 46 by 18cm.

1. No matter what you do, you will always be first, better than others.
 Whatever you do, you will be the leader.
 But you must be aware that this honor and merit
 Is the result of your excellent fate before and after birth.

2. The gods here are powerful and efficacious,
 Situated in such a magnificent temple.
 Here gentlemen inquire about upcoming disasters, and do not beg for favors.
 On returning home you will receive luck and fortune in abundance.

3. The dark clouds will slowly disperse,
 And the moonlight will be seen clearly on the seashore.
 The thousand disasters and ten thousand misfortunes will follow the clouds,
 And the five fortunes and thousand lucky happenings will quickly come.

4. A light goes out before the journey is half finished.
 Alone, away from home, you are sorry for yourself.
 But only wait until the cock crows and the dragon chases the sun.
 With feelings of pity the people bid you farewell.

5. Do not close your door and sit at home without doing anything,
 Only relying on incense burned in the incense pot.
 If you wait until thirsty before digging the well,
 How will you be able to overcome this difficulty?

6. After a long drought, the dragon rolls uncomfortably in the well.
 Until today he is comparatively calmer because his body is lighter.
 It is better to wait for the clouds and a change in the head and horns (the dragon).
 The clouds will bring sweet rain to relieve people's distress.

籤詩條，木刻版，46×18公分。

T'IEN TU YUAN SHUAI

T'ien Tu Yuan Shuai, the patron of actors and musicians, is a seldom seen god in Taiwan. He is the main god in Lukang's Yu Chu Kung and five other small temples. There are also a few house altars where he is worshiped. Because he is not among the popular deities people seek for comfort or to petition for favors, there is no real demand for his image. Consequently, artisans rarely carved his statue.

Fortunately, T'ien Tu Yuan Shuai (fig. 6) was the first religious statue I purchased. Had I bought a Kuan Yin, a Matsu, a T'u Ti Kung, or any of the more familiar gods or goddesses, I would in all likelihood have placed it in some prominent spot in my living room as a reminder of the importance of religious devotion on Taiwan and been satisfied. But I did not know anything about this god, not even his name. Before I displayed the statue, I wanted to know more about it.

I took it to the United States Information Service Cultural Center in Kaohsiung, where I was the director. None of my staff could enlighten me in any way. I tried all of my friends. My queries were met either with a shake of the head or a wild guess. It took two years to positively identify the god.

The two-year search piqued my curiosity and intensified my interest in religious practices. Asian religions had fascinated me since my days as a soldier in Korea, where I was drawn to temple architecture. A week-long vacation in Japan was spent, in large part, visiting famous religious sites in Kamakura, Nikko, and Kyoto. My first two Foreign Service posts were Saigon and Hong Kong, cities where colonial culture vied with Buddhist roots.

In all those places, religion was an obvious component of society, but in Taiwan, especially in the rural areas, it seemed central. In 1967, when I arrived, Taiwan was mainly an agricultural society; its inhabitants for the most part were descendants of Fuchien, arguably China's most religious province. Taiwan's colonial experience was at the hands of Japan, where Buddhism was held in high regard.

My early years in Taiwan were spent first in Taichung and then Kaohsiung, cities where a short bicycle ride put one in the midst of rice paddies and sugar cane fields. Bicycle riding through rural Taiwan, which became my recreation of choice, was facilitated by two Taiwan enterprises: the National Railroad and the Nan Hua Publishing Company, K'ang Ting Road, Lung Shan District, Taipei.

For a few New Taiwan dollars, one could take a bicycle on a train, get off at any station, ride until tired, then peddle to the nearest town on the main north-south line, wait for a local train, and return home. With a copy of the excellent and accurate railroad schedule in one's hip pocket, the journey was always trouble free.

Nan Hua published detailed and accurate *hsien* (county) maps. With a Nan Hua map, one was never lost. Over the course of my years biking in rural Taiwan, I peddled through every *hsien* south of Taichung except mountainous Nantou. Most trips were day trips; however, many were two or three-day rides where I, usually accompanied by a friend, would spend nights at small inns selected at random.

➜ Figure 6
T'ien Tu Yuan Shuai, patron of actors and musicians. This was the first statue in my collection.
Height 25cm.

田都元帥是戲劇與戲曲之神，圖中彫像是我的第一件蒐藏品。高25公分。

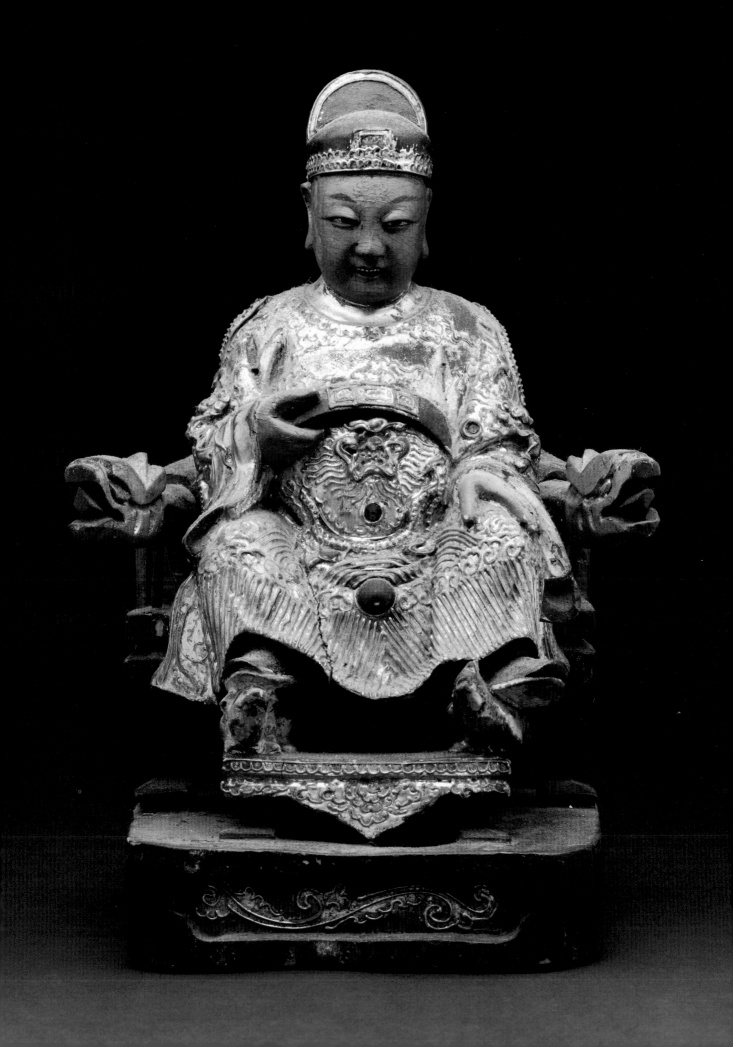

My longest ride was from Su Ao to Taitung along the east coast. It took six days.

Sleeping accommodations on Taiwan's east coast were primitive. In one small inn, the bathing amenity consisted of being handed a basin and directed to a water faucet protruding from a brick wall over a drain in the cement floor. Such "roughing it" did not occasion a complaint either from me or from my traveling companion, a fellow Foreign Service Officer. We were out for adventure, and such bathing was an adventure. Besides, we could not complain of the price: the equivalent of one U.S. dollar.

The east coast road between Su Ao and Hualien in those days was not paved, and traffic for most of the route was one-way: alternating four hours in one direction, then four hours in the other. Naturally, there was little incentive to set up commercial establishments for travelers along that stretch. On our second day of biking, we came to the hamlet of Ho P'ing (Peace) as darkness fell. We inquired of a lady standing in front of her thatched roof house for the location of either a restaurant or a small inn. There were neither. With typical graciousness that one often finds among rural people, she offered to put us up for the night. We dined with her, her husband, and two children on vegetables flavored with a scrap of meat, white rice, papaya, and boiled water. I doubt I have ever tasted food in any four-star restaurant that was as satisfying as that meal.

Unfortunately, kindness to us may have caused her family some future unpleasantness. Midway through the meal, a police officer came and asked her husband about us. Later, his superior officer questioned us directly. He wanted to know what we were doing there and why we picked that particular family for our stopover. Our honest answers were met with suspicion.

It was on a bicycle ride, this time with my wife Joan, that I bought the Tien Tu Yuan Shuai statue (fig. 6). As we peddled through Chiayi on our way to the railroad station, we passed a woodcarver's shop. The display of newly carved statues caught my eye. On the spur of the moment, I decided to buy a statue, something I had wanted to do for a long time. The shop owner's prices, quite reasonable I am sure, were more than I wanted to pay for a souvenir. As I was about to leave, I noticed an older statue half hidden on the top shelf. Assuming it could be bought cheaply, I haggled with the owner over the price. I was attempting the negotiation in Taiwanese, a language I had studied only briefly and spoke poorly. In exasperation, the owner blurted out the price in Mandarin. Embarrassed upon finally under-standing how reasonable was the man's price, I quickly handed over the money and hastily departed without learning the name of the god or its story. Thus began my two-year search.

The search ended when a scholar pointed to the tattoo on the forehead as proof of identity. Tien Tu Yuan Shuai, I soon learned, like almost all Chinese religious figures, has more than one story. According to one legend, he was Lei Wan Ch'un, a Tang Dynasty general who died in battle. Shortly after his death, the emperor saw the character *t'ien* (field) in the sky. Because the surname "Lei" is made up of the combination of two Chinese characters: *yu* (rain) and *t'ien* (field), some believe that what the emperor saw was only half the character, the top part *yu* having been obscured by a cloud. The emperor interpreted this as a sign that General Lei had already ascended to Heaven. The emperor therefore proclaimed him Tien Tu Yuan Shuai (Marshal Tien Tu).

In the more popular legend, he was Lei Hai Ch'ing, chief musician and leading actor to the court of Emperor Tang Hsuan Tsung. It is said that once when the emperor became ill, he dreamed that Lei and his two brothers, who were also court musicians, played for him. As he was fully recovered on waking, he attributed it to their music. For this reason, actors and musicians worship him as their patron.

There is disagreement among authors as to which historical figure is the real Tien Tu Yuan Shuai.

According to Chung Hua Tsao, the title *Yuan Shuai* (Marshal) would seem to indicate Lei Wan Ch'un. As a career soldier, he has a greater claim to the title. On the other hand, Chung points out Tien Tu Yuan Shuai is usually carved as a young man with a smile so broad that his teeth show as if a bit tipsy and that he has a tattooed face. This representation is more in keeping with the court musician version. One explanation offered by some but disputed by others, Chung writes, is that the general is the younger brother of the actor.[18]

On Taiwan, musicians of both the Pei Kuan and Nan Kuan music traditions consider him their patron. He is also known as Hsiang Kung Yeh, and some consider him to be Hsi Ch'in Wang Yeh.

Tien Tu Yuan Shuai's tattoo is the result of a jest by the emperor's famous concubine, Yang Kuei Fei. During a banquet celebrating his obtaining the third highest honor on the imperial examination, Lei passed out from an overindulgence of alcoholic spirits. While he was in this inebriated state, the imperial concubine drew some designs on his face. They proved to be indelible, and he was thus marked for the rest of his life.[19]

18. Chung, *The Origins of Taiwan's Local Gods*, p. 302.
19. Chu, *Birthday Listing of Gods*, p. 124.

KUAN YIN

As is the case with many Buddhist deities, Kuan Yin's origins are Indian. Following the Indian model, the first Chinese representations of Kuan Yin were masculine in appearance, but gradually, the statues took on a more feminine look. In the twelfth century, a purely Chinese legend was written for her that completely ignored Kuan Yin's Indian roots.[20]

According to this story, she was Miao Shan, the third daughter of Miao Chuang Wang, a ruler of a northern kingdom during the time of the Chou Dynasty. As the king had no male heir, he wished Miao Shan to marry so her husband, to be chosen by the king, could succeed him. She refused and insisted on seeking religious enlightenment. After repeated failures to dissuade her, including burning down the nunnery where she had sequestered herself, he ordered her executed. Because the Jade Emperor did not wish her body disfigured, the executioner's sword proved ineffective and shattered with each blow delivered. The frustrated king ordered her strangled. As strangulation does not disfigure, Kuan Yin was finally put to death and descended into the realms of Hell. However, her mere presence turned Hades into a paradise. Frustrated at this disruption, the King of Hell ordered her returned to earth, where she was transported on a lotus flower to P'u To, an island near Ningpo.

To punish her father, the Jade Emperor commanded the god of plagues to afflict his body with ugly ulcers against which no medicine would be effective. Kuan Yin, disguised as a physician, treated her father with flesh cut from her arm and an eye gouged from her own head. This treatment had the double beneficial effect of curing the affliction and converting her father to Buddhism.

One often sees statues of Indian deities with multiple arms, eyes, and faces. The Chinese have an explanation based upon the above story for Kuan Yin carved in such a fashion. Her father commissioned a sculptor to carve a statue of her "with complete arms and eyes." Owing to the similarity of the sounds "complete" and "thousand" in Chinese, the confused sculptor made the statue with "many arms and eyes."

In Chinese, Kuan Yin means, "observing/heeding the sound." As she was about to enter into Nirvana, she paused and on hearing the anguished cries of humanity, postponed her entry into that longed for state in order to devote herself to ministering to the needs of her devotees.[21] She is known by a number of other names, but most commonly she is called Kuan Yin P'u Sa or simply Kuan Yin. *Pu sa* is the transliteration of the Sanskrit name for *Bodhisattva*, meaning one who has the essence of enlightenment.

With the exception of Lord Buddha, Kuan Yin is the deity most worshiped in China, Korea, and Japan. On Taiwan, according to Chung Hua Tsao, 600 temples are dedicated to her. The most numerous are located in Kaohsiung *Hsien* with eighty, Taipei City with sixty, and Chiayi with fifty-five.[22] Additionally, most of the almost 8,000 registered temples on the island enshrine Kuan Yin on one of their altars.

The Kuan Yin story illustrates how the Chinese blend and combine Buddhist and Taoist deities and practices. Kuan Yin's origins are Indian Buddhist. In the Chinese version, current since the twelfth century, it is the Taoist Jade Emperor, not Buddha, who shows concern for her plight. Some maintain that Taoists,

→Figure 7
Kuan Yin standing on a lotus.
Height 42cm.

觀音蓮花像，高42公分。

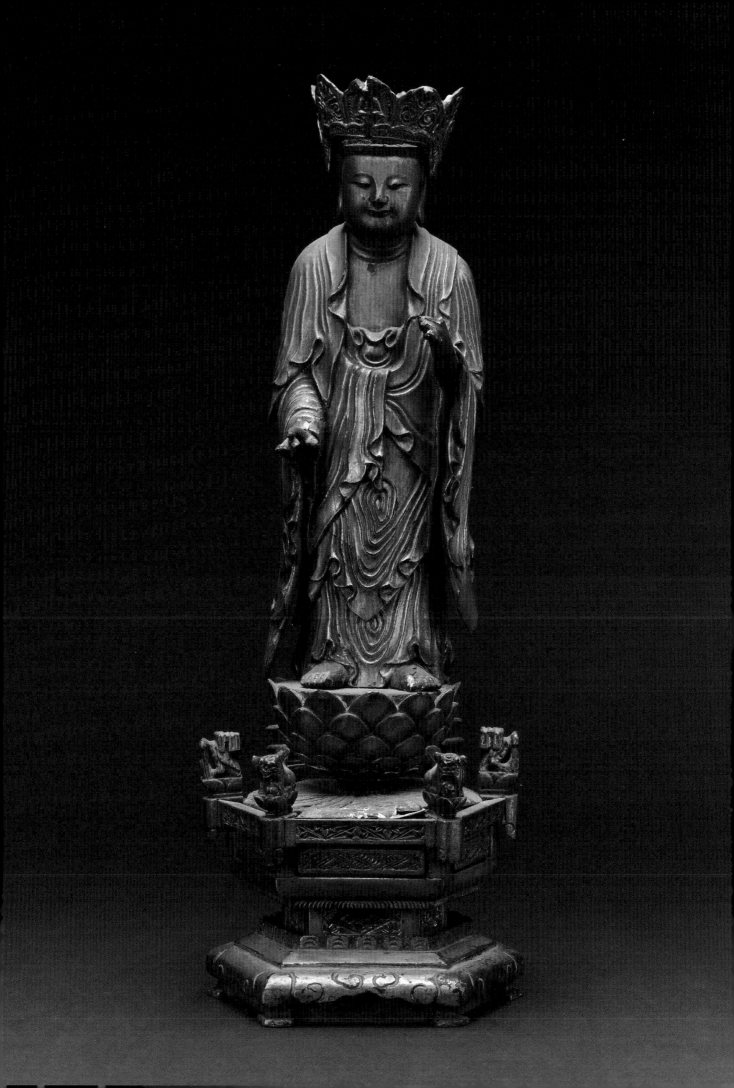

jealous of Kuan Yin's popularity, patterned Matsu's benevolent image after her.[23] While the accuracy of this is open to question, the two goddesses complement each other and coexist surprisingly well on Taiwan. Lung Shan *Szu*, Taipei's second oldest and best known temple, for example, has Kuan Yin enshrined as the main goddess in the central hall, while Matsu presides over the elaborate rear hall. The Kuan Yin statue in this temple is considered miraculous for when Lung Shan *Szu* was hit by Allied bombs during the Second World War, her image was untouched even though everything surrounding it was destroyed or charred.

The history of the Lung Shan Temple suggests Kuan Yin herself directly influenced the selection of the site. According to the tale, a rattan merchant from Chuanchou, heeding the call of nature, stopped at the spot to relieve himself. For delicacy's sake, he removed a sack of incense ash he was wearing for spiritual protection and hung it on a bamboo branch some distance away. When finished, he hurriedly left, forgetting about the sack. It remained there, hanging on the bamboo strand. During the night, neighbors were startled by a dim beam of light from the grove. Upon investigating the following morning, they found the sack with "Lung Shan Temple Buddha" written on it. They began lighting incense and directing petitions to this obviously powerful object. As petitions were granted, its fame spread, and money was collected for a temple.

Local people guessed the sack had come from the celebrated Lung Shan Temple in Chin Chiang County, Fuchien. A delegation went there and obtained a Kuan Yin statue to be enshrined in the Taipei structure that was completed and dedicated in the third year of Ch'ien Lung's reign (1738).

Most divinities have one special feast day, usually a birthday. Kuan Yin has three: her birthday on the nineteenth of the second moon, her enlightenment on the nineteenth of the sixth moon, and her death on the nineteenth of the ninth moon. As might be expected, observance of these feast days is more restrained than the carnival-like atmosphere that attends *paipai*s to Matsu, the City God, and other deities with more pronounced local identifications.

Many temples distribute free prayer counters like the one pictured here (fig. 8). Instructions advise petitioners to Kuan Yin to say the prayer printed below. After repeating the prayer fifty times, one should darken one circle. After all circles are filled in (12,000 repetitions), it is necessary to print at one's own expense, 1,200 copies of the sheet for others' use. If all of the above is done, the petitioner's wish will be granted.

On main altars, Kuan Yin is almost always flanked by her faithful servants, Shan Ts'ai, sometimes called Chin Tung (Golden Boy), and Liang Nu, who is also known as Yu Nu (Jade Girl) (fig. 9). The most appealing account of how these two became her attendants is told in Werner's *Myths and Legends of China*. According to the legend, the assemblages of gods at her beatification agreed that she should not remain alone and begged her to choose a deserving young man and a virtuous damsel to serve her. Tu Ti Kung was selected on her behalf to seek worthy followers. He chose a poor priest, a hermit since his parents' deaths. When presented to her, Kuan Yin tested his loyalty by throwing herself down a precipice. Without regard to his own safety, he immediately dived into the ravine in an effort to save her. He died in the attempt, but his spirit was elevated to godhood. He has remained at her side ever since.[24]

Jade Girl was the daughter of the Dragon King, whose son Kuan Yin had once saved. To repay her kindness, the Dragon King sent a luminous pearl to Kuan Yin so that even during darkness she might recite her prayers by its light. Jade Girl begged to be allowed to deliver the gift personally and remain with Kuan Yin so as to study doctrine under her guidance. Statues of Jade Girl often depict her holding the radiant pearl.

Kuan Yin's most common representation, that of a beautiful woman dressed in flowing robes with a

Figure 8
Kuan Yin prayer counter given free by some temples. The faithful are instructed to blacken one circle after repeating the printed prayer 50 times. When all circles are blackened, one's petition will be granted.
Size 38 by 21cm.

有些廟宇會有免費的白衣大士（即觀音）靈感神咒供信徒索取，信徒每念完一遍神咒，就把一個白圈塗黑，如此重複50次，等全部的圈都塗滿後，信徒的願望就會實現。
38 × 31 公分。

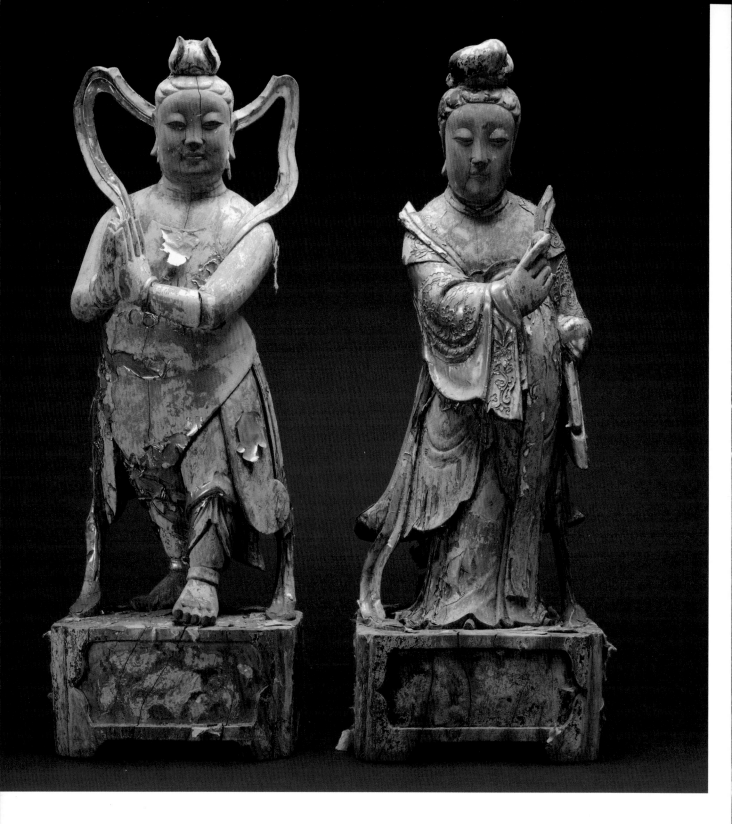

hood gracefully draped over her head, bears a resemblance to the Catholic Virgin Mary. Some theorize that Chinese carvers, taken with the graceful lines of the Madonna statue introduced into China by Jesuits in the fifteenth century, fashioned a new iconographic representation of Kuan Yin in imitation.[25] Since her depiction as a graceful maiden with a hooded veil predates the Jesuits' arrival, others propose that it was pictures of Mary brought by Nestorian missionaries in the seventh century that suggested the shape. This theory is discounted by scholars, who point out that Nestorians were not Marianis (those who venerate the Virgin Mary). They suggest a more likely explanation for her eventual iconographic evolution is the aping of classic Greek sculpture introduced to India during the conquests of Alexander the Great. Such similari-

Figure 9
Jade Girl and Golden Boy, attendants to Kuan Yin. Height 60cm.

觀音的童侍金童玉女像，高60公分。

→Figure 10
Sending Children Kuan Yin.
Height 21cm.

送子觀音像，高21公分。

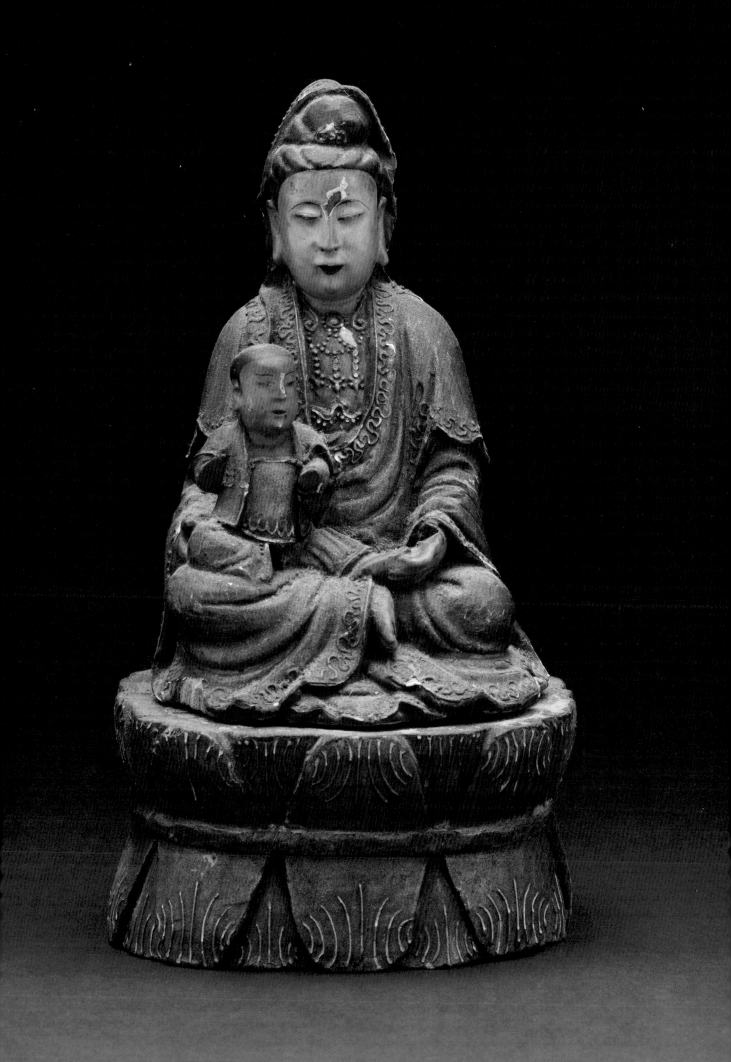

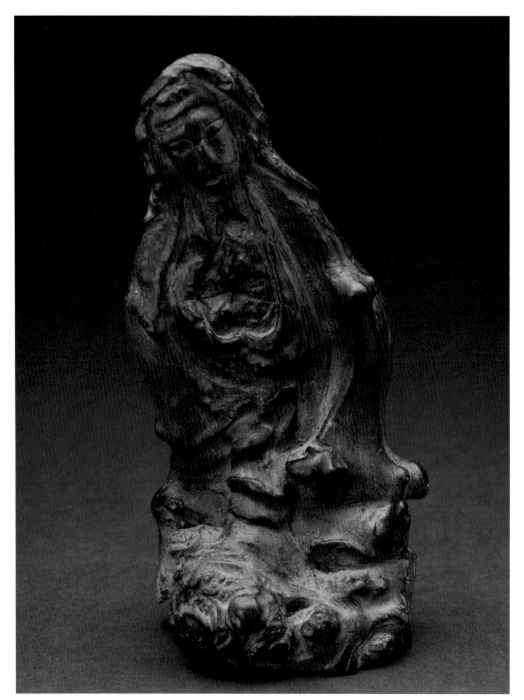

Figure 11
Ch'iao tiao (ingenious carving) of Kuan
Yin. By adding just a few facial features,
the artisan turned this root into a
remarkable likeness of Kuan Yin.
Height 13cm.

觀音巧彫像，彫刻師傅僅刻上一些臉部
線條，便把樹根轉化成了唯妙唯肖的觀
音像。高13公分。

ties exist, but Kuan Yin's representation, when introduced to China from India, was that of a male and
without the familiar head veil. We may never know the reason for the look-alike appearance, but what is
obvious is the perceived similar natures of Kuan Yin and Mary. A Buddhist nun once told me that they are
in fact the same goddess. They just have different names in different cultures.

In her hand, Kuan Yin may hold any one of a number of objects, from a lotus to a whisk, but she is
most often seen holding either Buddhist prayer beads or a gourd. When carved with an infant, she is called
the Sending Children Kuan Yin (fig. 8) and is prayed to by hopeful mothers.

The small statue pictured here (fig. 9) is a rare example of *ch'iao tiao* (ingenious carving). With the
exception of the eyes and mouth, this statue is an untouched root. Nevertheless, the resemblance to a
Sending Children Kuan Yin is striking.

Figure 12
A scroll of Hell hung by Taoist priests at funerals.
Here, Kuan Yin appears in the initial of the ten
courts, leading virtuous souls across the Golden
Bridge to Paradise. Size 152 by 77 cm.
Catalog number E426239, Department of
Anthropology, Smithsonian Institution.

道教法師在葬禮上所懸掛的〈地獄十殿圖〉。圖中，
觀音站在十殿之首，引領善靈走過金橋進入天堂。
152×77公分。
編號E426239，史密森尼博物館人類學部門。

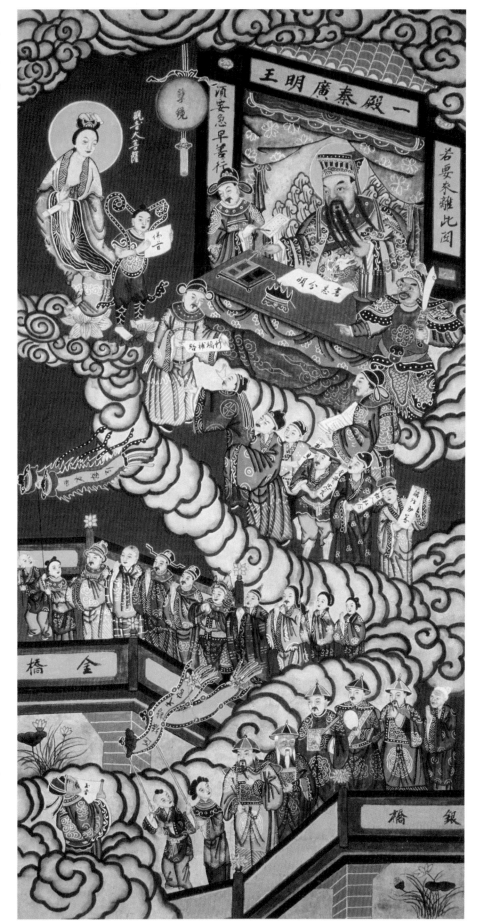

20. "Gods and *Pai Pais*," *Echo*, October 1973,
 p. 32.
21. Werner, *Myths and Legends of China*, p.
 251.
22. Chung, *The Origins of Taiwan's Local
 Gods*, p. 89.
23. Anderson, "Kuan Yin: Goddess of Mercy,"
 Echo, October 1973, p. 29.
24. Werner, *Myths and Legends of China*, p.
 271.
25. Ibid., p. 55.

MATSU

媽祖

In China, Matsu is known as Tien Shang Sheng Mu, the patroness of seafarers. Temples dedicated to her in China are concentrated in coastal cities. In tiny Hong Kong, where there is an abundance of fishermen, sailors, and stevedores, there are twenty-four temples where Tin Hau (her title in Cantonese) is worshiped. On Taiwan, adherents to her cult come from all professions, and her temples can be found far inland and even in mountainous areas.

Most boatloads of early immigrants to Taiwan carried a statue of the goddess and incense ash from a home temple with them. They consigned themselves to her care, and should rough waters threaten their craft, the helmsman would offer incense before Matsu's statue while sailors threw large quantities of spirit money into the angry sea. Upon settling, immigrants built small shrines to her in thanksgiving for safe passage across the treacherous Taiwan Strait. In time, many of these shrines became large impressive temples. Reliance on her protection continues.

The *China Daily News* reported on September 8, 1976 that twenty-seven seamen and their families made a pilgrimage to Peikang's Chao Tien Kung to thank Matsu for saving their lives. Captain Hsiung Jen Chun told the paper that one month earlier, a violent typhoon suddenly engulfed his small craft. The crew, fearing death, huddled together and prayed to Matsu. The strong winds immediately lessened, and the waves subsided. In gratitude, they contributed 5,000 dollars to the temple.

Matsu was born on the twenty-third day of the third lunar month, during the last year of the reign of Emperor Chien Lung of the Sung Dynasty (A.D. 960) in the small fishing community of Mei Chou, Fuchien. According to one legend, her father is said to have been an upright and just minor official named Lin, who was respected by all in the community. Her mother was a devotee of Kuan Yin, who appeared to her in a dream and promised to send a child. Upon waking, she knew that she had conceived. Because the Lin family's only boy was sickly, she felt confident that Kuan Yin would send a strong male child. Nine months later, a red ray illuminated the bedroom of the pregnant Mrs. Lin, and Matsu was born shortly thereafter.

Mrs. Lin's initial disappointment at not bearing a son soon faded as the child proved an ideal baby. She never cried as an infant, so her mother nicknamed her Mo Niang, the Silent Maiden.[26] As a young girl, she was noted for her filial piety, zealous worship of Buddha, and her love of reciting Buddhist texts. It is said that at the age of ten she could recite a complete *sutra* after reading it only once.

At the age of thirteen, Mo Niang is said to have encountered a monk who transmitted Taoist secrets to her. Three years later, a spirit emerged from the village well to present her with a brass charm. Armed with this, she was able to exorcise evil spirits, and her fame spread.[27]

In the most popular version of her life, she was a daughter of a Mei Chou fisherman. One afternoon as her father and brothers were engaged in coastal fishing, she dreamed they were in danger. Mo Niang, in a trance-like state, walked to the water's edge, where she fixed a stare on their small boat. A sudden squall threatened all coastal craft. However, her gaze safely guided her father and brothers back to shore

→Figure 13
Matsu, goddess of seafarers and patroness of Taiwan.
Height 17cm.

媽祖，船員和台灣島的保護女神。
高17公分。

48

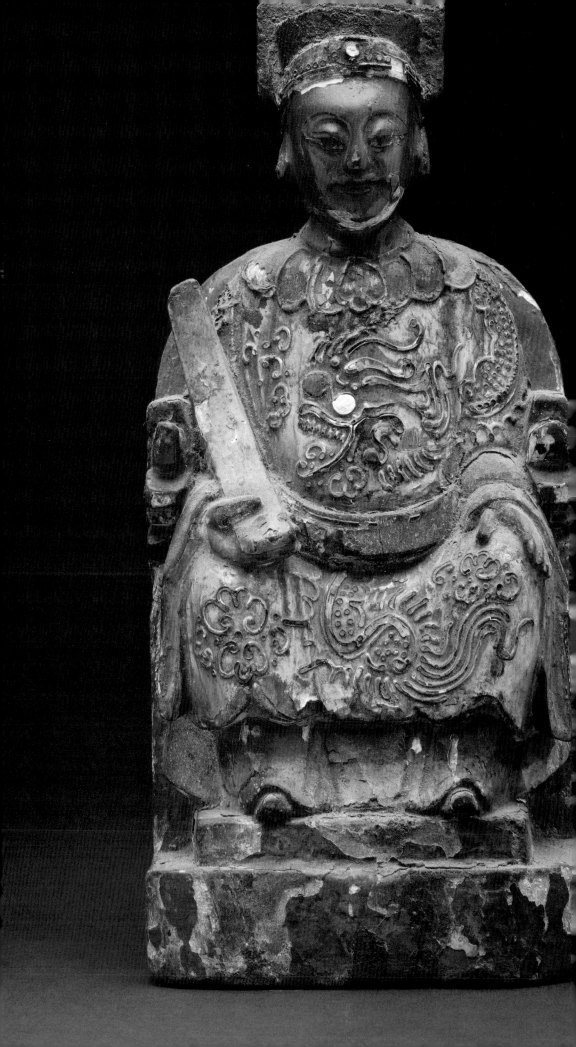

while all others perished. In a variation of the tale, she fell asleep in the course of doing household chores. She dreamt her father's boat overturned offshore. In her dream, she plunged into the sea and rescued her two brothers by holding one in each hand and saved her father by grasping his clothes with her teeth. Her mother, finding her asleep with her chores undone, awakened her, which caused Matsu to open her mouth thus loosing her dream grasp on her father's clothes. Shortly after, it was learned that the boat actually had capsized. The brothers survived, but the father had drowned.[28]

When she was twenty-six years old, she called her family together on the night of the eighth day of the ninth lunar month and told them that she longed for the Pure Land and had grown tired of the world. She reminded them that the following day was celebrated as the double nine, when people ascended heights in order to view long vistas and contemplate long life. On that morning, she would make her own ascent. Her sisters begged to accompany her. Upon reaching an appropriate height the following morning, she bade her sisters goodbye and told them she was to ride the clouds for 10,000 miles. With her clothes fluttering in the breeze, she ascended accompanied by celestial spirits.[29]

Matsu is reported to have returned to earth many times to aid people in their sufferings, expel demons, or end droughts. At first, the people of Mei Chou erected a simple altar in her honor, but as her fame spread and her cult grew, a proper temple, enlarged many times, was erected.

In recognition of the influence of her cult, Matsu was entitled Tien Fei (Heavenly Concubine) during the Yuan Dynasty. "Concubine" carries a negative connotation among European-centered nations. Scholars interpret the title as recognition of her sway over the waters. They point out that "the emperor is the personification of Heaven, the empress of the earth, and the emperor's concubine of the sea." While this explanation may sooth Western sensibilities, it is wasted on the Chinese, who undoubtedly were never offended in the first place.[30]

In 1683, the Ch'ing emperor, K'ang Hsi, conferred on her the title: Tien Hou (Heavenly Queen).[31] The honor was politically motivated. The Ch'ing, an alien Manchu Dynasty, sought to mollify the Han people they had recently conquered. This was especially important on Taiwan where Ming forces held out against the usurpers. K'ang Hsi reasoned that showing respect for Han culture and religion would, if not gain support, lessen resistance. In overcoming Ming forces in Amoy and on Quemoy, for example, the Ch'ing claimed victories were due to Matsu's miraculous intervention. In recognition, the emperor honored her as the "Defender of the Nation." When the Ch'ing naval forces overwhelmed the defenders of the Pescadores (Penghu), again they claimed Matsu interceded on the Ch'ing side. Proof of her efforts on their behalf was given when officers entered the local Matsu temple and found that her statue's clothes were damp and her face wet with perspiration.

For many, her birthday is the most important religious feast of the year. The focal point is Peikang's Chao Tien Kung, where festivities and ceremonies typically last an entire month. Matsu temples from around the island take turns, according to a prearranged schedule, in bringing statues (*fen shen*) of their gods in procession to pay homage to her. The largest of these pilgrimages traditionally came from the central coastal town of Tachia in Taichung *Hsien*. *Central Daily News* reported that in 1980, more than 50,000 of the faithful came from Tachia and the surrounding towns. They traveled by train, bus, taxi, private car, motorcycle, bicycle, and even pedicab. The parking of 316 buses, 200 cars, 100 taxis, and 1,000 motorcycles snaked two kilometers along the road leading from the town into the countryside.

Several that year, as had been the custom for decades, walked the almost 250 kilometer round-trip, traveling mainly during the cool evening and night hours. The trek takes four days each way. *Taiwan Daily News* reported that in 1976, 3,000 made the walk carrying a Matsu statue in a sedan chair. Volunteers took

→Figure 14. Matsu. Height 20cm.

媽祖像，高20公分。

turns shouldering the palanquin's poles. That year, a Peikang resident, Ch'en Wan Te, went to Tachia to act as Matsu's Pao Ma Tzu, a clownish herald. The paper carried a picture of Mr. Chen dressed in Ch'ing Dynasty clothes, with one pant leg rolled up over the knee, wearing a peasant's conical hat, and sporting an enormous false mustache. He preceded the palanquin, beating a gong and affecting a humorous gait. Although the eight-day trek dressed as a clown was exhausting, Mr. Chen said that because "Matsu's grace was so great" he was willing to lead the way.

On arrival at Peikang, pilgrims gather at a public park some distance from the temple where they are greeted by a Chao Tien Kung reception committee and escorted in procession to the temple by dragon and lion dancers, acrobats, musicians, and a deafening clamor of drums and firecrackers.

I attended several such celebrations, including the official ceremony inside the temple early on the morning of Matsu's birthday in 1971. This rare privilege came at the invitation of Kristofer Schipper, himself a Taoist priest and a world authority on Taoist rituals and practices. We traveled together from Tainan the night before in my vintage Volkswagen, spent the night at a small inn in Putzu, ten kilometers south of Peikang, and woke at 4:00 am in order to arrive at the temple in time for the early morning ceremony.

Taiwan journalists in those years tended to exaggerate and inflate numbers, but I can attest that the *Central Daily News* reporter did not embellish. One cannot approach the temple by car for the streets are crammed curb-to-curb with pilgrims. On the roads leading into town, processions of visiting faithful carrying sedan chairs cue up, waiting their turn to inch closer to the temple. The street in front of Chao Tien Kung by noon will be ankle deep in paper casings from spent firecrackers. From the quantity of black powder exploded during these days, it is surprising, almost miraculous, how little mayhem ensues. Unfortunately with so much loose fire play, tragedy does occur. In 1977 alone, two incidents of careless firecracker tossing resulted in two deaths and several injuries. The amount of hearing loss that results from close participation in the doings cannot be estimated.

Leaping acrobats, strutting stilt walkers, muscular *kung fu* masters demonstrating their skill, or *tangkis*, both male and female, flogging and reflogging their bloody backs, intermittently stop the flow towards Chao Tien Kung. Directly across from the temple's court, a permanent stage juts out from the second floor of a building. Here, Taiwanese opera entertains all day long. The stage is positioned to allow Matsu, from her center altar, to view and enjoy the entertainment. The milling crowd, of course, is free to watch as well.

When one finally nears the temple, one must elbow oneself inside where every inch is occupied by the faithful passing private statues through the purifying smoke coming from the main incense pot or making the rounds placing joss sticks before each altar. Flames shoot in a continuous red ball from the chimney of the temple's furnace, where spirit money is burned. The black smoke floats in a thick spiral until it thins slowly and finally dissipates in the distance.

When the Tachia walkers complete their eight-day walk, they are greeted as returning heroes as the town throws an enormous party in their honor, much to the distress of editorial writers, who complain that religious freedom is all right in its place, but there should be some rein set on lavish waste. *Taiwan Daily News*, for example, grumbled in their April 16, 1976 issue that the equivalent of a quarter of a million American dollars was wasted slaughtering 500 pigs, 32,000 fowl, and buying rice, vegetables, and enough wine and soft drinks to wash it all down.

Matsu is so important to the religious life of Taiwan that there is no limit to the amount of boasting the faithful do in promoting their own temple. Nevertheless, judging by the duration of the birthday celebrations and number of pilgrims and visiting delegations from all over Taiwan, Peikang's Chao Tien

→Figure 15
Matsu. Height 30cm.

媽祖像，高30公分。

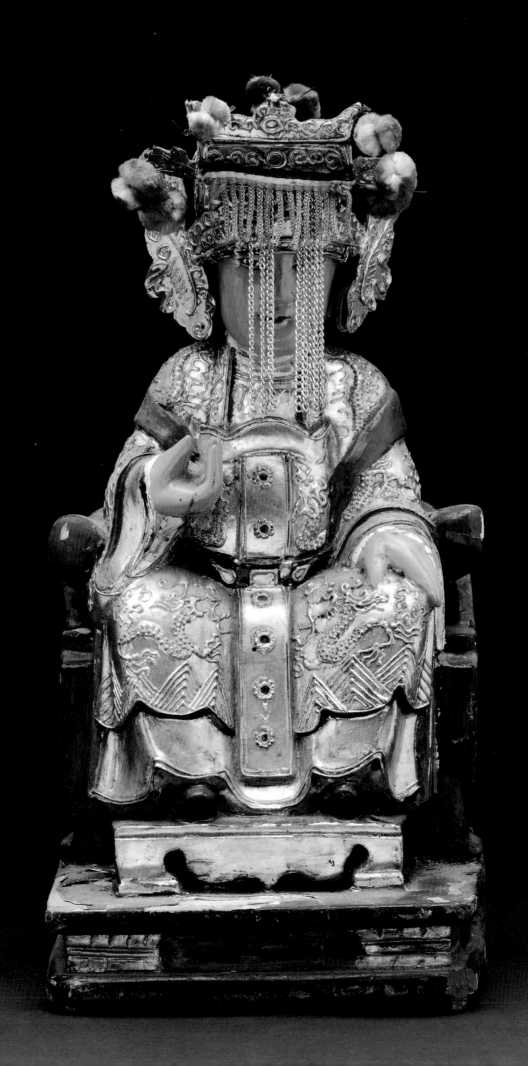

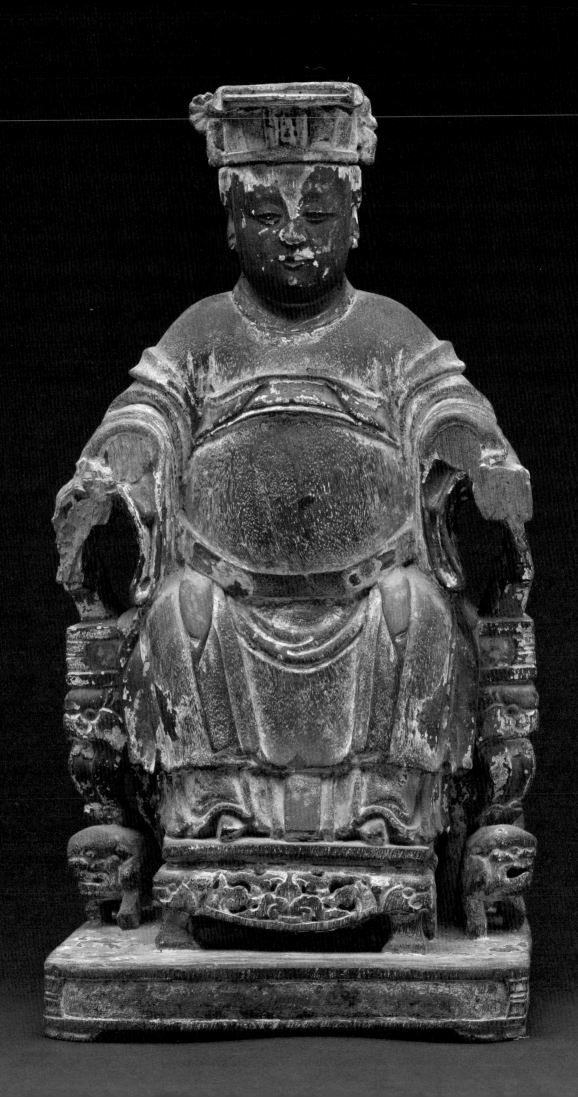

Kung is by far the most popular. A question that bubbles beneath the surface and occasionally percolates up into the press is: "Which temple has the oldest Matsu statue?"

Peikang's Chao Tien Kung, Lukang's Tien Hou Kung, Tachia's Chen Lan Kung, Penghu's Tien Hou Kung, Kuantu's Matsu Kung, Putzu's Pei Tien Kung, and Changhua's Nan Yao Kung all claim their statue was the earliest arrival. The English-language *China Post* reported that an unnamed monk from Lukang's temple had "submitted reliable documents and proved their Matsu statue arrived on Taiwan in 1684 and was the first."[32] Provincial Assemblyman Wang Yin Kuei was quoted in *United Daily News* as claiming Peikang's statue that arrived in 1698 is the first. The *United Daily News* correspondent further confuses the issue by reporting that when the statue came, Peikang was then called Penkang.

A brochure published by Feng Tien Kung in Hsinkang, a town just south of Peikang in Chiayi Hsien, claims their Matsu arrived with early settlers in 1622, the second year of Ming emperor Tien Ch'i's reign. The pamphlet not only claims their statue was the first, but also that Hsinkang is the original Penkang. My search for clarification met with shrugged shoulders from Taiwanese temple goers. The explanation finally came from Hwang Chun P'ing of the Taiwan Association of America. He explained that Penkang was an early river settlement. When the river changed direction, its inhabitants moved, some a few miles to the northwest to establish present day Peikang and some a few miles towards the southeast to what is today Hsinkang.

By any stretch of the imagination, Penkang is a curious name for a settlement. "*Pen*" in ancient times was the name of a plant, but most dictionaries give it only one meaning: "stupid." Penkang translates as: "Stupid Port." As for the curious name, Hwang explained that many early towns transliterated the names of existing aboriginal settlements. Penkang apparently was the closest they could come in Chinese to the aboriginal word for the place.

In rural Taiwan, a temple traditionally has been the center of community activities. A temple's importance is in direct ratio to the village size – the smaller the village, the more important the temple. It serves as a community center where oldsters in tree-shaded courtyards can relax, drink tea, or play chess. Women going to or from the market can stop to gossip, and children have an open space to play. As a village grows into a larger town or city, those functions are diminished. Nevertheless, the temple is still a magnet for communal activity.

Typically, clan ancestors migrating from Fuchien during the Ch'ing Dynasty would have brought a Matsu statue and a sack of incense ash from home in order to establish a new temple on Taiwan. Most of the older temples today trace their origins to "mother temples" in Fuchien, and pilgrims often travel back to reaffirm spiritual roots by "entwining incense" smoke.

In most temples, including those dedicated to Matsu, a committee is formed to operate the temple. Committee membership is traditionally limited to those with clan links. The committee leader is called the *Lu Chu* (Pot Master), a position that is determined by consensus or through divination. A temple may have many small incense pots scattered around the temple, but the pot in question is the large incense urn directly opposite the main god and usually just inside the temple door. The Pot Master nominally is responsible for making daily offerings to the god and organizing annual festivals and other religious activities. It is a prestigious position that carries with it prominence and influence well beyond the religious life of the community.

In spite of the fact that she is the goddess of the seas, Matsu's intercession has been invoked for any number of matters in no way connected with water. The most curious of these concerned a dispute over land itself. The lack of sufficient documentation over a tract in Pei Men Hsiang, Tainan Hsien left ownership

←Figure 16
Matsu. Height 31cm.

媽祖像，高31公分。

unclear. Legal action had dragged on for twenty years until, through divination, the Chung Chia Shai Association learned that Matsu herself wished the problem to be taken to the Tainan City Court.

A delegation of the Chung Chia Shai Matsu Association carried a one-foot statue of the goddess to the court, gathering a crowd as they went and creating a novel scene that attracted newsmen. The press reported in colorful prose "from the head of the street to the tail of the alley, people were consumed with the unprecedented affair of Matsu suing in court."[33] After making a short appearance in the courtroom, the statue, at the request of officials, returned to a vehicle outside to await the results. Deliberations then proceeded normally without "celestial interference."

Modern-day miracles attributed to her abound. Perhaps the most bizarre concerns an Allied bombing raid on a factory near Peikang, the location of Chao Tien Kung. According to this tale, the American bomber pilot saw a girl standing on the riverbank, catching in her skirt bombs that threatened the temple town.[34] Despite marvelous feats attributed to her, Matsu is not all powerful and not all things to all men. Bernard Gallin in his classic study of Taiwan society entitled: *Hsin Hsing, Taiwan: A Chinese Village in Change*, writes: "Local residents tell a story about a man from a neighboring village who went to the Lukang Matsu temple and prayed for success in the lottery. When he did not win, he returned to the temple and with a sword lopped off one of Matsu's ears."[35]

Two of the more interesting minor gods in Chinese mythology, Ch'ien Li Yen (One Thousand Mile Eyes) and Shun Feng Erh (Efficacious Ears), almost invariably accompany Matsu. According to their legend, they were the brothers Kao Ming and Kao Lan who lived during the decline of the Shang Dynasty and who fought for the corrupt Emperor Chou Wang against Chiang Tzu Ya of the new Chou Dynasty. Because one could hear and the other could see a thousand miles, the brothers knew their adversaries' plans in advance, so the generals they served were never defeated.

In desperation, Chiang Tzu Ya sent an emissary to inquire of a Taoist magician how to deal with the pair. The magician explained that the two were actually tree spirits who entered statues of Ch'ien Li Yen and Shun Feng Erh at the Huang Ti Temple. To render them powerless, the messenger was to tell Chiang to destroy the roots of the tree. In order to pass the message on to Chiang without the two demons learning of and thereby frustrating the plan, the emissary was advised to impart the information in the presence of soldiers beating drums and waving flags. Their marvelous powers thus rendered ineffective, the message was passed and the roots subsequently ripped up by a contingent of soldiers. During the following day's battle, Chiang Tzu Ya easily won the victory.[36]

Despite the fact that Matsu lived many centuries later, these two are always associated with her. According to one myth, one day, Matsu heard

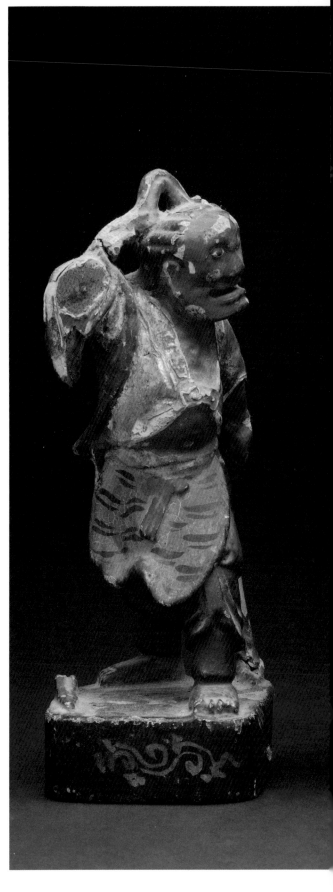

千里眼和順風耳像，他們是媽祖的忠僕，擁有聽見和看見遠方的力量，能幫助媽祖保護船員、漁民和海上過客。最高18公分。

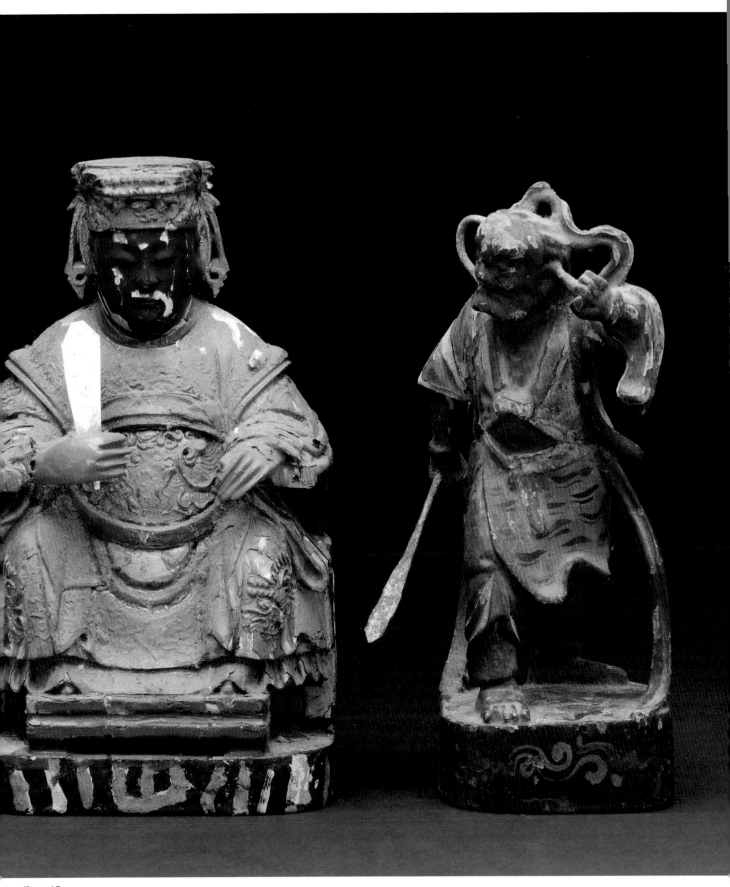

Figure 17

Ch'ien Li Yen (Thousand Mile Eyes) and Shun Feng Erh (Efficacious Ears). They are Matsu's faithful servants whose powers to see and hear great distances help her protect seafarers, fisher folk, and anyone crossing the waters. Height 18 cm (tallest).

Figure 18
Temple caretaker passing my Matsu statue over the incense pot in the Tainan Matsu temple.

台南媽祖廟的廟公手持我的媽祖像在香爐上繞一圈

loud sobs coming from a sedan chair. Inside was a young maiden who was being offered as a human sacrifice to the monsters Ch'ien Li Yen and Shun Feng Erh. Matsu changed places with the girl and agreed to keep the rendezvous. When the monsters beheld such a beautiful maiden, their delight reached a frenzied pitch. Rather than meekly submit, Matsu sternly challenged them to forsake evil ways and follow a righteous path. Indignant, they determined to take her by force but quickly realized they were no match for her. They sought to flee but were stopped in their tracks by a magic thousand-pound boulder flung by Matsu that pinned them underneath. They begged for mercy, promising to forsake evil and do her bidding. Now the pair accompany her always as her faithful servants.[37]

It is said that during the Sung and Yuan times, inhabitants along China's southern coast often saw Thousand Mile Eyes and Efficacious Ears with Matsu. This convinced them that she was using the awesome power of these demons to protect the fisher folk from dangers at sea.[38]

The association that these two attendant gods have with Matsu in the minds of the faithful was amply illustrated by the rash actions of one Matsu Association during her 1977 birthday celebrations. *Taiwan Daily News* reported that the Lukang City government, in an attempt to discourage waste and lavish spending during holidays and at festivals, decreed that only one religious procession would be allowed during Matsu's birthday, and temples and associations should coordinate a united parade. In the Ta Nan Men neighborhood, a small Matsu group publicly defied the order and organized their own procession complete with a Matsu statue, but lacking her two attendants, Thousand Mile Eyes and Efficacious Ears. The Association's unauthorized procession approached Nan Yao Kung and requested the loan of their two gods. Upon refusal, over one hundred men crowded the temple and forcibly seized the statues. The temple committee

appealed to the city authorities, who in turn demanded the police arrest the culprits and recover the statues. The police wisely acted with studied and effective slowness. By early evening, with their procession and devotions completed, the Matsu Association, which numbered among its devotees a former provincial assemblyman, returned the statues to Nan Yao Kung, declaring their motives were purely devotional. As attendant gods, statues of Ch'ien Li Yen and Shun Feng Erh are always carved in the standing position. Ch'ien Li Yen shades his eyes against the sun's glare, and Shun Feng Erh cups his hand over his ear to block out the sound of wind. They both have demon-like appearances – Ch'ien often with a pock-marked blue face and Shun with an equally ugly red face. In festivals in which Matsu partakes, ten-foot tall bamboo and cloth parade figures of the two, each carried by a lone man inside, peeking out through a mesh peep hole in the structure's belly, strut up and down the streets of Taiwan's towns and cities.

Some have compared Matsu to Kuan Yin, the goddess of mercy, and to Mary, the mother of Jesus, because the three are favorites of mothers and are prayed to for succor in difficult times. The three make an intriguing iconographic study. Statues of Kuan Yin bear a marked resemblance to that of the most popular representations of Mary. The standing pose, head veil, and soft flowing robes of each almost duplicate the other.

Matsu has undergone an iconographic alteration. There is an attempt in the newest representations to show her as a simply dressed maiden standing with compassionate eyes lowered, gazing down on a troubled world. But, an examination of Matsu's traditional statues and those of Kuan Yin and Mary show there is no comparison, only contrast. Matsu's clothes and headgear are those of a court official, and she is almost always seated in a regal looking chair, while Kuan Yin and Mary are most often depicted standing. Surprisingly, Mary, who lived long enough to see her thirty-three year old son die, is invariably portrayed as a beautiful, sometimes discernibly pregnant, young maiden. Matsu, who died young, has for centuries been carved as a portly matron. Although once given the alluring title of Heavenly Concubine, on Taiwan, she is always referred to as Matsu, which means Maternal Ancestor or more simply, "grandma."

26. Liao, *Mythology of Taiwan*, p. 71.
27. Ibid., p. 72.
28. Kramer and Wu, *An Introduction to Taiwanese Folk Religions*, p. 25.
29. Liao, *Mythology of Taiwan*, p. 74.
30. Werner, *A Dictionary of Chinese Mythology*, p. 503.
31. Wu, "Matsu: Goddess of the Sea," *Echo*, January 1971, p. 14.
32. "Matsu, the Sea Goddess Celebrated," *China Post*, April 20, 1979.
33. "Matsu Sues in Court," *Taiwan Daily News*, May 3, 1978.
34. Shen, *Introduction to Chinese Gods*, p. 179.
35. Gallin, *Hsin Hsing, Taiwan: A Chinese Village in Change*, p. 251.
36. Dore, *Researches into Chinese Superstitions*, Vol. IX, p. 208.
37. Masuda, *Taiwan No Shiukyo*, p. 185.
38. Liu, *Taiwan's Temples and Ancient Remains*, p. 256.

CHUNG T'AN YUAN SHUAI
(LI NA CHA)

中壇元帥

Chung T'an Yuan Shuai, commonly known as T'ai Tzu Yeh, was Li Na Cha, the third son of Li Ching, a general under the Chou. He was said to have been born miraculously after his mother had been impregnated by T'ai I Chen Jen, a Taoist priest-magician. Gestation lasted two and a half years, after which she gave birth to a scented flesh ball illuminated by a red halo. Li Ching slashed at the repulsive creature with his sword. A boy emerged wearing a red silk apron that emitted rays of dazzling light. A golden bracelet circled his wrist.[39]

According to the *Feng Shen Yen I*, a Ming novel that is still popular, Li Na Cha at seven years of age was already six feet tall. He had the body, but not the temperament, of a grown man. His childish nature and fiery tongue were to plague him through his short life. His first confrontation with authority occurred while he was washing his magic garment. The cloth made the water boil and run red. The turbulence shook the foundations of the Sea Dragon King's palace. After a series of ill-conceived insults, Na Cha killed first the messenger sent to inquire into the cause of the commotion and then the king's own son.

Na Cha then fought and wounded the Dragon King himself. The Dragon King appealed to the Jade Emperor, whose soldiers were sent to apprehend Na Cha. Failing to find the fugitive, they arrested his parents. Na Cha turned himself in and committed suicide in order to save his parents from disgrace.

On T'ai I Chen Jen's advice, Na Cha's spirit appeared to his mother in a dream and requested that a temple be built in his honor. She complied but without informing her husband. When Li Ching happened upon the temple one day, he flogged Na Cha's statue and burned the structure to the ground. Upon reincarnation, Na Cha sought out his father for revenge. But the father was saved through the intervention of a Taoist who subdued Na Cha with a magic flame-throwing pagoda. To keep the boy in line, he presented it to the father. Illustrations of Li Ching always show him holding the miniature pagoda.

Shen P'ing Shan, without criticizing those who worship the deity, reminds us that Li Na Cha was not a historical person. His legend comes from the novel *Feng Shen Yen I*, that is "sprinkled throughout with doubtful deities." Shen cites Matsu's attendants (Thousand Mile Eyes and Efficacious Ears) as examples of purely mythical beings like Na Cha that nevertheless are worshiped.[40]

Keith Stevens, among others, notes that Na Cha is one of several Chinese gods whose identity has changed from an original Hindu deity. In the Indian legend, Na Cha was Nata, the third son of Vaisravana.[41] His journey from Indian folklore through Buddhism to Taoism mirrors those of Monkey and Kuan Yin and illustrates the easy blending of popular religions and the ready acceptance by the faithful.

Jonathan Chamberlain perceives an eerie echo of Na Cha's story with that of Kuan Yin's

→Figure 19
Chung T'an Yuan Shuai, commonly known as T'ai Tzu Yeh. He is a boy-god prominently featured in *Feng Shen Yen I*, a fanciful novel about the establishment of the Chou Dynasty and the coronation of the gods.
Height 24cm.

中壇元帥,一般又稱太子爺,是描述周朝創立、諸神受冕之神魔小說《封神演義》中的一名男童神祇。

像高24公分。

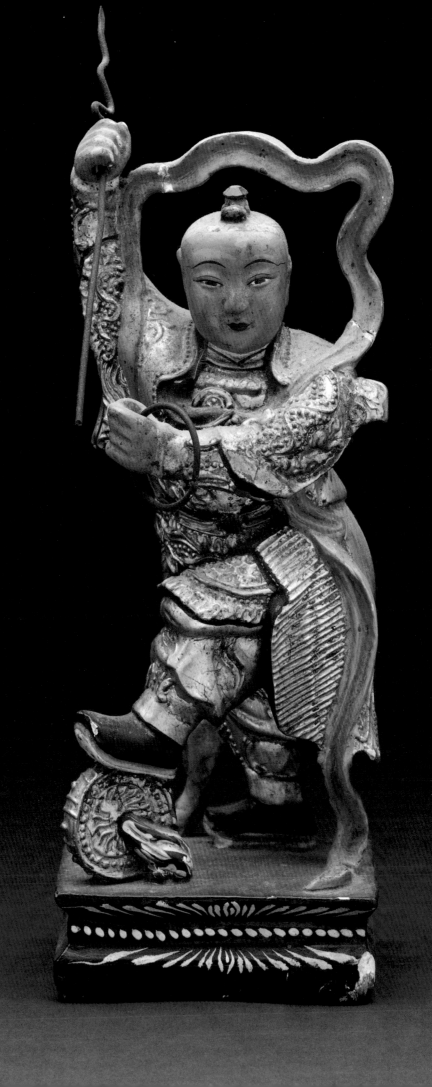

Chinese persona: Miao Shan. Both are Indian in origin. She was the third daughter of a king; he the third son of a king. She saved the third prince of the Sea Dragon; he killed the third son of the Sea Dragon. Her father burned down her nunnery; his father destroyed his temple. Kuan Yin cures her father; Na Cha tried to kill his.[42]

On Taiwan, where he is believed to be a powerful force for expelling evil spirits, Na Cha is recognized as Commander of the Wu Ying Shen, captains who guard the five directions of a village: north, south, east, west, and center.[43] During village *paipai* celebrations, flags representing the captains are placed at the four edges of the village. As Na Cha is the commander, his flag is posted in the town's center.

There are at least sixty temples dedicated to him spread evenly throughout the island. The most impressive is Kaohsiung's San Feng Kung. Covering 2,000 ping (one ping is 6 ft. x 6 ft.) it was, according to *Independence Evening News* (December 11, 1976), the largest temple on Taiwan at that time. The temple committee claims its origins go back to K'ang Hsi's reign (1662-1723). Its present structure was erected in 1964 at the cost of eighty million New Taiwan dollars.[44]

Li Na Cha is enshrined in the main sanctuary, and two other halls honor Kuan Yin and the Jade Emperor. On the night of December 10, 1976, a faulty wire connection caused a fire. Damage was estimated at twenty million Taiwanese dollars. Fortunately, the treasured original statue was out on a visit to another temple and escaped damage. This absence raised doubts in some and relief in others. Over teacups and beer bottles, the mysterious visit to another temple was hotly debated. Some questioned why a deity known for miraculous powers was unable to save his own house. Others countered that his absence proved his ability to see into the future. He foresaw the coming calamity and wisely left.

The U.S.I.S. Cultural Center where I was assigned from 1967 to 1970 was located only a few blocks from San Feng Kung. I was drawn to it often because of my interest in popular religion and because of the intermittent bustle in the large plaza fronting the temple. With space at a premium in Taiwan's expanding towns, such a large plaza in the middle of Taiwan's second largest city was a magnet for all sorts of activity and a convenient gathering place.

On festival days, Taiwanese opera and puppet performances would compete with each other on makeshift stages facing the open central door. The dueling microphones produced a din unintelligible to me, but pleasing, I assume, to the image of Na Cha and entertaining to those − who were not absolutely stone deaf − in the milling crowd.

The open space was also a convenient place for political candidates to harangue voters and demonstrate their sincerity by chopping off chickens' heads while swearing to their honesty and the purity of their record. On other days, hawker stands would draw hungry and thirsty neighbors, temple goers, or pilgrims who arrived on buses to marvel at this expensive edifice devoted to three popular gods.

My frequent visits drew the attention of a temple orchestra member. He was, I later learned, not only a musician, but also a music teacher and the artisan who made the musical instruments. Through him I became acquainted with the temple committee. Over the course of three years, I was entertained by them in restaurants and reciprocated by inviting them to dinner at my home.

Shortly after we met, I put the question to the music teacher that I asked all my acquaintances: "Can you identify this statue I bought in Chiayi?" He was unable to supply the identity, but delighted to find a foreigner who was fascinated by local religion. At our next meeting, he

➔Figure 20
Chung T'an Yuan Shuai carving dating from the mid-nineteenth century. This is the oldest statue in my collection. Height 25cm.

製作於十九世紀中的中壇元帥像，是我的蒐藏品中最古老的彫像。
高 25 公分。

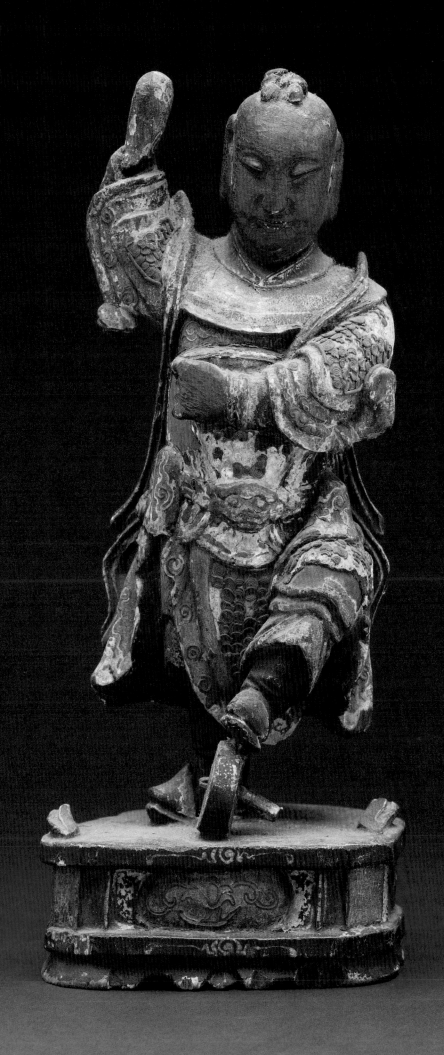

presented me with the statue of Matsu pictured here (fig. 21). It had little heft and was driftwood dry. The paint and gold leaf were weathered away, and some of the wood had broken off. As he was not a wealthy man, I accepted it with embarrassment and plotted a way to recompense him by a future return favor. The statue by anyone's reckoning is not a valuable piece or a rarity. Nevertheless, I treasure it for it was the second statue in my collection that grew to over 200. It encouraged me to seek more statues, learn their identities, study their legends, and find out how they fitted into the local culture.

Statues of Na Cha depict him as a young boy. He is usually standing with one foot on a fire wheel, holding either a spear or a sword in one hand and a golden bracelet in the other. His hair is fashioned in two tufts knotted at the top. He wears a red apron across his chest and stomach. The one pictured here (fig. 20) with the red face and the right arm extended above his head is my oldest statue. Judging by the style and the dryness of the wood, carvers I have consulted estimate it was made in Fuchien during Ch'ing times, probably mid-nineteenth century.

→Figure 21
A damaged and weathered Matsu statue. I have included it in this chapter because it was a gift from a staff member of Chung T'an Yuan Shuai's temple in Kaohsiung.
Height 17cm.

破損失修的媽祖像。我把它放在此章內，是因為它是高雄中壇元帥廟的一名廟方人員給我的贈禮。高17公分。

39. Werner, *Myths and Legends of China*, p. 306.
40. Shen, *Introduction to Chinese Gods*, p. 189.
41. Stevens, *Chinese Gods*, p. 64.
42. Chamberlain, *Chinese Gods*, p. 94.
43. Shen, *Introduction to Chinese Gods*, p. 189.
44. "Main Hall in Province's Largest Temple Destroyed by Fire," *Independence Evening News*, December 11, 1976.

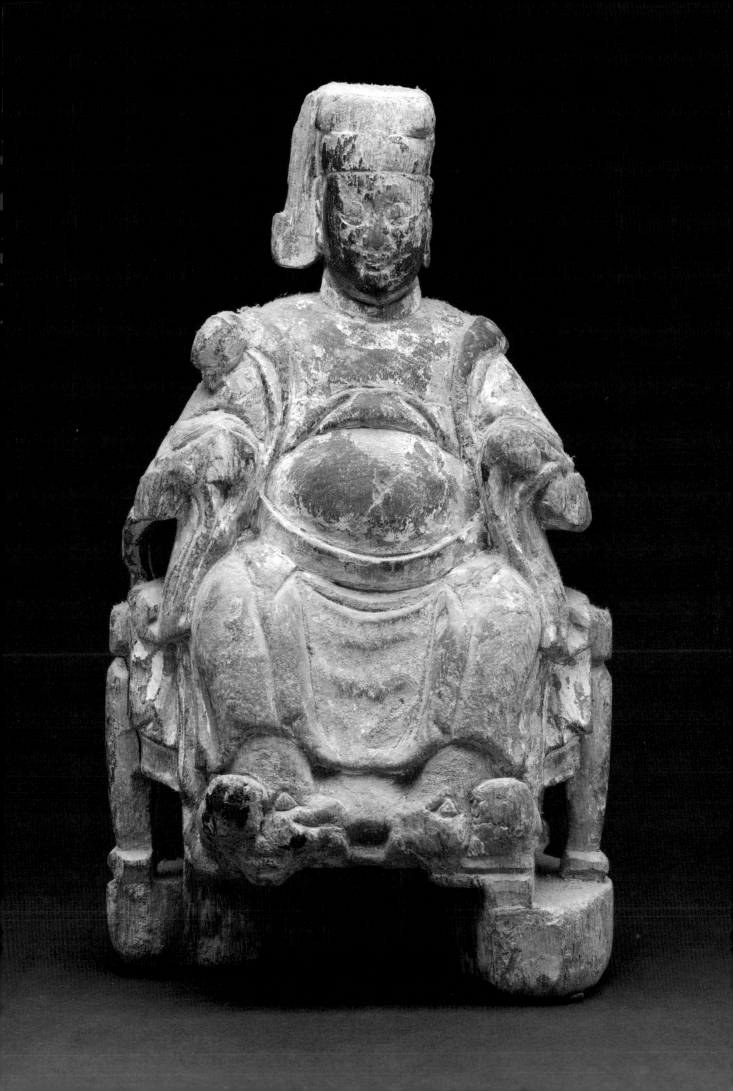

LAO TZU 老 子

Many, but certainly not all, scholars would agree that the man called Lao Tzu, who is credited with authoring the *Tao Te Ching* upon which Taoist philosophy is based, did exist and was a minor official at Loyang, the Chou Dynasty capital. Beyond those few facts is a vast array of legends, fanciful stories, and speculation.

The account of his birth is an example of a bizarre tale few take seriously. In it, his mother, miraculously conceived by supernatural "breath," carried him for eighty-one years. The delivery was a primitive Caesarean section: her armpit was cut to allow the babe, complete with whiskers and a full head of white hair, to emerge.[45]

There is no agreement on his name. One theory holds that when his mother was pregnant, she was betrothed to a man named Li, so he adopted that surname. Some claim that because he was born under a plum tree, he took "Plum" (Li) as his name. Others say he used his mother's name "Lao" because he was fatherless.

According to the *Historical Memoirs* written by Ssu Ma Ch'ien in the first century B.C., Lao Tzu was born in 604 B.C. and was a contemporary of Confucius, whom he met and debated. He lived for almost 200 years and was the Chief Archivist in the Chou Court. As an occasional ambassador, he visited small bordering principalities, urging them to unite with the Chou.[46]

Tiring of court life, Lao Tzu mounted a green ox and traveled far west of Loyang in search of a quiet hermitage. At the urging of a border official, he delayed his departure long enough to jot down his thoughts. The result is the *Tao Te Ching*.

During the Han Dynasty, the book was edited and divided into eighty-one parts and chapter headings were added. Much later, Emperor Hsuan Tsung of the T'ang Dynasty formally chose *Tao Te Ching* as the title for this 5,000-character volume. The book gained wide acceptance during the Yuan Dynasty and was adopted by various philosophical schools.

A library of books has been written about the *Tao Te Ching* − what it means, what it doesn't mean; and about Taoism − what is orthodox and what is heterodox. Serious scholars spend their lives studying the *Tao Te Ching* and occasionally coming out with a new translation that disproves past theories. Ernest latter-day hippies, counterculture types, and confused teenagers love to plumb the depths of the enigmatic verses in the little volume. Here I will skip what is obviously beyond the scope of this book. For those interested in the subject, I suggest Holmes Welch's *Taoism: The Parting of the Way* as a good starting point. Should that whet the appetite, there is a mountain of material waiting among which *The Taoist Body* by Kristofer Schipper is undoubtedly the most authoritative.

Few Taiwanese, I suspect, especially those in rural areas, have studied or read the *Tao Te Ching*. Yet most would recognize Lao Tzu as T'ai Ch'ing (Supreme Pure One), one of the San Ch'ing Tao Tsu (Three Pure Ones), Taoism's sacred triad. Yu Ch'ing (Jade Pure One) and Shang Ch'ing (High Pure One) complete

➜Figure 22
Lao Tzu, generally considered the author of the *Tao Te Ching*. He is the father of philosophical Taoism. Height 39cm.

老子，一般皆認為是《道德經》的作者，為道家的始祖。像高39公分。

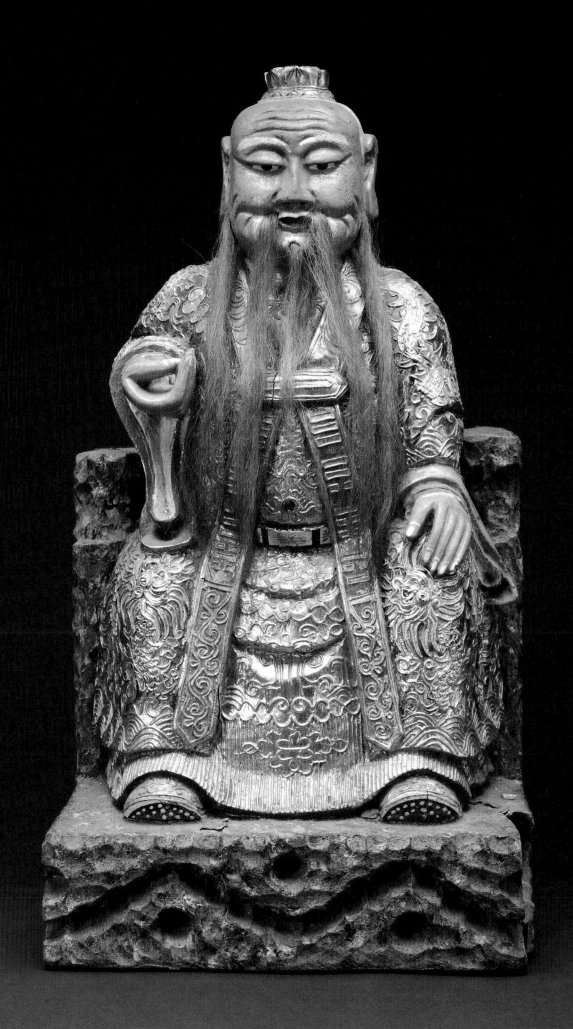

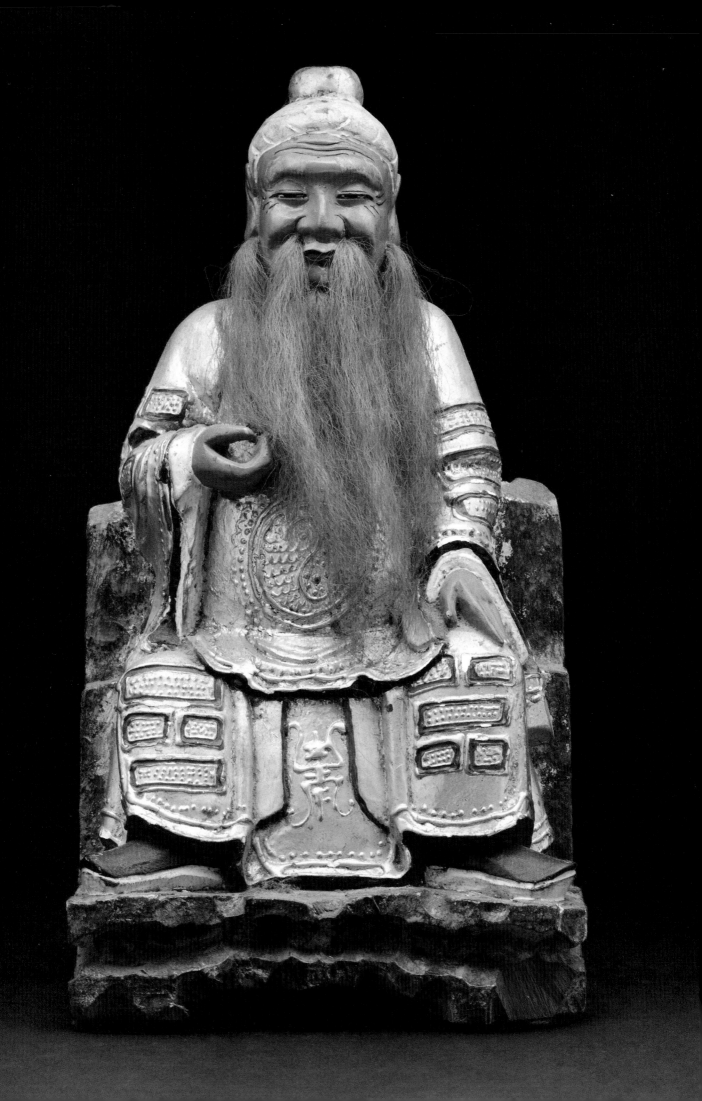

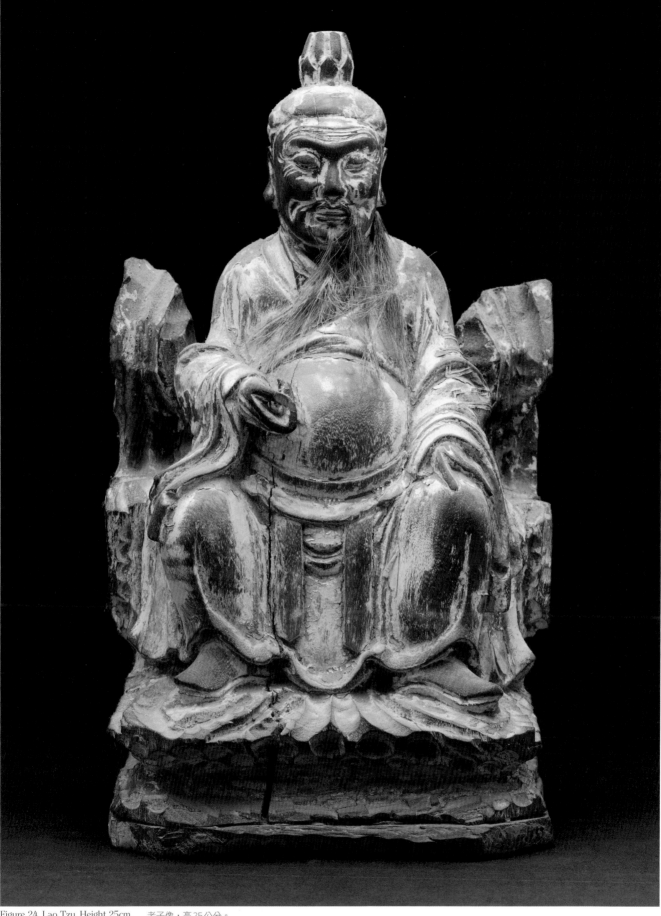

Figure 24. Lao Tzu. Height 25cm.　老子像，高25公分。

←Figure 23. Lao Tzu. Height 28cm.　老子像，高28公分。

the trinity. Scrolls of the three are often hung during Taoist rituals.

There are, according to Chung Hua Tsao, fourteen temples to Lao Tzu scattered throughout the island from Chilung to Kaohsiung.[47] They are situated, according to Chung, in settings that suit the reverent and solemn purpose of the faithful and pilgrims who visit them. The only Lao Tzu temple I have visited was in mountainous Nantou *Hsien*. It fits his description accurately: an architecturally impressive structure in a remote, pleasing environment. One rarely sees statues of Lao Tzu on home altars for it is unlikely one would address a petition to him for some personal favor. Such requests are directed to more accessible gods who occupy less lofty positions and are assumed to be more concerned with family affairs.

Every Taiwanese I have ever asked identified themselves as "Buddhist," even when asked the question standing in a T'u Ti Kung or Hsuan Tien Shang Ti temple. No one that I have asked answered: "Taoist." Ethnologists lump most worship in Taiwan, other than exclusively Buddhist, under the heading of "popular religion." Their academic nomenclature not withstanding, there are many gods whose histories or legends are strictly Taoist, and there is a distinct Taoist clergy. The current Taoist Pope is resident in Taipei.

Confucianism, according to scholars, is not a religion but a prescription for personal and governmental conduct, a guide for ordering society. Confucius is a sage, not a god. This historic accuracy is disregarded by the Taiwanese faithful. Lin Heng Tao's directory lists fifteen temples where he is enshrined as the main god. Additionally, he is worshiped on numerous side altars.

Despite the historical improbability that Lao Tzu and Confucius ever met, Chung Hua Tsao repeats the story of their get-together with snatches of their conversation, including a properly humbled Confucius lauding Lao Tzu as obviously "great" (*wei ta*).[48] Precise dating in antiquity is impossible, but there is no doubt the two great innovators were contemporaries. Lao Tzu was born around 600 B.C. and Confucius about fifty years later. Coincidentally, the birth of Siddhartha Gautama (founder of Buddhism) fell between the two. Zoroaster, the great Persian religious reformer, is said to have been born a mere quarter of a century before Lao Tzu. Socrates followed in 470 B.C.

Granted that the above dates are mere historical guesses, it is a source of wonderment that in six millennia of recorded time, such an outpouring of prodigious philosophical activity should have been crammed into a bit more than one century. Their innovative ideas have been rethought and polished over time and continue to be reworked and to influence religious and philosophical endeavors.

Zoroasterism has evolved into Parsiism, practiced in India today. And echoes of Zoroaster's teaching, so evident in Greek thought, can be heard in Christianity, Judaism, and Islam. Buddhism not only continues as a religious system, but secular philosophers seek inspiration from it. Confucianism, no longer a state philosophy as it once was, is still a force for ordering personal relationships in much of East Asia. As for Taoism – the religion that owes its origins to Lao Tzu – it has become a mix of magic and ritual, bearing little resemblance to the *Tao Te Ching*. Yet it is a vibrant force in Taiwan, China, and parts of Southeast Asia.

Lao Tzu is always carved as a wise sage whose white hair is fashioned in a topknot. His plain robes often are decorated with *t'ai chi* and eight trigrams symbols.

45. Chu, *Birthday Listing of Gods*, p. 70.
46. Ibid., p. 70.
47. Chung, *The Origins of Taiwan's Local Gods*, p. 119.
48. Ibid., p. 115.

CHANG T'IEN SHIH

張 天 師

Chang Tao Ling, the man who became the first T'ien Shih (Celestial Master, commonly referred to as the Taoist "Pope" in Western writing), was a descendant of Chang Tzu Fang, an advisor to Liu Pang, founder of the Han Dynasty. As a child, he possessed a brilliant and retentive mind. At age seven, he thoroughly understood the *Tao Te Ching*. As he grew into manhood, his academic reputation was such that the Han emperor Chang Ti sought to promote him to an important office. Chang was summoned three times, but refused each call. Chang decided to reject official life in favor of a contemplative one that afforded him the necessary time to meditate on the *Tao* (Way) and to experiment with life-prolonging elixirs.[49]

Chang retired to a Szechwan mountain retreat, where he studied the Yellow Emperor's "nine pot, one pill" method of concocting medicine and wrote a twenty-four-chapter book on the *Tao*. While thus engaged, Lao Tzu miraculously appeared and instructed him in Taoist magic and passed on secret incantations. Armed with this knowledge, he could converse with gods, exorcise devils, transform his shape at will, and fly like a bird.

Chang acquired several thousand disciples and established a state governed by a Taoist hierarchy. Upon reaching age sixty, he arrested the aging process and began "younging." His face and body took on the appearance of a youth again. He ended his early ministry on the seventh day of the first lunar month in A.D. 155 when, together with his wife, he ascended to Heaven.[50]

Taoism has been a political as well as a spiritual force since Chang Tao Ling blended Lao Tzu's philosophical doctrines with magic and folk customs into an organized religion. Various Taoist celestial masters have vied with Buddhists for imperial favor or engaged in open rebellion against the government. At one point during the Three Kingdoms Period (A.D. 222-265), the reigning pope, Chang Tao Ling's grandson Chang Lu, controlled a temporal army that occupied a large part of central China.[51]

Tradition dictates that the man who leads the Taoist religion should be a lineal descendant of Chang Tao Ling. The first eight were. The line, while not completely broken, has been bent and twisted many times. Hui En P'u, the sixty-third in the line was born to the reigning Celestial Master in 1896. He studied law and politics in Kiangsi. Upon his father's death in 1924, he became Celestial Master. Political events frustrated his attempts to exercise religious authority. First dislodged from his religious center at Lung Hu Shan (Dragon Tiger Mountain) in Kiangsi by government confiscation[52] and later harassed by Communist forces, he fled from one Chinese city to another. At the fall of the Mainland to the Communists, he escaped first to Macao, then Hong Kong, and eventually Taiwan. In Taipei, he found initial refuge at Chio Hsiu Kung, a Lu Tung Pin temple on Chung Ch'ing North Road. He set about organizing and regularizing Taoist worship on the island, albeit with only partial success. He died in 1970 after an exhausting trip to the Philippines to visit Manila Taoists.[53] With no sons to succeed him, he named his nephew, Chih Yuan Hsien, to be the sixty-fourth Celestial Master, thus bending the succession line into a pretzel shape.

Chih Yuan Hsien resides in pale imitation of his predecessors' pomp and splendor. He presides over

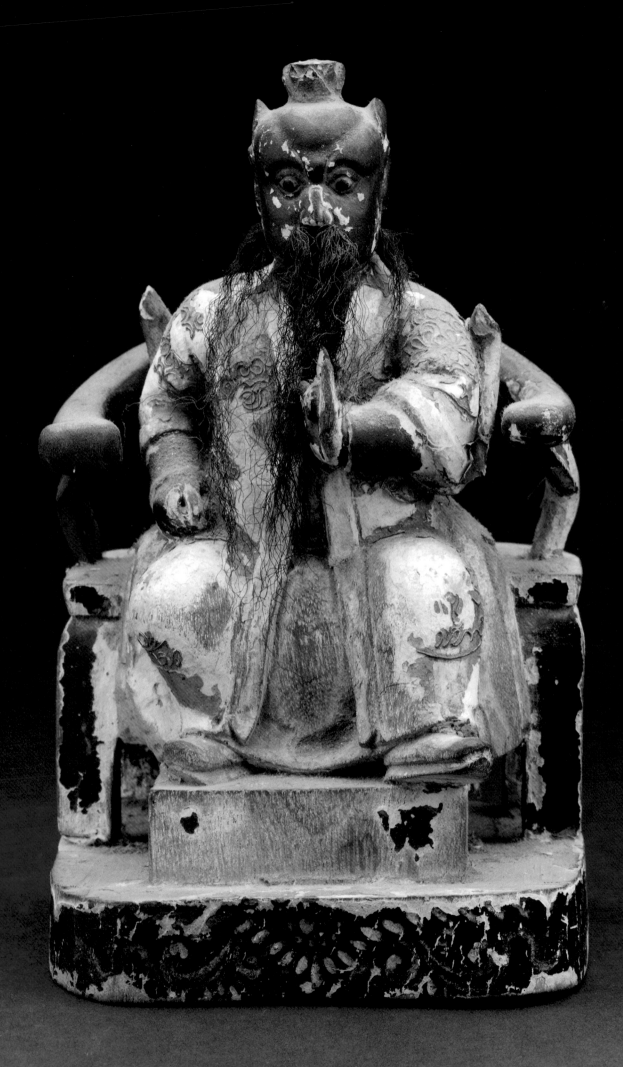

Yin Ming Shih, a Taoist master, demonstrates two ceremonial poses. (Fig. 26~27)

道長殷明石示範兩種儀式過程 (圖 26 ～ 27)

Figure 26
Ritual Master Using Ritual Bell Inviting Gods.

道長手持法鈴請神

←Figure 25
Chang T'ien Shih, a Han Dynasty scholar. He is credited with establishing religious Taoism. Celestial Masters, commonly referred to as "Taoist Popes," in theory, are his descendants.
Height 19cm.

張天師，漢朝文人，亦為道教創立者。理論上，一般稱為道教教長的「天師」皆是他的後裔。像高19公分。

a religion that is fragmented. In an *Asia Magazine* interview he lamented: "According to all sects of Taoism, it is only the Celestial Master who is permitted to ordain priests. Years ago on the Mainland–and I remember this well–thousands of priests would come from all parts of China to be ordained. Now, few even bother. Once this crown was pure gold and these gems rubies and opals. Now they are merely artificial."[54]

As was the case with all previous popes, he received from his immediate predecessor Chang Tao Ling's eighty-one ounce copper demon-expelling sword, engraved with Taoist charms as a symbol of his authority. This was followed by an elaborate initiation ceremony in Tainan that included a barefoot climb up a ladder whose thirty-six rungs were swords, edges turned upright. Although he is often referred to as Celestial Master, he has no real authority to command. In the magazine interview, he said he spent his days studying Taoist texts, but when asked to summarize the basic tenets of Taoism, he fell back on a Confucian principle replying: "In two words – filial piety." On reflection, he added: "All ethics, social obligations, meaning to life and its purpose are contained in filial piety. When children pay proper respect to their

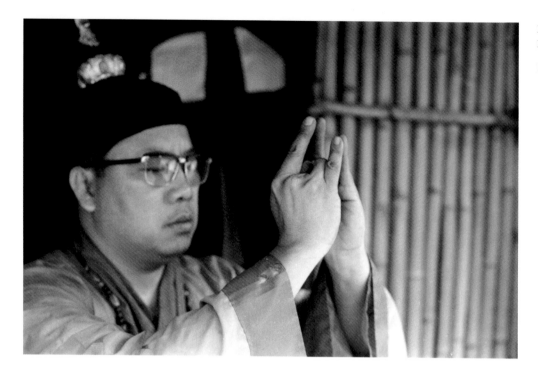

Figure 27
Four Saints Approach Heaven.

四聖朝天

parents, and a family to its ancestors, they touch upon the essence of life's meaning and of the *Tao*."[55]

Taoist priests in Taiwan officiate at funerals and large *paipais* called *chiao* (rites of purification, renewal, and thanksgiving). They sacrifice to the dead ancestors and make use of charms and amulets to drive away evil spirits and cure the sick.[56] Loren Fessler, writing a research paper for the American Universities Field Staff on the work of Kristofer Schipper, an L'Ecole Francaise d'Extreme-Orient scholar and ordained Taoist priest, claimed that in the late 1960s, there were only 500 Taoist priests in Taiwan. I am not sure what that figure represents. It may be only those recognized by the pope. My assumption is that many more claim that title without proper ordination but are accepted locally as such.

Chung Hua Tsao writes that there are ten temples where Chang Tien Shih is enshrined as the main god. That may be true. However, I have been able to identify only one: Tien Shih Kung Miao in Pei Tou, Changhua.

I was fortunate to make the acquaintance of, and establish a friendship with, Yin Ming Shih, a Taoist priest and teacher associated with the San Yuan Kung in Taoyuan. He kindly consented to demonstrate bits and pieces of various ceremonies and allowed me to photograph over one hundred attitudes struck during the presentation. On the back of each snapshot, he wrote the meaning and purpose of the action performed. Two are pictured here: "Fa Shih Ch'ing Shen Ch'i Yung Fa Chung" (Ritual Master Using Ritual Bell to Invite Gods) (fig. 26) and "Szu Cheng Ch'ao Tien" (Four Saints Approach Heaven) (fig. 27). The meaning of course is obscure for as University of Hawaii religion professor Michael Sasso points out: "The ritual of religious Taoism is esoteric and not meant to be directly understood and witnessed by all the faithful."[57] For English readers seeking a better under-standing of the role of the Taoist priest on Taiwan, Kristofer Schipper, writing in the same volume as Sasso, explains with as much clarity as the ordinary lay person can grasp.[58]

Pictured below also are two magic charms (gifts from a Taoist friend) (fig. 28) supposedly written by the Taoist Pope. The two unintelligible characters are written on yellow cloth over the large red ink signature chop of the pope. One promised to "protect and bring happiness by beheading goblins and controlling demons." The other will give "peace and prosperity by ridding the dwelling of evil spirits."

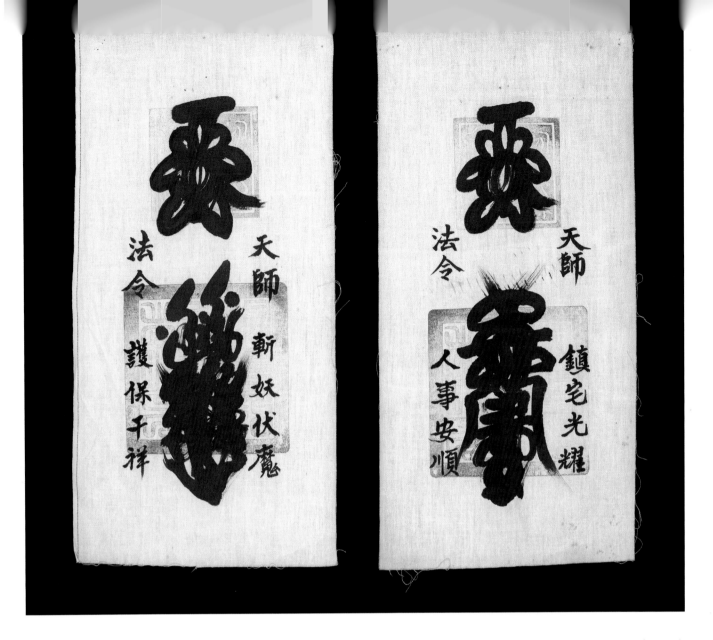

天師　斬妖伏魔　法令　護保千祥

天師　鎮宅光耀　法令　人事安順

Figure 28
Two charms allegedly written by the
"Taoist Pope."
Size 36 by 18cm.

據説是由道教長所寫的兩張符。
36 × 18公分。

Fanciful accounts tell us that Chang Tien Shih was over nine feet tall. He had a square face with thick eyebrows and red eyes set in slightly triangular sockets. His arms hung down to his knees, and he walked like a lion.[59] In carvings and pictures, the Celestial Master's face is usually depicted as black, the effects of various chemicals ingested during experiments in his search for the elixir of immortality.[60] He is seen either seated on a throne or riding on a tiger.

49. Shen, *Introduction to Chinese Gods*, p. 194.
50. Ibid., p. 194.
51. Ibid., p.195.
52. Werner, *A Dictionary of Chinese Mythology*, p. 41.
53. Shen, *Introduction to Chinese Gods*, p. 195.
54. Vinecour, "The Taoist Pope," *Asia Magazine*, March 29, 1981, p. 5.
55. Ibid., p. 5.
56. Stevens, *Chinese Gods*, p. 80.
57. Wolf, *Religion and Ritual in Chinese Society*, p. 325.
58. Ibid., pgs. 309-324.
59. Liu, *The God Statues of Taiwan*, p. 104.
60. Ibid., p. 105.

LU TUNG PIN

呂洞賓

Both Taoists and Buddhists acknowledge Lu Tung Pin, a T'ang Dynasty scholar official. He is Miao Tao Tien Tsun or Fu Yu Ti Chun to the Taoists, and Buddhists pray to him as Wen Ni Chen Fo. He was born into an official family in Shansi around the middle of the sixth century. His father was the prefect of Hai Chou in Kiangsu, and his grandfather had been the president of the Ministry of Ceremonies.

Having been disillusioned with worldly affairs after the death of his two young sons, Lu Tung Pin retired to a mountain cave, where he lived with his wife in seclusion. The written name, by which commonly he is known, is a visual clue to these austere living arrangements. The character *lu* is written as two "mouths" connected, symbolizing husband and wife. *Tung* is Chinese for "cave," and *pin* means "guest." When his wife died, he continued on in the cave, living as a hermit. He eventually gained the status of an immortal.

According to one version of his story, his disillusionment came not from the loss of children, but from a chance meeting with Chung Li Ch'uan, one of the Eight Immortals who is also known as Han Chung Li. While he was warming a cup of wine, Lu Tung Pin fell asleep and dreamed he was appointed prime minister. The dream covered a span of fifty years, during which time he married twice and had several sons and numerous grandsons. However, he eventually fell out of favor with the emperor and was exiled in disgrace. As he awoke even before the wine was fully warmed, he understood the dream to mean that power, wealth, and status, measured in Taoist terms, last but an instant. Lu decided to forgo his quest for government honors and devote himself to studying the Way.[61]

Because he once supposedly cut an emperor's hair, barbers consider Lu Tung Pin as their special patron. Scholars, physicians, druggists, herbalists, ink slab makers, bookshop owners, fencers, jugglers, and magicians also honor him.[62] Women wishing to conceive may address their prayers to him. Those who do must observe specific taboos. Sexual activity is to be avoided during turbulent weather: excessive heat or cold, high winds, torrential rain or thunderstorms. It should never occur in the moonlight, near wells, hearths, temples, coffins, graves, when one is angry, drunk, or sick. It would be a serious breach for it to happen on a parent's birthday.[63] In addition he is, together with Kuan Kung and the Kitchen God, a divination god.

Lu Tung Pin is included among the Eight Immortals, a collection of personages, three historical and five legendary, who for various reasons and at different times, attained immortality. Although seldom worshiped, they provide the motif for high relief sculptures and paintings in numerous temples and walls, as decoration on clothing and handicraft. Lu Tung Pin is the exception. Many temples honor him as the main god in China and on Taiwan.

There are thirty-two temples dedicated to Lu Tung Pin on Taiwan, the most famous of which is Chih Nan Kung built in 1889 on the outskirts of Taipei. The main statue is a copy of a Taipei woodcarver's personal god. It was so effective in granting wishes of petitioners that a committee was formed to build

➔Figure 29
Lun Tung Pin, a T'ang Dynasty scholar. Both Taoists and Buddhists acknowledge him. He is also included as one of the Eight Immortals. His Chih Nan Kung temple in suburban Taipei is among the island's most active and prosperous.
Height 41cm.

呂洞賓是唐朝文人，道教和佛教皆有祂的蹤影，祂也是八仙中的一員，台北近郊供奉呂洞賓的指南宮是本島香火最鼎盛的廟宇之一。像高41公分。

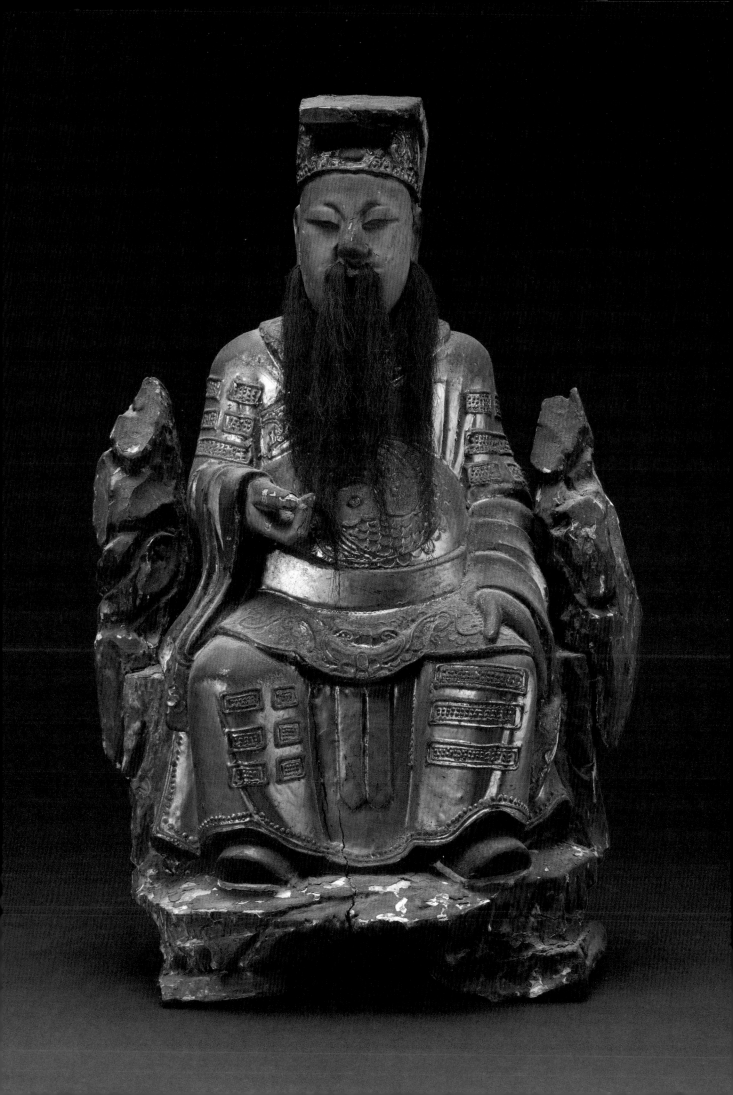

a temple so more could worship him. It is said that a believer who prays there and then retires to one of the temple's special bedrooms will be visited in a dream by the god, who will answer questions, solve problems, or explain why a difficulty cannot be overcome.[64]

Because he lost his wife and children and lived for many years a lonely hermit, he is supposed to be jealous of happy young couples. There is a superstition in Taipei that should lovers visit Chih Nan Kung together, the god will end their affair. A polite way for one partner to break a relationship is to suggest a visit to Chih Nan Kung. The other partner will understand, and they can part company without loss of face.

The temple, nestled on a hillside, is accessible by shuttle, car, or taxi, but many of the roughly 30, 000 who visit weekly choose to climb the more than 1,000 steps to the complex. Most Taiwan temples enshrine a main god and honor several secondary deities. Chih Nan Kung is unique in the array of significant gods honored within its courts. Although the temple is dedicated to Lu Tung Pin, devotion is emphasized to Buddhist, Taoist, and Confucian deities as well. Many will argue that Confucianism is not a religion in the strict sense. Nevertheless, incense is burnt and offerings are made to statues of Confucius here and at other Taiwan temples. In addition to Confucius, deities honored at Chih Nan Kung include: the Jade Emperor, San Pao, Kuan Yin, Lao Tzu, Meng Tzu, and patriarchs Yao, Shun, and Yu.

The temple complex also includes a children's play area and a small menagerie that at times has held a black ape, a boa constrictor, and rare birds. A scholarship program for college-bound students is a welcomed community service and an indication of the temple's wealth.

Lu Tung Pin is carved wearing a flat tilted hat. In pictorial representations, his famous devil-slaying sword is slung across his back. Carvings often depict him holding a *yun chou* (whisk or "cloud sweeper"), a Taoist instrument enabling him to fly at will or walk on the clouds of Heaven. Some old timers of Tien Tai Shan, Wang An Hsien, Peng Hu will point to an indentation in the rocks as proof of his cloud-riding prowess. Legend has it that one day, he and Li Tieh Kuai landed there and engaged in a chess competition. After losing one game after another, without a win, the enraged Lu hurled the chessboard to the winds and stomped off in anger, leaving a footprint relic as evidence of his visit.[65]

61. Dore, *Researches into Chinese Superstitions*, Vol. IX, p. 42.
62. Stevens, *Chinese Gods*, p. 77.
63. "Gods and *Pai Pais*," *Echo*, April 1973, p. 5.
64. Wei and Coutanceau, *Wine for the Gods*, p. 154.
65. "A Vestige of Lu Tung Pin?" *Independence Evening News*, June 20, 1979.

SZU MING TSAO CHUN
(KITCHEN GOD)

司 命 灶 君

Pictures of Szu Ming Tsao Chun (Controller of Fate, Lord of the Stove) far outnumber those of other deities. Woodblock prints or lithographs purchased for the New Year can be seen above or near stoves in all traditional households.

According to one legend, the Stove or Kitchen God was the remorseful husband of a neglected wife who, after coming to his senses, committed suicide by bashing his head against the stove as an act of contrition. In recognition of this penitent act, the Jade Emperor appointed him Kitchen God. In a more popular story, he was the third son of the Jade Emperor. Of a lazy nature, he neglected his celestial duties and passed his days in idleness with various goddesses. When news of his dalliance reached the Jade Emperor's ears, the irate father demoted the boy to the lowliest position in the celestial bureaucracy: Stove God. Fulfilling that office was deemed fitting punishment for although in the constant company of women, he would be unable to leave his station above the stove to indulge in frivolous pleasure.

On the twenty-fourth day of the last lunar month, the Kitchen God must return to Heaven to

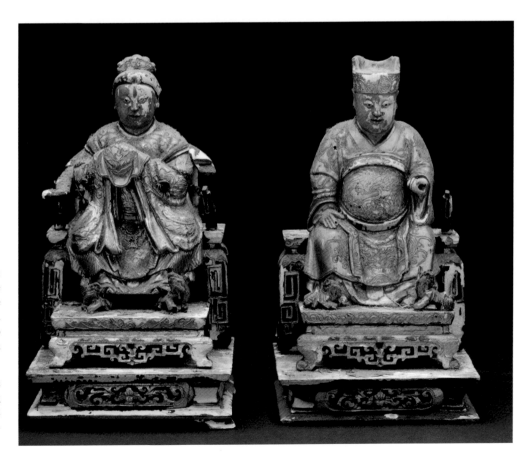

Figure 30
Szu Ming Tsao Chun, familiarly known as the Kitchen God, and his wife on the left. Pictures of him appear above the stove in every traditional household. Once a year he returns to Heaven to give an account of the family's behavior. Height 18cm (tallest).

司命灶君（右）和他的妻子（左）的彫像。司命灶君一般稱為灶神，每個傳統家庭都會在火爐上方懸掛祂的圖像。每年祂都會回天庭一次，呈報各個家庭一年來的表現。最高18公分。

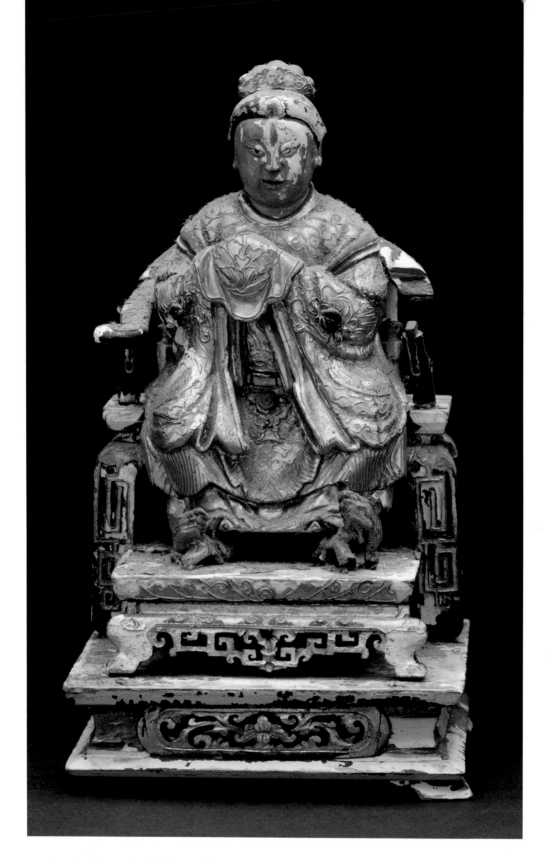

report on family members' behavior. Some traditions hold that all gods with terrestrial responsibilities, such as the City God and Tu Ti Kung, also make this same trip and rest until the fourth day of the New Year when they must return. To avoid a spiritual vacuum, a number of heavenly gods are substituted. They arrive together on the following day, known as "The Day the Heavenly Gods Descend."

Although occupying the lowest rung on the celestial ladder, his official title is Szu Ming Tsao Chun. As such, he is responsible for determining the number of years each household member will

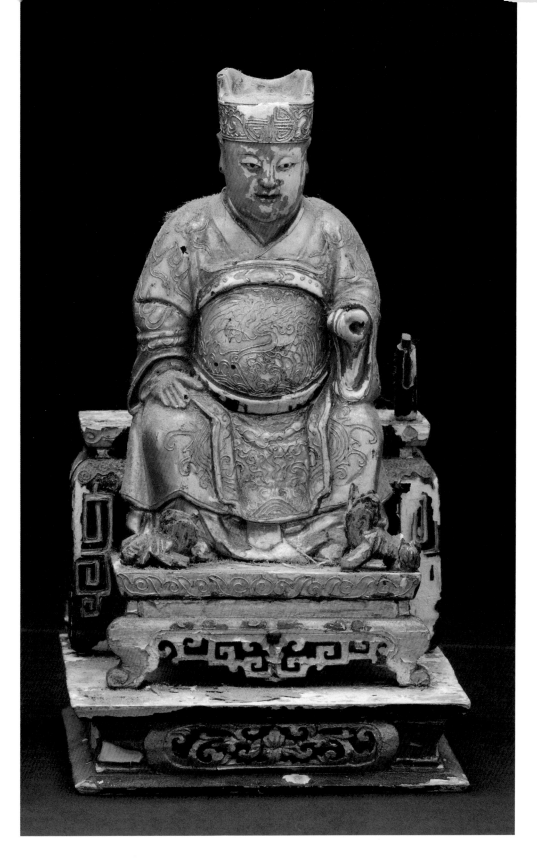

live. He is ideally situated to perform his task. From his perch above the stove, he is privy to all domestic disputes and every bit of gossip. On the twenty-fourth day, the Kitchen God's picture is taken down and burned so that he may ascend to Heaven with the smoke. While a simple burning satisfies most, many prefer a more elaborate send-off. Early in the morning, spirit money will be burned and firecrackers exploded. A sedan chair or a horse will be fashioned from yellow paper and burned so that the god will have a comfortable journey. Some smear his mouth with sweets to insure only sweet words will be

reported. Others soak his picture in wine in hopes that the Jade Emperor will disregard as unreliable the testimony of a drunkard.

The custom of displaying his image, still practiced throughout Taiwan, seems to be declining among families living in high-rise apartment houses. Mindful of tradition, but eager to be modern, one can rationalize ignoring the custom, because kitchens are small and gas ranges are unlike the time-honored brick stoves. The Kitchen God would obviously feel out-of-place in such cramped quarters, watching over a cooking appliance that produces fire with the mere turning of a dial. Additionally, apartment kitchens are not gathering places for family members and domestic staff. There would be no revealing conversations to overhear, no domestic spats to witness.

Most representations of the Kitchen God are paper and designed for household use, but statues of him can be found in temples. There is a powerful cult in central Taiwan that worships him in conjunction with Kuan Kung and Lu Tung Pin. Temples honoring this triad hold séances, regularly scheduled at three or nine-day intervals for faithful who seek advice. Communication is by a divining rod-shaped stick that is held by an entranced and often illiterate medium who traces messages in a shallow box. When moved by a spirit, the medium's arms will begin to jerk around forward and sideways outlining patterns in the box. At his side, an interpreter will decipher the scribbles and call out the words to a scribe who will write out the message.

On the night of May 14, 1972, I happened to be passing the Sheng Shou Kung in Taichung. An unusual amount of activity for that time of night in the temple aroused my curiosity. I parked my car and entered the brightly lit building. A young man named Lin, perhaps surprised at the presence of a Westerner, greeted me. As we spoke in Chinese, I introduced myself using my Chinese name: T'ang Neng Li. He offered to explain the proceedings.

Lin said that a person who truly believes might receive answers to questions or solutions to problems channeled through the triad of Kuan Kung, Lu Tung Pin, and Szu Ming Tsao Chun. A question or petition can be addressed to any deity, whether Chinese or Western. Answers, mostly in poetic form, are transcribed and significant ones are published monthly. Some unusual ones recorded were from Sun Yat Sen, Mother Mary, and Jesus. Lin claims that the Chinese understanding of Jesus is deeper than Westerners because Jesus talks to them directly.

The ceremony began with incense, bells, gongs, and chanting by the medium and white-robed attendants who were separated from the congregation by a wooden rail. Spirit money was burned and, while still flaming, waved over the divination box as if to purify it.

An elderly man petitioned first. Bothered by a recent string of bad luck, he sought information about his previous existence. Should his present misfortune prove to be rooted in some ancient, evil existence, he could take steps to expiate his hidden sins through a series of sacrifices and good deeds. Unfortunately, he received no answer that night. Lin told me that only T'ai Tzu Yeh was answering that night, and the boy-god was unwilling to help the old man. The divination séance continued with unsatisfactory results for some time when the medium began shaking vigorously and scratching with the stick at a fast pace. Lin turned and pointed at me. After a few minutes, the medium calmed again, and Lin took a sheet of paper from the scribe and walked over to where I sat.

"This is for you," he said, handing me the paper. "T'ai Tzu Yeh has acknowledged your presence and presents you with this poem" (fig. 31). It was a standard four-line, seven characters per line poem, yet it was, to me at least, a remarkable piece of writing. The first character of the first line was *T'ang*. *Neng* headed up the second, and *Li* the third. Lin was the only one in that temple, which I had never

→Figure 31
A divination poem obtained at Taichung's Sheng Shou Kung in 1972. Size 19 by 13cm.

1972年取自台中聖壽宮的一首籤詩，
19×13公分。

本宮太子元帥恩主　賞詩　唐能琲　大德

聖壽宮
台中市民生路一〇九巷二號

唐宮參礼飲嬌臨
能金聲玉振之聲音
猩完顯明勸善人
炊高研智作瀛欣

壬子年　四月二日
五一曲

before visited, who knew my name. Skeptics will claim the poem has the sound of stock verbiage or formula writing, and Lin had ample opportunity through hand signals or other secret communication to arrange the whole charade, and the skeptics undoubtedly have reason and logic on their side. Nevertheless, to compose such a poem on the spur of the moment is a feat to be marveled at.

The following is a rough translation:

> From this temple:
> Graceful Lord Marshal Tai Tzu
> Presents this poem to
> The Honorable T'ang Neng Li
>
> Mr. T'ang comes devotedly to attend this temple's ceremony.
> This will enable him to learn more and more of the holy message.
> Understanding the truth clearly, one can advise others.
> Such a longing for enlightenment leads to great joy.

The third day of the eighth month in the lunar calendar is celebrated as the Kitchen God's birthday. The lone temple on Taiwan dedicated to him is located in Chu Tung, Hsin Chu. In 1979, *Taiwan Daily News* covered the birthday activities with a report accompanied by a photo of a sea of walking pilgrims sharing the road with taxis and motorcycles. The temple, identified in the report only as the "Kitchen God Temple," is located on Wu Chih Shan, more than 300 meters above sea level. Because the only road to the temple was a mere four meters wide, two-way traffic moved at a snail's pace and at times jammed to a halt. Many stranded all day at the foot of the mountain were unable to make the climb at all but forced to resign themselves to "we'll try again next year." Surprisingly, no disputes or disturbances were reported among the throng, described by the reporter as sweat-covered from the exhausting climb. No doubt the Kitchen God's presence and the free vegetarian food provided by the temple committee served to calm the crowd.[66]

Although the Kitchen God sits on main altars with Kuan Kung and Lu Tung Pin, the temple in Chu Tung is the only one dedicated to him alone. He does appear on the altar (in a listing by Lin Heng Tao), sharing the main god honors with Sakyamuni at the Yun Kuang Szu in Pei P'u, Hsin Chu.[67] I have never visited that temple, but while the pairing of Buddhist Sakyamuni with the lowest god on the Taoist pantheon seems strange to the extreme, it does exemplify the easy tolerance and open-mindedness of the Taiwanese faithful.

The portraits hung over the stove invariably depict the Kitchen God alone. Because, according to the popular story, his banishment was punishment for dalliance with celestial maidens, one does not think of him as a married man. Yet, other legends hold that he was once human and married. Various names are offered for his wife, Ch'ing Chi being the one most mentioned. Except for temples, statues of the Kitchen God are seldom carved and rarely for his wife.

66. "Stove God's Birthday Yesterday," *Taiwan Daily News*, September 24, 1979.
67. Lin, *Taiwan Temple's List*, p. 118.

KUAN KUNG

Kuan Kung, one of the most respected historical personages to be deified, was born in the second century A.D. in what is today Shansi Province. Buddhists have accepted him and granted him the religious title of Hu Fa Yeh (Lord Protector of the Law). To the Taoists, he is Hsieh T'ien Ta Ti (God who Assists Heaven). Confucians revere him as Shan Hsi Fu Tzu (Sage of Shan Hsi). He is also known as Kuan Yu, Kuan Ti, and Wu Ti, as well as numerous other names and titles.

Kuan Kung's popularity is such that he has been claimed not only by major Chinese religions, but as a patron by three powerful classes in Chinese society: soldiers, scholars, and merchants. Of the three, the military have the strongest claim. The literati's worship is based on the belief that he could recite from memory, a lengthy commentary on the *Spring and Autumn Annals*, a tome that he is often depicted holding in his right hand.[68] Merchants claim him as their own because he is said to have established the accounting system after having been captured once in battle. He kept a careful account of all his expenses and, after being set free, returned the exact amount to his captors. This record, in the Chinese mind, was the world's first ledger.

Because as a youth he killed the local magistrate, Kuan Kung was forced to flee his native Shansi. One day upon hearing a neighbor girl and her parents weeping, he inquired into the cause of their grief. Her father replied that his daughter was being forced by the local magistrate to become his secondary wife. The old man's appeals to the magistrate were met with curses. Moved with indignation, Kuan Kung hurried to the official's mansion and slew the magistrate. He fled westward towards the T'ung Kuan Pass. A description of the fugitive had been forwarded to the guards with orders to apprehend him. Before reaching the Pass, he bent over a clear pool to drink and was astonished to find his face, mirrored in the water, had turned into a dark ruddy hue: a protective camouflage effected by the gods to award him for bravery in defending a maiden's virtue. His visage thus altered, he approached the Pass. When the guards asked his name, he replied, "Kuan" (gate or pass). With a new face and a new name, he was allowed to continue his journey.

The story of his oath of sworn brotherhood with Chang Fei and Liu Pei as told in the Ming novel, *San Kuo Yen Yi*, is known to all Chinese school children. Kuan Kung met the pair in Chihli after his escape. Chang Fei was a butcher and Liu Pei a seller of straw shoes. Despite Liu Pei's humble profession, he was a descendant of an emperor and considered to be the legitimate successor to the Han Dynasty.[69] The initial meeting was not auspicious. Kuan Kung and Chang Fei came to blows after an argument about a bet. Liu Pei rushed to mediate. A sense of justice and common interest in opposing corruption and usurpation overcame their initial differences. They met in a peach garden and became sworn brothers. They pledged their fidelity to one another, to strive for peace and justice, and to live and die together.

Through his life, Kuan Kung held to his oath and remained loyal to Liu Pei, the legal heir to the

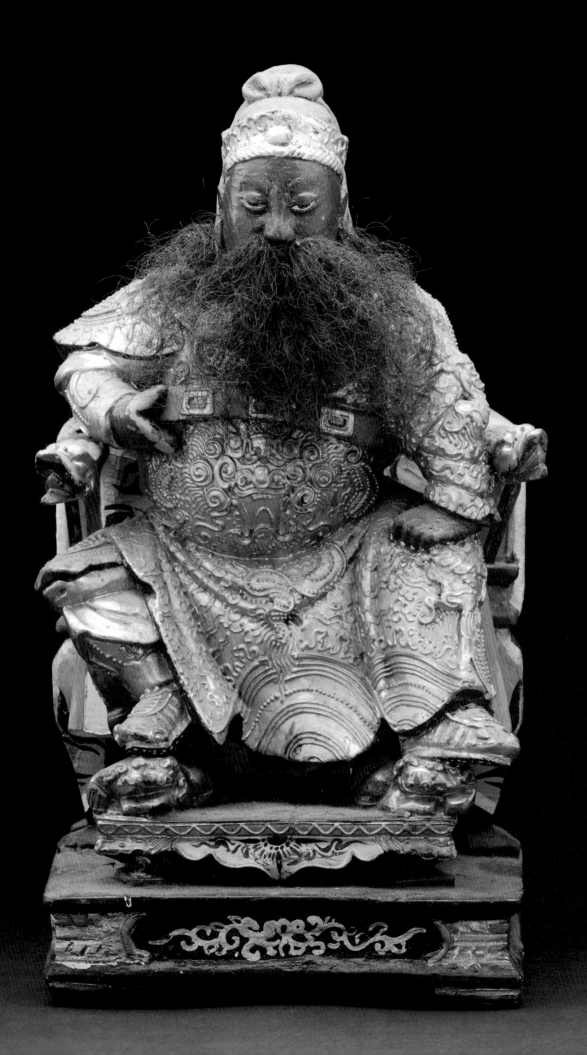

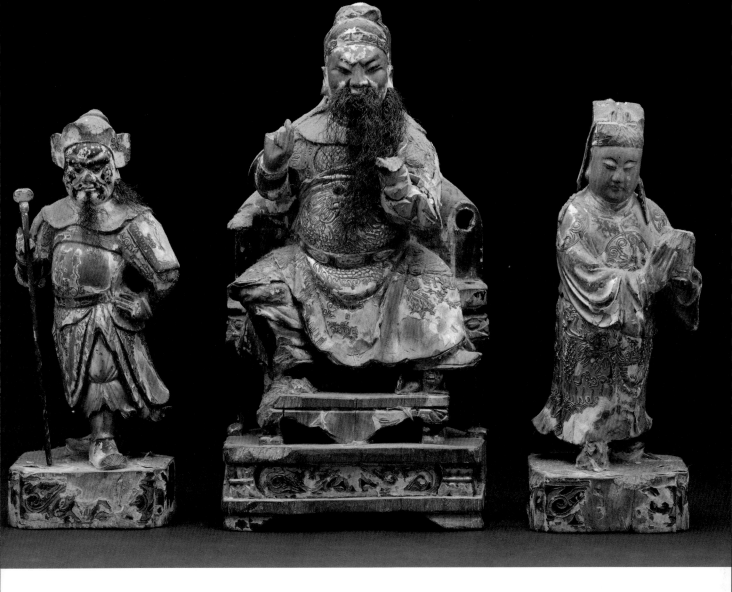

Figure 33
Chou Ts'ang, Kuan Kung's faithful
lieutenant, and Kuan P'ing, his adopted
son. They often flank him on main
altars. Height 29cm (tallest).

周倉是關公忠心的侍從，關平則是關公
的養子，關公的主神壇上常見兩人的雕
像隨侍在側。最高29公分。

←Figure 32
Kuan Kung, a second century A.D.
scholar/soldier from Shansi Province.
Taoists, Buddhists, and Confucians
revere him. Statues of him are found
not only in temples, but also on altar
niches in many business establishments.
Height 31cm.

關公，山西省人，西元二世紀時的武
將，受道教、佛教和儒家所尊崇。關公
像不僅在寺廟中可見，在許多公司行號
的小神壇中也可見到。像高31公分。

Han Dynasty. Because of his virtuous character and his steadfast allegiance, various religious sects and successive governments have promoted him as an example to be followed. In temples, he is commonly seen accompanied by Chou Ts'ang, his faithful standard-bearer, and Kuan P'ing, his handsome adopted son.

His military victories and setbacks have provided endless material for historians and fiction writers. Kuan Kung lived during the Three Kingdoms period, an age of alliances that shifted at a dizzying pace. He served under many commanders, always with distinction. Eventually, an officer under the command of Generalissimo Ts'ao Ts'ao, "Subduer of the 'Yellow Turbans'," captured Kuan Kung and Kuan P'ing. When Kuan Kung refused the officer's demand that he switch allegiance, he was decapitated and his head sent to the Generalissimo in a box. Upon receiving it, Ts'ao Ts'ao had a wooden body adapted for the head and buried it with full military honors.[70]

Temples to Kuan Kung are among the earliest built on Taiwan. Not surprisingly, many are in and around Tainan, the area first occupied by troops loyal to Koxinga, the Ming Dynasty holdout against the Manchu Ch'ing. A town twelve kilometers to the east of Tainan City takes its name, Kuan Miao, from temples established there: Shan Hsi Kung, built in 1719, and Kuan Ti Miao, built in 1736. Liu Wen San has suggested a reason why early immigrants from Fuchien, striving to prosper in a hostile environment,

turned to this god and sought his protection: Kuan Kung's personal life and deeds embody the five character traits that define the ideal citizen and contribute to societal stability. They are: *jen* (benevolence or humanity), *i* (righteousness or loyalty), *li* (ceremony or propriety), *chih* (wisdom or sagacity), and *hsin* (sincerity or truth).[71]

Temples dedicated to him continue to be built and most likely will in the future. In 1977, a ten-story tall statue of Kuan Kung, said at the time to be the largest in Asia, was built in Hsinchu. At the base of the statue is an auditorium and altars to Wen Ch'ang, Lu Tung Pin, K'uei Hsing, and Chu I, the four other gods who along with Kuan Kung, are considered the patrons of the literati.

The popularity of Kuan Kung is attested to by the outpouring of faithful on his birthday. According to several press reports, upwards to 5,000 crowded into Taipei's Hsing Tien Kung in 1977 on that auspicious day to pay respects. Hsing Tien Kung is one of Taipei's largest and most popular temples. According to temple records, it was originally called Hsing Tien Tang and was located in the Yen P'ing District. Through divination, the temple committee was ordered to move to its present location in Chung Shan District and change the name to Hsing Tien Kung.

The temple is unique. It espouses Sectarian Confucianism (Chiao P'ai Ju Chiao), a variation on traditional worship, a plainer, less ostentatious way to relate to deities.[72] In the old Hsing Tien Tang, *Fu Luan* séances were a popular way to communicate with the gods to seek their help. Since moving to its present location, Hsing Tien Kung has abandoned séances and substituted a sedate form of exorcism called *Shou Ching*. *Shou Ching* presupposes that bad luck or evil behavior is the result of supernatural influences occupying one's body. Many temples perform such rituals, most of which are elaborate and costly. Hsing Tien Kung's ceremony is simple, and its services are free.

The Taiwan Provincial Government in 1977 published a pamphlet criticizing many religious practices in the wake of three deaths at the Shou Tien Kung in Nantou. The pamphlet described a *Shou Ching*-like rite as follows: Exorcism for a child is relatively simple. A plate of rice is covered with an article of an unruly child's clothing. A *tangki* lights three joss sticks, inserts them in the rice, and then says some prayers. Afterwards, the marks made by the clothes on the rice are interpreted, and advice is offered. The *tangki* keeps the rice as payment. Exorcism for adults is more complicated. Brandishing a sword, cracking a whip, and sprinkling wine, a *tangki* dances and chants incantations. Advice is then offered and a payment received.[73]

I witnessed such a ceremony in a small temple in Ts'ao T'un, Nantou. A mother brought clothes of her disobedient boy to the temple, where a woman placed them on a dish of rice, waved lighted joss over the clothes, and chanted an incantation. She lifted the clothes, studied the impressions, and then asked the petitioner if her family altar had two ancestral tablets. She had: one for her own family named K'o, and one for Yi. Her elder son had married into the Yi family and taken the Yi name in order to inherit land. The medium explained that the trouble resulted because the Yi ancestor resented his land falling into the hands of the K'o clan. She advised the mother to either burn enough spirit money to pay the dead ancestor Yi for the land her son was occupying, or sell it and move far away.

Neither the description in the government pamphlet nor my Nantou experience describes what takes place at Hsing Tien Kung, where volunteers are trained in proper ritual practices and chants before being allowed to officiate and advise petitioners. On designated days, the temple is filled with dozens seeking spiritual help for solving family problems. I have witnessed several of these gatherings. Judging from the preponderance of women and the sprinkling of children, mostly young boys, waiting in line for an attendant, I judged most were seeking help in controlling rebellious offspring. The

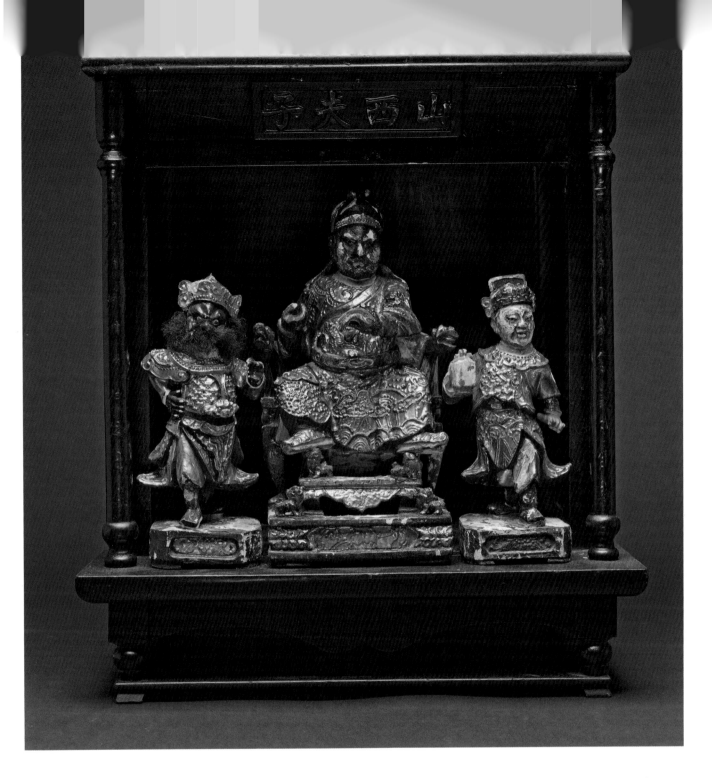

Figure 34
Chou Ts'ang, Kuan Kung, and Kuan P'ing.
Height 22cm (tallest statue).

周倉、關公和關平像（由左至右）。
最高22公分。

attendant would take only minutes with each one seeking to rid themselves of the evil influences disturbing their spirit. Satisfied that a bit of chanting would do the trick, the petitioners would move on, and the next in line would take their place. The success of the Hsing Tien Kung method is attested to by the fact that it established a large branch temple in Peitou.

Hsing Tien Kung prides itself on having a positive impact on society. Among other efforts at civic betterment, in 1978, it built a large public library. It also encourages its faithful "not to burn spirit money, hold *paipai* entertainments, donate god medallions, and to refrain from killing animals and wasting money on large banquets."

In spite of the government's sporadic campaign to curb the excesses of expensive religious pomp, magistrates and mayors regularly participate in birthdays and other rites for gods. President Chiang

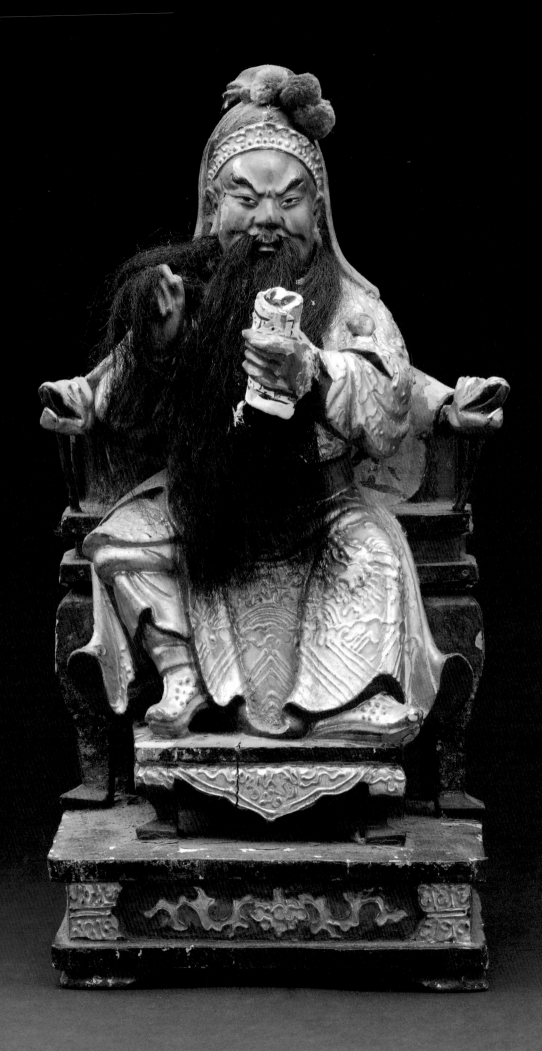

Ching Kuo himself generated a huge public outpouring in July 1977 when he contributed a bronze statue of Kuan Kung to the P'u Ch'i T'ang in Ta Ch'i, Taoyuan. Parades, firecrackers, and feasting greeted the arrival of the bronze figurine. The statue was a personal prized possession that President Chiang Ching Kuo carried from the Mainland. To add significance to the occasion, he entrusted the presentation to Wei Ching Meng, one of his closest advisors, a colorful official and a favorite of foreign correspondents who knew him simply as "Jimmy."[74]

In the summer of 1977, Taiwan papers carried dozens of stories about a ten foot tall statue of Kuan Kung that a fisherman found drifting off the Tainan coast. He sold it to a Taipei antique dealer for 10,000 New Taiwan dollars (US$250.00).[75] It was resold and enshrined at the Nan Sheng Kung in Touliu, where it was met with great pomp and ceremony. In preparation, the temple hastily arranged to have appropriately sized images of Chou Ts'ang and Kuan P'ing carved to accompany the giant statue. The origin of the statue, how long it had floated in the water, and its age were questions of intense newspaper interest. Most speculated that Red Guards, who were desecrating Chinese temples at the time, threw it into the sea, and it floated across the Strait to Taiwan's western coast. A wooden statue of that size is rare. It must have been highly valued. It is finely carved from camphor, and experts believe it to be between 300 and 500 years old. Although no one can verify any of the above, the faithful consider, no matter what, its very survival is a minor miracle.

Taiwanese do not consider T'u Ti Kung, the City God, or the Jade Emperor to be personal gods, but offices or positions in the celestial bureaucracy to which righteous souls can be appointed. Some consider that the historical Kuan Kung has been appointed and is now serving as the eighteenth Jade Emperor,[76] the supreme divinity under whom all gods – Buddhist, Taoist, and those of other religions including Islam and Christianity – serve.

On altar niches in business establishments, Kuan Kung is often seen in the company of T'u Ti Kung and Ts'ai Shen. In temples where divination is performed, the Kitchen God and Lu Tung Pin flank him. In temples where he is enshrined as the main god, Chou Ts'ang and Kuan P'ing always accompany him.

Chou Ts'ang is often described as a giant with a curled up beard and a swarthy complexion. Hence, he is usually depicted with a black face. Until he met Kuan Kung, he led a band of brigands. Afterwards, he became Kuan Kung's faithful standard-bearer. On hearing of the death of his leader, Chou Ts'ang cut his own throat with his sword, not wishing to survive his general.

Kuan P'ing, the son of a relative, as a young man showed a talent for military arts. After his adoption by Kuan Kung, Kuan P'ing stayed faithfully by the general's side, sharing his victories and defeats and eventually his execution in A.D. 220.[77]

←Figure 35
Kuan Kung holding a copy of the *Spring and Autumn Annals*, a tome he could recite from memory.
Height 28cm.

關公手持《春秋》像，傳說關公對《春秋》熟記於心。高 28 公分。

68. Dore, *Researches into Chinese Superstitions*, Vol. VI, p. 81.
69. Ibid., p. 72.
70. Dore, *Researches into Chinese Superstitions*, p. 77.
71. Liu, *The God Statues of Taiwan*, p. 173.
72. Tung, *Understanding Taiwan's Folk Beliefs*, p. 163.
73. Taiwan Provincial Government, "How Much Superstition Harms People," p. 12.
74. "President Presents Bronze Kuan Kung Statue," *Youth Warrior Daily News*, July 17, 1979.
75. "Giant Statue Moved to Touliu Temple," *China Post*, August 9, 1976.
76. Tung, *Understanding Taiwan's Folk Beliefs*, p. 163.
77. Dore, *Researches into Chinese Superstitions*, Vol. VI, p. 87.

TS'AI SHEN
(GOD OF WEALTH) 財神

The people of Taiwan, like people everywhere, hope for, work for, and not surprisingly, pray for financial success and security. They have patrons for almost all human endeavors, including one for the acquisition of wealth. The faithful of other religions may pray to a variety of saints and gods for financial success, but to my knowledge, no major world religion has a deity whose title included the word "wealth" or whose attention is directed solely to bringing luck in all financial activities from peasant farming, to small business ventures, to gambling.

Traditional business enterprises, especially family owned ventures, would not contemplate opening without a god's niche somewhere on the premises. Central to this small altar would be a statue of Ts'ai Shen. Here, he would stand in solitary splendor or be accompanied by Tu Ti Kung and Kuan Kung. (Tu Ti Kung, as the one most concerned with the land upon which a business stands and one, who in life aspired to eliminate poverty, is a logical addition. Kuan Kung, because he is considered to have devised the ledger system, has always been a favorite of merchants.) Some might add either Kuan Yin or a round-bellied, smiling figure resembling the Buddhist Maitreya (Mi Le Fo) for good measure. If there were space, a small incense pot with smoldering joss sticks, candles, or electric votive lights would be added.

There is a Civil Ts'ai Shen and also a Military Ts'ai Shen. An often-mentioned model for the Civil Ts'ai Shen is Pi Kan, a sage who lived during the Shang and was martyred because he reproved the emperor for his wickedness.[78] Pi Kan, however, is not the only candidate. Others including T'ao Chu Kung, a title taken by the historical Fan Li,[79] and Wen Ch'ang Ta Ti are cited.[80]

Chao Kung Ming, an adversary of Chiang Tzu Ya, is considered the human antecedent of the Military Ts'ai Shen. The story of their struggles is told in adventurous detail in the novel *Feng Shen Yen I.* Chiang, using traditional means, was unable to cope with Chao, who could ride a black tiger and hurl pearls that burst like bombshells. Chiang, out of desperation, resorted to witchcraft. He fashioned a straw image upon which he wrote Chao's name. He burnt incense before it for twenty days, and on the twenty-first, Chiang shot arrows made of peachwood into its eyes and heart.

The magic worked, and Chao died forthwith. Later, Chiang Tzu Ya, regretting his rash act, canonized Chao Kung Ming as the Celestial President of the Ministry of Riches and Prosperity.[81] Others consider Kuan Kung as the Military Ts'ai Shen.[82]

The god of wealth is an essential part of the New Year's celebration. Early in the first lunar month, Ts'ai Shen is given a noisy welcome back from his yearly celestial sojourn in a ceremony known as *Ying* (welcoming) *Ts'ai Shen.* Temples or business organizations have in the past used this occasion to seek contributions from merchants. The procedure was either a simple personal call or an elaborate and colorful procession with the Ts'ai Shen borne in an ornate palanquin. The bearers announced his arrival by bumping one of the carrying poles against the establishment's door. This was answered by a torrent of firecrackers acknowledging his presence. The god and the delegation would not be rewarded with a

Figure 36
Ts'ai Shen, the god of wealth, an
obvious favorite of businessmen.
Height 24cm (statue).

財神即財富之神，顯然是商界的最愛。
像高24公分。

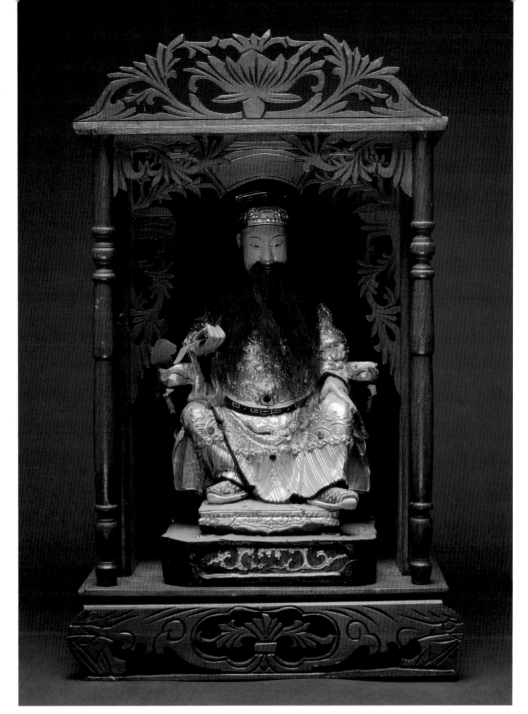

contribution, however, until the bearers passed over the exploding firecrackers a number of times.

Tens of thousands of printed posters or woodblock prints of Ts'ai Shen are sold during the New Year, and statues of him are in constant demand. Despite this popularity, he is almost never honored with a temple of his own.

The Civil Ts'ai Shen is carved wearing embroidered clothes, a wide jade belt, court headdress, a pale face, and holding a scepter or gold ingot. The military counterpart wears martial clothing and helmet, has a dark face and curly whiskers, holds a weapon, and rides on a black tiger.

78. Williams, *Outlines of Chinese Symbolism and Art Motives*, p. 212.
79. "Increasing Weath, Source of Belief," *Economic Daily News*, February 20, 1980.
80. "The Story of Ts'ai Shen," *United Daily News*, February 5, 1978.
81. Werner, *A Dictionary of Chinese Mythology*, p. 515.
82. Stevens, *Chinese Gods*, p. 123.

T'U TI KUNG
(EARTH GOD) 土地公

Unquestionably, the most popular statue is that of T'u Ti Kung, the Earth God. Not only is he regarded as the protector of rice paddies and other agricultural fields, but merchants honor him as well and place his statue on an altar niche along with the god of wealth and Kuan Kung in their places of business. Liu Wen San claims that even in modern Taiwan, all levels of society worship him, and his statues can be found on urban family altars.[83]

Field temples dedicated to him, often no bigger than dollhouses or large television sets, dot the landscape by the thousands throughout rural Taiwan. Not all will be enshrined with his statue, but simply contain a tablet with his honorific title: Fu Te Cheng Shen (Beneficent and Virtuous Just God). Although not the general practice, some city neighborhoods build elaborate temples.

His origins are animistic. Primitive civilizations, including Chinese civilization, worshiped nature, especially the land that brought forth the fruits to sustain life. Such animistic origins notwithstanding, to the faithful, T'u Ti Kung has come to be a title conferred on virtuous men who have attained godhood.

There are several legends about the original T'u Ti Kung. According to one, he was Chang Fu Te, a kind-hearted tax collector during the Chou Dynasty. After his death, an avaricious man, who squeezed every possible tax coin from the peasants, succeeded Chang. In comparison, Chang seemed like a god, so the people built a temple and enshrined him as Fu Te Cheng Shen.

Other stories describe him as a faithful servant who froze to death in a snow storm after giving his coat to his master (master's daughter in one version) for extra warmth, or that he was a charitable man whose purse was never diminished no matter how much he donated to the poor; or yet another that he was an official in the employ of the legendary Emperor Yao and taught the people how to plant.

Today on Taiwan, T'u Ti Kung is considered an official under the City God (Ch'eng Huang) in the celestial bureaucracy. Whereas the City God has jurisdiction over a province, county, or city, T'u Ti Kung's responsibility is restricted to a district, neighborhood, or village. His power is likewise limited. He can handle the minor miscellaneous ghosts, but powerful malevolent spirits are the responsibility of more potent gods.

While he polices ghosts on the one hand, on the other he checks on the affairs of the living, keeps records of their activities, and reports his findings to the City God. For the family head, reporting births, marriages, deaths, and unusual occurrences to the local T'u Ti Kung temple is as necessary as registering them with the police.

If there is a severe drought or flood or some other natural disaster, those who provided the local T'u Ti Kung with a house and periodic sacrifices have every right to expect that he, as protecting deity for their area, should intervene. If after repeated requests and sacrifices the disaster continues, an appeal will be made directly to the Jade Emperor requesting that he be replaced. The villagers can suggest, with no certainty of success, the name of some departed local personage to be appointed to the job.

On the other hand, the Jade Emperor, satisfied with the performance of a particular T'u Ti Kung, may

➔Figure 37

T'u Ti Kung. Temples to him are found in every city and town through Taiwan. Thousands of shrines to him, some no bigger than television sets, dot the rural landscape. Carvings of this benevolent and approachable god far outnumber those fashioned for any other deity. Height 31cm.

土地公像。台灣的大街小巷到處可見土地公廟，沿著鄉間更可看見數以千計的神龕，有些甚至不比電視機大多少。慈眉善目的形象使祂的彫像數目遠遠超過其他神明。高31公分。

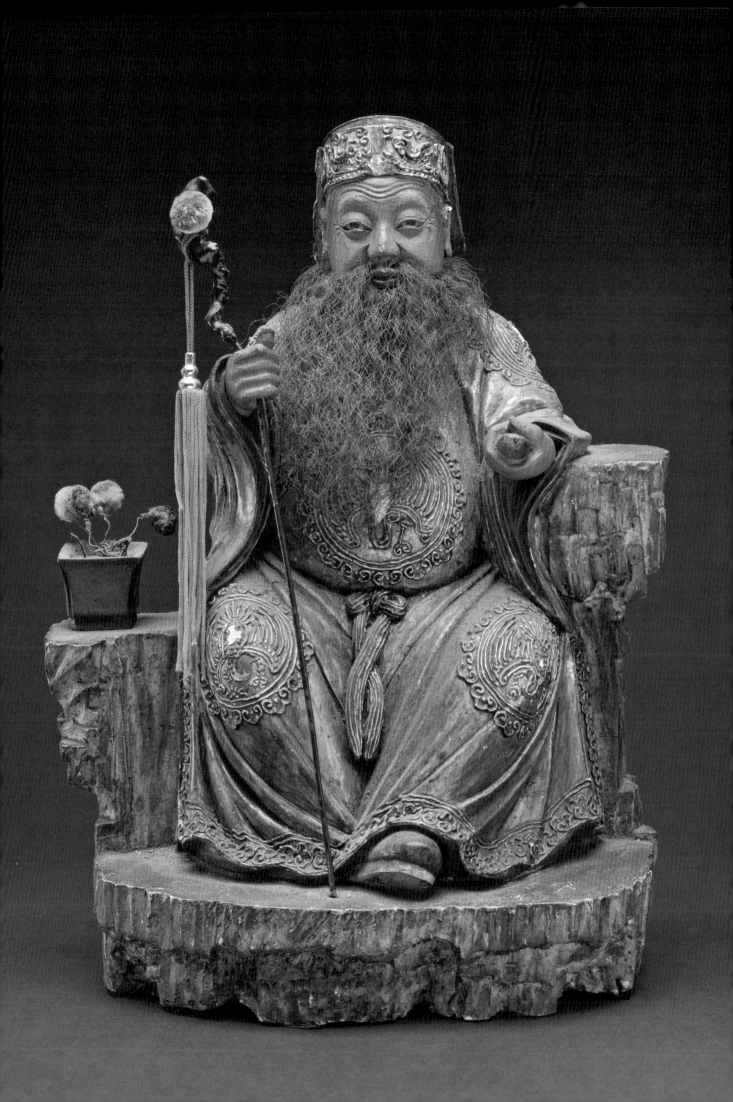

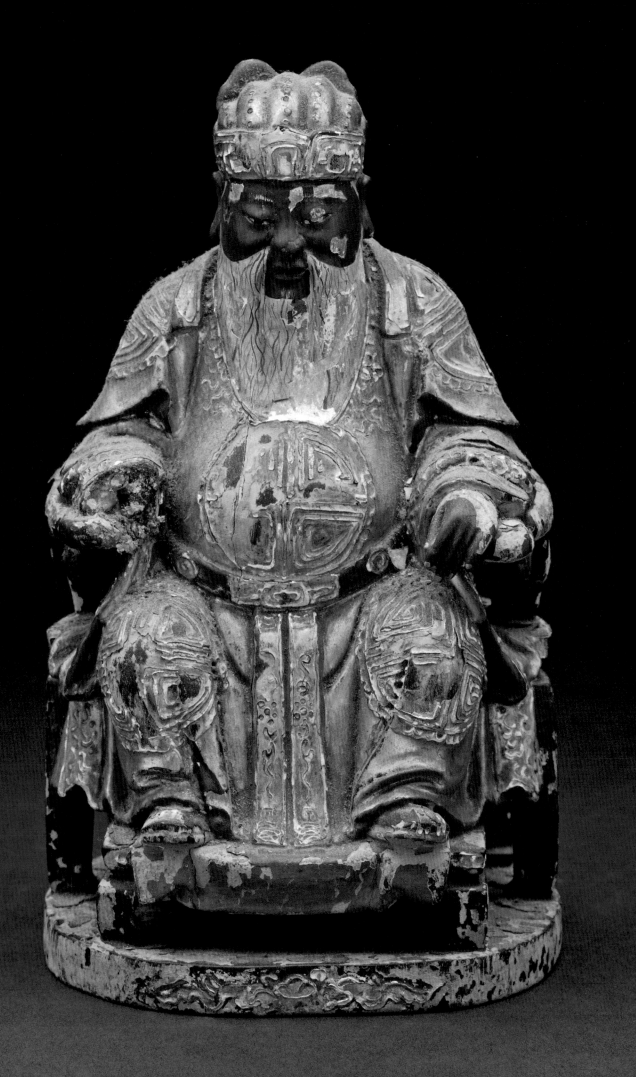

promote him to a higher position. His wishes are made known through a séance or the throwing of divination blocks. Such was the case of a rich man in Chu Ko Li, Puli County, who built a bridge at his own expense for the benefit of the village. He reigned for decades in a small Tu Ti Kung temple. One of the temple's faithful explained to me that through the throwing of divination blocks, the villagers learned that the man had been promoted to a City God in Kwangtung Province. A poor farmer who had repaired the bridge was appointed to take his place. A new statue was carved, and a Taoist priest infused the farmer's spirit into it during an "open eyes" ceremony.

The tradition of a selfless benefactor being recognized as a local deity runs throughout Chinese history. Many prominent personages have shared the honor with the humble Puli farmer. Liao Yu Wen mentions two: Yueh Fei, the Sung Dynasty general who was betrayed by Ch'in Kuai and who embodies the virtue of loyalty, was honored as a Tu Ti Kung; and Shen Yueh, who is credited with devising the system of determining the four tones of the Chinese language, also became a Tu Ti Kung upon his demise.[84]

Although Tu Ti Kung is only a title or generic name for a collection of individual local gods, statues carved to him are among the most uniform. He is always seen as a kindly whitebeard seated on a rock or simple chair, holding a staff or gold ingot. One might expect that such an official would merit an impressive chair or throne. The custom of placing him on a rock (a convention among Chaochou carvers) arose during the Ming. According to legend, the Emperor T'ai Tsu upon stopping at an inn and finding all the tables occupied, instructed the inn keeper to put Tu Ti Kung's statue on the floor so that he could have his chair. When the emperor left, the god was put back. During the night, Tu Ti Kung appeared to the inn keeper in a dream, demanding that he be returned to the floor so as not to contravene the emperor's orders. The story spread, and since that time, carvers have usually fashioned the god without an official chair.[85]

In addition to complying with T'ai Tsu's request, it seems appropriate to place the Earth God on a rock, so he can rest as close to the earth as possible. This custom, according to Liao, is most prevalent on the Mainland provinces of Henan and Kwangtung.[86] Failure to follow the practice can cause uneasiness among the traditionally minded. Such was the case when a new two-story temple was built in Hsinchu, and Tu Ti Kung was enshrined on the second floor. Some considered it a form of respect to place him in an exalted position, but most considered it a bad omen and argued that he belongs on the ground.[87]

Tu Ti Kung has a wife, Tu Ti P'o, and occasionally, one can find her statue by his side. But this is rare for she is neither loved nor respected. The story is told that as a tax collector, Tu Ti Kung wished to ease everyone's burden by forgiving many tax debts. His dream was that all should be equally rich. For this, his wife scolded him. She argued that if all were equal, no one would be willing to do the necessary work. Tu Ti Kung was unmoved and countered that it would be too cruel to leave some in an impoverished state. But the practical wife had the last word: "If all are rich," she pointed out, "when our daughter marries, who will carry her sedan chair?" Thus silenced, Tu Ti Kung abandoned his campaign for universal equality.

Despite her reputation, communities, out of respect and concern for her husband and sometimes in gratitude for favors granted, will carve a statue of her to be placed at his side. This is the exception, not the rule. In all of Tainan Hsien, only five of the hundreds of Tu Ti Kung temples have her as an accompanying deity.[88] She is depicted as a severe, unattractive crone without any trace of a kindly expression. Even concubines will be carved for an especially loved Earth God. And it has been reported that, in at least one case, this was done at his request. He appeared in a dream to one of the temple faithful and demanded a concubine, as he had grown tired of his wife. When a concubine is provided, she should be smaller than the wife and placed on the right; the left, being the place of honor, is reserved for the rightful wife.[89]

←Figure 38
T'u Ti Kung. Height 16cm.

土地公像，高16公分。

Milo Chang's Studio Collection

- Chinese Folk Arts
- Precious Ancient Embroidery
- Taiwan Aboriginal Arts

102 Chien Kuo N. Rd. Taipei
(Nanking E. Rd. Sec. 2, across from Windsor Hotel)
TEL: 581-0046

台北市建國北路102號 （南京東路二段匯中飯店對面）

The devotion to T'u Ti Kung is illustrated by the dispute over a temple in Lan Hsing Li, in the western district of Taichung City. Mrs. Ch'en Lin Hsiang Hui owned the one *ping* of land (six feet by six feet) that the small structure occupied. Unfortunately, the temple stood in the path of a road the city was planning to build. Neighbors and the temple faithful protested when Mrs. Chen agreed to tear down the tiny structure. Because the Taichung mayor was a relative of Mrs. Chen, the temple representatives threatened to initiate impeaching proceedings against him. Additionally, because he was a Christian, they accused him of indifference to Tu Ti Kung.[90] At a turbulent and sometimes acrimonious meeting, the temple faithful finally agreed to allow the destruction of the temple provided a new one, complete with a stone bench and table, were built in the T'ung Hsin Garden near the Wu Ch'uan Liu Bridge. The site met a *feng shui* expert's approval, and expense was borne by either the government or Mrs. Chen.[91]

After pictures of my collection appeared in the December 1976 issue of *Artist Magazine*, an advertisement for Roma floor tiles (fig. 39) appeared in the January 9, 1977 edition of Ching Chi Daily. The advertisement promised that Tu Ti Kung would protect Roma floor tiles in your home. An enlarged photo of the god dominated the full-page color ad. A quick glance was all that was needed to discover the photo of the god was lifted from the *Artist Magazine* feature on my collection. Both *Artist Magazine* publisher Ho Cheng Kwang and I were more amused than upset that of the tens of thousands of Tu Ti Kung statues on Taiwan, Roma Tiles chose one from my collection (fig. 38) to promote their product. I am at a loss to explain the fascination with or the advertising potential of this particular statue. But my friend, Milo Chang, to call attention to his studio, featured it again (fig. 39).

↑➔Figure 39
Something about one of my T'u Ti Kung statues, a photo of which appeared in a 1977 issue of *Artist Magazine*, caught the imagination of two business establishments that lifted the picture from the magazine and used it in their advertisements.

1977年的《藝術家》雜誌曾刊出我的一個土地公像的相片，有兩個商家看見了，便突發奇想，把相片拿來放在廣告裡。

83. Liu, *The God Statues of Taiwan*, p. 51
84. Liao, *Mythology of Taiwan*, p. 131.
85. Ibid., p. 133.
86. Ibid., p. 133.
87. "High Position May Be Wrong For God," *China Post*, January 5, 1976.
88. Liao, *Mythology of Taiwan*, p. 129.
89. Wolf, *Religion and Ritual in Chinese Society*, p. 145.
90. "T'u Ti Kung Temple Problem," *Taiwan Daily News*, February 28, 1976.
91. "Initial Agreement on Moving T'u Ti Kung Temple," *Taiwan Daily News*, February 29, 1976.

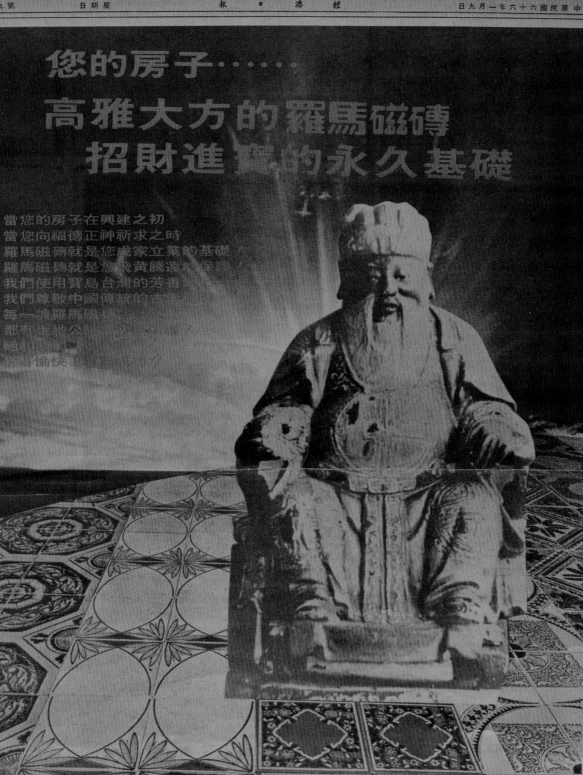

您的房子……

高雅大方的羅馬磁磚
招財進寶的永久基礎

當您的房子在興建之初
當您向福德正神祈求之時
羅馬磁磚就是您成家立業的基礎
羅馬磁磚就是您飛黃騰達的保障
我們使用寶島台灣的芳香
我們尊敬中國傳統的古
每一塊羅馬磁
都有
愉快

磚背面有 商標才是真正 羅馬彩色磁磚

榮美窯業股份有限公司

全省展示中心電話：
台北第一展示中心：☎3118191-5　台中展示中心：☎(042)236135
台北第二展示中心：☎3717040　　　　　　　　　　225231
新竹展示中心：☎(034)429626　高雄展示中心：☎(052)70845
中壢展示中心：☎(035)230053　台南展示中心：☎(062)171010
斗六展示中心：☎(055)22324　　屏東展示中心：☎(07)246890

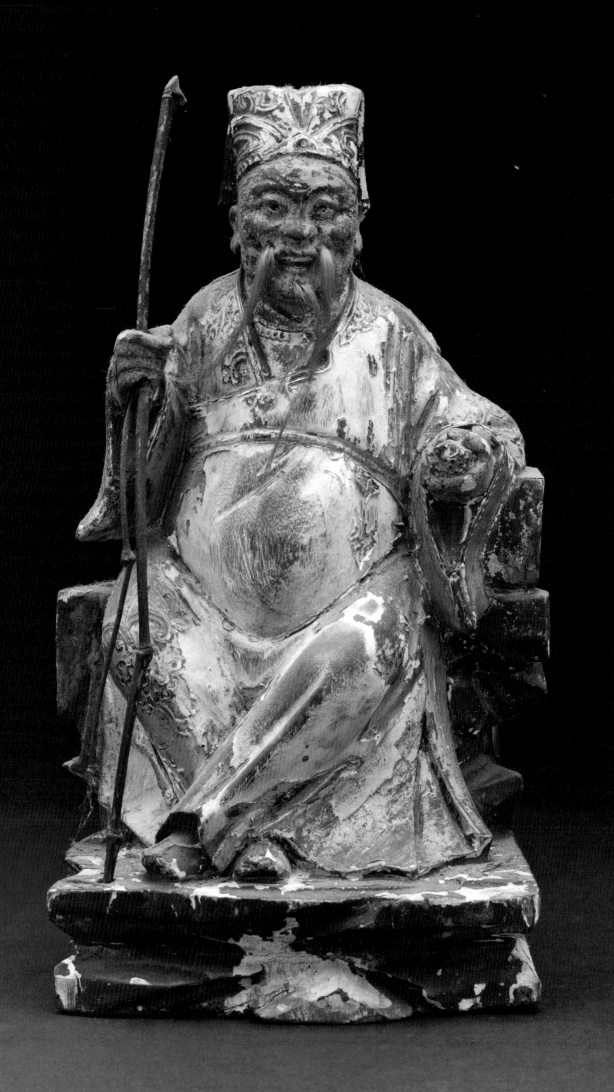

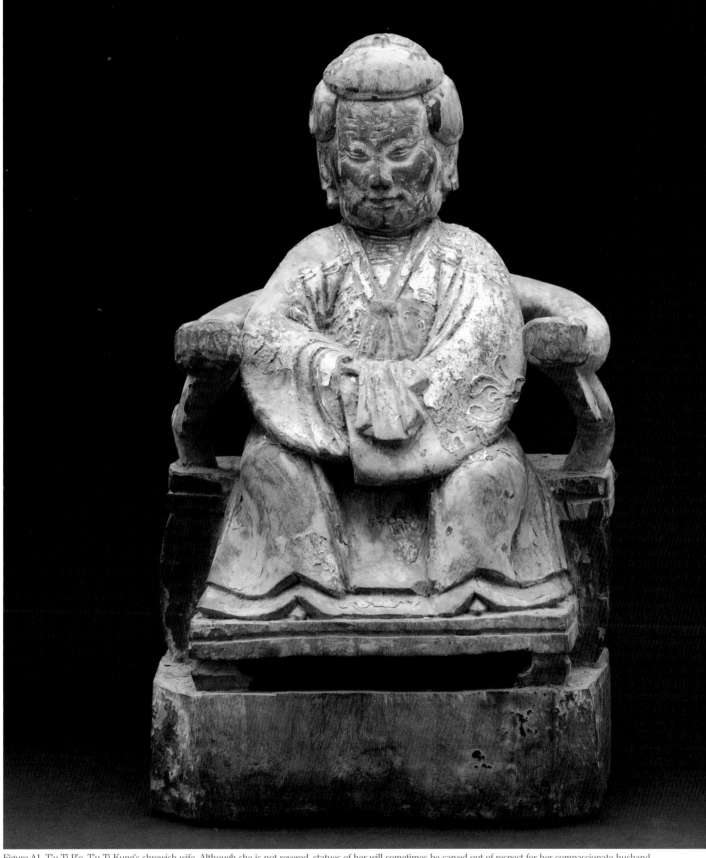

Figure 41. T'u Ti P'o, T'u Ti Kung's shrewish wife. Although she is not revered, statues of her will sometimes be carved out of respect for her compassionate husband. Height 28cm.

土地婆是土地公的妻子，雖然她未被供奉，但出自於對慈善的土地公的尊崇，人們有時仍會刻她的雕像。像高28公分。

←Figure 40. T'u Ti Kung. Height 23cm.

土地公像，高23公分。

PAO SHENG TA TI

保生大帝

Pao Sheng Ta Ti, the patron of Chinese doctors, was born in Pai Chiao Village, Tung An District, Chuanchou Prefecture, Fuchien Province during the Sung Dynasty. As a young man, he was called Wu Pen, but later was known by a variety of honorific titles: Wu Chen Jen and Ta Tao Kung among them.

Stories and legends of this god abound. It is said that he was miraculously conceived, and at his birth, the room was filled with a brilliant light. Early in life, he received instruction in herbal medicine and exorcism from Hsi Wang Mu. Armed with this knowledge, he devoted his life to treating the sick and ridding communities of evil spirits.

He is credited with having restored a skeleton to life and returning it to skeletal form when an official doubted his power. He also cured a tiger that, in the course of devouring a maiden, got a bone stuck in his throat. After administering the effective remedy, the tiger became his disciple. Once, a heavenly dragon that had an eye infection transformed itself into human form in order to pay a visit to the doctor. Upon being cured, the dragon reverted to its original form and ascended to Heaven.

According to one story, a healthy man visited Pao Sheng Ta Ti to test his skill. As the examination failed to indicate any sickness, the doctor denounced the man as a fraud and predicted that he would be punished for his jest. When the man died within ten days, Pao Sheng Ta Ti was criticized for causing the death of a blameless man.

His ability to diagnose was tested again. Court officials summoned Pao Sheng Ta Ti as a last resort to treat a rash that covered the body of the empress and which baffled court physicians. As it was taboo for any to touch the empress, the common practice for examining her was to tie a string to her pulse. The attending physician would then make the diagnosis based on the vibration of the string. To test Pao Sheng Ta Ti, the empress had the string tied to an inanimate object and strung through a door to the next room where he was required to conduct the examination without benefit of seeing the patient. He quickly guessed the trick and instructed the servants to tie the string on the patient's wrist. Thus convinced, the empress allowed him to proceed in the normal fashion.[92]

In 1699 when a plague swept across Taiwan, statues of Pao Sheng Ta Ti were brought from Fuchien and worshiped in makeshift temples. As the plague subsided within a short time, the immigrants credited this to his influence.[93]

There are 140 temples dedicated to Pao Sheng Ta Ti on Taiwan.[94] Tz'u Chi Kung in Hsueh Chia, Tainan County is recognized as the pioneer edifice to this god. Soldiers of the victorious Koxinga brought statues of the god when they attacked the Dutch at Fort Providentia and Fort Zeelanda in 1661. Just west of present-day Hsueh Chia, they set up a small temporary shrine to the god that in time became the present-day Tz'u Chi Kung, an imposing edifice named after the Fuchien mother temple in Pai Tui *Hsiang*. According to material published by the temple, the main statue was already an honored antique when brought from the mainland. If true, this should make it the oldest temple statue on the

➜Figure 42
Pao Sheng Ta Ti, the patron of Chinese doctors. Pao An Kung, his Taipei temple, is among the most popular in the city.
Height 28cm.

保生大帝，中醫的守護神，供奉保生大帝的台北保安宮是本市最受歡迎的廟宇之一。像高28公分。

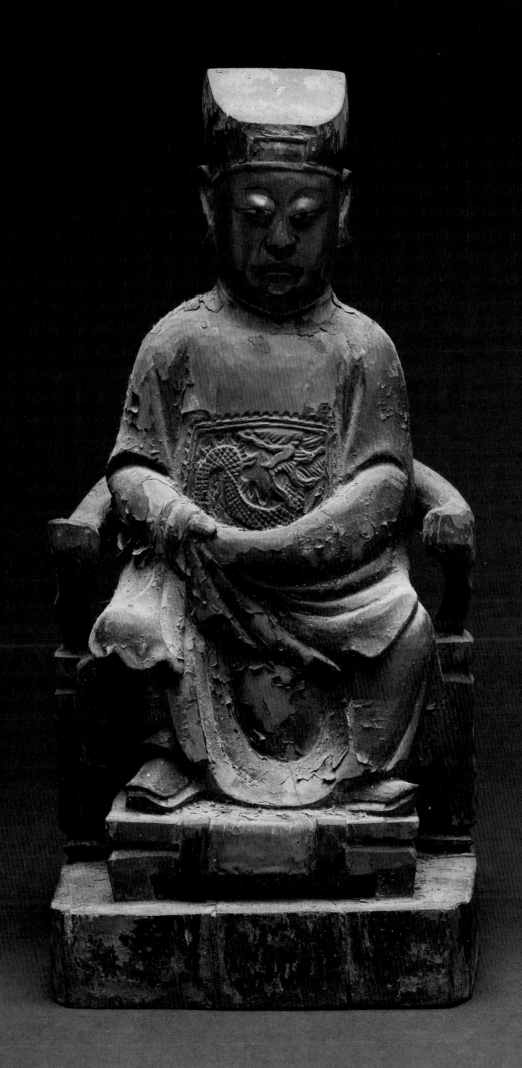

island by far.

Carvings of Pao Sheng Ta Ti depict him as a distinguished scholar seated serenely with arms folded inside his sleeves, often with the thumb of his right hand protruding, pinning down the sleeve of his left arm. His feet may rest on animals that serve as his messengers.

Many temples have close relationships with local governments. In some cases, elected officials are members of temple boards. Tz'u Chi Kung is a good example because it cooperates often with the Tainan Hsien Government. Tainan magistrates, as well as other officials, often participate in *paipais* and other temple celebrations. In 1976, with the government's active encouragement, the temple set up a ninety-ping (one ping equals six square feet) museum to display articles celebrating Tainan's history and culture.

Taipei's Pao An Kung is Pao Sheng Ta Ti's most impressive temple in northern Taiwan. Together with Lung Shan Szu and Tsu Shih Miao, it is considered one of the three most important in the city. Pao An Kung is located in the Ta T'ung District near the Confucian temple. In 1709, Ch'en Lai Chang, a Chuanchou man, received a *k'en chao* (official permit) to develop the area. Over the years, immigrants from T'ung An came to dominate the area. In 1805, a subscription was raised to build a temple. It was completed in 1809, and Pao Sheng Ta Ti was enshrined as the main god with Chu Sheng Niang Niang, the matron who hastens child birth, as an accompanying deity. As one of the specialists attached to the celestial Ministry of Medicine, she was an appropriate inclusion. At that time Ch'ih T'ou Fu Jen was honored on a side altar. She is considered the protector of women who risk time in Hell's Pool of Blood because of blood shed during delivery.

Of the many antique artifacts adorning the temple, the stone lions guarding the entrance way are two of the oldest. They were ordered in 1809 from a master carver in Fuchien. These beasts always come in pairs: one male, one female. According to tradition, the male's mouth should be open; the female's closed. When delivered, both were open-mouthed. The infuriated temple committee refused to pay the carver. They nevertheless positioned them guarding the door where they rest today.[95]

Pao An Kung conducts a fire-walking ceremony yearly, a common practice at temples throughout Taiwan. However, because of its prominence in the capital city, Pao An Kung's ritual is undoubtedly the best known among the foreign community. At the several fire-walkings I attended in rural Taiwan, I was, as a rule, the only foreigner. At Pao An Kung's ceremony in 1977, I was shoulder-to-shoulder with shutter clicking Westerners. The ceremony began with a muscular bare-chested man rhythmically beating the temple drum while others constructed a twenty-foot long charcoal path which, when lit, sent flames shooting upward. The flames quickly died to red embers that were then coated with salt. A Taoist priest emerged from the temple, leading twenty or so men carrying gods singularly or in sedan chairs. The procession quickly crossed in a trot and returned to the temple. The vast majority of firewalkers are young or middle aged men. Women and oldsters rarely join in. However, on that day, a man whom I guessed to be eighty, unable to trot, crossed the fire in a slow plodding walk. When the coals cooled sufficiently, many of the faithful scooped up ashes that would be put to use for a variety of spiritual purposes. Taxi cab drivers sometimes hang pouches filled with ashes from their rear view mirrors for protection. In rural areas, pig farmers have been known to mix ashes with feed to enrich the diet.

According to a Pao An Kung temple member, the paramount reason for fire-walking is the re-purification of the temple's statues that have been sullied in the past year by exposure to unclean petitioners. Such might include, but are not limited to, those who have committed crimes and women

➔Figure 43
Pao Sheng Ta Ti. Height 19cm.

保生大帝像，高19公分。

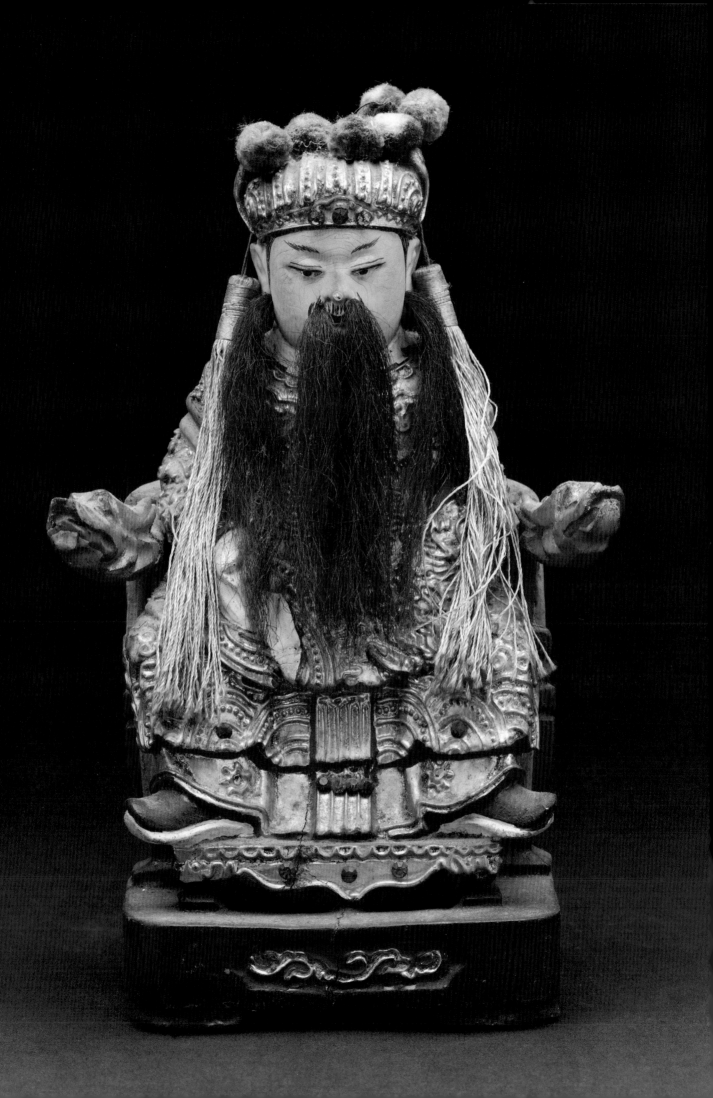

during their menstrual cycle. Although often ignored, there are rules for participation in fire-walking. White clothes should be worn, and one should refrain from sexual relations for at least three days prior to the walk.

Westerners, used to tricks and sleights of hands by professional magicians, are fascinated and puzzled by ordinary men and women rushing over hot coals without harm or pain. Salt may be the secret. *Taiwan Daily News* on January 11, 1977 quoted Nantou Magistrate Liu Yu Yu as urging teachers to address the apparent miracle of fire-walking. He specifically asked chemistry and physics teachers to explain the dampening effect of salt on embers and that only those who trod heavily or step on an unsalted spot will suffer. Yet injuries do occur. The same newspaper four months later on March 3rd reported the hospitalization of ten walkers from Fengyuan who crossed the fire before the flames died sufficiently. Naturally, the religiously faithful offer a different explanation. Injuries occur, they claim, only to those who broke the taboos or are impure. Such was the case of a man in Hsia Ch'i Chou who died of burns after falling during the ceremony. His neighbors believed he was punished for failing to observe three days of sexual abstinence prior to the event. 'The god was angry because that man came there dirty.'[96]

Pao Sheng Ta Ti's birthday (15th day of the third lunar month) is always celebrated with elaborate rites and processions. The 1,000[th] year anniversary of his birth fell on March 21, 1978. It was an occasion for an outpouring that drew pilgrims and the curious to Pao An Kung not only from all over the island, but overseas as well. A procession, featuring lion and dragon dances, acrobats, drum companies, and numerous visiting deities carried aloft in sedan chairs or palanquins, snaked its way through Ta Tung and the adjoining districts of Yen Ping and Chien Ch'eng.

Notwithstanding, the Taipei government's efforts to curb excessive spending on *paipais* and other religious activities, the birthday celebration was a costly extravaganza. Ironically, two years earlier the local police station organized a wall poster exhibit for elementary and middle and high school students on the theme: "improving religious customs and trimming waste." The temple offered its walls to exhibit the winning posters.[97] Despite this extravagant birthday lapse, the temple consistently has been a friend to the government and an asset to the community. Government officials have held up Pao An Kung as a model for other temples to emulate. Considered one of the richest temples, it consistently contributes to hospitals, orphanages, and old folks homes.

For several years, Pao An Kung has allocated tens of thousands of dollars for scholarships. Any student with a grade average over 70 and a good conduct record was eligible.[98] In 1976, Pao An Kung established a "sister temple" relationship with Lung Te Miao in Ts'ao Tun Chen, Nantou by funding a scholarship program there and allocating money to build an activities center with a library, games area, and meeting rooms.[99]

92. Masuda, *Taiwan No Shiukyo*, p. 33.
93. "Gods and *Pai Pais*," *Echo*, April 1972, p. 5.
94. Liao, *Mythology of Taiwan*, p. 46.
95. "Ta Lung Tung District's Pao An Kung," *Ta Hwa Wan Pao*, May 29, 1977.
96. Wolf, *Religion and Ritual in Chinese Society*, p. 162.
97. "Poster Exhibition at Pao An Kung," *China Daily News*, April 14, 1976.
98. "Pao An Kung Contributes Scholarship Money," *Youth Warrior Daily News*, February 25, 1977.
99. "Pao An Kung's Income Used for the Public," *China Daily News*, December 3, 1976.

CHU SHENG NIANG NIANG

One reason for the popularity of Taipei's Pao An Kung is the prominence given to the altar of Chu Sheng Niang Niang, the goddess of progeny. E. T. C. Werner, among others, holds that Chu Sheng Niang Niang is in fact Ch'en Ching Ku, who is also known as Lin Shui Fu Jen.[100] Others, such as Shen Ping Shan, list the goddesses separately. A number of interviews with temple faithful have done little but add confusion. Some maintain they are the same, while others insist they are different. However, Yin Ming Shih of Taoyuan's San Yuan Kung, a teacher of Taoism and an iconographic authority, agrees with Werner that they are the same. Liao Yu Wen speculates that many who petition her know only that she is the celestial guardian who manages affairs relating to conception and birth. He believes some even confuse her with Matsu.[101] Here they shall be treated as different natures of one deity.

Altars to her as the patroness of safe births and protector of children can be found throughout the island. In spite of her popularity, there are only two temples where, under the name of Chu Sheng Niang Niang, she is enshrined as the main goddess: Chu Sheng Kung in Ch'iao Tou *Hsiang*, Kaohsiung *Hsien* and Yung Fu T'ang in Chu Tien *Hsiang*, Pingtung *Hsien*.[102] The Lin Shui Fu Jen Ma *Miao* (temple) in Tainan City honors her under the title Lin Shui Fu Jen. Although it has moved from its original location and is now situated on P'eng Lai Street, it is one of Tainan's oldest, dating from the fifty-first year of Ch'ien Lung's reign (1787).

According to one legend, Ch'en Ching Ku was born in Lin Shui *Hsiang*, Fuchien. One day while taking a meal to her brother, she met a woman begging for food. She gladly handed over that destined for her brother. In return, she was given a book of magic rituals. With knowledge learned from this, she was able to work many miracles. Learning of her powers, the Min principality king commissioned her to kill a monstrous white snake that had been disturbing the countryside. In gratitude for her ridding the kingdom of this monster, the king presented her with thirty-six palace ladies as servants.[103] In another version, Ch'en Ching Ku married and became pregnant at the age of twenty-four. While soliciting gods during a drought, she aborted and in the process died. She left a will explaining that she was to become a goddess and would aid women during difficult deliveries.

Women seeking to conceive visit Pao An Kung and other temples where Chu Sheng Niang Niang is enshrined on side altars to perform a simple ceremony called "Changing the Flower." After making a vow to reward the goddess, they place a flower in their hair, a white flower for boys and a red one for girls. Should they give birth to the desired sex, they must make good the promised vow.[104]

At Pao An Kung, one can see a number of embroidered miniature slippers (fig. 44) hanging at the side of her altar. A mother of a

Figure 44
Amulet slippers for the protection of children. This pair is from Chu Sheng Niang Niang's altar at Taipei's Pao An Kung.
Length 5cm.

保護孩童的守護鞋，這雙鞋是從供奉註生娘娘的台北保安宮取得。長5公分。

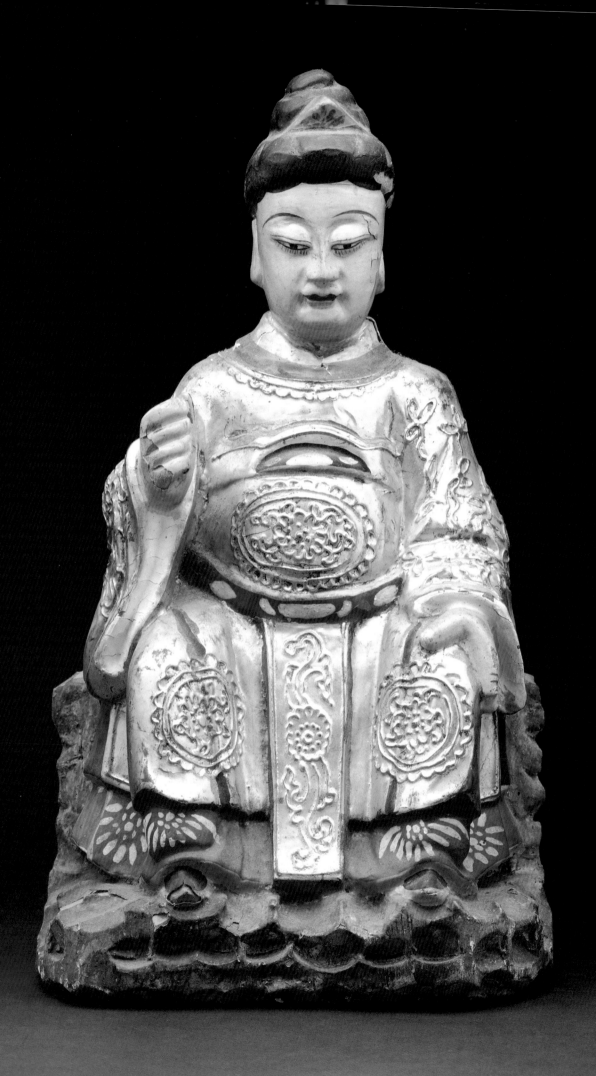

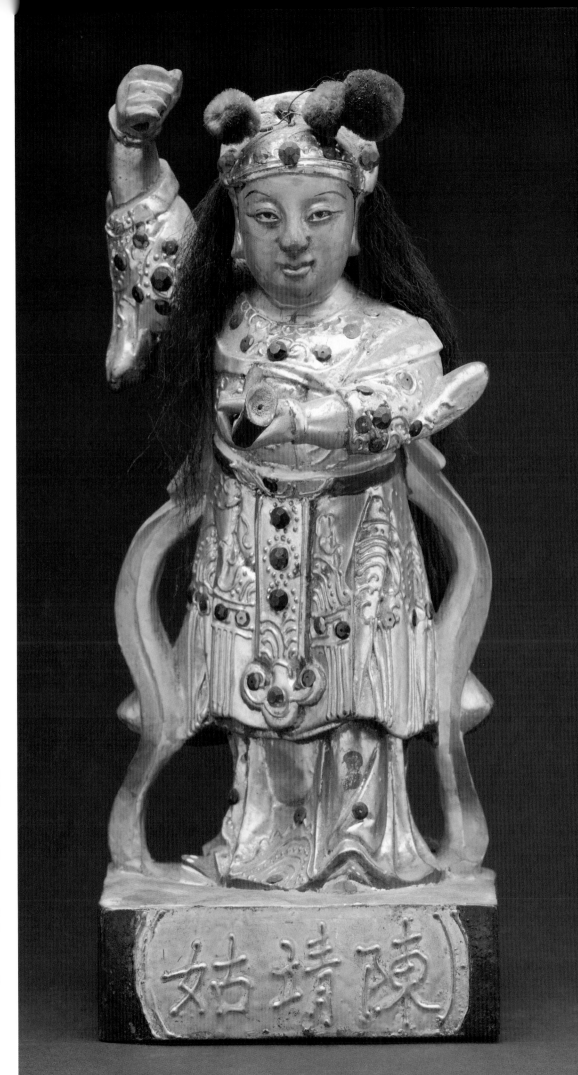

←Figure 45
Chu Sheng Niang Niang, also known as Lin Shui Fu Jen. She is the patroness of safe births and the protector of children. Height 29cm.

註生娘娘，又稱臨水夫人，是生產和孩童的守護神。像高29公分。

→Figure 46
Ch'en Ching Ku, who many believe is another manifestation of Chu Sheng Niang Niang. Height 27cm.

陳靖姑像。許多人認為她是註生娘娘的另一個化身。像高27公分。

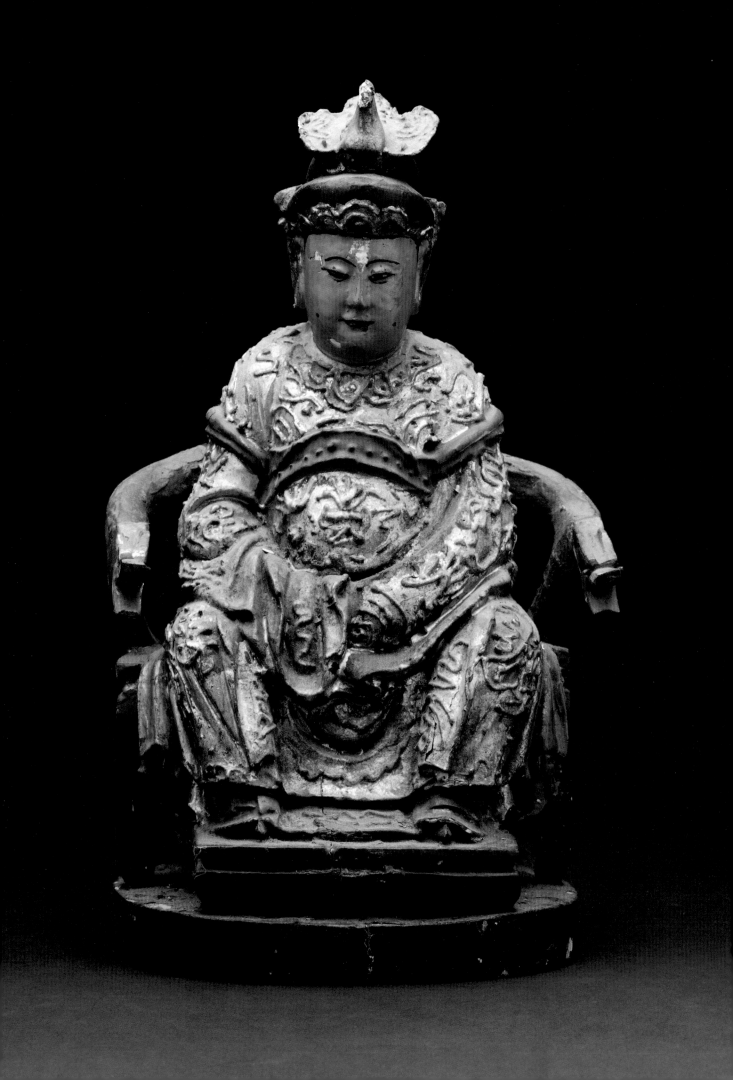

Figure 48
Niao Mu. Height 23cm.

鳥母像，高23公分。

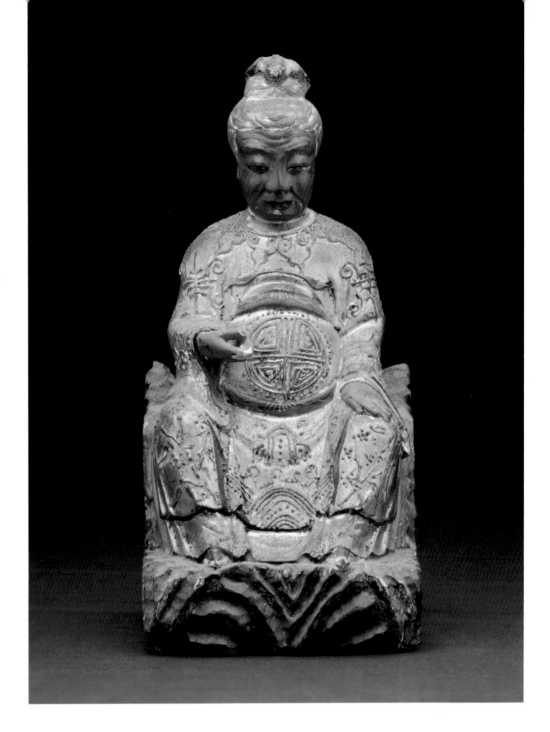

←Figure 47
Niao Mu (Bird Mother), who assists
Chu Sheng Niang Niang.
Height 28cm.

鳥母，為註生娘娘的侍女。
像高28公分。

sick child may take a pair and hang them around the neck of the child as an amulet. Should the child recover, the mother must return two pairs to the altar exactly one year later.

A mother may entrust a child to the goddess' care by scorching a religious medal or ancient coin with smoke from the incense pot on her altar. The charm, thus sanctified, will be hung around the child's neck on a red string for a period of time. Upon reaching adulthood at the age of sixteen, the girl or boy will offer sacrifices to the goddess, thanking her and thereby symbolically leaving her protection.[105]

Lin Shui Fu Jen is one of the three goddesses worshiped as the San Nai, an important Taoist faction on Taiwan. Li Nai Fu Jen (Li Sha Niang) and Lin Nai Fu Jen (Lin San Niang), who complete the trinity, are enshrined in individual temples in Fuchien.[106] On Taiwan, however, they are not worshiped separately. Before the spread of modern medical facilities on the island, rites of this faction were said to be especially efficacious for easing difficult pregnancies. Taoist adherents of San Nai practice rituals with such colorful names as: Expelling Snakes with Flower Bowls, Beating the Peach Soup, Collecting

Bamboo to Receive the Soul, Ordering the Troops, and Setting the Stove. The San Nai School believes there is a garden in the netherworld where flowers, representing human souls, bloom. Illness occurs when one's personal flower is attacked by bugs or covered by cobwebs. The Garden Father and Garden Mother share overall responsibility; ducks and dogs, which Lin Shui Fu Jen previously had subdued, act as guards; and the Hoe Boy and Dustpan Boy cultivate the plants. If sickness occurs, one must seek the intervention of the Garden Father and Garden Mother.[107]

Lin Shui Fu Jen temples and Chu Sheng Niang Niang altars usually have sets of P'o Chieh, or Niao Mu. P'o Chieh are maid servants said to have been some of the palace ladies awarded to Ch'en Ching Ku by the king of the Min principality in gratitude for ridding the area of the wicked monster snake.

Niao Mu (Bird Mother) is a generic title conferred on certain virtuous widows and virgins who have devoted themselves to aiding women during pregnancy and childbirth. Birds were associated with the reproductive process from early times as is evidenced by the story of Chien Ti, the daughter of a Shang Dynasty nobleman. It was the custom during the Shang to offer flesh sacrifices on the return of the migratory swallows in the spring. During the sacrifice ceremony, Chien Ti became aware that she was pregnant and concluded the gods had entrusted the swallows with the mission of sending a child to her. On that basis, the assumption grew that there was a relationship between swallows and childbirth.[108] While there are no temples dedicated to Niao Mu, statues of this deity are not uncommon and are among the easiest to identify as each usually has a distinctive bird resting on the hair or headgear. At the Hualien City God temple, for example, the twelve baby amahs who flank Chu Sheng Niang Niang's altar have small birds perched on the hair of each.

Individual Niao Mu statues that one occasionally sees are probably representations of local women who, after death, have been venerated as minor goddesses. An interesting example of such a woman can be found in Taipei's Sung Shan Matsu temple. The Chu Sheng Niang Niang altar has one more than the usual number of amahs. The extra one honors a deceased resident of the neighborhood named Tu Yu Niang. There were few midwives during her lifetime, and she was continually being called upon to assist in the delivery of babies. She refused to accept money or other compensation. After her death, the grateful people of the area had a statue of her fashioned, but without the decorative bird, and at first venerated her as a deity. Eventually, she was placed in the Matsu temple as an extra amah for Chu Sheng Niang Niang.[109]

Chu Sheng Niang Niang is always carved seated in a serene pose and is usually hatless. Ch'en Ching Ku, who is credited with killing the monster snake, is frequently portrayed with a raised un-sheathed sword in one hand and a shaman's buffalo horn trumpet in the other.

100. Chu, *Birthday Listing of Gods*, p. 86.
101. Liao, *Mythology of Taiwan*, p. 118.
102. Ibid., p. 123.
103. Chu, *Birthday Listing of Gods*, p. 87.
104. Tung, *Understanding Taiwan's Folk Beliefs*, p. 155.
105. Wei and Coutanceau, *Wine for the Gods*, p. 37.
106. Shen, *Introduction to Chinese Gods*, p. 184.
107. Ibid., p. 185.
108. Ibid., p. 122.
109. Liao, *Mythology of Taiwan*, p. 123.

CH'ING SHUI TSU SHIH KUNG

清水祖師公

All stories about the man who became Ch'ing Shui Tsu Shih Kung, more commonly called Tsu Shih Kung, agree that he lived during the Sung Dynasty in the An Hsi area of Chuanchou County, Fuchien. Beyond agreement on that, the stories bear no resemblance.

According to one legend, Tsu Shih Kung entered a Buddhist monastery when he was a small boy. Because he was badly treated by the monks, he escaped and settled near a clear pool (*ch'ing shui*). From this idyllic retreat he sought enlightenment, treated the sick, and supplied the needy with rice that, upon his command, issued forth from a miraculous hole in the ground. In another story, he was a Sung loyalist who led armies against invading barbarian tribes.[110] In a third, similar to the Hsuan T'ien Shang Ti legend, he was a butcher who cut out his stomach in order to cleanse it of past sins.[111]

Tsu Shih Kung is depicted with a black face. There are two fanciful explanations for his complexion. According to one, fire spirits already occupied the clear pool he chose for his mountain retreat. Objecting to this intrusion, they imprisoned him in a burning cave for a week. When released on the seventh day, he emerged unburned, but with a charred face. In another story, his pregnant and about to deliver sister-in-law asked him to cut wood for the stove. For unexplained reasons, he used his legs for fuel. When she discovered him calmly sitting with his legs on fire, she rushed to his aid. Mistaking her concern for an attack, he jumped into the stove and disappeared up the chimney, eventually rising to Heaven with the smoke.[112]

Miracles attributed to Tsu Shih Kung's intervention are numerous. Many times through the centuries he has been credited with ending dry spells. During his lifetime, a prolonged drought was devastating parts of Fuchien. Already, the fame of the monk was celebrated throughout the province. A delegation was sent to bring him to the affected area. As soon as he arrived, it began to pour. Again, a drought was ended in 1185 after the people of Teh Hua prayed for his intercession. In 1276, a bitter drought in Chuanchou led to cannibalism. The local magistrate's prayers to a statue of Tsu Shih Kung known to be efficacious had the desired effect. Toward the end of the nineteenth century, Taipei suffered a number of plagues. During one of the more virulent, all who sought refuge in his Wan Hua temple were spared.

Perhaps the most remarkable miracle occurs daily in sight of countless pilgrims and tourists at Ch'ing Yun Yen temple in Penang, Malaysia, where Tsu Shih Kung is installed as the main god. Numerous poisonous pit vipers curl around statues, carvings, and amongst potted plants, posing no threat to the faithful who go about their private worship, indifferent to these toxic guests. When I was in Penang in 1978, I confess I had misgivings about visiting this temple. But curiosity overcame fear, and I went to see for myself. I entered gingerly at first, observing the interior from the doorway. I counted dozens of snakes draped on every conceivable resting spot, and a handful of worshipers lighting incense and throwing "moonblocks" in divination. The sight of frail grandmothers passing back and forth within inches of serpents shamed me into risking the interior. I spotted an older gentleman whom I correctly guessed to be the caretaker. He said snakes would never bite while in the temple and emphasized the point by causally

fondling one resting on an incense urn nearby. He said the sixth day of the first lunar month, Tsu Shih Kung's birthday, sees a dramatic increase in the serpent population as snakes emerge from the nearby woods ostensibly to pay respects to this powerful deity. He was not able to explain the connection between Tsu Shih Kung and snakes or why Penang is host to such company.

Immigrants from An Hsi, site of the main Tsu Shih Kung temple, established most of the more than sixty temples to him on Taiwan. The most aesthetically pleasing is in San Hsia, on the outskirts of Taipei. It differs from all others because the paintings and carvings were done not by artisans, but by artists.

The god's temples in Taipei and Tanshui are also worthy of note. Taipei's was built in 1791 and received its incense from the mother temple in Fuchien. Fire destroyed it some twenty-seven years later. Taiwan's history, especially in the nineteenth century, was witness to feuds and pitched battles among various Fuchienese clans and regional groups. Unfortunately, temples were not spared the communal mayhem. The Taipei temple was badly damaged in a factional fight in 1854. Money contributed by people in An Hsi helped finance the rebuilding, which was begun in 1868 and completed in 1875.

Tanshui's main Tsu Shih Kung statue is noteworthy because it predates the temple itself. The statue was brought to Taiwan by a monk during the Hsien Feng reign (1851-1862) and was worshiped on the altar of the Ong family. The statue has a distinctive facial feature that sets it apart from representations of other Chinese gods: it has a large and sharply pointed nose. "Big nose" or "high nose" is the Chinese gentle slur for any Westerner. For this reason, it is strange that any Chinese statue would be carved with such an attribute. But the nose itself is the basis of the statue's fame. From time-to-time, the nose will detach itself and fall harmlessly onto the lap of the statue seated in the lotus position. The reason for such a separation is assumed to be either as a warning of some impending disaster or because the god is displeased.

No one is quite sure when the nose first dropped off. Some say it was knocked off during the rough crossing from Fuchien. Others claim it detached itself during a *paipai* parade as it was passing a certain house. Later that night the house was gutted by fire. The only paste needed to refasten it is a simple mixture of incense ash and water. If done properly by one in Tsu Shih Kung's favor, no force can remove it as one *kung fu* expert, who tested the legend, learned to his embarrassment.[113]

During the Japanese period, it was reported that a police officer stopped men carrying Tsu Shih Kung's sedan chair in a procession. Just then the nose fell off. A monk pasted the nose back on and challenged the Japanese policeman: "If you can pull the nose off, the faithful will obey your order. If not, you must let the procession pass." The officer failed, and the procession proceeded.

In the 1884 war between France and the Ch'ing Government, Taiwan played a small, but bloody role. Western armies, used to the soft resistance characteristic of previous encounters with Chinese forces, were surprised at the tenacity of local troops, especially around Tanshui. Several times, French landing parties secured beachheads, but were unable to hold them. The French were forced to resort to shore bombardment and blockade tactics from the relative safety of their modern warship for most of the nine-month long conflict.

When several better-armed French soldiers were captured during one foray, Tanshui residents credited Tsu Shih Kung with the military success. The Kuang Hsu Emperor, upon learning of the victory, sent a plaque to the temple to commemorate the triumph. This greatly increased the prestige of the temple, and the ranks of its devotees rose yearly until by 1932, it became necessary to build a larger temple. And, thus began a decades-long saga.

During construction, the statue was transferred to the Taipei Tsu Shih Kung temple. When the enlarged Tanshui temple was completed, a delegation went to Taipei to reclaim the statue, a request that was at first refused. Negotiations ensued. Taipei ordered an identical copy carved and challenged the

➜Figure 49
Ch'ing Shui Tsu Shih Kung, a monk from An Hsi, Fuchien. The pointed nose on his most famous statue has been known to drop off, an omen of impending disaster.
Height 43cm.

清水祖師公，福建省安溪縣僧侶。祂最著名的雕像的鼻子部分已掉落，據說為災變的前兆。像高43公分。

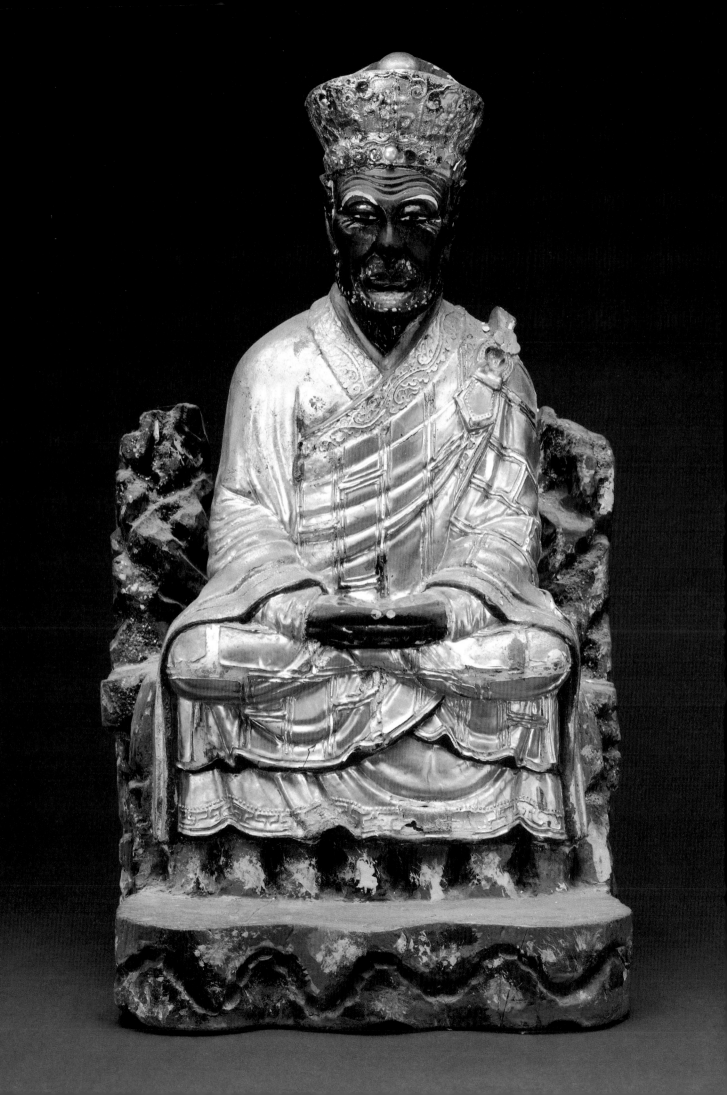

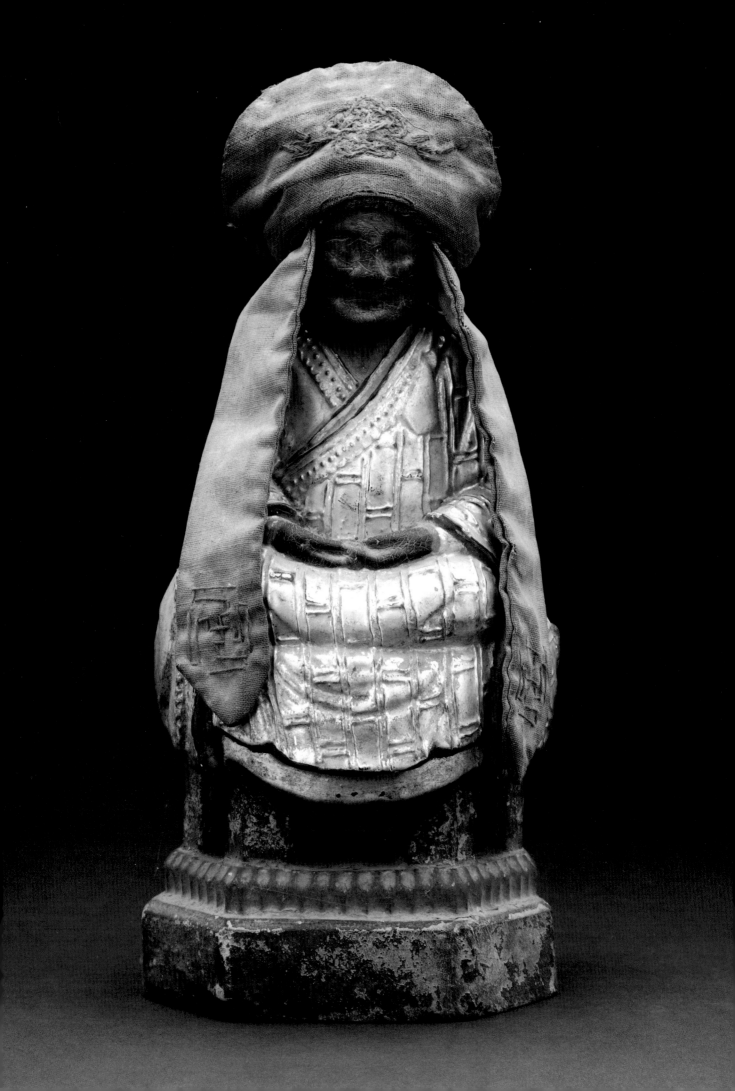

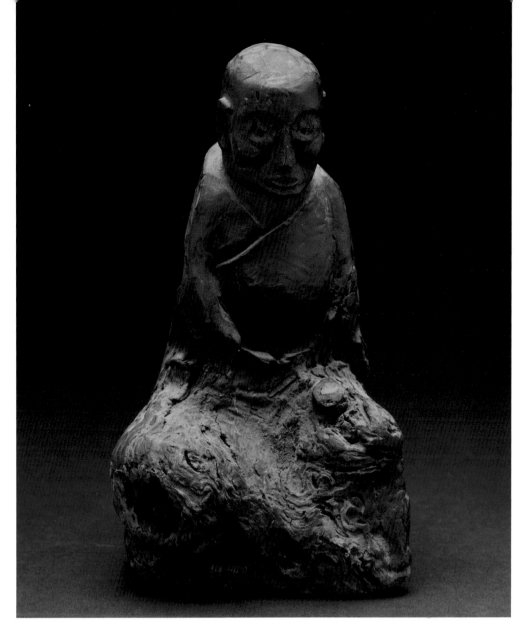

Figure 51
Ch'ing Shui Tsu Shih Kung carved
from a root.
Height 17cm.

以樹根刻成的清水祖師公像。
高17公分。

Tanshui representatives to choose between the two. The night before the selection date, an Ong family member dreamed that a fly would rest on the crown of the original statue. On the following day, it happened as foretold in the dream. The Taipei committee, realizing they were about to lose the prize, refused to hand it over and sued in court. A Japanese judge heard the case. Tanshui's Tsu Shih Kung's representative offered convincing proof of the statue's authenticity. The judge, seeking only to promote harmony, offered a compromise: the statue should alternate between the two temples, spending equal amounts of time in each, a scheme that worked until 1977. On its regular rotation back to Tanshui in March of that year, a temple staff member noted that the statue's chin seemed more pointed. Further examination showed that strong commercial glue, not incense ash, affixed the nose. When confronted, the Taipei temple professed innocence and blamed pilgrims from other temples, who had recently visited, with the switch and the theft.[114]

←Figure 50
Ch'ing Shui Tsu Shih Kung.
Height 25cm.

清水祖師公像，高25公分。

110. Liao, *Mythology of Taiwan*, p. 63.
111. Wu, *Taiwan's Folk Culture*, p. 70.
112. *Echo*, February 1971, p. 5.
113. Liao, *Mythology of Taiwan*, p. 67.
114. "Tan Shui Tsu Shih Yeh Statue," *United Daily News*, April 4, 1977.

LOHAN 羅漢

Although Indian in origin, statues of the Eighteen Lohan are found in many of the larger temples throughout Taiwan.

The Eighteen Lohan are an offshoot of the Sixteen Arhats, the original disciples of Buddha. It is generally believed that an *arhat*, a Sanskrit word meaning venerable, worthy, or deserving of honor,[115] volunteered to remain in existence and not experience Nirvana until the advent of Maitreya, the Future Buddha.[116] Sometime, probably in the ninth or tenth century, the Chinese added two to the original sixteen. Since that time, even though there have been other groupings of Lohan in China, ranging up to as many as 500 in a set (the number of disciples appointed to witness the Buddha-truth and save the world)[117], eighteen has been the most popular number for Lohan.[118]

Thomas Watters, writing in 1899, was unable to determine just when the number was increased to eighteen. He claims pictures of the sixteen were done in T'ang times and preserved at a Buddhist monastery in Chekiang. During the Ch'ing, they were presented to Emperor Ch'ien Lung, who ordered them copied and distributed so existing sets could be checked against these originals and corrected.[119]

While the number was fixed at eighteen, despite Ch'ien Lung's efforts, the identities were not as Chung Hua Tsao notes in his book on origins of Taiwan deities.[120] E.T.C. Werner, in his *Dictionary of Chinese Mythology*, holds that the images are not personages at all, but merely symbols of virtue.[121] My early attempts at matching Lohan names with Indian Arhats came to a speedy halt. Not only was there no conformity among sets in Taiwan temples, but also authorities such as Werner and Henry Dore offer dizzying arrays of possible matchings.

The labeling of the statues at the many Taiwan temples I visited seldom agreed with one another. One temple, the Matsu temple in Hsinkang, listed Fei Po twice, thus adding to the confusion. Their display, however, is fairly uniform: nine Lohan occupying a niche on the wall to the right of the front altar, and nine on the left. An exception is the main Kuan Tu temple, where eighteen large statues are presented single file in animated poses; protected by a metal railing and in front of a battery of hundreds of smaller statues covering an entire wall.

Confusion over names does not appear to concern the faithful, who doubtless have only a hazy idea of their history or sacred mission. In any event, the Lohan are not prayed to or solicited for favors to the extent of other deities. Pious temple goers regularly place incense before sets of Lohan but only, I suspect, in order to be inclusive in one's devotion. The Lohan are unique in that there is no iconographic standard. Most gods have common identifying depictions such as clothing or accompanying symbols (Kuan Kung's face is always red; T'ai Tzu Yeh's foot always rests on a fire wheel; Ts'ai Shen always holds a gold ingot, etc.). But other than wearing Buddhist robes, carvings of the Lohan vary wildly. The carver, not bound by conventions, is free to create. Consequently, their representations often have more artistic merit than the other gods that crowd temple altars. Some are carved with Asian faces,

The Eighteen Lohan. Indian in origin, they represent the first disciples of Buddha. Their blameless lives entitled them to experience Nirvana, an honor they declined preferring to remain outside the blissful state in order to aid mankind.(Fig. 52~69)

十八羅漢源自印度，是佛陀的第一批弟子。由於一生清白，祂們得以達至涅槃境界，但祂們沒有接受此殊榮，反而選擇留在人間，幫助眾生。（圖52～69）

→Figure 52
Hsiang Lung. Height 46cm.

降龍羅漢像，高46公分。

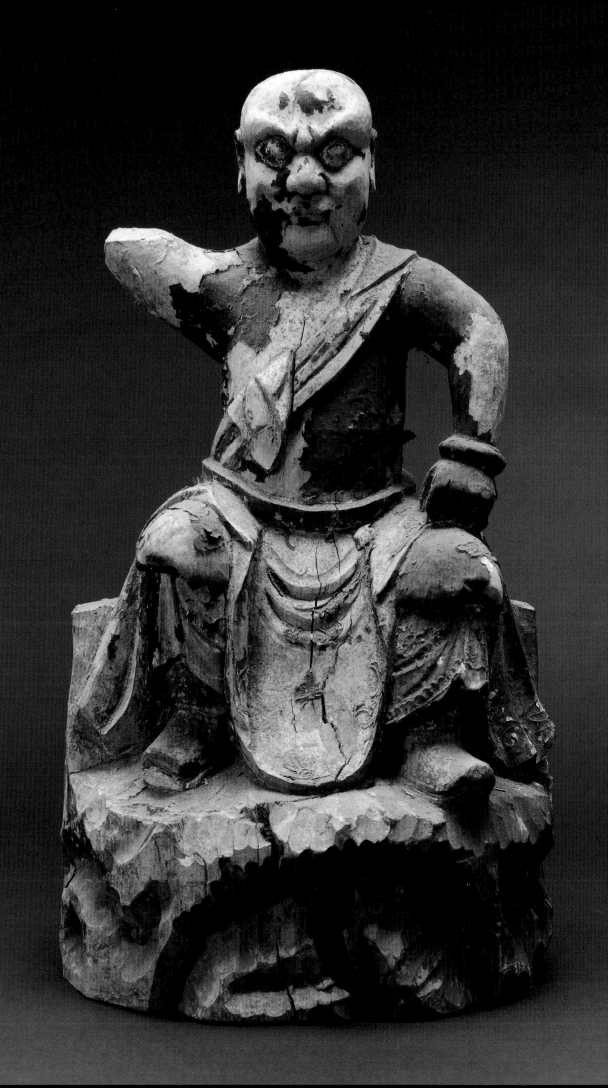

but many have an Indian or European look. I saw one Lohan in Lukang, for example, who looked exactly like former Vice President Hubert Humphrey. Perhaps because these carvings predated the birth of Humphrey, I should say the former U.S. Vice President looked exactly like a Lohan in Lukang.

The woodcarver from whom the statues in this collection (figs. 52-69) were purchased wrote the name of each on the underside with a brush pen. This set, like many on Taiwan, honors Emperor Liang Wu Ti as a Lohan, because after first rejecting Bodhidharma's advice to seek enlightenment through the contemplative life, he later did abandon his throne for a monastery. Another favorite, Pu Tai Lohan, bears a striking resemblance in this set to Maitreya, the Future Buddha, and has been acknowledged as his incarnation by several scholars. Dore identifies him as a T'ang Dynasty monk named Chang Ting Tzu, who spent his entire life in the Yueh Lin Szu monastery and who was renown for many miracles.[122] Keith Stevens has reported that a number of temples in Shantung have Lohan identified as the former Ch'ing emperors Ch'ien Lung and K'ang Hsi. The Chih Kung Tsu Shih Lohan here (figs. 55) is a carbon copy for Ch'ing Shui Tsu Shih, the result perhaps of the woodcarver's whim.

The carver claimed the set originally rested on side altars in a local temple. He said that when a new, larger structure was being built, he was commissioned to carve a new set, and the old one was left to him to dispose of as he pleased.

I purchased the set late one rainy night in the spring of 1972. The woodcarver had them stored in a lean-to shed, open to the elements, behind his shop. The area was unlighted, but I could see enough to convince me these were a collector's rare find. We quickly settled on a price, and I asked him to ship them to Taipei for I doubted my 1960 Volkswagen convertible could accommodate the eighteen statues. He agreed to ship them by train. I begged him to take care in the packing for I feared that what gold leaf was left after months of exposure to wind and rain would flake off. He assured me that they would not move or bang against each other because he intended to nail them together. I knew a statue that is no longer *ling* (efficacious) reverts to mere wood. Nevertheless, I was horrified at this obvious disregard for what once was considered holy, and I was terrified at the damage that such a procedure might do. I declined his offer, paid the man his money, and one by one, loaded them into the Volkswagen: four on the back seat, four in the luggage compartment behind, two on the floor in back, two on the front seat, two on the front floor, and four under the front hood. After a good night's sleep in a small Chiayi inn, the eighteen gods and I set out early the next morning for Taipei.

115. Dore, *Researches into Chinese Superstitions*, Vol. VII, p. 333.
116. Ibid., p. 338.
117. Soothill, *A Dictionary of Chinese Buddhist Terms*, p. 472.
118. Dore, *Researches into Chinese Superstitions*, Vol. VII, p. 352.
119. Watters, April 1899, "The Eighteen Lohan of Chinese Buddhist Temples," *Journal of the Royal Asiatic Society*, 1899.
120. Chung, *The Origins of Taiwan's Local Gods*, p. 95.
121. Werner, *A Dictionary of Chinese Mythology*, p. 263.
122. Werner, *A Dictionary of Chinese Mythology*, p. 371.

➜ Figure 53
Liang Wu. Height 46cm.

梁武羅漢像，高46公分。

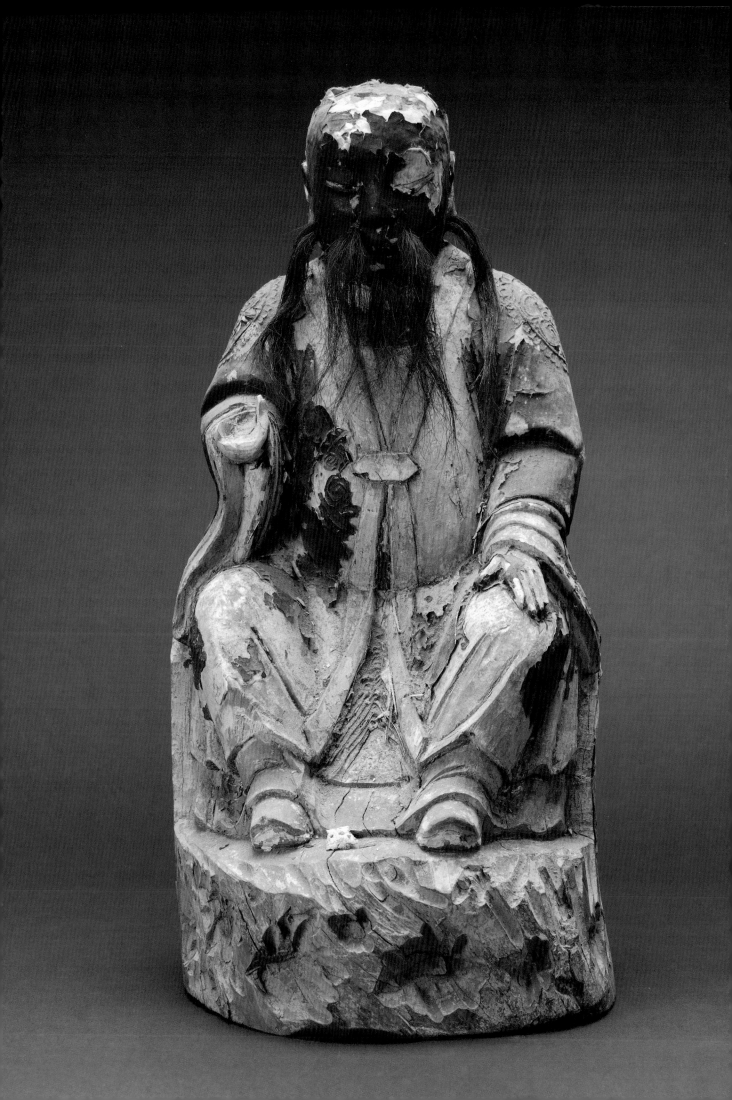

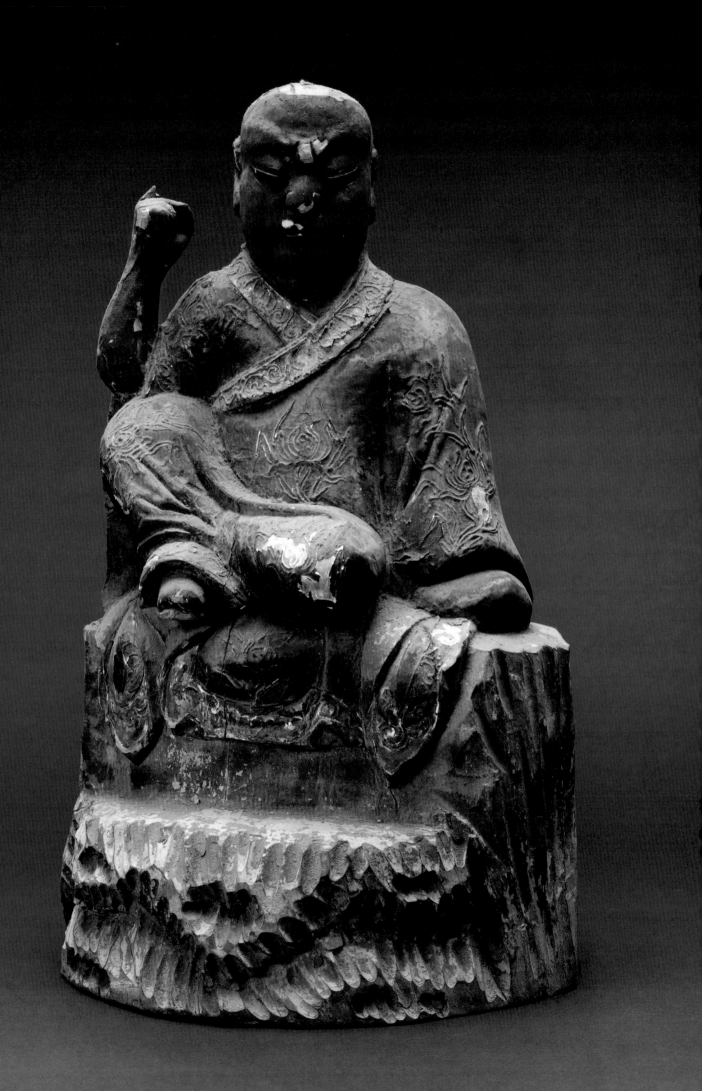

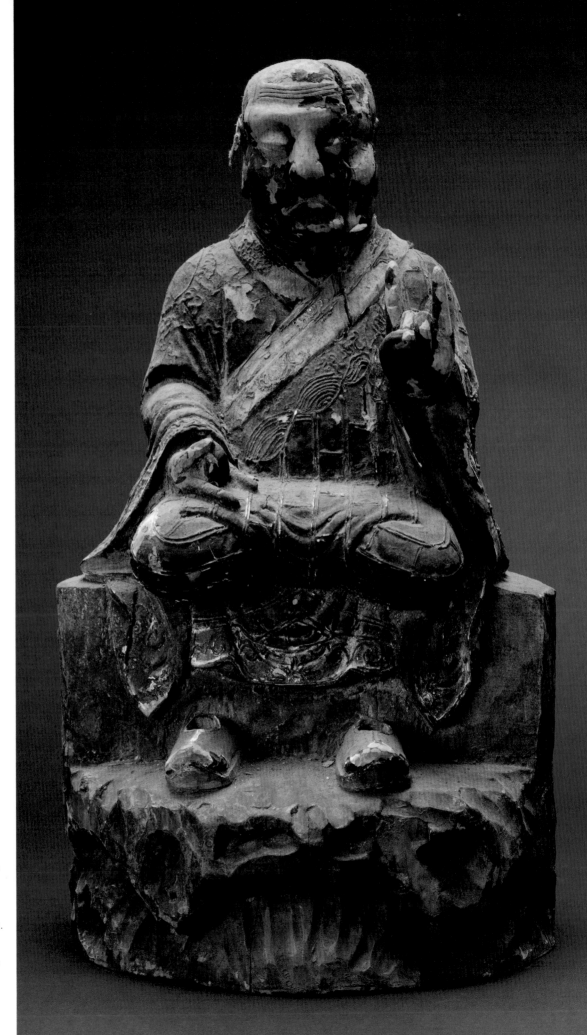

←Figure 54
Yeh To. Height 46cm.

夜多羅漢像，高46公分。

→Figure 55
Chih Kung Tsu Shih.
Height 46cm.

志公祖師像，高46公分。

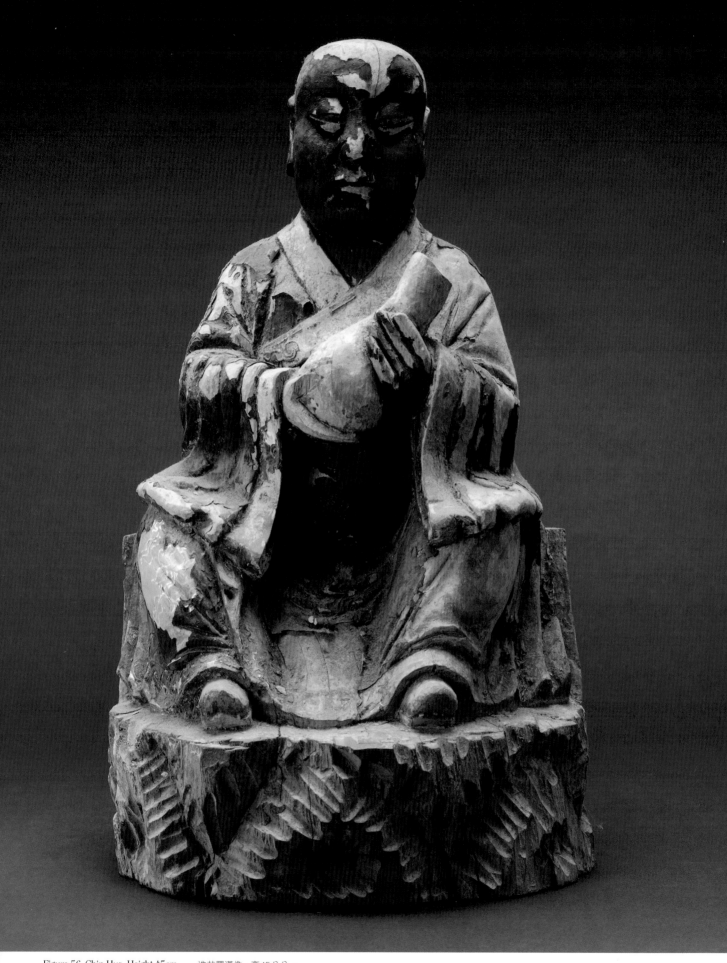

Figure 56. Chin Hua. Height 45cm.　　進花羅漢像，高45公分。

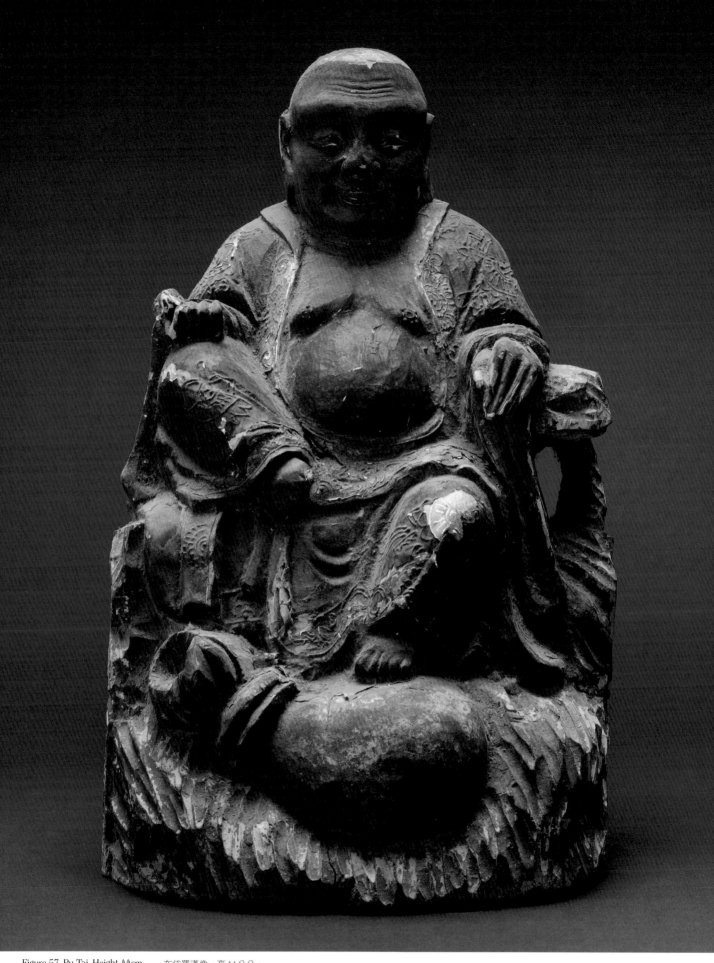

Figure 57. Pu Tai. Height 44cm.　布袋羅漢像，高44公分。

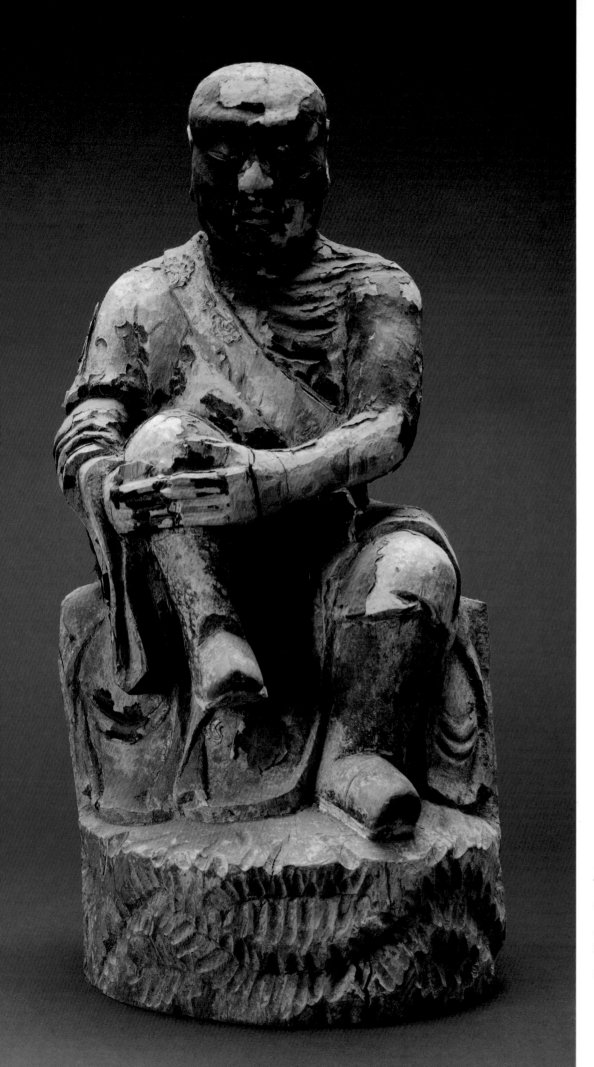

←Figure 58
To Li. Height 46cm.

多利羅漢像，高46公分。

→Figure 59
P'o Lo. Height 45cm.

婆囉羅漢像，高45公分。

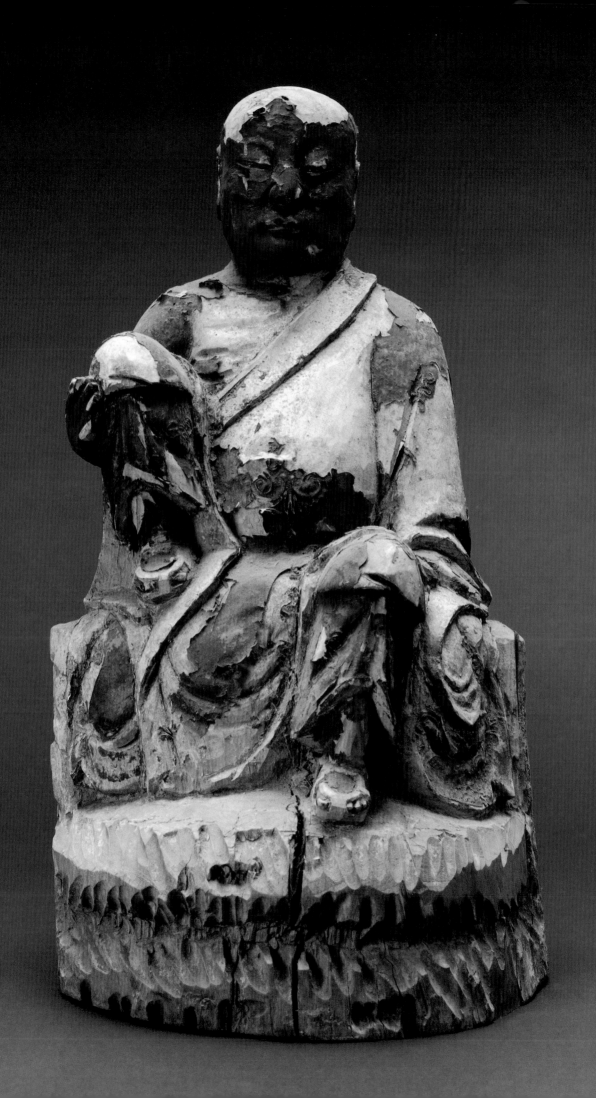

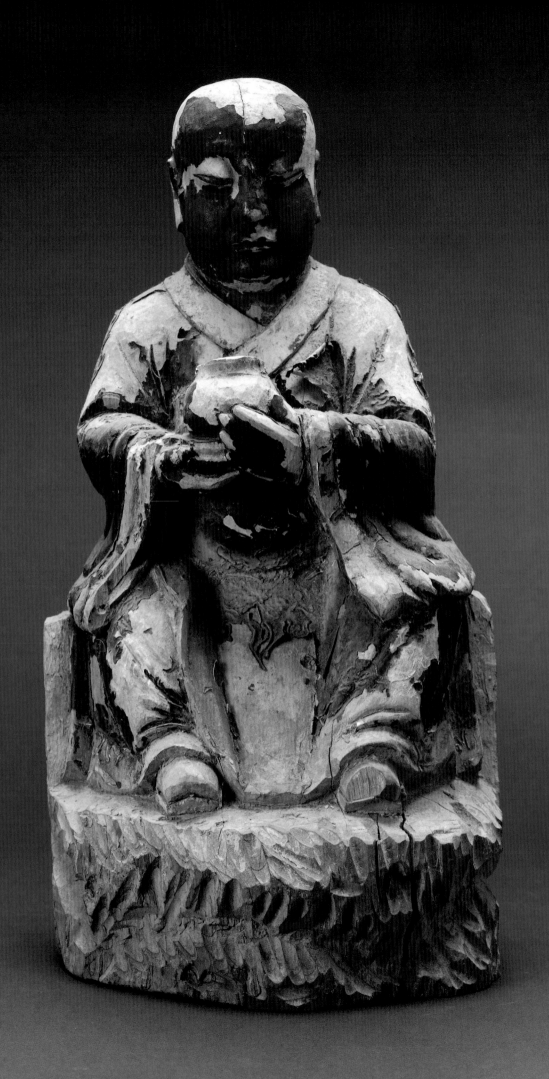

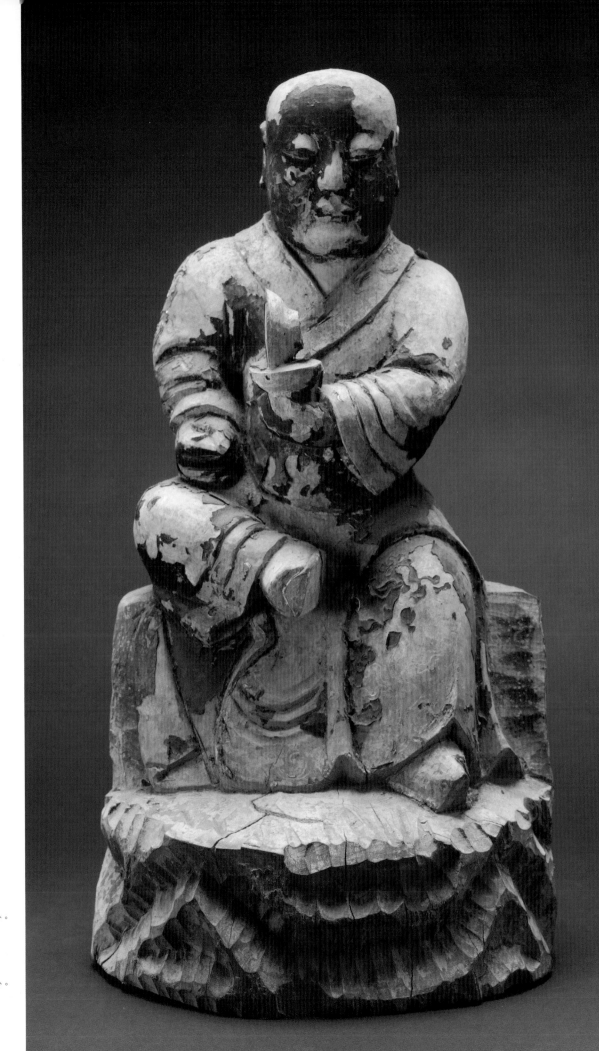

←Figure 60
To Lo. Height 46cm.

多羅羅漢像，高46公分。

→Figure 61
Fei Po. Height 48cm.

飛缽羅漢像，高48公分。

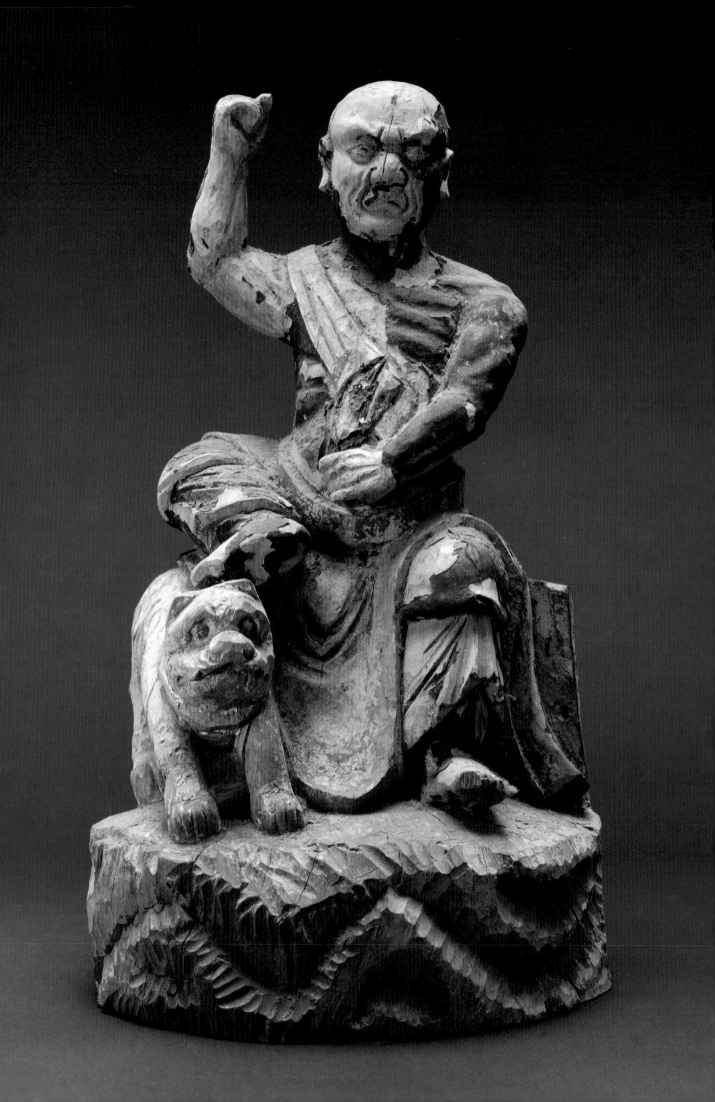

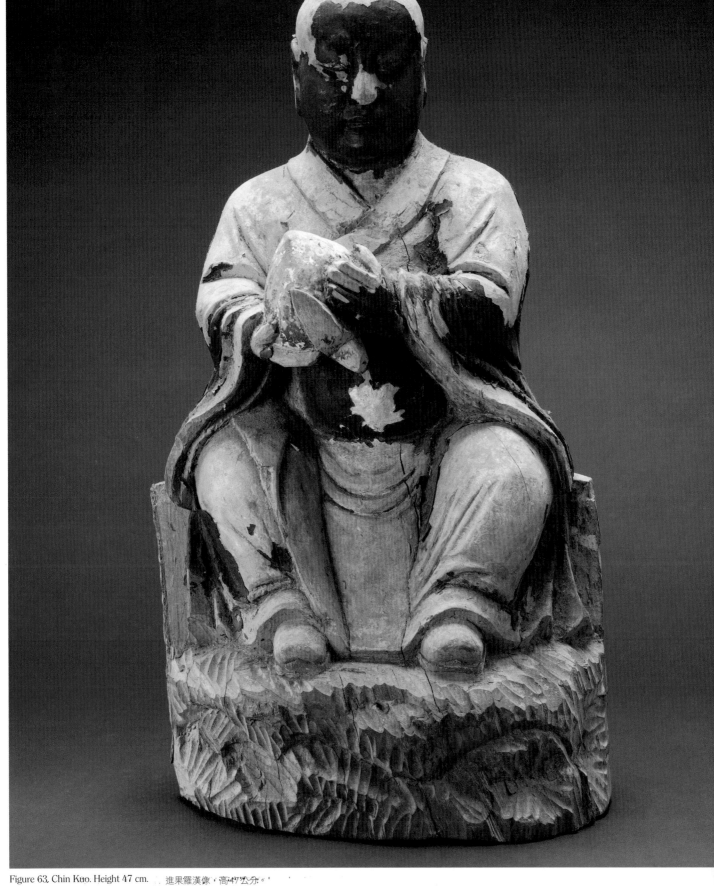

Figure 63. Chin Kuo. Height 47 cm.　進果羅漢像，高47公分。

←Figure 62. Fu Hu. Height 48 cm.　伏虎羅漢像，高48公分。

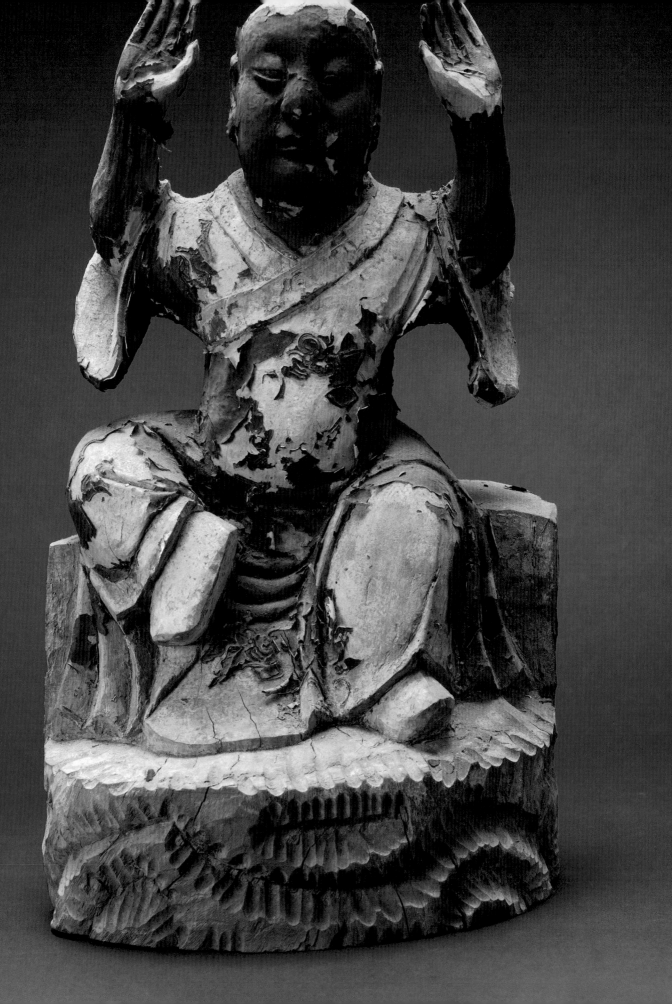

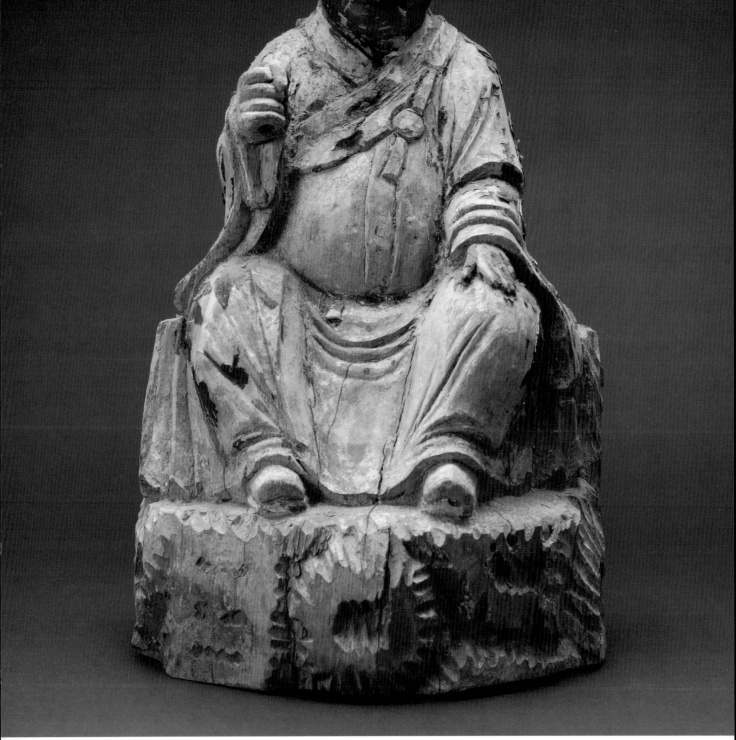

Figure 65. Mulien. Height 47cm.
←Figure 64. Li Feng. Height 46cm.

目蓮羅漢像，高47公分。
力風羅漢像，高46公分。

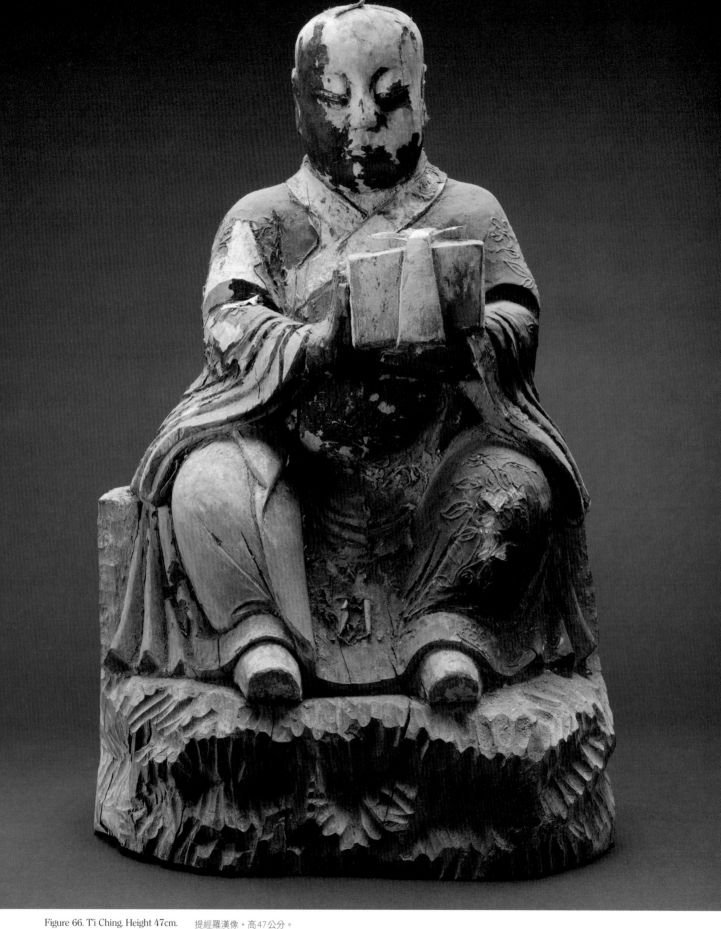

Figure 66. Ti Ching. Height 47cm.　　提經羅漢像，高47公分。

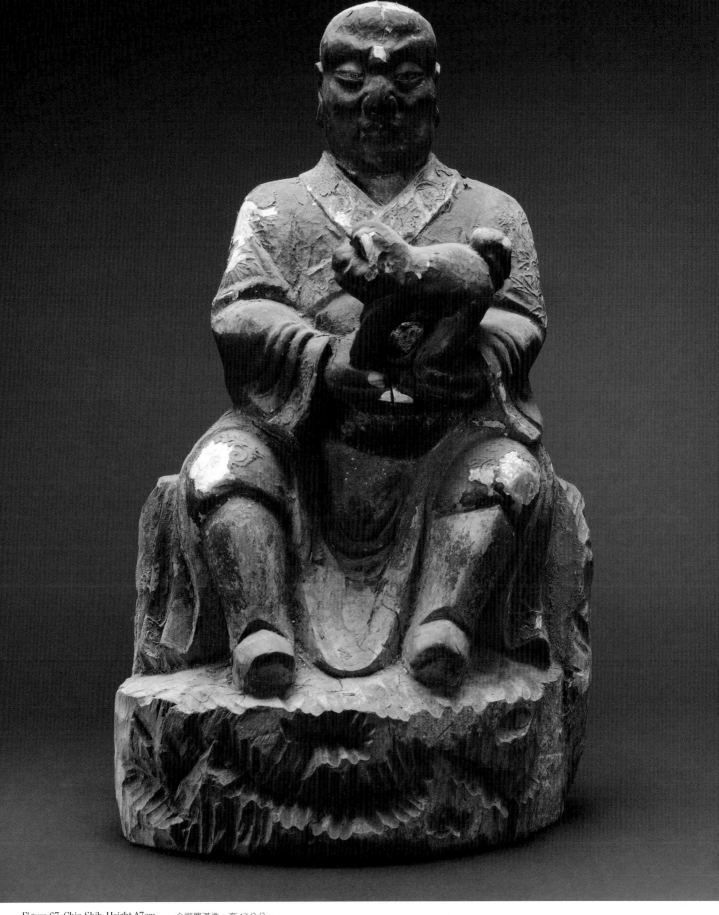

Figure 67. Chin Shih. Height 47cm.　金獅羅漢像，高47公分。

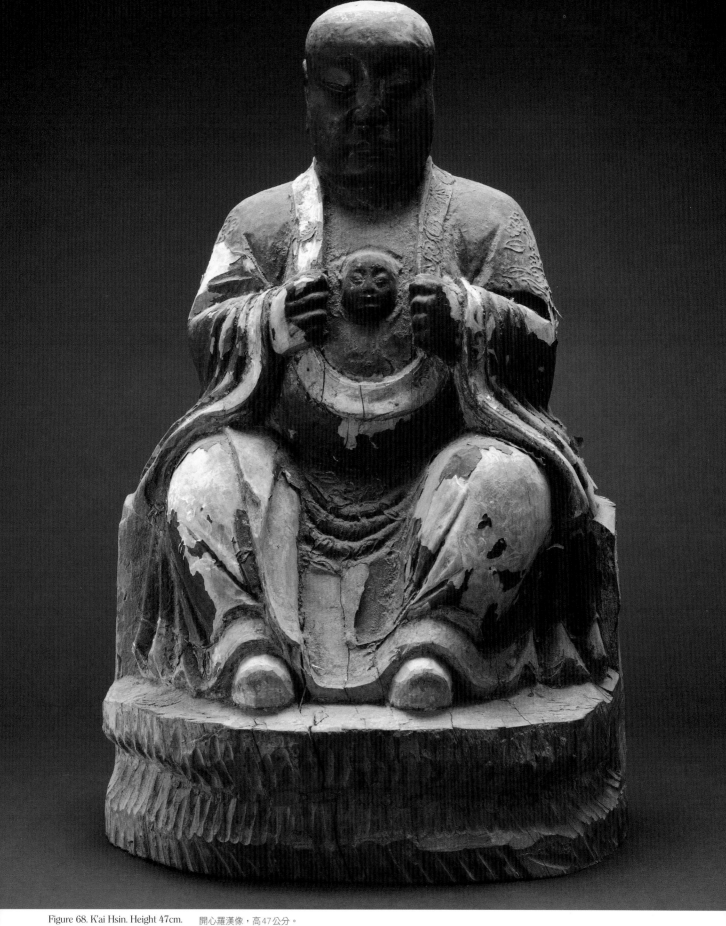

Figure 68. K'ai Hsin. Height 47cm.　　開心羅漢像，高47公分。

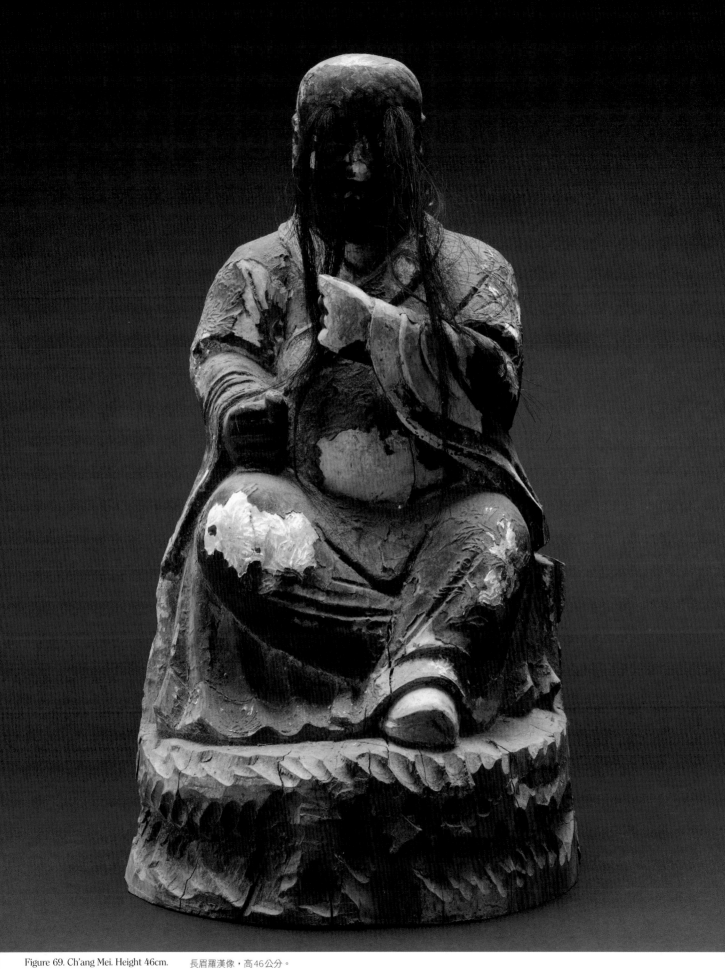

Figure 69. Ch'ang Mei. Height 46cm.　　長眉羅漢像，高46公分。

SAN PAO
(BUDDHIST TRIAD)

三 寶

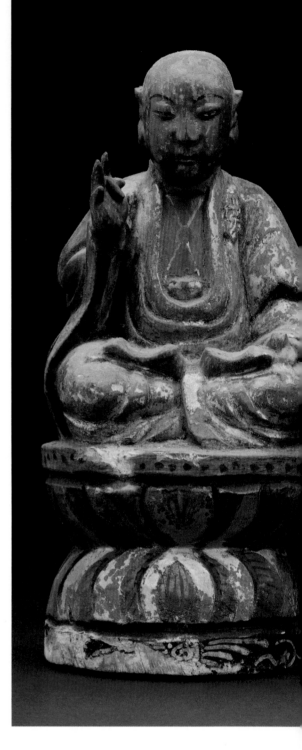

The Buddhist concept of triad "seems to have been borrowed from the trio of Indian deities: Brahma, Vishnu and Siva."[123] Actually there is not one triad, but many, and the groupings in India, Tibet, Mongolia, and China are different.[124]

According to the *Dictionary of Chinese Buddhist Terms*, the Three Precious Ones (San Pao) are: Buddha, *Dharma* (the Law), and *Sangha* (Ecclesia or Order).[125] *Matthew's Chinese − English Dictionary* defines the San Pao as Sakyamuni, Amida Buddha, and Maitreya Buddha.

On Taiwan, the grouping is most commonly thought of as Shih Chia Fo (Sakyamuni who is always placed in the middle), O Mi To Fo, and Ju Lai Fo. They represent Buddha, the Precious Law, and the Precious Monkhood. Some, however, simply consider them as the Buddhas of the past, present, and future.

Shih Chia Fo, generally conceived to be the principal Buddha, lived during the sixth century B.C. in northern India. He attained enlightenment at the age of thirty-five and spent the rest of his life preaching and teaching by example. O Mi To Fo's history is less clear. Keith Stevens writes that he is "a spiritual figure of speech, the saving mercy which makes possible the release of the whole of creation from sin, sorrow, punishment and suffering."[126] The *Dictionary of Chinese Buddhist Terms* defines Ju Lai as "he who comes as do all other Buddhas; who took the absolute way of cause and effect and attained perfect wisdom."[127]

Mi Le Fo, the Buddha of the future or the Buddhist Messiah, logically fits into one of the many rearrangements. In the future, he is destined to descend and establish world peace. In many ways, he is the most interesting because, by his appearance, he seems the most human. Legend claims he once consented to be reborn as a Lohan.[128] In fact, woodcarvers often include him as the Pu Tai Lohan. His is one of the easiest statues to identify. His obese exposed belly, with a deep naval dimple, sags in a protruding mass below plump starlet-like breasts. Elongated ears hanging down on either side of his shining bald pate frame a smiling face, accentuated by a wide-open grin. He is an appealing figure nicknamed "Happy Buddha." Ceramic statues of him find their way into shops and private homes throughout the world. For many, he is not a supernatural being, but a beautiful figurine that brightens moments when their eyes meet his gaze.

In 1964, an eight-story-tall statue of Mi Le Fo (fig. 72) was erected at Pao Chio Szu in Taichung. Upon its completion, it joined a growing number of mammoth structures that, in imitation of the Great Buddha at Pa Kua Shan in Changhua, serve the dual purpose of devotional center and tourist attraction. The Taichung Mi Le Fo was the focal point of a controversy in the spring of 1976 that demonstrates

Figure 70
San Pao, "Three Precious Ones," a Buddhist Triad. Identification of the three can vary, but they are often considered simply as Buddhas of the past, present, and future.
Height 19cm.

三寶，即佛像、法像、僧像，有關三者身分的說法不一，通常僅說是佛陀的過去、現在及未來樣貌。像高19公分。

138

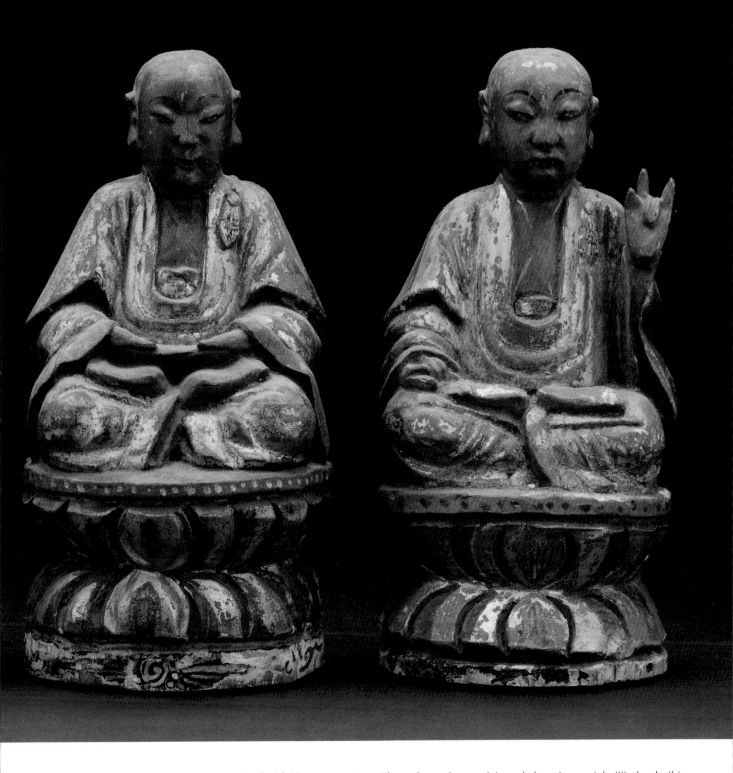

problems the faithful have in coping with modern urban society and changing social attitudes. In this instance, a central tenet of Buddhism – respect for life, even non-human life – was pitted against the needs of society to maintain a healthful, sanitary environment. A large number of swallows built nests in the nostrils and ear lobes of the giant cement structure, thus fouling the statue and creating an environmental hazard. Many of the Pao Chio Szu committee wanted to get rid of the little birds. Others, citing Buddhists' traditional concerns, argued against eliminating the birds, depriving them of their nest homes, or disturbing them in any way. In any event, some noted that the Buddha himself was not complaining.[129]

One month later, the Taichung government warned the temple committee to take steps to control the swallows. The birds were discoloring the water in the decorative pool and fouling the surrounding

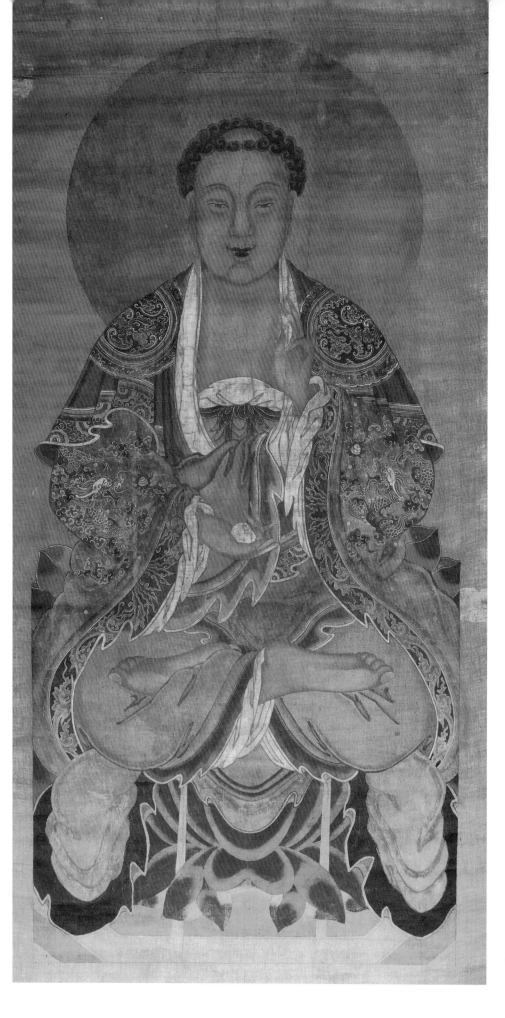

Figure 71
Scrolls of the San Pao. Size 185 by 84cm.

三寶圖，185 × 84公分。

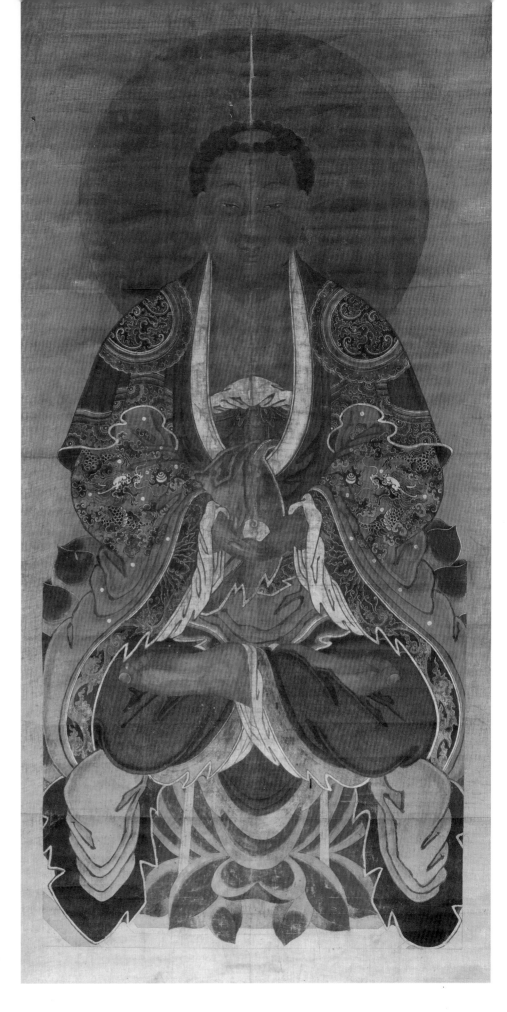

Figure 71-1
Scrolls of the San Pao. Size 185 by 84cm.

三寶圖，185 × 84 公分。

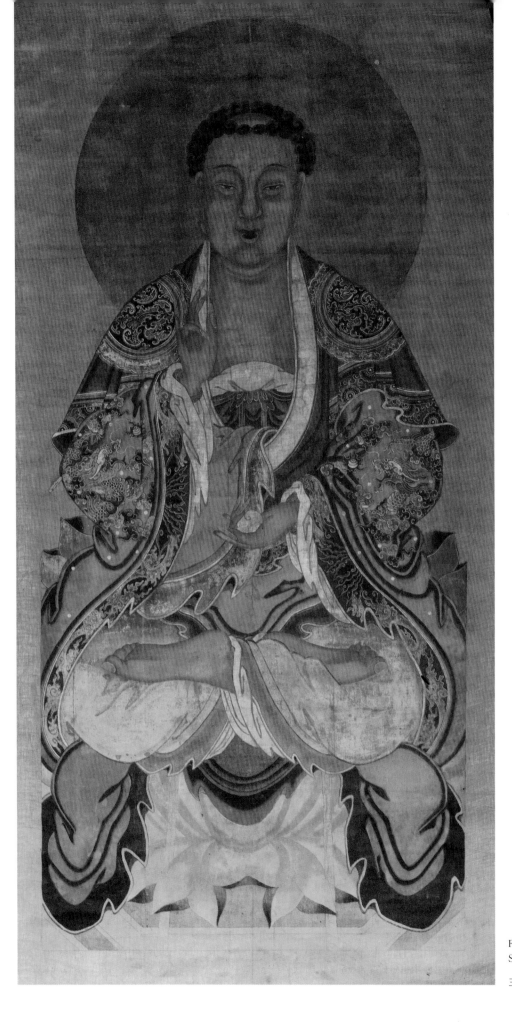

Figure 71-2
Scrolls of the San Pao. Size 185 by 84cm.

三寶圖，185 × 84公分。

Figure 72
The Taichung Mi Le Fo, the focal point of controversy in 1979, when destructive swallows nested in his nostrils and earlobes.

曾在1979年起起軒然大波的台中彌勒佛像，當時有很多燕子在佛像的鼻孔內和耳垂上築巢，造成佛像破壞和環境問題。

area. Additionally, trash containers were overflowing, detracting from the overall appearance.[130] Four days later, the government acted and closed the temple. Tourists were able to view the Mi Le Fo only from behind a metal barrier barring access to the temple grounds. *Taiwan Daily News* observed Mi Le Fo seemed undisturbed by the turn of events and kept on smiling throughout the trouble.[131]

As the majority of temples on Taiwan are a blending of Buddhism, Taoism, and Animism, statues of the triad are found usually only in those few which are exclusively Buddhist in nature. In representations, the three persons are most often carved or drawn in the lotus position and identical in every detail save the hands. Those of the center figure rest on the lap, while the other two lift one hand each as if in a blessing.

The Buddhas in this set of scrolls are identified as Fo Pao (Sakyamuni in the center), Seng Pao (Monkhood on the right), and Fa Pao (Buddha of the law on the left).

123. Dore, *Researches into Chinese Superstitions*, Vol. VI, p. 17.
124. Ibid., p. 15.
125. Soothill, *A Dictionary of Chinese Buddhist Terms*, p. 63.
126. Stevens, *Chinese Gods*, p. 88.
127. Soothill, *A Dictionary of Chinese Buddhist Terms*, p. 210.
128. Stevens, *Chinese Gods*, p. 94.
129. "Mi Le Fo and Swallows' Nest," *Taiwan Daily News*, May 12, 1976.
130. *Taiwan Daily News*, June 16, 1976.
131. *Taiwan Daily News*, June 18, 1976.

CHIU T'IEN HSUAN NU

九天玄女

Most agree that Chiu Tien Hsuan Nu (Dark Lady of the Ninth Heaven), a central figure in the Chinese creation story, and Nu Wa are the same celestial entity. Legends of her in most books on Chinese mythology run along similar lines. She was present at the beginning and helped mold man from yellow earth. When rebellion erupted with Kung Kung, an upstart chief, a fight ensued. With defeat certain, he struck his head against a pillar supporting the heavens, opening a crack in the dome. Water gushed through, flooding earth. Grinding and melting stones of five colors, she prepared a cement strong enough to patch the crack and save humankind.

She was said to be the wife, sister, and successor of legendary Emperor Fu Hsi, who ruled from 2852 to 2738 B.C. Fu Hsi is credited with teaching people how to cook meat and inventing the writing system after studying mystical diagrams on the back of a turtle. The numerous legends of Fu Hsi and Nu Wa/Chiu Tien Hsuan Nu are covered in great detail in many Chinese language books. Werner's *Myths and Legends of China* and Dore's *Researches into Chinese Superstition* are excellent English language sources for the same material.

Lin Heng Tao lists ten temples dedicated to Nu Wa on Taiwan. Most are in rural areas with three in Yun Lin *Hsien* alone. The three are located in the small villages of Hou Hu *Ts'un*, Tzu Mou *Ts'un*, and Shan Nei *Ts'un*, which are within four kilometers of each other in the northwest quadrant of Yuan Ch'ang *Hsien*.

Nu Wa was renowned as a Taoist teacher reputed to have instructed the Yellow Emperor himself. She is the patroness of female shamans, a few minor trades such as umbrella makers, and, notably, marriage go-betweens. Despite the fact that she and her brother lived together as man and wife, she is credited with establishing the principles for orderly marriage. Their incestuous living relationship is excused and rationalized as a necessary arrangement designed to propagate and continue the race after the great flood.

As primitive society approached animal level where couples in loose and unstable relationships produced offspring indiscriminately, she urged Fu Hsi to draw up marriage laws to stabilize the social order. She advised him to forbid pre-marital relations, prohibit marriage between members with the same family name, institute the practice of go-betweens with regularized dowries, and establish a marriage ceremony. In spite of her insistence on moral propriety, she was not averse to using sex as a weapon. In the legendary history of the fall of the Shang as recounted in the epic romance *Feng Shen Yen I*, she used magical means to draw King Chou Hsin into the worst depravities with his concubine until he was destroyed.[132] Early accounts describe the goddess as having the body of a snake and head of an ox. Apparently after the creation of humans, she herself assumed a woman's shape.

Figure 73
Chiu T'ien Hsuan Nu, the mythological deity credited with repairing a crack in the heavenly dome thus saving the world from inundation.
Height 31cm.

九天玄女，曾修補天界的裂縫，使人間免於被大水淹沒的神祇。
像高31公分。

132. Stevens, *Chinese Gods*, p. 55.

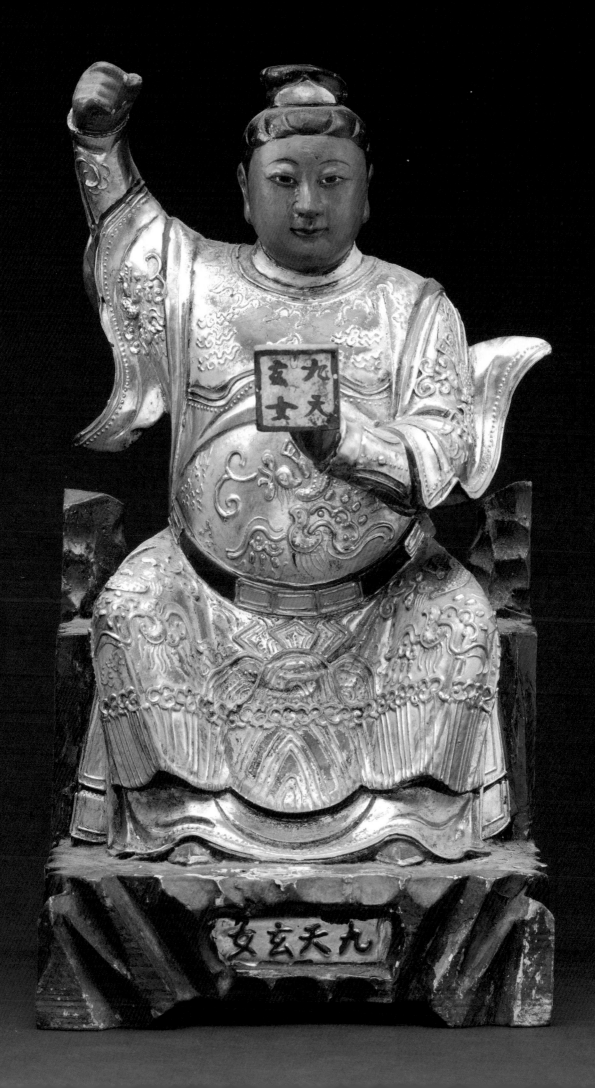

SHEN NUNG TA TI

神農大帝

Shen Nung Ta Ti, a legendary emperor who was supposed to have reigned between 2838 and 2698 B.C., is worshiped as the god of both agriculture and traditional medicine. He is believed to have invented the pottery process and various agricultural implements and to have instituted the practice of holding markets for the exchange of commodities.[133] He is also credited with teaching primitive man how to cultivate the land, the art of husbandry, and the curative powers of herbs.

A transparent stomach that allowed him to observe the chemical reaction of the various herbs on his body aided his investigation of one hundred herbs. Unfortunately, his experiments with poppies polluted his insides to such an extent that his see-through stomach was clouded over, effectively ending his medical investigations.[134] He is credited with writing the first *Pen Ts'ao*, the book of herbal medicine. The book has been revised and expanded many times. A Ming version included approximately 1,000 treatises on vegetable, animal, and mineral remedies.

Statues of Shen Nung Ta Ti often depict him as a primitive man with residual horns and pointed ear-pressing tufts of hair. As he lived before weaving was invented, he wears a grass skirt over which hangs his ample stomach. His skin tone can be red, pink, brown, or black. In some temples, he is enshrined as Yao Wang Ta Ti (god of medicine). In such temples, he may wear military clothing.

Many of the eighty-four Shen Nung Ta Ti temples throughout Taiwan are among the oldest on the island. Most are concentrated in the south with the most numerous in Tainan Hsien and Penghu *Hsien*. There are no temples in Taipei dedicated to Shen Nung Ta Ti, but he is installed as an accompanying god in several of the larger ones. Perhaps his most famous is in the rear hall of Pao An Kung. When the Japanese first arrived as colonizers, they were aghast at his features: horns, bare feet, and a red half-naked body barely covered by a few leaves. Considering him a *lo ch'a* (rakshasa, a Hindu monster that devours humans),[135] they hacked his statue with a sword and forbade further worship of this bizarre idol. His shrine was converted into a classroom and later a small factory. When the factory moved in 1925, the Japanese authorities (now firmly in control and more comfortable with Taiwanese customs) allowed worship of Shen Nung Ta Ti to be resumed there.[136]

Traditionally, his birthday celebrations (twenty-sixth day of the fourth lunar month) were elaborate affairs in rural communities and among herb doctors. Pao An Kung celebrated his birthday with *paipai* parades. However, worship to him has decreased with rapid industrialization and increased use of western medicine.[137] The government's policy of controlling the price of rice has, in Liu Wen San's opinion, discouraged farmers from petitioning the god of agriculture. "What could they ask for?" Liu wondered. In 1980, Liu made multiple visits to Tainan's Shen Nung Tien but never saw worshipers burning incense. On a few visits he found the temple locked and the caretaker either tending his noodle stand or driving a taxi.[138]

Nevertheless, the god is still considered important, at least symbolically, and newspapers often carry accounts of officials publicly worshiping at his temples. During a dry spell in 1976, for example, Ilan

Figure 74
Shen Nung Ta Ti, a legendary emperor. He is worshiped as the god of agriculture and traditional medicine. Having lived before the discovery of weaving techniques, he is always garbed in foliage.
Height 31cm.

神農大帝是傳說中的帝王，被尊為農業與傳統醫藥之神。由於出生在紡織技術未開發的遠古時代，所以祂的彫像總是以樹葉為衣。像高31公分。

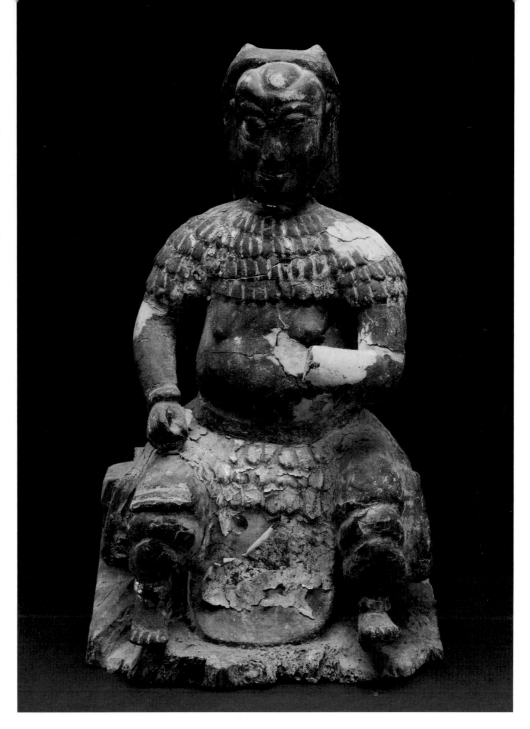

Magistrate Li Feng Ming chose the god's birthday to publicly pray for rain at Shen Nung Ta Ti temple, Wu Ku Miao, one of Ilan's oldest which dates from the seventeenth year of Chia Ch'ing's reign (1813).[139] Chiayi Magistrate Tu Te Ch'i donned dynastic robes to make similar obeisance at the Shen Nung Ta Ti temple on the occasion of the god's birthday in 1979.[140]

　　Shen Nung Ta Ti is also known as K'ai T'ien Yen Ti, Wu Ku Hsien Ti, Yao Ta Ti, and Wu Ku Wang.

133. Werner, *A Dictionary of Chinese Mythology*, p. 419.
134. Wu, *Taiwan's Folk Culture*, p. 64.
135. Liao, *Mythology of Taiwan*, p. 30.
136. Chu, *Birthday Listing of Gods*, p. 108.
137. Liao, *Mythology of Taiwan*, p. 31.
138. Liu, *The God Statues of Taiwan*, p. 212.
139. "Li Feng Ming Prays to Agriculture God for Rain," *Taiwan Daily News*, May 25, 1976.
140. "Offering to the God of Agriculture," *Independence Evening News*, May 22, 1979.

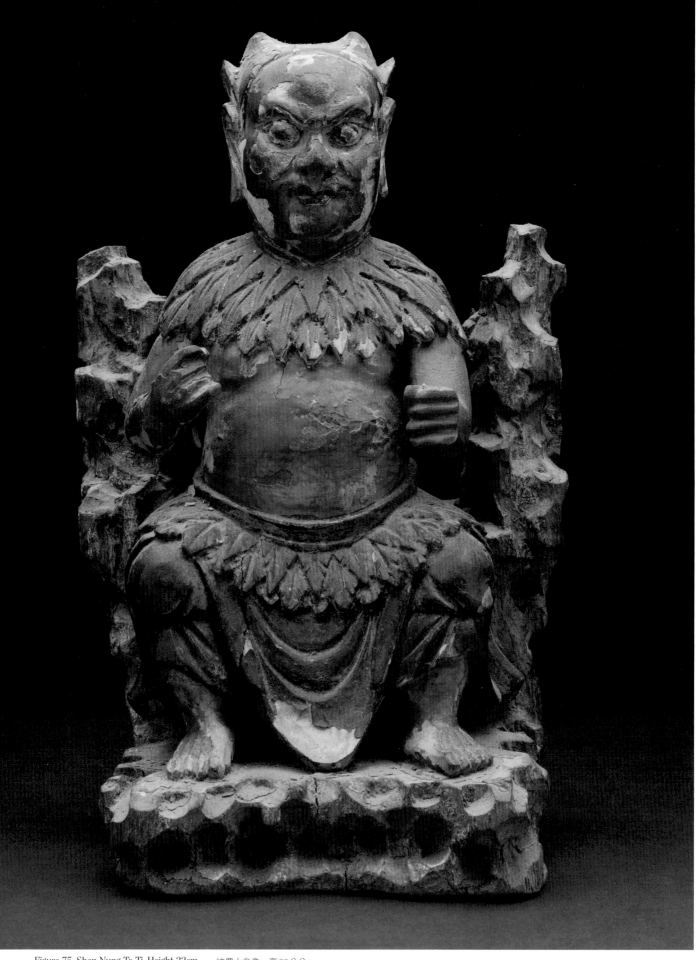

Figure 75. Shen Nung Ta Ti. Height 22cm. 神農大帝像，高22公分。

SHOU HSING
(LONGEVITY GOD)

壽 星

Shou Hsing, the god of longevity, was originally a stellar divinity worshiped by the first emperor of the Ch'in Dynasty, because it was believed that when brightest, the country would flourish.[141] The need for something more personal than a star for worship purposes gradually led to the deity being represented in human form.

Longevity is one of the *wu fu* (five blessings) eagerly sought by all Chinese. The other four are: wealth, health, virtue, and natural death. The popularity of early Taoism was due in part to the promise it held for extending life through various hygienic regimes.

Besides Shou Hsing, Chang Kuo Lao of the Eight Immortals and P'eng Tsu also represent longevity. (P'eng lived to a ripe old age as a reward for a courtesy extended to the Eight Immortals. Once when the Eight were crossing a field being plowed by the young P'eng, he stopped until they passed lest his work soil their clothing. They were so impressed with his thoughtfulness that each awarded him an extra one hundred years of life. Added to the mere twenty which fate allotted him, he was able to live until 820 years of age.) Turtles, deer, cranes, bamboo, and pine also symbolize long life.

There are no temples to Shou Hsing on Taiwan, but pottery or glass statues of him, together with the gods of progeny and wealth, adorn temple roofs throughout the island. He is usually represented as a venerable elder with a high forehead, indicating wisdom, standing and carrying a staff and the peach of immortality. Cheap ceramic or wooden statues of him are favorites of tourists and are commonly used in Chinese restaurants as decoration.

Although no temples are built in his honor, Shou Hsing plays an integral role in worship rituals. There are specific rules to be followed when petitioning gods. Meats commonly offered are pork, chicken, duck, fish, and eggs. Purists insist on the order and amounts for specific ceremonies. With the exception of birthday rites for Confucius, when a goat or even a cow will be sacrificed, large animals are rarely used. Obviously, one would never offer meat to a Buddhist deity. However, paper money bearing the imprint of the triad symbolizing ideal existence (the gods of wealth, progeny, and longevity) are integral to all sacrifices and petitions. During Matsu's birthday and similar festivals, tons of paper money made from woodblocks such as the one pictured here (fig. 77) are burned.

Statues of Shou Hsing seated in the position of a main god are rare. There may be others in this pose, but in all my travels, the one in my collection (fig. 76) is the only one I have ever seen. I came across it in an out-of-the-way antique shop on the third floor in downtown Taipei. As it was partially blackened by incense smoke, I knew it must have been worshiped at one time. As was my custom, I bargained but to no avail. The antique dealer would not consider a reduction of even one Taiwan dollar. Never had I dealt with a dealer who was not prepared to haggle. The usual procedure is for the seller to name a ridiculously high price and the buyer to counter with an unreasonably low offer. The game is played out with each side moving to the mid point and the deal made at a price approximating the

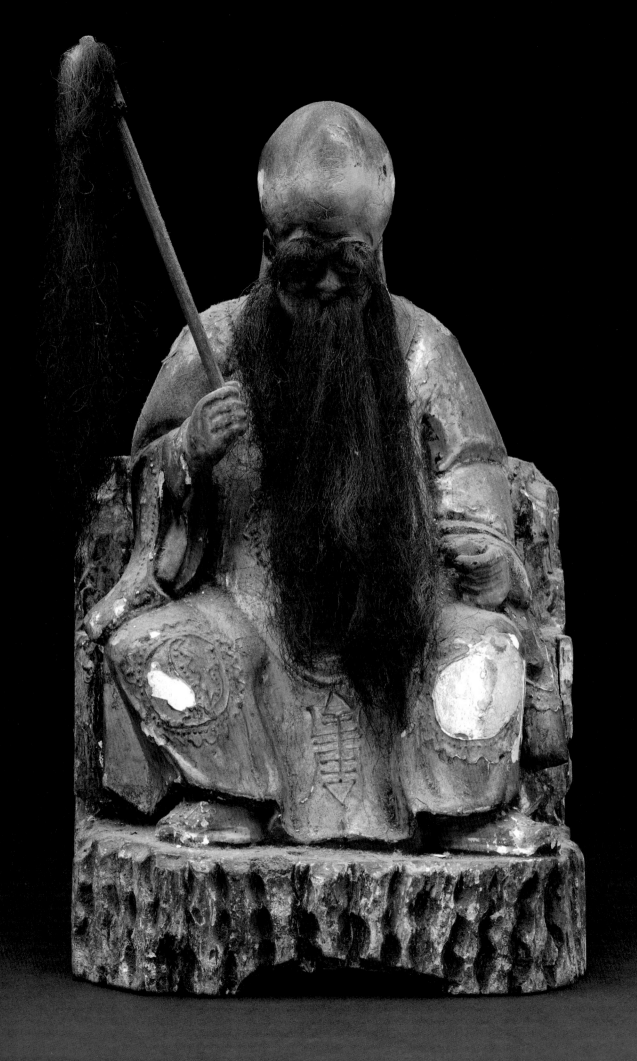

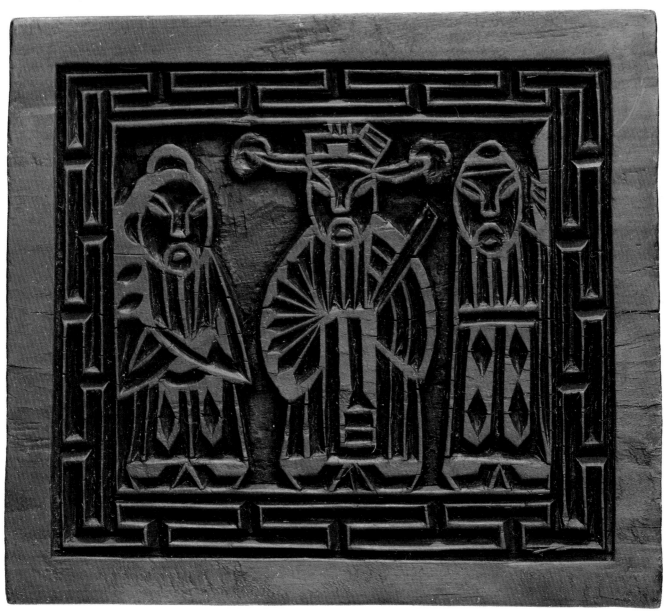

Figure 77. Spirit money woodblock. Size 11 by 12cm.　　木製紙錢模板，11 × 12公分。

←Figure 76
Shou Hsing, a stellar divinity worshiped as the god of longevity. Pottery statues of him grouped with the gods of progeny and wealth can be seen decorating temple roofs throughout Taiwan. Spirit money burned at funerals and during festivals carry the image of these three. Height 25cm.

壽星，被尊為長壽之神的星神，台灣各地廟宇的屋頂經常可見壽星、福祿星和財神的陶製群像。葬禮和節慶時焚燒的紙錢上也繪有三者的圖像。像高25公分。

real value. I left believing he would receive no other offers and intending to return within a week. I made three more fruitless trips to his shop. On my fourth, I was greeted by a smiling antique dealer and a vacant spot on his shelf. The statue had been sold. I chalked up the loss to my stubbornness. Two months later, the statue appeared in colorful wrapping under our Christmas tree. My wife, who had endured my complaining about the man's failure to bargain, went to the store and paid his price.

141. Burkhardt, *Chinese Creeds and Customs*, Vol. 111, p. 149.

T'AI YANG HSING CHUN AND T'AI YIN NIANG NIANG

太陽星君和太陰娘娘

Early Chinese society, like many other ancient civilizations, worshiped the sun and the moon.

The sun, heavenly provider of the energy necessary for vegetation, was personified as T'ai Yang Hsing Chung. Chinese mythology tells us that there originally were ten suns whose essences were embodied in ten large crows. Naturally, the excessive heat they generated threatened life. So Hou I, legendary Emperor Yao's archer, shot nine of the superfluous sun-crows out of the sky, leaving only the present one.[142]

Worship of the sun and the moon can be traced back to the Chou Dynasty, for we find in the *Li Chi*, the Book of Rites, evidence that animals were sacrificed to both. An eclipse of the sun caused great consternation for the early Chinese, because it was believed that this phenomenon was caused by the Heavenly Dog's attempt to devour it. Hoping to frighten away the beast, peasants rushed outdoors and made whatever noise possible in an attempt to save their benefactor.[143]

Chinese temples held regular worship ceremonies to the Sun God throughout the year when the sun and earth were in proper alignment. Incense was burned, *sutra*s chanted, and special cakes were offered. After the god had satisfied himself with the essence of the sweets, called sun cakes, they were taken home to be consumed by the family.[144] This practice appears outdated and is not popular on Taiwan.

The *sutra* chanted praised the sun for its contribution to life and likened it to the bright light of Buddha. Faithful who recited it seven times each morning were assured immunity from Hell. Recitation also alleviates suffering of deceased friends and relatives in Hell and reduces their sentences.[145]

There is also a "Moon *Sutra*" that promises anyone repeating it seven times will not cross the threshold of Hell after death, and daily recitation will increase longevity for parents.[146]

On the fifteenth day of the eighth lunar month, when the moon is thought to be at its roundest and brightest, the Chinese celebrate Chung Ch'iu, the Moon or Mid-Autumn Festival. The origins are religious, but, as is the case with many Christian feasts, it has become a secular festival with the emphasis on social amusements.

Although it is likely that worship of a personified moon predated the Ch'ang O legend, some identify her as the Moon Goddess.[147] In the myth, she is the wife of Hou I. For his service, he was given the elixir of immortality by Hsi Wang Mu only to have it stolen by his wife. To avoid punishment for her misdeed, she fled to the moon where she remains in icy splendor in a magnificent, but frigid, palace.[148] Another myth tells that Hou I, in searching for his wife, wandered into the palace of Tung Wang Kung, who eventually appointed Hou I the Sun God.[149]

The several moon legends make the earth's satellite a crowded place. A three-legged toad resides there. Some say the animal is actually Ch'ang O transformed. The gods changed her into that repulsive shape as further punishment for her transgression.[150] Wu Kang, an actor, is also there. His performance once so displeased the gods that they banished him to that celestial outpost and condemned him to hew down all cinnamon trees that grew there. Unfortunately, every incision he makes miraculously heals upon the

→Figure 78
T'ai Yang Hsing Chun (Sun God). He, along with T'ai Yin Niang Niang (Moon Goddess) are believed to control light and dark and the temperature. Height 27cm.

太陽星君和太陰娘娘在信仰中為掌管光暗和溫度之神。像高27公分。

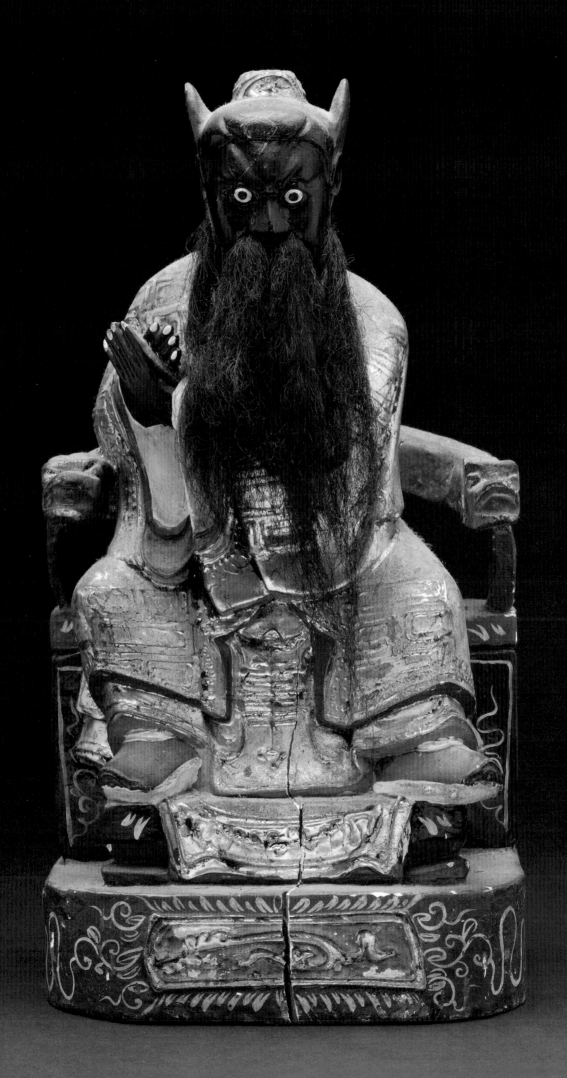

withdrawal of his ax. A hare that is forever pounding the drugs of immortality with his pestle and mortar and Yueh Hsia Lao Kung, the marriage god who connects future spouses with a red thread, also share tenancy of the moon with the above personages. A statue of Yueh Hsia Lao Kung can be seen at Tainan's Chung Ch'ing Szu, one of the city's oldest temples. Its history dates back to the sixtieth year of the K'ang Hsi reign (1722). Yueh Hsia Lao Kung resides on a side altar as an accompanying god to the San Pao Fo.[151]

On the night of the Moon Festival, it is traditional to arrange moon-viewing parties on mountaintops, other high places, or on boats where one has an unobstructed view of the moon. Moon cakes, large round pastries filled with a variety of delicacies from preserved eggs to sweet bean paste, are exchanged, and round fruit, such as apples or oranges, symbolizing the moon, are consumed. The fruit occasionally will be cut into slices and reshaped to resemble the lotus upon which Buddha rests. Good food, strong drink, and convivial conversation comprise the night's entertainment.[152] Sometimes poetry will be read in imitation of Li T'ai Po, one of China's most famous poets, who after composing a poem to the moon, drowned in a drunken attempt to embrace its reflection in the water.

Taoists have adopted T'ai Yang and T'ai Yin as two stellar deities. Together they control the light and dark, and the hot and cold weather.

Statues of T'ai Yang Hsing Chun and T'ai Yin Niang Niang are not common but can sometimes be seen on secondary altars. He is most commonly portrayed with a red face (occasionally with a third eye in the center of his forehead), pointed ears, large round eyes, a fierce demeanor, and holding a sun disc with both hands extended; she as a mature beauty, seated on a throne, and holding the moon disc.

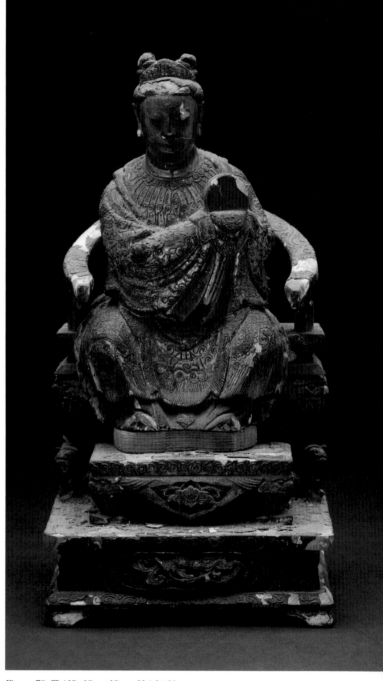

Figure. 79 T'ai Yin Niang Niang. Height 21cm

太陰娘娘像，高21公分。

142. Werner, *A Dictionary of Chinese Mythology*, p. 470.
143. Ibid., p. 469.
144. Shen, *Introduction to Chinese Gods*, p. 82.
145. Dore, *Researches into Chinese Superstitions*, Vol. V, p. 519.
146. Ibid., p. 523.
147. Williams, *Outlines of Chinese Symbolism and Art Motives*, p. 403.
148. Ibid., p. 279.
149. Werner, *A Dictionary of Chinese Mythology*, p. 159.
150. Ibid., p. 403.
151. Chung, *The Origins of Taiwan's Local Gods*, p. 400.
152. Shen, *Introduction to Chinese Gods*, p. 82.

LEI KUNG
(THUNDER GOD)

The Jade Emperor commissioned Lei Kung, the god of thunder, to be his executioner of those who waste grain, are unfilial, or who engage in other egregious behavior. For this reason, naughty children are threatened with: "If you do not behave, Lei Kung's thunder will get you."

Although a purely mythical figure, there are several stories linking him with various historical personages, but such legends do not appear to be popular on Taiwan. Ancient agricultural societies, China included, revere natural phenomena that sustain, nurture, or threaten life: the earth, sun, rain, wind, thunder, and lightning, etc.

In ancient times, he was conceived of as a dragon monster with a human head. Later, he was believed to have been a monkey with a human body, thus leading some to confuse him with Sun Wu Kung, the Monkey King. At one point he was drawn as a pig, in contrast to the god of wind, who was pictured as a dog.

Since early dynastic times, Lei Kung has been carved as a bird-beaked warrior often brandishing a battle-ax and standing on two drums, a depiction influenced by the introduction of Buddhism from India into China. His resemblance to the Hindu Garuda is unmistakable.[153]

There are few temples to Lei Kung on Taiwan. The P'i Li Kung in Chung Ho, one of the oldest temples in the Taipei area, is northern Taiwan's only Lei Kung shrine. According to the temple custodian, it was built over 300 years ago on the banks of the Hsin Tien River. Lin Heng Tao's book places its establishment during the K'ang Hsi reign (1662-1723). At that time, the aboriginal inhabitants and the Chinese settlers shared the area. The custodian believes that in the early days, before the aborigines were driven out, both groups worshiped there. With increased Chinese immigration and the resulting explosion of temples to more popular gods, P'i Li Kung was neglected. Today, few outside the immediate neighborhood know of it.

There are five representations of Lei Kung, each with a different facial hue (gold, yellow, red, pink, and green) on P'i Li Kung's main altar. Tien Mu, the goddess of lightning, also resides there. Variously described as an assistant or wife, she holds a wondrous mirror, the searchlight qualities of which aid Lei Kung, who like any elderly person, is afflicted with failing eyesight.

Lei Kung once spotted a young widow drying watermelon seeds, but mistook her for one wasting grain. With his terrible thunder, he killed the innocent woman on the spot. Naturally, he regretted his hasty action when he learned the truth. To prevent a reoccurrence, the Jade Emperor gave Tien Mu a magic mirror and instructed her to reflect light on any suspected evildoer before Lei Kung strikes so that his weak eyes can clearly ascertain the facts. This, some believe, is the reason lightning flashes before thunder. According to one theory, lightning is caused by the collision of the *yang* (sky, masculine) and the *yin* (earth, feminine). Because lightning originates from the ground up, a female deity commands it. In a slight twist on the above legend, the Jade Emperor, to compensate the blameless widow,

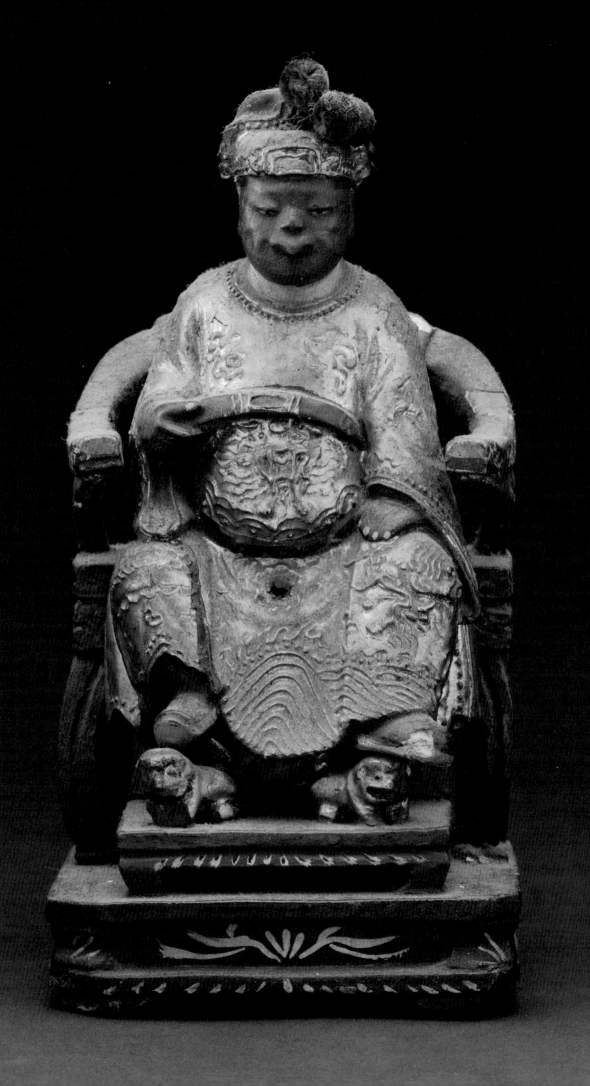

commissioned her as Tien Mu.[154]

In a variation echoing one of the Confucian twenty-four acts of filial piety, a young penniless widow, striving to satisfy her mother-in-law who grumbled that she was never served meat, cut a portion of her arm, cooked it, and offered the dish to the old lady. After a few bites, she complained that the meat was tough, cursed her daughter-in-law and called on Lei Kung to strike her dead. Immediately, a deafening roar of thunder took her life away. Only then did the old lady notice the blood that had clotted, covering the missing portion of her daughter-in-law's arm. News of the tragedy reached the Jade Emperor who brought the girl to the celestial palace.[155]

Lei Kung and Tien Mu can be seen together in scrolls of Hell hung by Taoist priests at funerals or covering the walls of some temples. From an upper corner, Lei Kung, guided by Tien Mu's mirrors, directs his deadly thunder bolt at sinners such as "unfilial husbands and wives."

Lei Kung's depiction in the "Hell scroll" (fig. 81) corresponds to the following description in Stevens' book: "...half-man/half-bird with a human body and arms, chicken's feet and claws, a monkey's head (apart from his bird-like beak) and, uniquely, he has a pair of wings."[156] Statues of Lei Kung are rare, but Taoist priests who practice the "Five Thunder Magic" sometimes have his likeness on their personal altars. The one pictured here (fig. 80) previously belonged to a Taoist priest who migrated to Taiwan from Fuchien. The pose is more in keeping with what might be found on an altar. The wings and chicken feet are missing, but the green face and the bird's beak definitely identify him as Lei Kung.

Lei Kung has a benevolent side. He assists rain gods in ensuring bountiful harvests, and his threat of retribution discourages bad behavior and promotes virtue.

Figure 81
Lei Kung accompanied by Tien Mu, goddess of lightning. They are depicted in the upper left hand corner of this scroll of Hell's ninth court striking dead unfilial wives and husbands. Size 152 by 77cm. Catalog number E426247, Department of Anthropology, Smithsonian Institution.

〈地獄十殿圖〉的第九殿圖，左上角描繪雷公和電母正將不忠的丈夫和妻子擊斃。152 × 77公分。編號E426247，史密森尼博物館人類學部門。

←Figure 80
Lei Kung, god of thunder. He is the patron of Taoist priests who practice the "Five Thunder Magic." Height 23cm.

雷公為雷電之神，祂是道教法師習「五雷法」的守護神。像高 23 公分。

153. Burkhardt, *Chinese Creeds and Customs*, Vol. 11, p. 174.
154. Chu, *Birthday Listing of Gods*, p. 97.
155. Chu, *Birthday Listing of Gods*, p. 98.
156. Stevens, *Chinese Gods*, p. 133.

K'UEI HSING 魁 星

Is K'uei Hsing one individual god, a deity with two manifestations, or a composite? That is a question scholars cannot answer: a poser troubling for them, but not for the faithful for whom K'uei Hsing is the first start of the Big Dipper and one of the five patron deities of literature and learning.

His story is a jumble of history, legend, fable, and fantasy. Simply told, he was a brilliant, but ugly, scholar who gained first place in the imperial examinations. It was the custom for the emperor to award a golden rose to the winning contestant. The emperor, upon seeing such a repulsive visage, turned away in loathing. The scholar, indignant at this affront, threw himself into a river in disgust. The gods took pity on him and arranged for a sea monster to rise out of the water in time to catch him and transport him to Heaven, where he took residence in one of the stars of the Dipper.

The other four gods of literature are Chu I (prayed to by those lacking sufficient preparation and confidence), Kuan Kung, Lu Tung Pin, and Wen Ch'ang Ta Ti.

K'uei Hsing's academic brilliance and physical appearance, similar in varying respects to those of Chung K'uei (revered as the destroyer of demons) or Wen Ch'ang Ta Ti, has led some to confuse the three or consider them as one. Research into the various sources leaves one more puzzled than informed. Werner, for example, gives K'uei Hsing's earthly name as Chung K'uei. To add to the confusion, there are three homonyms for "k'uei" (stride, high, and eminent), and all are used in the stories of these deities.

Keith Stevens believes many confuse Chung K'uei with K'uei Hsing because both were unjustly deprived of their rightful scholarly awards. Chung K'uei called attention to the injustice by committing suicide on the steps of the imperial palace.[157] Chu Yuan Shou has written that in Yuan times, Chung K'uei was pictured as a deity whose features resembled K'uei Hsing to a marked degree: a repulsive naked hunter with horns, posed holding an iron fork and balanced on one foot with the other kicked backwards.[158] Later representations softened his features until now, he resembles less the evil spirits he is said to swallow and more an itinerant Taoist eccentric.

Some maintain that Wen Ch'ang Ta Ti, a renowned scholar and a member of the Board of Rites during the T'ang Dynasty, and K'uei Hsing are merely two natures of the same god. As both are star gods residing in the Big Dipper and Wen Ch'ang Ta Ti is said to have had as many as seventeen reincarnations,[159] it is an understandable assumption. Werner suggests that together with Chung K'uei, they form a "composite deity."

After K'uei Hsing's suicide, literati began to worship and sacrifice to him as the god of literature. The character "k'uei" is written as a combination of the "kuei" (disembodied spirit or demon) and "tou" (bushel). Carvers fashioned statues of the god balanced on one foot with his left leg in a backward kick, a pose that closely resembles the lines of the written character. Paintings and sculptures became more or less standardized in the Sung Dynasty. Since then, he has been represented as a cleft-headed

→Figure 82
K'uei Hsing, a favorite of the literati. Although he placed first in the official examinations, the emperor, repulsed by the scholar's ugliness, refused to award him the prize. Indignant at the affront, he committed suicide. Height 29cm.

魁星是讀書人的最愛，祂曾高中科舉，但卻因面貌醜惡，被皇帝拒於門外，魁星因此羞憤自盡。像高29公分。

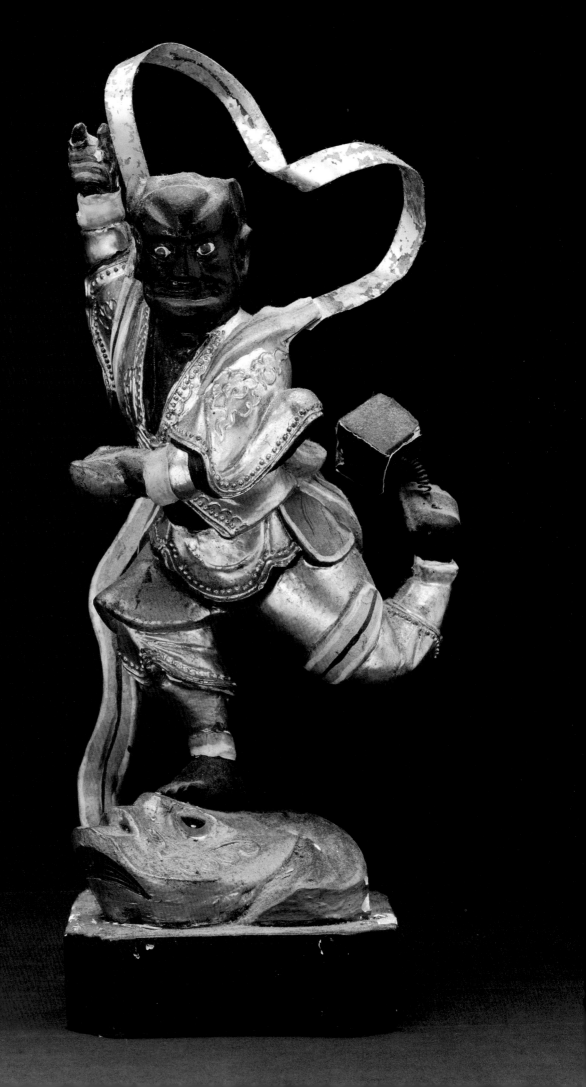

Figure 83

Scroll of the third court of Hell. In the upper left, a soul is depicted being rewarded for showing reverence for the written word by burning paper in a temple furnace. Size 152 by 77cm.
Catalog number E426241, Department of Anthropology, Smithsonian Institution.

〈地獄十殿圖〉中的第三殿圖，左上方有一人在金爐中焚燒紙錢，此舉表示出對文字的注重，所以獲得獎勵。152 × 77公分。編號E426241，史密森尼博物館人類學部門。

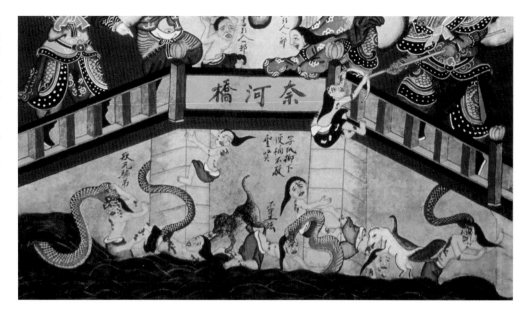

Figure 84
Detail of the fifth court of Hell. Snakes
devour those who used paper sanctified
with writing as toilet tissue.
Catalog number E426243, Department
of Anthropology, Smithsonian
Institution.

地獄第五殿細部圖。曾把珍貴的文字紙
張拿來當草紙使用的人正在被蛇吞噬。
編號E426243,史密森尼博物館人類學
部門。

monster with a blue face and protruding teeth. He holds a constellation in one hand, a pen in the other, and balances his half-naked body on the sea monster.

As for Wen Ch'ang Ta Ti, the literati always considered him important, but worship to him was given a boost during the Yuan Dynasty, when all departments of government were ordered to build shrines in his honor.[160] In addition to officials and scholars, professions tangentially related to literature, such as book dealers, printers, and paper suppliers, consider Wen Ch'ang Ta Ti their patron.[161]

Wen Ch'ang is usually portrayed in one of two forms: a bearded, handsome official or a prosperous scholar either sitting on a throne and dressed in blue robes or astride a white mule or horse.

During the Ch'ing Dynasty, officials and scholars raised money to build shrines to him. These structures also housed literary clubs called Wen Ch'ang Associations that organized "Respect Words Societies" throughout the empire. These societies supplied bamboo baskets to the local governments for collection of paper upon which writing appeared. On Wen Ch'ang Ta Ti's birthday, scholars would collect the baskets, burn the paper at temples, carry the residue in solemn procession to boats, and ceremoniously scatter the ashes over the water.[162] Desecration of the written word was an offense serious enough to be illustrated in Taoist scrolls of Hell. In King Yen Lo's Hell court, a man is being devoured by snakes for using paper sanctified by the written word as toilet tissue "thus showing disrespect for the sages" (fig. 84). In contrast, in King Sung Ti's court, a man pictured burning such paper in a temple furnace is promised "filial children and wise grandchildren who will pass examinations one after another" (fig. 83).

While it is true that Wen Ch'ang and K'uei Hsing are seen as two manifestations of the same god, they are considered by aspiring scholars to have narrow responsibilities and influence. K'uei Hsing is seen as the god of examinations while Wen Ch'ang is believed to be able to foretell examination results.

When China abandoned the official examination system early in the twentieth century, the position of the entrenched literati declined, and consequently, the reputations of Wen Ch'ang Ta Ti and K'uei Hsing suffered. Nevertheless, as a news account in the July 24, 1976 edition of the *Taiwan Jih Pao* makes clear, he is not totally forgotten. It reports that a certain youngster name Liu, who was an honor student in high school, scored poorly on the national college entrance examination. However, his neighbor, a girl named Teng, who was a mediocre student, obtained the highest honors after her

mother appealed to Wen Ch'ang Ta Ti. Modern students have been known also to stick paper images of K'uei Hsing in their pockets as talismans before taking important examinations.

According to historical records on Taiwan, the educated elite used to celebrate K'uei Hsing's birthday (seventh day of the seventh lunar month) with feasts complete with banquets, theatrical performances, and animal sacrifices. The selection of the head of a sheep and some crab for sacrifice is an illustration of scholars' fondness for punning. The expression *"chieh yuan"* means: first on the list for the second official degree. Because *"chieh"* is formed by combining the words sheep and horn, and because the shape of the character *"yuan"* resembles a crab, the scholars could placate the gods, remind themselves of an academic and career goal, and enjoy delicacies at the same time.

During the feast, it was customary to play a game called "Seeking the Imperial Examination." Dragon eyes (a fruit similar to litchi), hazelnuts, and peanuts were used to represent the first, second, and third places on the examination. The three would be tossed on the banquet table and whomever the dragon eye rolled towards was considered to have gained the first place. The hazelnut represented the second place and the peanut the third. The game was played until everyone at the table obtained at least one examination honor. At the conclusion of the feast, firecrackers were exploded and spirit money and a paper and paste image of K'uei Hsing was burned.[163]

157. Stevens, *Chinese Gods*, p. 105.
158. Chu, *Birthday Listing of Gods*, p. 134.
159. Werner, *A Dictionary of Chinese Mythology*, p. 555.
160. Shen, *Introduction to Chinese Gods*, p. 79.
161. Ibid., p. 79.
162. Ibid., p. 79.
163. Chu, *Birthday Listing of Gods*, p. 134.

HSUAN T'IEN SHANG TI

In December 1976, I accompanied Gary Seaman, an American scholar, to a *paipai* and a mass fire-walking ceremony at Shou Tien Kung in Sung Po *Ts'un*, Ming Chien, Nantou *Hsien*. Shou Tien Kung is the most important temple of the Hsuan Tien Shang Ti cult.

The mass fire-walking was one of a series of events celebrating the three and half year construction of the new temple dedicated to Hsuan Tien Shang Ti. This new temple was the last in a series that began in a grass hut over 300 years earlier. According to a legend, four pioneers from Fuchien: Li, Chen, Hsieh, and Liu, brought a Hsuan Tien Shang Ti statue with them and placed it in a makeshift hut. As the statue miraculously glowed nightly, they solicited funds to build a proper temple for this obviously potent image.[164]

Hsuan Tien Shang Ti, who is also known as Shang Ti Yeh, Chen Wu, and Pei Chi Ta Ti, is thought by some to be the reincarnation of Yuan Shih Tien Tsun, the first person of the Taoist Trinity. Other theories hold that he is the personification of the polestar or K'ai Hsin Tsun Che of the Eighteen Lohan.

Elaborate preparations were put in place for the December ceremony. Police devised and publicized new traffic patterns and parking regulations for the small village. Roads were temporarily designated one-way to facilitate flow, and parking was curtailed. Tour buses, after discharging passengers, were directed to remote staging areas to wait until police permitted them to return and collect their passengers. As we traveled tandem on Seaman's motorcycle, such traffic restrictions did not concern us.

A local carver who specialized in fashioning sedan chairs for god statues had invited my friend to the blessing of one of his creations. He lived alone in a small two room, thatched cottage: one room for a kitchen and one for carpentry. Boards stretched across the ceiling joists sufficed for sleeping. He proved to be a gracious host, cooking our evening meal himself: stewed fish, rice, cabbage, and Shaohsing wine.

A *tangki* performed the sedan chair blessing and climaxed the ceremony by slicing his protruding tongue with a Taoist sword. With his tongue as instrument and his blood as ink, the *tangki* wrote charms on each of the chair's arms.

Shortly after our visit, Shou Tien Kung was to become a household name, absorbing the attention of the provincial and national governments, religious sects, the academic community, the media, and the general public for months. It is not an exaggeration to claim that the tragedy discovered on the evening of March 7, 1977 at Shou Tien Kung and the ensuing scandal was one of the biggest news stories of 1977.

The facts of the case were never in dispute. Shou Ming T'ang General Manager, Huang Yun Chi, ordered three men, a *thangki* and two assistants from Erh Shui in Changhua, to perform a *Ta Tso* (meditation). The meditation was to last nine days in a small, windowless room (6ft. x 6ft.) on the third floor of Shou Tien Kung. A small opening in the door served for ventilation and for the meals consisting of water and fruit. Cooked food was prohibited.

The *Ta Tso* began on February 27, 1977. Within a day and a half, groans were heard coming from the room. Shou Tien Kung officials sought permission from Huang to open the door and check on the three

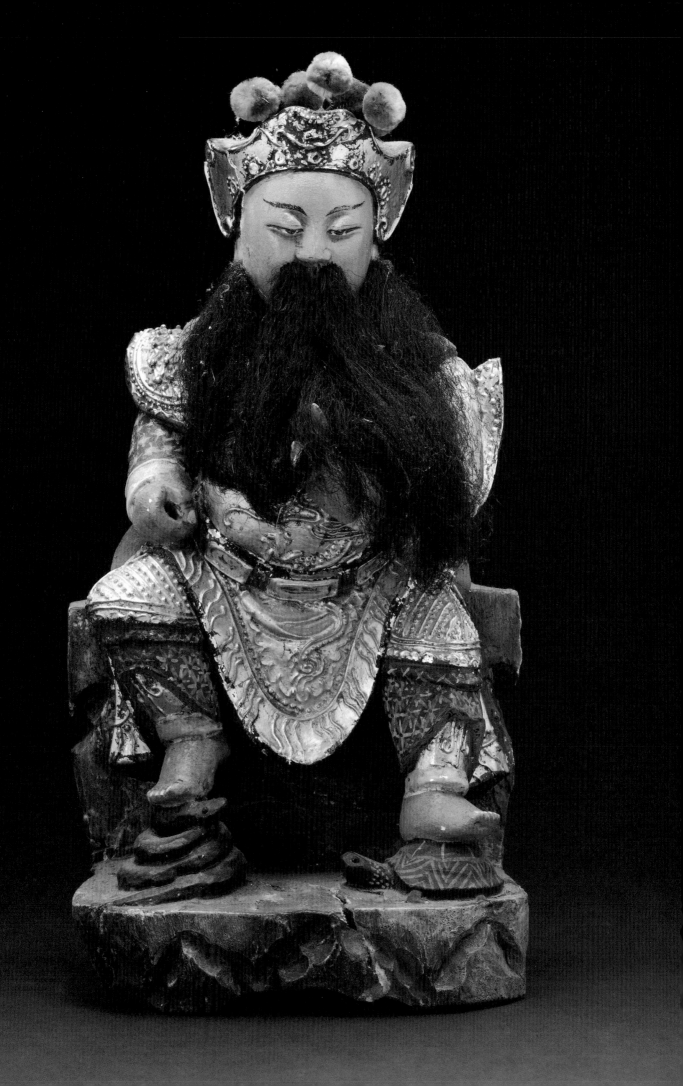

←Figure 85
Hsuan T'ien Shang Ti. The object of
a powerful cult, he is always depicted
with bare feet resting on a snake and
a turtle. The unfortunate suffocation
of three cult members at Shou T'ien
Kung, his main temple, during an
extended meditation, caused a
national uproar and a reexamination
of religious practices. Height 29cm.

玄天上帝為民間信仰中的重要神祇，總
是被描繪成赤腳踩龜蛇的模樣。供奉玄
天上帝的受天宮曾發生三名信徒在打坐
期間窒息死亡的慘劇，此事件引起全國
嘩然，也促使人們重新思考宗教活動的
合宜性。像高29公分。

Figure 86
Anti-superstition pamphlet issued by
the Provincial Government after the
Shou T'ien Kung tragedy.
Size 19 by 13cm.

受天宮悲劇發生後，地方政府所發行的
反迷信宣傳手冊。19×13公分

men. Huang refused, arguing that it would disrupt the meditation. From that time on, water and fruit placed by the door remained untouched. Within a few days, an unpleasant odor was detected. Despite these indications and pleas from the temple officials, Huang insisted that the door not be opened until "the time is up." On the night of March 7, when the *Ta Tso* was completed, the door was opened and the three discovered dead. Police were called and an investigation initiated.

The story became headline news in every major daily, with over sixty stories appearing within four days of the event. Elected representatives demanded Governor Hsieh Tung Min take action to prevent "superstitious" activities. For the next several months, while the investigation continued, editorial writers and media commentators demanded the government rid the society of superstition. Elected officials who attended *paipai*s or burned incense at temples were labeled idolaters by the press. The Provincial Government, in cooperation with the Education and Information Ministries, announced they were seeking examples of superstitious exploitation to include in a publication explaining, "how superstition harms people" (fig. 86).

A trial was held in the Taichung District Court, and on May 21st, the five most concerned with the affair were sentenced to prison terms ranging from a few months to several years. In August, the Nantou government concluded that the deaths were the result of poor temple management and directed the temple to replace those responsible officials. Indignant letters to editors appeared sporadically for the next two months. In October, *United Daily News* ran a lengthy four-part commentary by Academia Sinica's Li Yi Yuan entitled "Religion and Superstition." Li acknowledged the government's difficulty in determining what is religion and what is superstition. Some acts Li wrote are obviously superstitious. He cited the examples of a taxi driver hoping to avoid accidents by hanging a pouch of incense ash from a Matsu temple on his rear view mirror; and, a lazy government official expecting a rapid rise in his or her career by relying on fortunetellers or *feng shui* experts. Driving carefully and working diligently, not superstitious practices, are what are required, he noted.

The vexing problem of how to prevent the fervent faithful from going beyond official dogma or custom, resulting in worship spilling over into superstitious behavior, is one bedeviling every world religion. Statues of saints decorating Roman Catholic churches are representations of exceptionally holy people who may be able to intercede for the living in a spiritual way. Nevertheless, in some areas, the wooden or plaster statues are worshiped as if the images themselves possessed power. The church officially frowns on this but is helpless to eradicate such superstition. Similar examples could be given for other religions.

Li implied that social problems could not always be solved by the wave of a magic government wand. Although Taiwan in the 1970s was making rapid strides in technology and modern science, it still had a sizable population with six years or less of schooling. He pointed to societal expectation gaps between highly educated and poorly educated, and between rural and city dwellers. When modern society produces many uncertainties

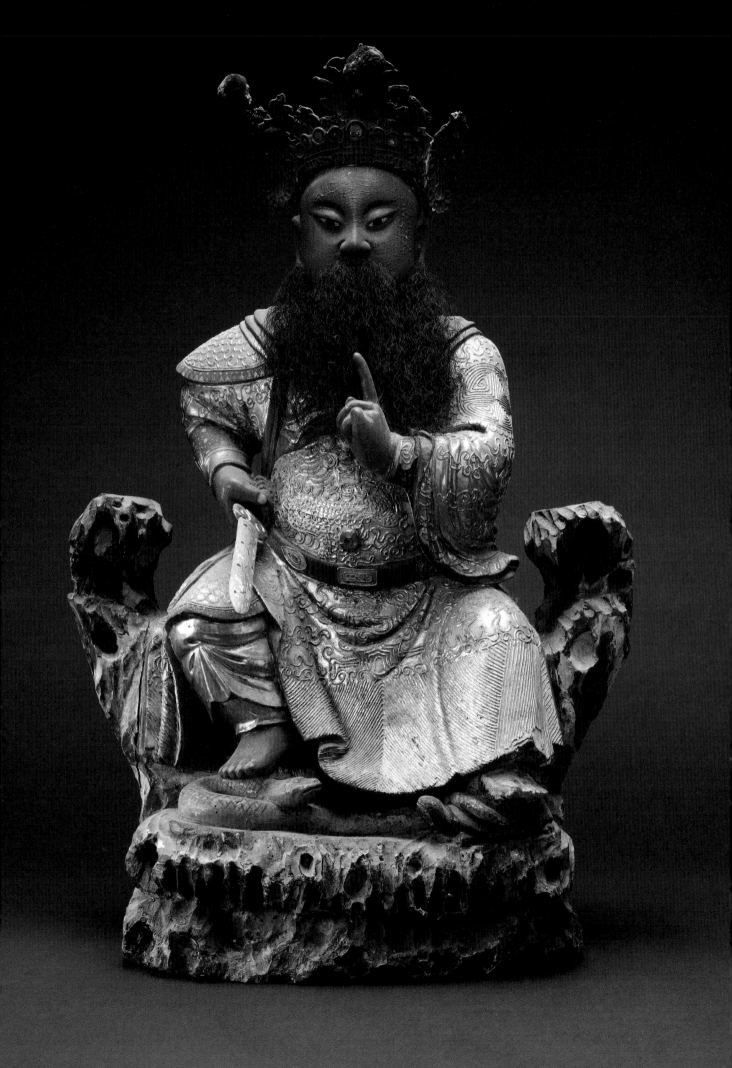

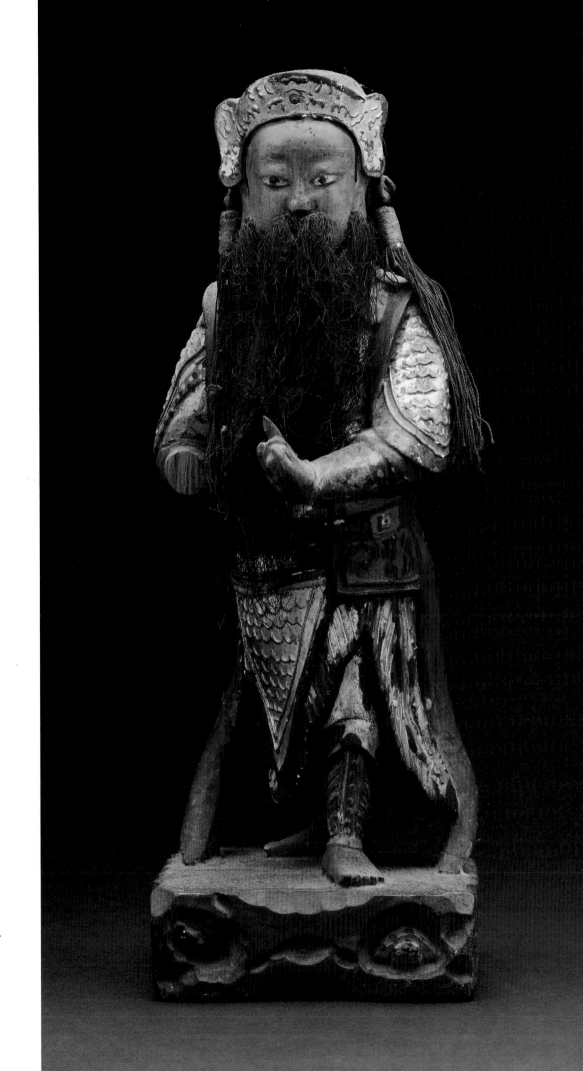

←Figure 87
Hsuan T'ien Shang Ti.
Height 53cm.

玄天上帝像，高53公分。

→Figure 88
Standing Hsuan T'ien Shang Ti.
Height 29cm.

玄天上帝立像，高29公分。

and even intellectuals are often depressed and anxious about their future, how, Li wonders, can we blame the less educated who seek answers from a Taoist priest or a *tangki*?

Although Li stressed that education is the key to eradicating superstitious behavior, he ended his series with a cautionary, almost pessimistic note. He quotes psychologist Yang Kuo Shu who condemned current teaching, which he claimed fostered "failed intelligence: education which requires memorization only, not analysis." Yang characterizes typical teachers as ones who admonish the students: "Be quiet and do not ask questions. I am the teacher. If you speak again, I will punish you."

There are over 250 temples dedicated to Hsuan Tien Shang Ti, most of which are located in central and southern Taiwan. Considered a *wu* (martial) god, his numerous intermediaries invariably turn violent and flagellate themselves when entranced. When revived, these self-inflicted wounds caused by beatings with spiked balls (fig. 93), piercing of cheeks, and slicing of tongues more often than not appear to cause neither permanent physical damage, nor pain. The effect of such phenomena naturally serves to increase faith in his power and deflate skeptics.

Hsuan Tien Shang Ti's statues are among the most easily recognizable. His bare feet invariably rest one on a turtle and one on a snake. Variations of his legend abound. One claims that at the request of the Jade Emperor, he fought the Demon King, whose armies were ravaging the universe. The Demon King conjured up a gray tortoise and a monstrous serpent as his allies in battle but to little avail, as Hsuan Tien Shang Ti eventually subdued them. The two defeated beasts then became his servants.

Popular legends agree that, in life, he was a butcher who came to regret killing innocent animals but differ on the subsequent particulars of the story. One holds that to atone for so many killings, he determined to throw his knife into the water. However, fearing some might step on it and injure themselves, he decided the only safe place to bury it was in his own chest. Buddha, in recognition of his selfless act, dubbed him K'ai Hsin Tsun Che and enshrined him as one of the Eighteen Lohans.

On Taiwan, followers of his cult believe Kuan Yin appeared to him and admonished him for following such a bloody profession. To expiate his former sins, he cut out his intestines and stomach with his butcher's knife. Upon touching the ground, his stomach was transformed into a tortoise and his intestines into a snake. He ascended to Heaven with both beasts who became his faithful servants. In a slightly different version, the snake and tortoise remained after he ascended. When reports of havoc wreaked by the pair reached Heaven, he returned to subdue them.

The story is told that Chu Hung Wu, while leading an uprising against the Mongol Yuan Dynasty, was once given refuge in a Hsuan Tien Shang Ti temple. When the Yuan were finally overthrown, Hsuan Tien Shang Ti was recognized as intervening on the side of the Ming, and worship to him increased.[165] Some like to think the god is biased towards Taiwan, because the island was the last Ming outpost in the struggle against the Manchu Ch'ing.

164. *Taiwan Daily News*, March 2, 1976.
165. Wu, *Taiwan's Folk Culture*, p. 65.

WANG YEH

Ch'ien Sui Yeh, commonly called Wang Yeh, is a generic name for a class of deities traditionally worshiped as plague gods by coastal Fuchienese and Taiwanese in particular.

There are numerous and conflicting legends about the original Wang Yeh, but there is a common theme running through all these stories: the gods were scholars/mandarins who died untimely deaths. The number and names are not fixed. As many as 360 have been mentioned in legends, but five is a common temple grouping. Most are worshiped singly. A study during the Japanese occupation of Taiwan found 132 different Wang Yeh surnames. An accurate count of Wang Yeh temples on Taiwan is impossible as not all are registered, but most authorities place the total at over 700. One reason advanced for the abundance of temples on the island, especially Wang Yeh temples, is that government control during the late Ming and early Ch'ing was weak and sporadic. Many temples began as simple thatched shelters housing one statue. If the statue proved efficacious, a proper edifice would be built.

In the most popular legend, Emperor T'ai Tsung of the T'ang Dynasty employed a number of scholars to test the magic of the Taoist patriarch, Chang Tien Shih. The emperor ordered the scholars to hide themselves with their musical instruments in the basement under the imperial banquet hall. During the feast in honor of Chang, the emperor secretly signaled the scholars to play. He then asked Chang if monsters caused the sudden commotion. The Taoist gave no answer but, with his magic sword, traced a diagram on the floor. The music ceased immediately. Upon investigation below, the scholars all were found dead much to the distress of the emperor. To atone for his imprudent jest, the emperor ordered massive sacrifices for their souls throughout the land and entitled them as Wang Yeh.

Another version concerns the journey of five scholars named Ch'ih, Li, Chu, Hsing, and Chin to the capital city for the imperial examination. While stopping at an inn, they witnessed evil spirits poisoning the community well. In order to prevent others from drinking this now toxic water, they threw themselves, one after another, into the well. In appreciation, the local people worshiped them as deities. A third story, with a patriotic twist, holds that 360 scholars, loyal to the Ming, committed suicide rather than serve the victorious Ch'ing.

When pestilence or calamity befalls a community, it often is attributed to powerful and malevolent demons. To rid the area of disaster, a handsome and sturdy boat is built. In it are placed statues of one or more Wang Yeh, incense, and a quantity of food. The craft is then towed out to sea and set adrift with the current, taking with it the evil influences of the offending spirits. According to this theory, wherever the ship beaches, pestilence will follow. In order to placate these guest spirits, the inhabitants erect a temple and offer sacrifices. As the current frequently carried these Wang Yeh ships to Taiwan, temples to them dot the southern coastal landscape. They are rarely found in northern Taiwan. A variant of the custom is to set the boat on fire, carrying the evil influence aloft with the smoke. Such vessels can be

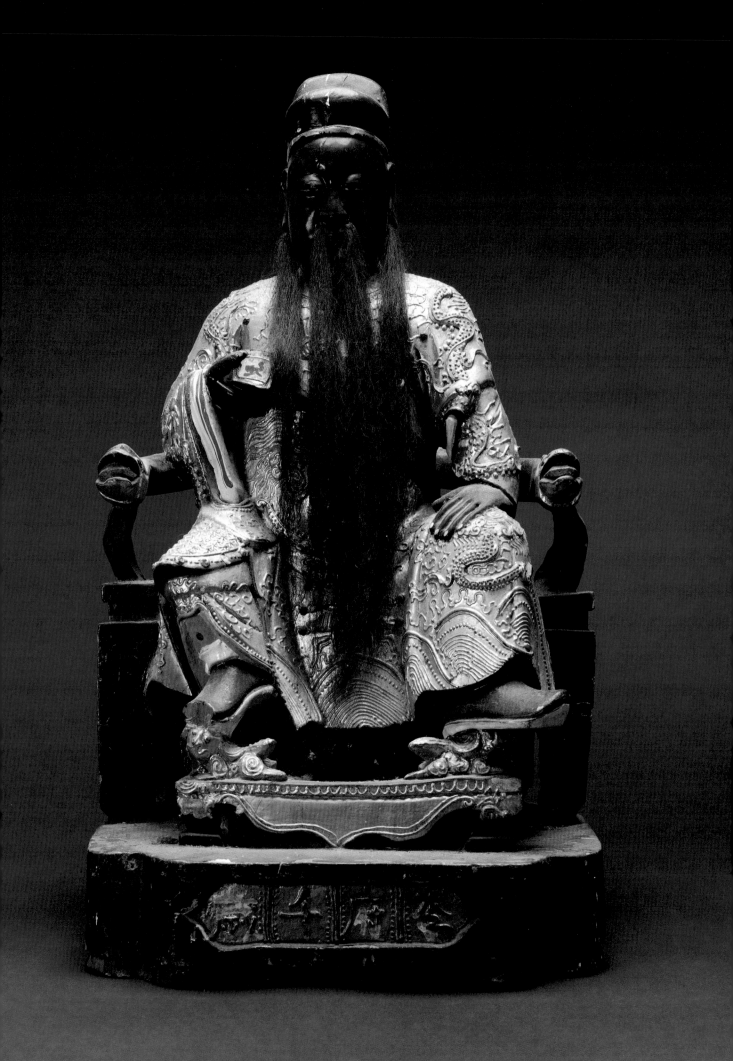

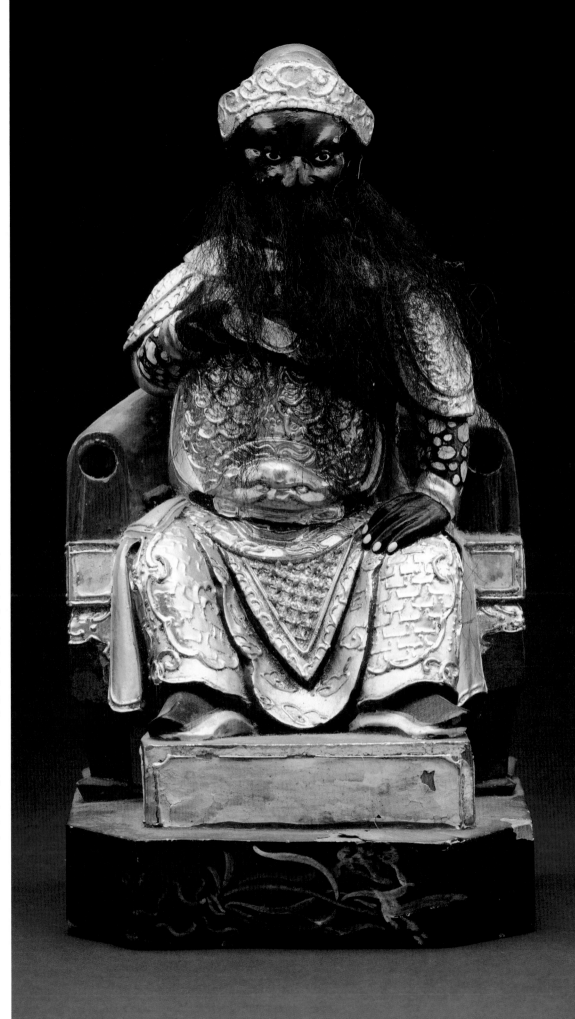

←Figure 89
Wang Yeh, the title given to a group of scholars/musicians who died as the result of an emperor's jest. Along Taiwan's coastal areas, they are worshiped as plague gods. However, the title is a generic one that can be applied to any deified local worthy. Festivals to these gods often turn bloody as entranced adherents flagellate or otherwise abuse their flesh.
Height 47cm.

王爺原指一群受皇帝冤枉而死的讀書人／音樂家，在台灣的沿海地區也被敬為瘟神。然而，這個稱呼也廣泛運用在被神化的地方人物身上。這些神祇的慶典通常十分血腥，入神狀態下的信徒會鞭笞或虐打自己的肉體。
像高47公分。

→Figure 90
Wang Yeh. Height 27cm.

王爺像，高27公分。

either small models or full-size ocean-going crafts.

The largest and the most famous Wang Yeh temple, not suprisingly, is located where a ship set adrift from Fuchien found shore. Facing the Taiwan Strait in the northwest corner of Tainan Hsien is the Tai Tien Fu temple, sometimes called Nan K'un Shen. The story is told of fishermen in the first year of the K'ang Hsi reign (1662) that were spending the night in makeshift reed huts being amazed by the sight of an elegant ship with three tall masts sailing towards shore. In the morning when they awoke, tall masts were nowhere in sight. All they found was a small, dilapidated craft beached in the sand.

On boarding, they found five Wang Yeh statues and an image of a military aide. The five Wang Yeh were identified as: Li, Chih, Wu, Chu, and Fan, five of the scholar-musicians slain by Chang Tien Shih's magic. They deduced the ship, with its celestial cargo, had been launched from Fuchien after religious rites of propitiation. After deliberation, it was agreed that such a concentration of spiritual power landing figuratively in their laps must be a good omen and bode well for the future. They built a humble thatched shrine and burned incense to assuage the gods. From that time on, their ships always returned overburdened with fish. Wishing to build a proper temple, they sought unsuccessfully to raise funds. Disheartened, the fishermen decided to send the ship off again on another leg of its journey. It set sail, but miraculously circled and returned to the same spot, an indication that the gods were pleased and did not wish to leave.[166]

Word of the return spread, and worshipers and petitioners flocked to burn incense before the five gods. Money was easily and quickly collected, and a proper temple was built. Over the years, prayers were offered, petitions made, favors granted, and the temple renovated and enlarged several times. Mo Chen Li, writing in the April 19, 1978 issue of *Min Tsu Wan Pao*, credits Tai Tien Fu's influence and that of various religious practitioners, such as *fa shih*s (priests) and *tangki*s, in transforming the reputation of Wang Yeh. He surmises that previously, the faithful only beseeched Wang Yeh to spare them from plagues and other calamities and to be "not too hard on them" generally. Now they are solicited for succor by seafarers, the sick, businessmen, and others with special requests.

"In 1970, the Provincial Government designated Tai Tien Fu's nineteen-hectare complex a "Provincial Tourist Center" in recognition of the facility's contributions to tourism (pilgrim hostel, dining halls, auditorium, opera stage, gardens, reflecting pools, and baseball fields).

Not all Wang Yehs are plague gods, and not all plague gods are Wang Yehs. Many Wang Yehs are deified local heroes or personages whose reputation and worship is unknown beyond a circle of villages influenced by a nearby temple. One exceptional example is the deity (fig. 92) enshrined at the Fu An Kung in the small village of Fu Lai *Ts'un*, Tung Shih *Hsiang*, Chiayi. Under the headline: "Worship of a Foreign Statue Stimulates a Local Debate," *China Daily News* (April 23, 1977) introduced this purely local god, known as Japanese Wang Yeh, to the country at large.

During life, Morikawa Seijiro (Sen Ch'uan in Chinese) was a police officer assigned to the area. He was unwilling to carry out an order to squeeze more money from his impoverished charges. Unable to disobey the command of his superiors, he shot himself in front of the temple's altar. When a contagious disease threatened the area, Morikawa appeared to the village leader in a dream, alerting him to the potential devastation.[167] The villagers, grateful for this warning and for his sacrificial act of defiance, carved a statue of him in a police uniform and venerated it as the Japanese Wang Yeh. Decades later in 1977, some, while not disputing his virtue and commitment to the people, questioned the propriety of a foreigner becoming a Chinese deity.

Statues of wives or concubines also are carved, often for particularly loved or efficacious deities.

→Figure 91
Wang Yeh. Height 41cm.

王爺像，高41公分。

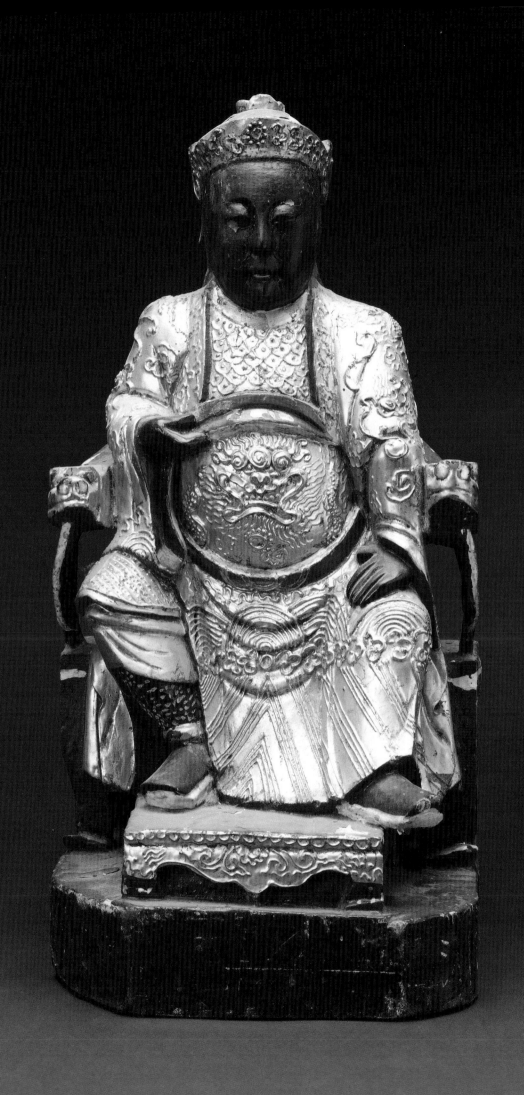

Figure 92. A Japanese policeman deified as a Wang Yeh.

被神化成王爺的一名日本警察像。

Wang Yehs are no exception, and in his book on the gods of Taiwan, Chung Hua Tsao identifies the following pairings: Chang Sai Hua accompanies Chih Wang Yeh; Lin Ts'ai Chih is Chu Wang Yeh's concubine; and Hsieh Yu Lan is Li Wang Yeh's secondary wife.[168]

Conspicuous at birthday celebrations and other rites to powerful deities of popular religion, such as Wang Yeh, are a number of *tangki*s who act as go-betweens or interpreters for the gods. These intermediaries, chosen often against their will by the gods during séances or dreams, become the link between the deity and the village. As those picked are usually from amongst the poorest or least educated, their selection gives them status and catapults them into positions of influence.

In the wake of the Shou Tien Kung tragedy, where three died during a *Ta Tso* meditation, public interest was heightened in the role *tangki*s play. A literal avalanche of press and magazine articles, many inspired by academics, sought to enlighten the public about the dangers of superstition. While being careful not to ridicule religion or religious practices, the thrust of the articles was that shamans and *tangki*s were "rascals" out to fleece the devout.

Tai Chi Hsiung, Director of the Taichung Lifeline Association, was among the many such crusaders. He set about to discover what he later called "The *Tangki*'s Mysteries" in a July 30, 1977 *Central Daily News* article.

After a four-month search, Tai claimed to have found two "retired *tangki*s" willing to talk about their former careers. His first informant was a seventy-two year old man who had practiced for fifty years. Although *tangki*s must vow to keep secret all relating to the practice, he did not feel bound by that oath, because he no longer believed. The second man, who practiced for forty years, gave up when modern medicine cured his severe illness after religious treatment failed. The two told Mr. Tai that it is important that an aspirant be susceptible to suggestion and be easily led.

The rice bowl ritual begins the process. Here, one kneels before three bowls and selects one. Under each is written one of the following three fates: "Five Thunder Bombardment," "Lonely throughout life," and "Meet with cruel and unlooked for misfortune." A master assists him in performing a "Selection by the God" drama. The writing of charms, wielding of swords, and magical rites are taught. Long hours are spent perfecting flagellation techniques, so that one can safely draw blood without cutting muscles. Enough potent liquor sprayed or spit on the wound by an assistant prevents infection.

Before becoming a full-fledged *tangki*, one must walk over hot coals. The purpose is to convince spectators that the deity in question is protecting the walker. The secret, according to Mr. Tai's informants, is to wait until gray ash covers the pit and sufficient quantities of salt are poured on the smoldering path. Finally, one must submit to a seven-day *Ta Tso* (the now infamous meditation in a sealed room with only water and fruit which resulted in the unfortunate Shou Tien Kung deaths).

There is no reason to question Mr. Tai's informants' honesty, but with probably over 1,000 *tangki*s on Taiwan, it is doubtful that every one is initiated in such a fashion or undergoes any training at all. The best undoubtedly are skilled tricksters, but others do, from time to time, burn their feet or suffer physically from their bloody excesses.

Almost all Wang Yeh carvings depict an official of severe countenance dressed in mandarin robes and sitting on a throne. Headgear offers no clue to identity as a variety are worn (two or more statues of the same Wang Yeh will sometimes be carved with different hats). Wang Yeh may have a full beard or may be clean shaven. The face can be flesh colored, brown, black, or decorated with tattoo marks. (Ch'ih Wang Yeh always is depicted with a black face, the result of the poisoned well water). Legs are spread wide, and the right knee is elevated slightly. Feet often rest on animals serving as footstools,

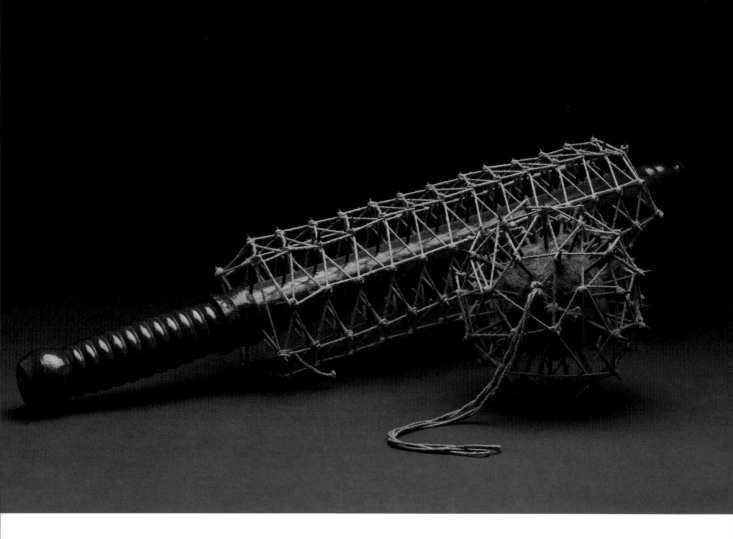

symbols of their subservience. The left hand is often resting on the left knee, while the right either clutches a wide belt or is thrust forward. While woodcarvers often copy existing statues, Keith Stevens has found that sometimes iconographic features are agreed upon by the local temple committee, who have often requested the specific deity's opinion by spirit communication using divining blocks. Not all gods thus carved are Wang Yeh. Koxinga, Kuan Kung, and Fa Chu Kung, among others, have similar characteristics.

Figure 93
Flogging instruments.
Length 61cm (longest).

鞭笞器具，最長處61公分。

166. "Tainan Hsien's Nan K'un Shen Temple," *Hsin Sheng Daily News*, June 3, 1977.
167. Stevens, *Chinese Gods*, p. 165.
168. Chung, *The Origins of Taiwan's Local Gods*, p. 355.

WU YING SHEN

In rural areas of southern Taiwan, the belief is strong that the boundaries of each village are manned by spiritual soldiers tasked with defending the inhabitants against supernatural warriors who intend to harm.[169]

During certain purification rituals, each of the five directions (north, south, east, west, and center) is marked with a flag to indicate the headquarters of a commander. Taoist priests officiating in the main temple will worship these five commanders, called Wu Ying Shen (Five Camp Gods) in addition to the main deities resident there. To rid the area of whatever evil has befallen it, sutras will be chanted, spirit generals invoked, and malevolent influences exorcised.

At other times during the year, these forts are not ignored because their soldiers, like their temporal counterparts, require provisions on a continuing basis. Sacrifices of food are made periodically, and incense is offered in a simple rite performed usually by a village family on a rotational basis. When the soldiers have eaten the essence of the meal offered, spirit money is burned for their use, and the food is returned to the household to be consumed by the family whose lot it was to feed the soldiers.[170]

E. T. C. Werner writes that from early times, Chinese used the spiritual forces of metal, wood, water, fire, and earth to indicate the four cardinal points and the center. Later, Taoists invested these spirits with jurisdiction of the five cardinal points.[171]

Statues are never carved for the five commanders, a flag or a stick being sufficient to symbolize headquarters. Occasionally in rural temples, one finds five different colored flags displayed to indicate the presence in the area of these commanders. Less frequently, carved heads stuck on sticks referred to as the Wu Ying Tou (Five Camp Heads) represent the five commanders. Tradition has it that the captain commanding the central fort is Chung T'an Yuan Shuai (Li Na Cha).[172]

At a *paipai* parade, one may spot a *tangki* marching with cheeks pierced by long needles, with no apparent discomfort, ahead of a god's palanquin. For added emphasis, the *tangki* may stick a captain's head such as one pictured here onto the end of a needle before stabbing it through his cheeks. Twice in southern Taiwan I have observed marchers embellished in such a fashion.

169. Jordan, *Gods,Ghosts, and Ancestors*, p. 51.
170. Ibid., p. 51.
171. Werner, *A Dictionary of Chinese Mythology*, p. 571.
172. Shen, *Introduction to Chinese Gods*, p. 188.

Figure 94

Spirit soldiers who defend the five directions (north, south, east, west, and center) of villages. During religious festivals, five flags are placed to represent the soldiers at sentry. Some villages signify their presence by a display of five heads in a temple. Height 32cm.

護衛各地五方（北、南、東、西、中央）的五營神將，祭典舉行時會升起五營令旗，用來代表軍營放哨，有些村莊則以五營首來表示。高 32 公分。

KUO SHENG WANG

郭聖王

Kuo Sheng Wang, also known as Kuang Tse Tsun Wang, Pao An Tsun Wang, and Sheng Wang Kung is one of the patrons of the Chuanchou immigrants, especially geomancers and pharmacists. There are at least thirty temples dedicated to him scattered throughout southern and central Taiwan in areas originally settled by Chuanchou immigrants. He is always depicted as a child with his right leg elevated in a playful pose.

According to a popular legend, he never attained adulthood, but ascended to Heaven as a boy. Kuo Ch'ien, his mortal name, was an orphan who worked as a shepherd for a rich miser named Ch'en in Chuanchou. Ch'en employed a geomancer to find an efficacious spot for his parents' grave. Relations with the geomancer soon soured for Ch'en was not only a tightwad, but a disagreeable boss who treated all in his employ with equal disdain. Despite their differences in age and station, the boy shepherd and the geomancer became fast friends. Ch'en surprised the geomancer one day by inviting him to dine on meat from a sheep his employer said was freshly slaughtered in his honor. Upon returning from the banquet, the geomancer told young Kuo that Ch'en had abandoned his former miserly way because he fed him such an extravagant dinner. Kuo felt compelled to inform him that the sheep in question earlier had fallen into a cesspool and drowned. The geomancer vomited immediately and vowed to revenge this insulting deception by never revealing the auspicious spot to Ch'en.

The geomancer decided instead to tell the secret of the lucky spot to young Kuo. He instructed Kuo to fetch his parents' bones that – as he was too poor to buy a proper burial plot – he had been keeping in a pot. Together they went to the sheep cote, which according to the geomancer's *feng shui* calculation, was the point of the "dragon's pulse." He then pounded the bones into bits and sprinkled them around that spot. He asked Kuo which fate he preferred: "Would you rather be an emperor and possess all you desired, or a god surrounded by incense forever?" Without hesitation, Kuo chose the latter. The geomancer then prophesized that soon countless poisonous black bees would swarm. When that happens, Kuo should run to where monks wear iron hats, buffalos ride on people, and fish grow on trees. He should then retire to a nearby mountain, sit on a rock, and wait to ascend to Heaven.

Within a short time, bees swarmed as foretold. Kuo escaped, but the miserly Ch'en was not so fortunate for he was stung to death. Kuo ran until it started to rain. An old monk covered his head with a metal begging bowl to protect him against the downpour, a cowherd hid under a water buffalo for shelter, and a fisherman retreated to a shady tree. In haste, his line, with a fish firmly hooked, was caught in the branches. Upon seeing all this, Kuo knew that he had come to the right place, so he climbed Feng *Shan*, a nearby mountain, and sat upon a rock. Within a short time, he ascended to Heaven. The local people, upon witnessing all these happenings, built a small temple in his honor and began to worship him.[173]

A second story believed by many faithful concerns a sickness that befell Ch'ing Emperor Yung Cheng when he was a young prince. A boy appeared to him in a dream and administered small pox medicine. In reply to the prince's query, the boy said his name was Kuo Ch'ien of Chuanchou. When the prince awoke,

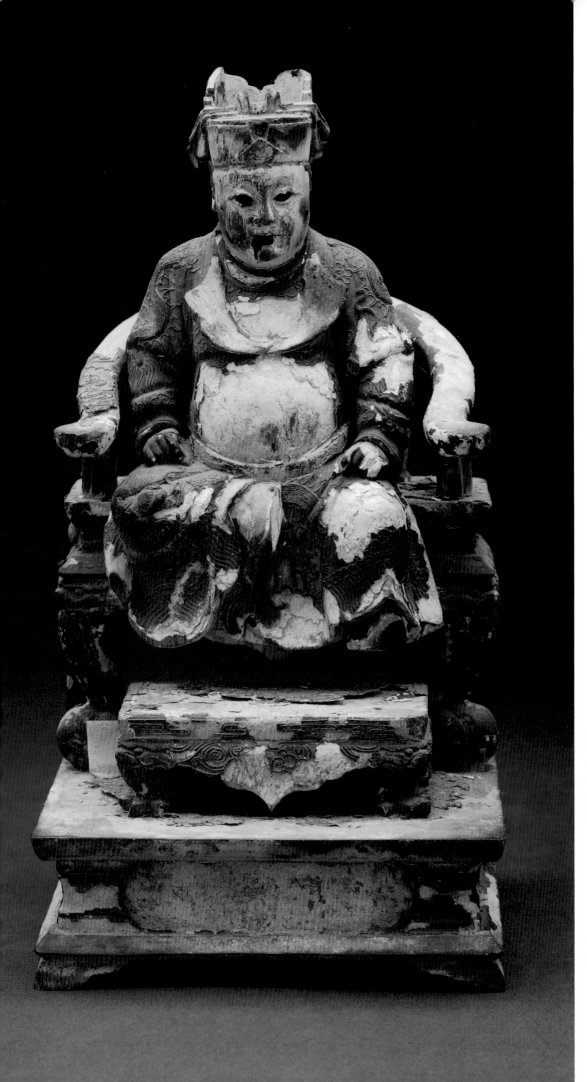

←Figure 95
Kuo Sheng Wang, a powerful
boy-god. He is a patron of
geomancers and pharmacists.
His cult is especially strong
among the descendants of
Chuanchou immigrants.
Height 18cm.

郭聖王，力量強大的男童神祇，
是風水師和藥師的守護神。郭聖
王的信仰在泉州籍移民之中尤
盛。像高18公分。

→Figure 96
Kuo Sheng Wang.
Height 18cm.

郭聖王像，高18公分。

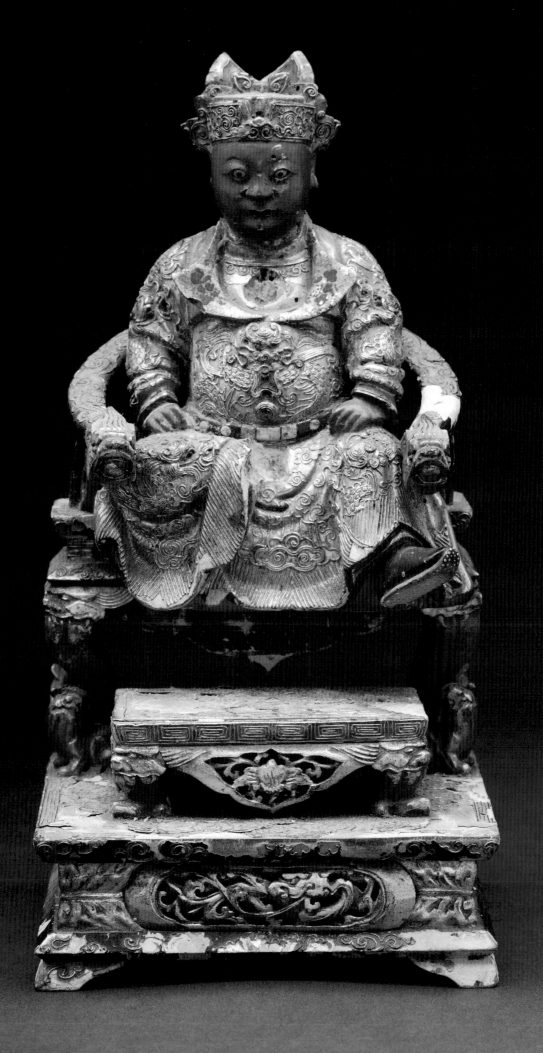

his sickness was gone. Emissaries were dispatched to Chuanchou to find Kuo Ch'ien. They learned that Kuo Ch'ien was the mortal name for the boy-god Kuo Sheng Wang of the Feng Shan Szu.[174]

Kuo Ch'ien appears in another version, but this time as a pious adult who strove only to serve the community. His mysterious disappearance one day set the neighbors on a search. They found him in a tree entranced in meditation. Their calling and shaking failed to wake him. After days, they deduced he had been miraculously transformed and took him, still warm with life, and placed him on a temple altar. In such a state, he was worshiped and petitioned and is credited with ending a drought. For his service to humanity, the Jade Emperor entitled him Kuang Tse Tsun Wang.[175]

Carvings of this god are uniform. He is depicted as a youth, dressed in robes and seated on a throne, with his right leg raised parallel to the ground at knee height with the sole of his right foot pointing towards his left knee, but not resting on it. The explanation for his unusual playful pose is that as he was seated on the rock, presumably in the lotus position anticipating death, his body began to stiffen. When he started to ascend, his master (his mother in another version), in an effort to prevent his departure, grabbed his left leg, thus pulling it straight.[176] Several temples celebrate his birthday on the twenty-second day of the second lunar month while others celebrate it on the twenty-second day of the eighth lunar month. The Feng Shan Szu in Yunlin's T'u K'u *Hsiang*, where members of the Kuo clan, descendants of Kuo Hung Fu, are numerous, celebrates both. Most temples to this boy-god are concentrated in Kaohsiung, Tainan, Pingtung, and Ilan. Hsi Lo Tien in Tainan City is considered the center of the Kuo Sheng Wang cult. It was founded in the fifty-fourth year of K'ang Hsi's reign (1716) when it received its incense from Feng Shan Szu in Chuanchou, Fuchien.

Although the boy-god is not popular in the north, I did stumble upon Wan Ying Tan, a small "god's altar" where he is enshrined. The popularity of "gods' altars" became an increasing concern of the government during the decade of the 1970s. Large temples are controlled by government regulations, whereas "gods' altars" at that time were unlicensed and unregulated. A "god's altar" could be set up in any house or apartment. When it became known that there was a powerful statue in someone's home, people in desperation would flock there seeking advice or cures. In 1978, *Taiwan Daily News* reported that such establishments mushroomed to 3,000 in Taipei City alone,[177] an excessive number considering Lin Heng Tao in his book lists only 135 registered temples in that metropolis.

Wan Ying Tan, located on Taipei's Ho P'ing Hsi Road, Second Section, is such a "god's altar" set up for commercial purposes. The owner, Huang Wan Men, a *fa shih* and a former conscript in the Japanese Army who saw service in the Philippines, charges for treating physical and mental ailments through charms and magical practices. His business card lists his expertise as: exorcising demons, repaying debts to a god, easing pregnancy, and curing children who cry in the night. Huang claims his clients include college graduates and Christians who seek his help after the modern methods they sought failed.

Kuo Sheng Wang ascended to Heaven as an unmarried teenager. Nevertheless, the twenty-second day of the first lunar month is designated as his wife's birthday. His wife was either a post-ascension phenomenon or a celestial maiden deliberately planted on earth to marry him as villagers suggested to anthropologist Jordan, who recounts the tale in *Gods, Ghosts, and Ancestors*.[178]

173. Wu, *Taiwan's Folk Culture*, p. 75.
174. Liao, *Mythology of Taiwan*, p. 85.
175. Chung, *The Origins of Taiwan's Local Gods*, p. 222.
176. Stevens, *Chinese Gods*, p. 74.
177. "In The Future God Altars Must Be Registered," *Taiwan Daily News*, August 11, 1978.
178. Jordan, *Gods, Ghosts, and Ancestors*, p. 43.

FA CHU KUNG

法主公

All of the Fa Chu Kung legends agree that he was a man named Chang who lived in An Hsi, Fuchien Province, during the Sung Dynasty. Together with his two sworn brothers named Hsiao and Hung, he slew a snake monster with three tails, a powerful spirit capable of transforming itself into human form. In the course of the battle, which took place in the Stone Ox Cave near the Nine Dragon Pond, Chang had his face blackened by the hot breath of the snake. Hsiao, while violently wielding his ax, cut Hung's forehead by mistake. This accident so upset Hsiao that his face turned red. That is why Fa Chu Kung temples usually display three statues: one with a black face, one with a red face, and one with a scarred forehead.[179]

The snake was killed, but the bloody battle cost Chang, Hsiao, and Hung their lives. Anxious villagers waiting outside the cave saw thick black smoke spiral up to Heaven at the conclusion of the fight. As their bodies were never found, the villagers understood the smoke to be the spirits of their deliverers. In thanksgiving, they set up an altar and began to worship the three.[180]

In one variation, the snake he killed had been demanding a young boy or girl each year as human sacrifices. In another, he perceived that an approaching wedding sedan carried a snake spirit disguised as the bride. With an extended arm, he halted the procession and exposed the bride as the thousand year old snake that had been troubling the area. Thus discovered, the snake fled to a nearby well where Fa Chu Kung slew it. In still another version, he forged, without benefit of fire, a four-foot long iron pole for dispatching evil snakes and other demons. He thrust it Excalibur-like into a rock where it remained undisturbed by other warriors, for only he could pull it from its stony sheath.[181]

In 1879, there was a citywide plague in Taipei. People living in the Yen P'ing District prayed for deliverance to a Fa Chu Kung statue on a private altar at Chen Nan Ch'a Hang, a local teashop. Because the arresting of the plague was credited to his intercession, Taipei tea merchants adopted him as their patron and raised money for construction of a suitable shrine for worship. Six years later, an impressive edifice was completed at the intersection of Yen P'ing Pei Road and Nan Ching Hsi Road and was named Fa Chu Kung Miao. The main statue was fashioned in Hsiamen (Amoy). A delegation of tea merchants took it from there to the Pi Ling Kung in An Hsi for an "open eyes" ceremony, to entwine incense and bring incense ash from the mother temple back to Taipei.

According to a government survey published in 1958, Fa Chu Kung Miao, only part of which is still standing as road construction claimed almost half of it during the Japanese occupation, is the only Taiwan temple dedicated to him.[182] Chung Hua Tsao, writing twenty-one years later in 1979, mentions other temples to him in Taichung, Changhua, and Tainan. Additionally, he cites two temples in Pu Tai *Hsiang*, Chiayi *Hsien*, that worship the Three Lords of the Nine Dragons, who in reality are Chang, Hsiao, and Hung.[183]

Pu Tai, on the windswept southwestern coast, has been traditionally one of Taiwan's poorest areas.

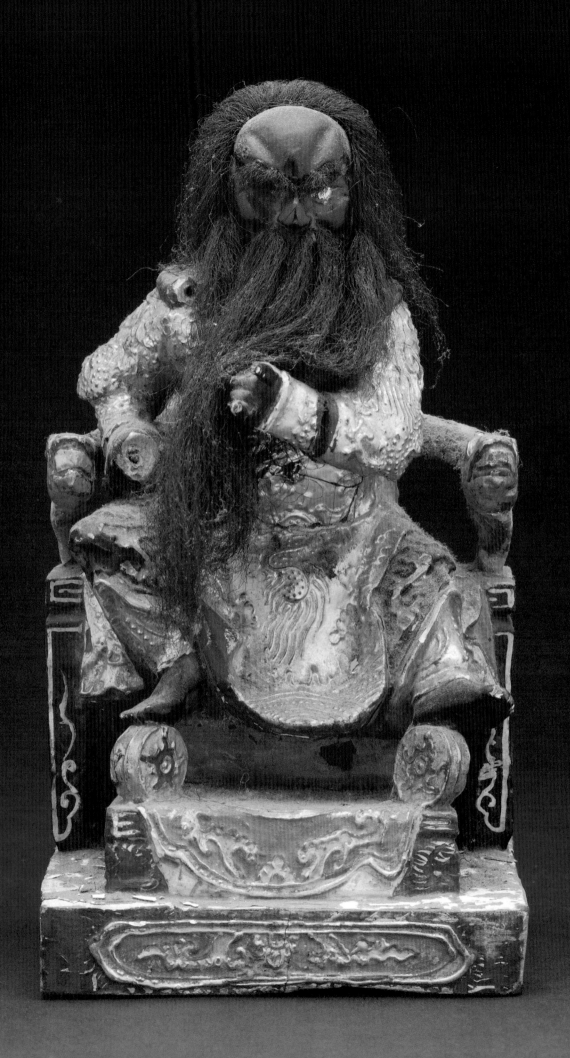

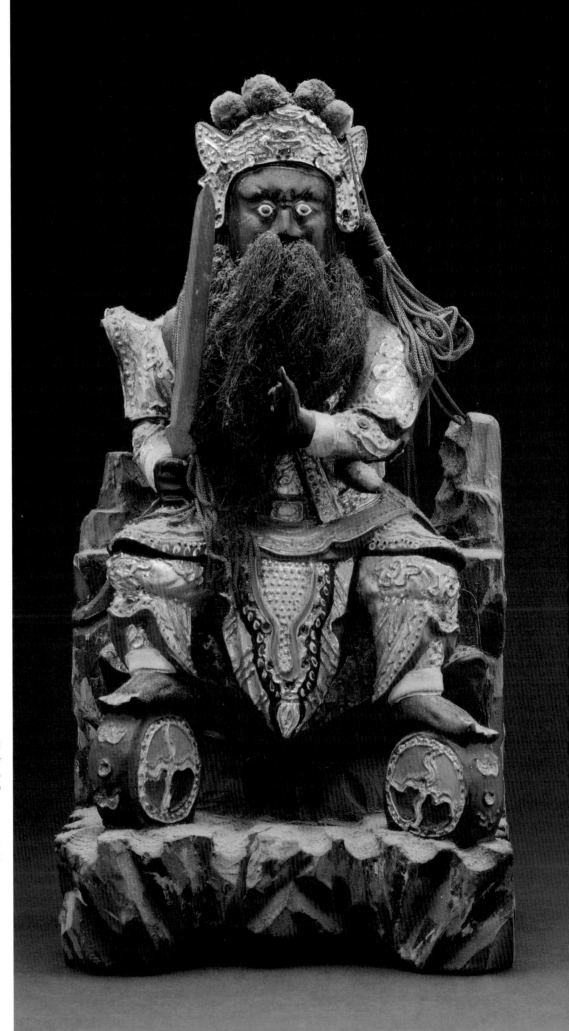

←Figure 97
Fa Chu Kung, who is always carved with the snake monster he slew draped around his neck. He is credited with arresting an 1879 plague in Taipei.
Height 20cm.

法主公，總是被描繪成把屠殺的蛇怪纏在脖上的模樣，相傳曾平服1879年侵襲台北的瘟疫。
高20公分。

→Figure 98
Fa Chu Kung. Height 27cm.

法主公像，高27公分。

Centuries of relentless salt-water breezes sweeping over the land have rendered it useless for anything but sea salt harvesting, which in the last century was its main industry. The two temples, in neighboring villages of Chiu Lung Li and Fu Hsing Li, just a few kilometers from each other, are a rarity in Taiwan for they not only worship the same gods (Three Lords of the Nine Dragons), but have the same temple name: Chiayi Miao.

Some, according to Liao Yu Wen, worship Fa Chu Kung under a variety of different titles such as Chang Sheng Chun, Tien Sheng Chun, and Chang Kung Fa Chu. He cites as an example the Sheng Min Tang in San Chi *Ts'un*, Wu Chieh *Hsiang*, Ilan, where the main god is entitled Chang En Chu. Despite disagreement by temple faithful there, Liao, analyzing the background and characteristics of each deity, concludes Chang En Chu and Fa Chu Kung are one in the same.[184] Whatever name he goes by, he is a favorite of Taoist priests who consider his spiritual magic powerful for expelling demons.[185]

Fa Chu Kung is carved with both feet resting on fire wheels and a red snake casually draped around his neck. He sits in a military position with two bulging eyes staring straight ahead. He can either be seen with or without a crown. If he wears one, it will be similar to that worn by "red head" Taoists. If hatless, his bushy hair will stick out wildly, adding to his terrifying appearance.

179. Liao, *Mythology of Taiwan*, p. 104.
180. Ibid., p. 103,106.
181. Shen, *Introduction to Chinese Gods*, p. 200.
182. Liao, *Mythology of Taiwan*, p. 106.
183. Chung, *The Origins of Taiwan's Local Gods*, p. 219.
184. Liao, *Mythology of Taiwan*, p. 106.
185. Chung, *The Origins of Taiwan's Local Gods*, p. 217.

CH'ENG HUANG YEH
(CITY GOD)

城隍爺

Figure 99
Niu T'ou (Cow Head) and Ma Mien (Horse Face). They, along with other assistants, often flank the Ch'eng Huang Yeh on the central altar in most City God temples.
Height 21cm (tallest).

牛頭馬面像經常出現在城隍廟的主祭壇上，和其他從祀隨侍在城隍爺兩側。
像最高21公分。

In ancient times, cities were protected from invaders and bandits by a wall and a moat. It was the magistrate's duty to keep these in good repair. In the spirit world, this responsibility falls on Ch'eng Huang Yeh, literally the Lord of the Walls and Moat. With the help of the Earth and Kitchen Gods, he maintains accurate accounts of all within his jurisdiction and upholds order among spirits. His temple, the other world equivalent of a magistrate's *yamen* (administrative offices), is the first stop on the way to Hell, the link between the *yin* and the *yang* worlds. Based on the information he has received from his various assistants, he has the right to suggest rewards for good deeds or punishments for evil behavior.

During the Three Kingdoms period (A.D. 222-265), Ch'eng Huang was already worshiped. During the

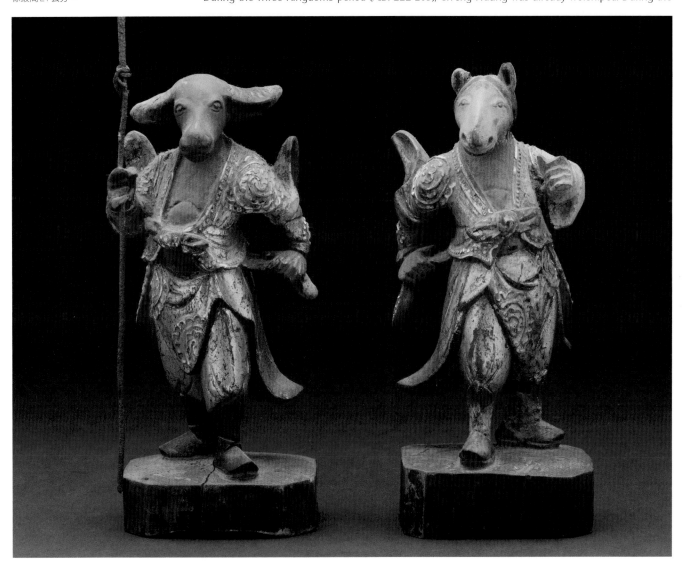

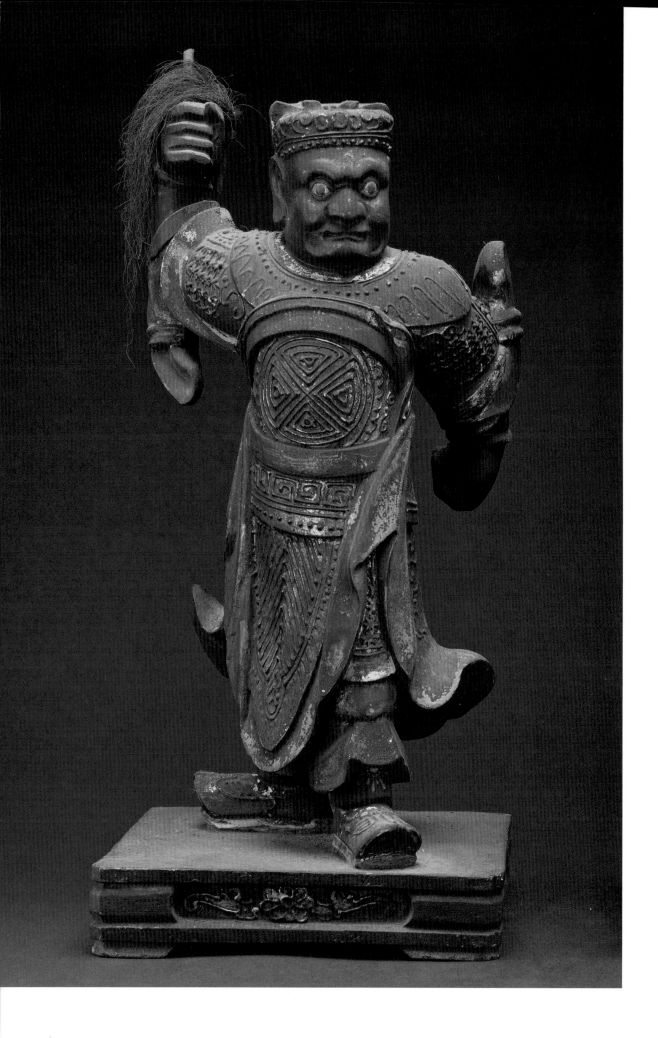

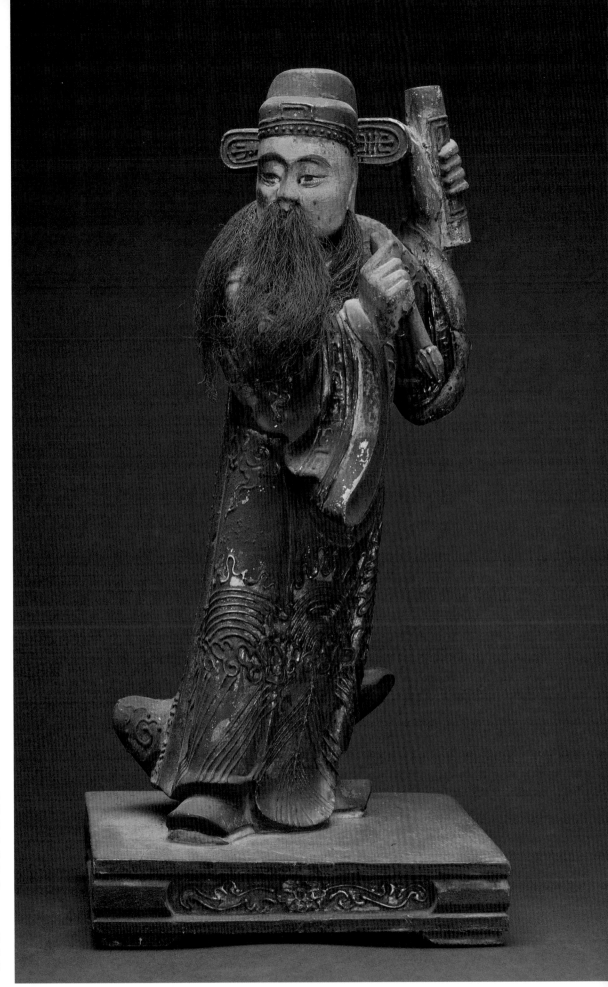

←→Figure 100
Wu P'an Kuan and Wen P'an Kuan, military and civil judges. They assist Ch'eng Huang Yeh in determining the disposition of departed souls in a district under his jurisdiction.
Height 34cm (tallest).

文武判官，即分掌文武的判官，祂們幫助城隍爺決定其管轄地人民死後的去向。像最高34公分。

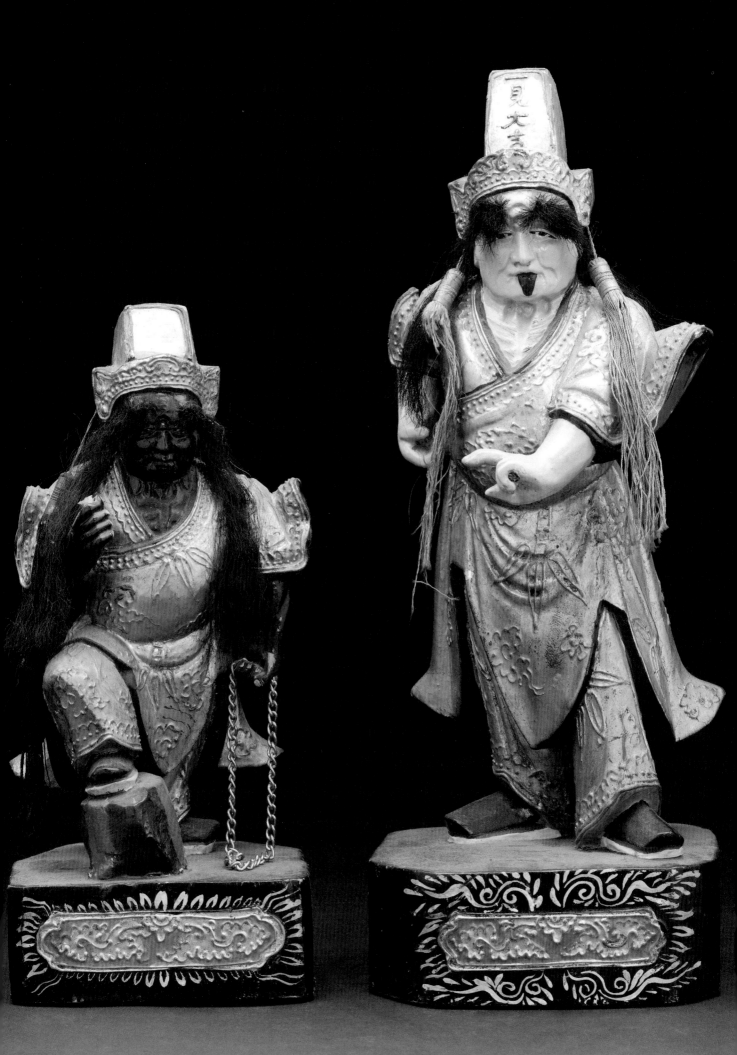

mid-Ming, most jurisdictions boasted impressive temples where, in addition to religious activities, some legal cases were adjudicated. During the Ch'ing, magistrates and other regional authorities were ordered to establish Ch'eng Huang temples, report there when assuming office, and perform the two kneelings and six kowtows before the altar on the first and fifteenth of each month.[186]

When the Ch'ing finally subdued Taiwan, those imperial orders were emphasized and strengthened for the island. The motive was more than religious. Taiwan during the early Ch'ing was a frontier not too dissimilar from the American Wild West of the mid-1800s. A visible "religious *yamen*" with a resident "spiritual magistrate" would, in the government's thinking, help tame an unsettled population and control lawlessness. The spiritual pacification process on Taiwan began with the building of the Tainan City God temple; Taipei and Chiayi soon followed. The number grew to twenty-six by 1934 and ballooned to fifty-four by 1977.[187]

It is no longer a legal venue, but the City God's court retains an official aura. For example, it, along with temples to other deities, has been host to electioneering. During the 1977 provincial assembly campaign, several candidates proclaimed their honesty with an oath before the god's statue. The seven candidates vying for Hsinchu seats together swore to run clean campaigns by a solemn oath and contributions of 50,000 New Taiwan Dollars each to the temple.[188]

When rumors of corruption damaged Nantou candidate Lin Tsung Nan, he vowed to take the "chicken head oath." In front of the City God and a crowd of voters, he chopped off a chicken's head to prove his innocence. The "chicken head oath" appeared popular that year for the press reported a number of other officials vowing and slicing, most notably Tainan mayor Su Nan Ch'eng who slaughtered his chicken at the Pao An Kung.[189] Such bloody oaths are not limited to electioneering. Disputes between neighbors sometimes are solved more quickly and economically by kneeling before the City God with chicken in one hand and cleaver in the other and swearing to the honesty of one's words.

As a member of the celestial bureaucracy, Ch'eng Huang is considered an office holder and, as such, is subject to promotion to a more prestigious municipality for successful administration or demotion or dismissal for failing to give satisfaction. If discharged, a recently deceased public-spirited local may be appointed in his place. On Taiwan, this is a common theme of puppet shows performed on makeshift stages in temple courtyards during *paipai*s.

A modern-day example is Lai Ho, reputed to be the Kaohsiung City God. In his indefatigable pursuit of justice and tranquility while alive, Lai is credited with curing hundreds of sick, freeing kidnapped innocents, promoting cultural activities, and aiding the government in various pursuits in his native Changhua. He died almost a century ago and was buried at Pa Kua Shan. His gravesite became a magnet for the sick and others seeking solace. The rumor soon spread that grass uprooted from his grave contained wondrous medicinal properties. When the area was plucked bare, it was divined that he had left to assume the position of Kaohsiung Ch'eng Huang.[190] Liao Yu Wen, in recording this tale, wonders how anyone can guarantee that the righteous Mr. Lai really became a god.

Liao fears "religious rascals" manufacture such tales to extort money from pious temple goers. He feels this is a "small matter" compared with an incident reported in *Taiwan Jih Jih Hsin Pao* in 1929. According to the newspaper account, Shao Chu, the daughter of Yu Yu Shan, died mysteriously while he and his wife were tending their field. Although the death of a seemingly healthy young girl baffled doctors, a female shaman was ready with an interpretation. The local City God, she explained, in making his inspection rounds, was smitten by her beauty. Upon returning to the temple, the god ordered two subordinates (presumably Generals Hsieh and Fan) to bring the girl back as he wished to make her his bride. Yu

←Figure 101
Fan Wu Chiu and Hsieh Pi An. They assist the City God in rounding up newly departed souls and bringing them to his court for initial judgment. Height 32cm (tallest).

范無救與謝必安幫助城隍爺押解剛死去的靈魂，把他們帶到堂前受審。
像最高32公分。

and his wife were advised not to oppose the marriage if they wished to live. Accordingly, they consented. A statue of Shao Chu was fashioned and a wedding banquet attended by government and temple dignitaries was held with Mr. Yu sitting in the honored seat reserved for the father of the bride.

One of the most active City God temples is the Hsia Hai Ch'eng Huang Miao in Taipei. During the Tao Kuang reign (1821-1851), a Chuanchou man by the name of Ch'en Chin Jung placed a statue of Hsia Hai Ch'eng Huang, the protector of five villages in the Tung An area of Fuchien, on a god's niche in his store. In 1853, a feud between settlers from Tung An and immigrants from Nan An erupted into street fighting which claimed the lives of thirty-eight Tung An men. The store was burned to the ground, but the statue was saved. The statue was again placed on a shop niche, but pressure began to grow for a proper edifice to enshrine the god. By 1860, the temple was completed on its present site in the Yen P'ing District, and incense was received from the City God temple in Lin Hai Men, Fuchien. In addition to the City God and his assistants, the thirty-eight who died in the communal fight are considered martyrs and collectively enshrined as I Yung Kung on a side altar.

Through the years, the temple has served as a spiritual fortress for those who trace their ancestry back to Tung An. Some consider it a material fortress as well. During the French incursion north of Taipei in 1885, petitions to the City God were credited with saving the area from attack.

Yearly on the god's birthday (thirteenth day of the fifth lunar month), the various organizations associated with the temple provide Taipei with an hours-long *paipai* parade featuring bands, acrobats, lion dances, stilt walkers, and nine-foot tall parade figures.

Although it was built later, about 1880, a smaller temple in Taipei's Sung Shan District claims to be the seat of the Hsia Hai City God. The caretaker told me the Hsia Hai was originally a water spirit. The only way such a spirit could escape was to catch or lure a human into the water as a replacement. A fisherman who was aware of the spirit's presence warned everyone to avoid the area. The spirit confronted him and protested that such warnings prevented him from ever being released. The fisherman counseled the spirit to accept his fate and work to help, not hinder humans, Chastened, the spirit followed this advice. When the Jade Emperor heard that a water spirit was working for the good of humankind, he immediately released him and elevated him to be City God of Taipei.

One rung up the celestial bureaucracy from the City God is the Provincial God. Sheng Ch'eng Huang Miao on Wu Ch'ang Street in Taipei's Central District is this spiritual governor's residence.

Lin Heng Tao lists three Ch'eng Huang temples in Tainan: one for the city, one for the *hsien*, and one for the *fu* (prefecture). Keith Stevens has identified one of the City Gods as Chu I Kuei, an anti-Manchu rebel who, in 1721, defeated Ch'ing forces in a number of skirmishes and installed himself in the then-capital Tainan as emperor. Stevens writes that on his visit to the Tainan temple, there were three images on the main altar. The temple keeper explained they all represented Chu I Kuei and were known as City God Senior, Junior, and the Third. He is also known as Ya Mu Wang. Chu I Kuei was eventually betrayed and taken to Peking in a bamboo cage and, by one account, beheaded and by another, crucified.

In the 1903 *Island of Formosa*, author James Davidson gives an unflattering account of the Chu I Kuei rebellion. He makes Chu a self-promoter who rose from a poor duck farmer to near emperor status by joining a gang of robbers and then enflaming citizens oppressed by the government's fiat monopolizing the camphor industry. The government's grab of this lucrative trade was enforced in 1720 by beheading over 200 settlers who defied the ban by chopping down and carting away trees.[191] The biased reports of European merchants and traders, unreliable dynastic memorials, and a broken oral tradition cloud the early historical record of Taiwan. Whatever the true facts are, Chu I Kuei, in the eyes of many Taiwanese

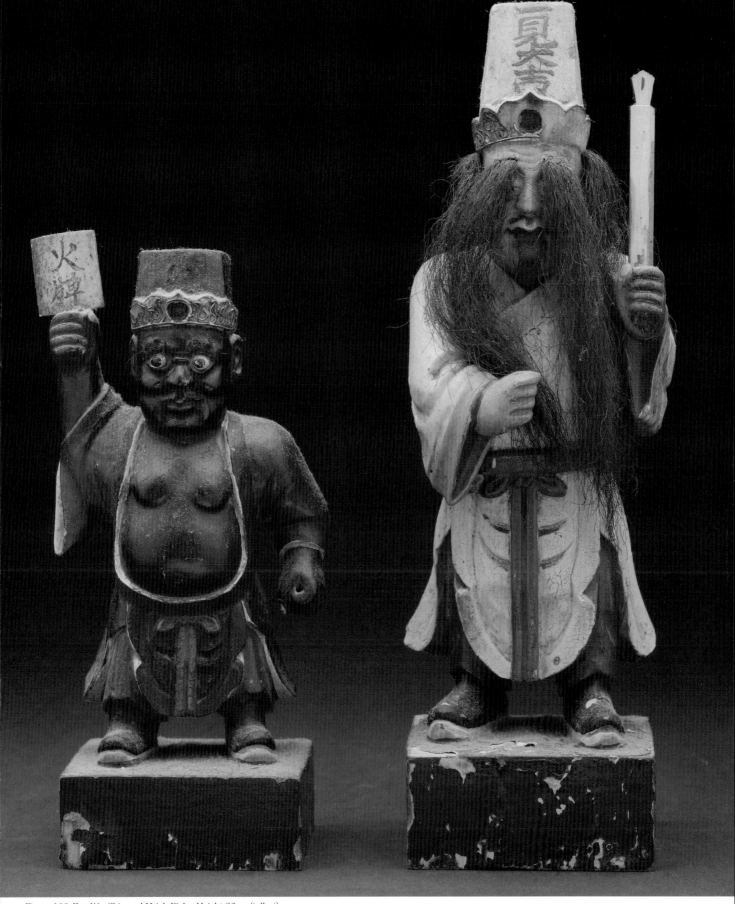

Figure 102. Fan Wu Chiu and Hsieh Pi An. Height 26cm (tallest).

范無救與謝必安像，最高26公分。

then and now, is a god.

In the City God's court are various judges and demon police who assist in collecting souls, making initial moral assessments, and escorting the dead to Hell for final judgment. The most prominent are General Hsieh Pi An and General Fan Wu Chiu, familiarly known as the Seventh and Eighth Lords. They are easily recognized as Hsieh is tall and thin, and Fan is short and squat.

According to one account, they were T'ang Dynasty generals in the employ of Chang Hsun during the An Lu Shan Rebellion. The history of this episode combines corruption, adultery, palace intrigue, treason, war, and patricide. It is more than enough to make the patriot livid and the romance reader turn pages. In A.D. 745, sexagenarian Hsuan Tsung took as his concubine, Yang Kuei Fei, one of his son's favorites. Soon the old emperor fell completely under her spell. In turn, Yang Kuei Fei, without objection from the aged Hsuan Tsung, legally adopted An Lu Shan, a young general who, it is commonly believed, became her lover. The plotting and sleight-of-hand treachery worked by An to gain control over superior forces in order to overthrow the palace, makes exciting reading. In the end, the emperor fled; Yang was executed; and An Lu Shan was eventually killed by his own son.

In the legend grafted on to this historical account, Generals Hsieh and Fan rushed to an An Lu Shan stronghold on the orders of Chang Hsun to seek the release of captured soldiers. Hsieh, who had the longer stride, arrived first. He was seized and hung from the city wall. When Fan finally caught up and saw Hsieh hanging, he attempted to hide along the banks of the city moat but slipped into the water and drowned. Chang Hsun was killed shortly afterwards. The Jade Emperor made Chang Hsun a City God in recognition of his exemplary life.

In the version more popular on Taiwan, Hsieh and Fan are sworn brothers who lived centuries ago in Fuchien. One day while on an outing, the clouds darkened, threatening rain. Hsieh advised Fan to seek shelter under a bridge while he returned home for an umbrella. The torrential rains that came swelled the river, and the water quickly rose under the bridge. Remembering his promise to wait, Fan decided to chance staying rather than seek safety elsewhere. Unfortunately, he was soon drowned. Meanwhile, Hsieh reached home only to collapse in a fever. Upon waking, he hurried back to the bridge to find the receding water reveal the corpse of his sworn brother. Hsieh flung himself into the stream in an attempt to join Fan in death. He was too tall to drown, so he climbed to the top of the bridge and hung himself. For these reasons, Hsieh is always carved with his long tongue extended, the result of hanging; Fan is pictured with skin darkened by time spent in the water. As a reward for their exhibition of extreme fraternal loyalty, a cardinal Chinese virtue, the Jade Emperor appointed Hsieh and Fan to positions in the netherworld bureaucracy with responsibility for seizing newly deceased evil spirits to and from the City God's *yamen*.

Every temple to the City God, and others with administrative responsibility for the netherworld, will have parade figures of these two for use during festivals. They are made of heavy bamboo draped with cloth and topped by a huge, carved, wooden head. Each is carried on the shoulders of a man who manipulates the figure from inside. When taken out in procession, they are awe-inspiring. As bodyguards, these two giant figures always precede the main god's palanquin to insure the security of the area.

The Seventh and Eighth Lords have been tasked with making periodic secret inquiries into the behavior of humans. It is said that if you meet General Fan Wu Chiu, whose name means "No Salvation," death is near. On the other hand, should you meet General Hsieh Pi An, you should immediately kneel down and give thanks for past blessings in order to be assured of protection in the netherworld. His name means "Certain Peace." On his hat is printed the slogan: "I Chien Ta Chi," which translates as: "One Glance Brings Luck."

In addition to the statues pictured here (fig. 101 & 102), I have included two scrolls of these minor deities (fig. 103 & 104). A sudden shower drove me to seek shelter in a small barbershop on a Taipei side street one evening in 1977. As I needed a haircut, I decided to wait out the storm in the barber's chair. As he clipped away, I became aware of surroundings unusual for such establishments in Taiwan or anyplace else. Cluttering a corner was a jumble of old furniture, temple lanterns, framed pictures, and a few scrolls. The haircutting done, I decided to indulge my curiosity and rummage through the assembled junk. My eyes were quickly drawn to two watercolors. Unrolling them, I was amazed to find they were Hsieh Pi An and Fan Wu Chiu. Suppressing an eagerness that would alert the seller to up the price, I handed the barber/junk dealer what he demanded, a fraction of what I subsequently paid a scroll mounter to restore the pictures. I have no idea of their age, who commissioned the paintings, or where they were hung. Whatever their artistic value, they evoke memories of towering parade figures strutting and dancing down Taiwan's streets, alleyways, and village paths.

On the soul's journey through Hell, it is subjected to unspeakable tortures at the hands of demons as punishment for past misdeeds. Niu Tou and Ma Mien (Cow-head and Horse-face), the most famous of these, flank the City God on his altar. The two are prominent in scrolls of Hell displayed by Taoist priests at funerals. These scrolls, which portray the torments of sinners in explicit detail, are used to chart the soul in its progress through the ten courts and on to eventual reincarnation. The pictures also serve as object lessons to those, especially children, attending the rite. In most sets, the pair appears more than once, but not necessarily in the same sequence. However, they are always seen in King Yen Lo's fifth court impeding the passage of sinners attempting to cross the narrow bridge over the snake-infested Nai Ho River.

When Kuan Yin visited Hell after being strangled on her father's orders, the kings of Hell sought to test her magic. She consented on condition that all sinners in Hell be gathered to hear her pray. The responsibility for rounding up all sinners was given to Horse-face and Cow-head. When assembled, Kuan Yin prayed, and Hell immediately became a paradise.

The third pair serving the City God is Wen P'an Kuan and Wu P'an Kuan, civil and military judges. Wen P'an Kuan documents the soul's moral behavior and determines reward or punishment. Wu P'an Kuan supervises the appropriate fate. The two are aided by a wondrous abacus that hangs in some Ch'eng Huang temples, most notably Tainan's Ch'eng Huang temple. On it are calculated one's good and evil deeds. When death comes, pluses for meritorious actions and minuses for grievous sins will be totaled and disposition indicated by the sum.[192]

The historical P'an Kuan was Ts'ui Chio, an official in the Board of Rites during the reign of T'ang Emperor, Kao Tsu. After Ts'ui's death, he was appointed as registrar in Hell. P'an Kuan is remembered for having increased the life span of Emperor Tai Tsung by falsifying his entry into the netherworld record. But in the case of Miao Chuang, Kuan Yin's vindictive father, he was unwilling to alter his destiny. After Miao Chuang burned down the nunnery where Kuan Yin was praying, the Jade Emperor ordered P'an Kuan to check his life expectancy in the register. A check was all that was ever made, and Miao Chuang was allowed to live out his life to its natural termination. P'an Kuan appears in the Kuan Yin story again when her visit to Hades turned it into a paradise. P'an Kuan advised King Yen Lo that justice required both punishment and reward. He reasoned that if Kuan Yin did not leave Hell immediately, there would no longer be punishment for transgressions and consequently, no inducement for righteous behavior.

Wen P'an Kuan can be seen on the City God's altar standing to the left. He has a calm, appealing face and often holds a book or writing implement. Wu P'an Kuan stands on the right. He is a scowling, dark-faced fellow who waves a weapon in a threatening manner. Both are dressed in official robes.

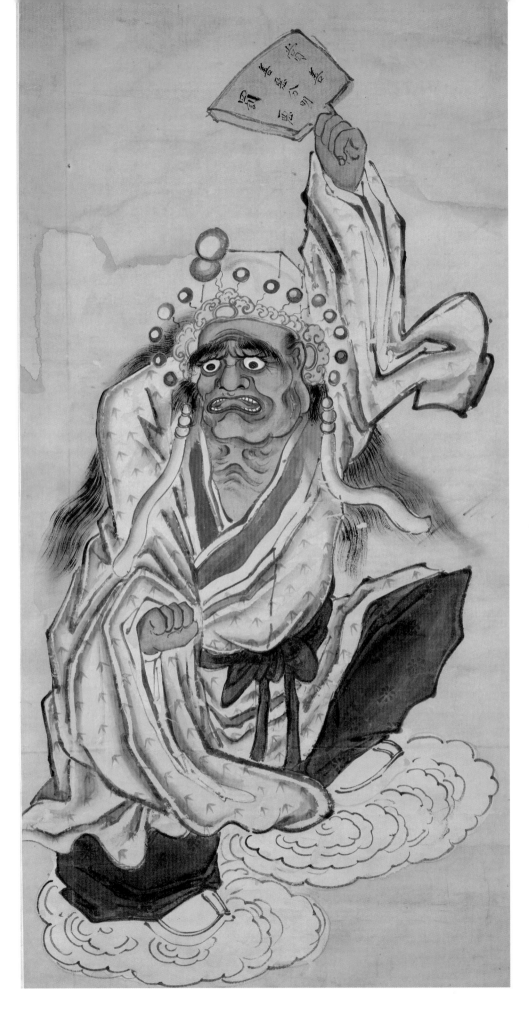

Figure 103
Scroll of Fan Wu Chiu.
Size 134 by 67cm.

范無救像，134 × 67公分。

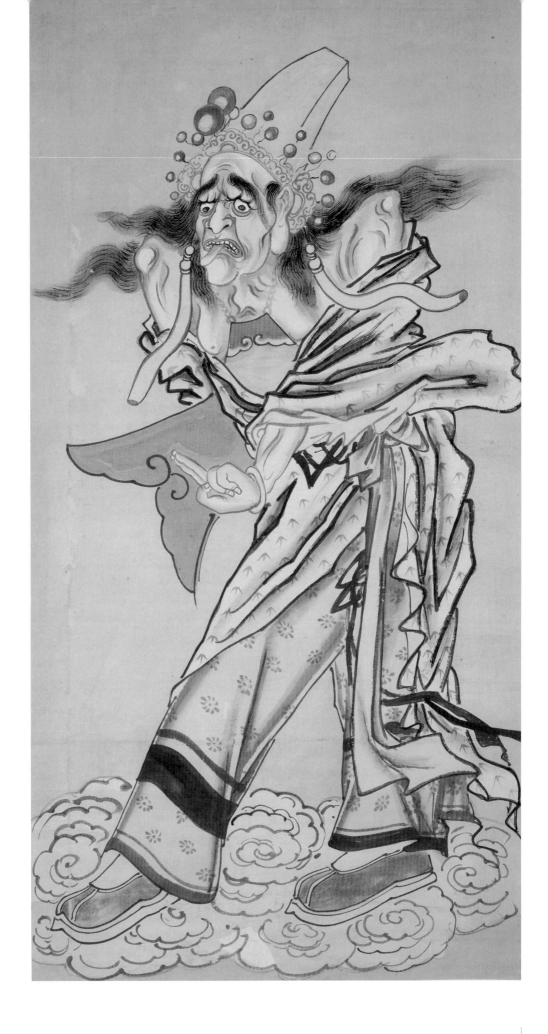

Figure 104
Scroll of Hsieh Pi An.
Size 134 by 67cm.

謝必安像，134 × 67公分。

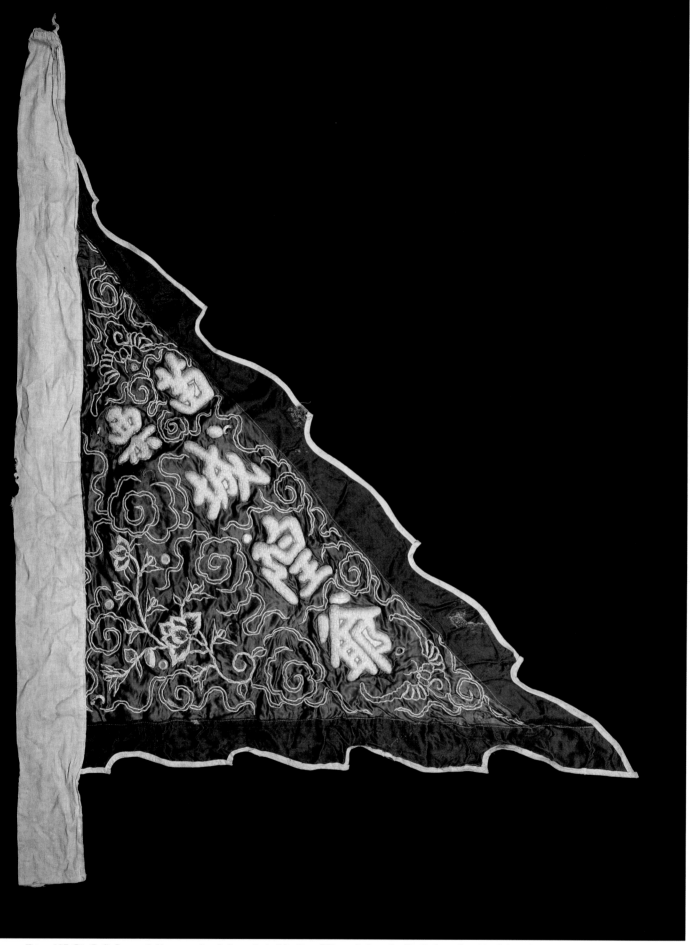

Figure 105. City God's flag, carried in procession during *paipai* celebrations. This one is from the City God temple in Miaoli. Length 122cm.

城隍旗，用在拜拜的遊行祭典中。圖中的城隍旗來自苗栗城隍廟，長122公分。

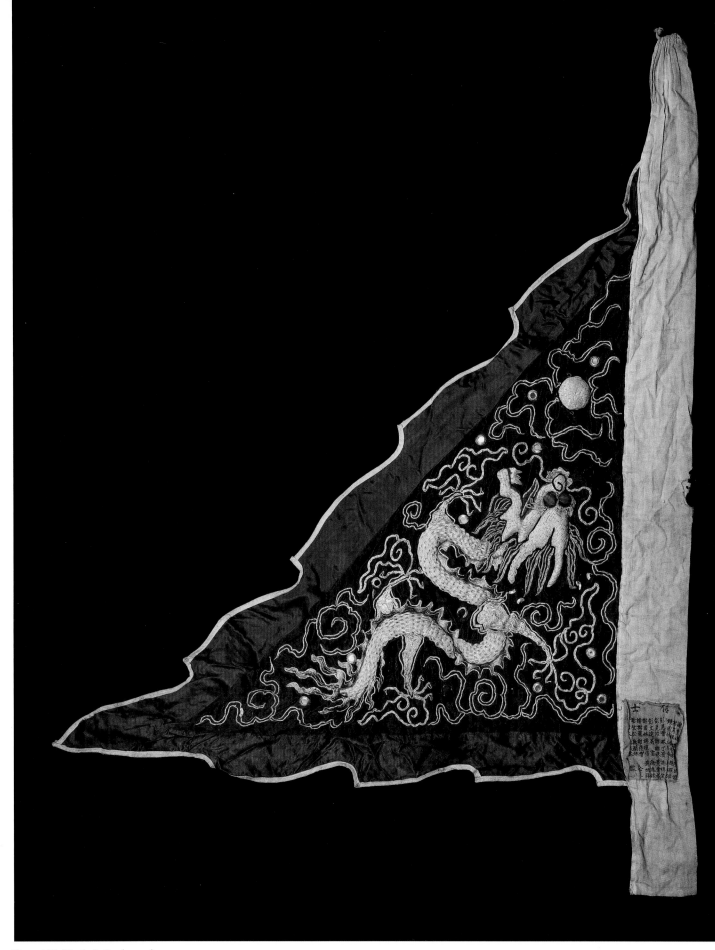

Figure 106. City God's flag (reverse).

城隍旗（背面）

On the iconography of Ch'eng Huang, Keith Stevens writes: "City God images appear to have no standard or unique characteristics but are all somewhat similar. Out of context, they are one of the many standard figures of a seated scholar-official: the mandarin with a black beard, official robes and in many instances with the scholar-official's winged cap. He is occasionally portrayed with the official tablet held in both hands before his chest, and less frequently with a flat topped crown."[193] Liu Wen San writes that there can be no standard carving, because City Gods are essentially a collection of deified humans. As human features vary, so City Gods' statues necessarily must differ one from the other.[194] I have in my collection a few statues that approximate Stevens' description but have not included them here because of Liu's admonition. Moreover, woodcarvers or dealers from whom I purchased them were unable to make positive identification. Some may be City Gods, or they might also be unidentified Wang Yeh or deceased local worthies around whom a cult began but faded when petitions directed to them went unanswered.

Figure 107. List of temple contributors attached to the City God's flag. Size 11 by 12cm.

城隍旗上列出的捐款信士名單。11×12公分。

186. Shen, *Introduction to Chinese Gods*, p. 96.
187. Chung, *The Origins of Taiwan's Local Gods*, p. 202.
188. "Election Oaths before City God," *Taiwan Daily News*, November 5, 1977.
189. "Su Nan Ch'eng Slaughters a Chicken," *United Daily News*, November 18, 1977.
190. Liao, *Mythology of Taiwan*, p. 99.
191. Davidson, *The Island of Formosa*, p. 70.
192. Liu, *The God Statues of Taiwan*, p. 122.
193. Stevens, *Chinese Gods*, p. 171.
194. Liu, *The God Statues of Taiwan*, p. 122.

TI TSANG WANG

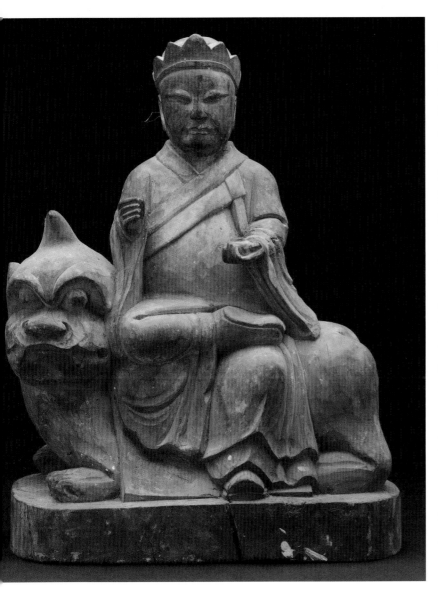

Figure 108
Ti Tsang Wang, the overlord of Hell.
He is seen here wearing Buddhist robes
and sitting on a mythical beast.
Height 25cm.

地藏王，冥界的主宰神明。圖中的地藏
王像身著僧袍坐在神獸上。
高 25 公分。

While Ti Tsang Wang is considered the King of Hell, his connection with it is ambiguous. His abode is not in Hell itself, and he takes little part in meting out punishments, as this is the prerogative of the Ten Kings of Hell who are considered to be subordinate to him. He is more thought of as a savior or deliverer who descends into the nether regions on errands of love and mercy.[195] He received the command to relieve the suffering of the souls in Hell from Sakyamuni (the Jade Emperor's order in the Taoist version). Unfortunately, because of the unceasing wickedness of man, he has been unable to fulfill his duty

The Christian concept of Hell is a place of eternal damnation. For the Taoists, Hell is a detour on the road to reincarnation. When asked: "Who rules Hell?" any Christian would answer without ambiguity: "Satan." The same question asked of a Taiwanese, even a devout Buddhist or Taoist, might elicit an involved explanation. Hell seems crowded with personalities who have some jurisdiction or responsibilities. There is the Lord of the Eastern Peak, who is identified as the alter ego of Yen Lo Wang, who controls the fifth court of Hell. The Eastern Peak of the Five Sacred Mountains is T'ai Shan in Shantung. This confuses the student who seeks neat answers because King T'ai Shan rules another Hell court.[196]

Scrolls of Hell exhibited by Taoist priests at funerals identify Yen Lo Wang as the presiding officer over the fifth court. There are ten courts of Hell where punishment is administered, and each is controlled by a king. Yen Lo Wang is the only one of the ten kings who suffers punishment. Originally presiding over the first court where initial judgments are made, he was deemed to be too forgiving towards sinners. Consequently, he was demoted to the fifth court where, once a day, he must submit to torture as chastisement for his unreasonable past leniency.

There are at least three historical figures over the years that have been identified as king of the fifth court. The most prominent is Pao Cheng, deified as Pao Kung. Legend claims that he was a native of Anhui

who lived during Sung times. He was first the Prefect of Kaifeng and later, an Imperial Secretary and Inspector. He had a reputation for incorruptibility and was renowned as an impartial judge.[197] The confusion over the identity of the fifth king exemplifies how legends vary over time and distance. For some, he is a distinct deity; others consider him a human incarnation of Yen Lo Wang.[198] I have found no references to temples dedicated to Pao Kung on Taiwan. However, Keith Stevens found a black-faced king labeled "Sen Lo Wang" in a set of Hell gods at a Kuan Kung temple in Taichung. The temple curator assured him that Sen Lo Wang was Pao Kung's secret name.

It is unlikely one would find a statue of him on anyone's personal altar. Nevertheless, he is not unfamiliar as he is the hero of several opera plays. As there is little demand for his statue, carvings of Pao Kung are not common. He is always depicted wearing official robes and seated on a throne. A crescent or yin-yang sign appears on his forehead, and his face is black, a symbol of his incorruptibility.

City Gods residing in the yin world, but not in Hell itself, make the preliminary judgment on the soul's disposition. They also have the power to reverse previous judgments. If a human was executed for a crime he did not commit, a City God will right the matter in the world of the shades by entering those realms of Hell and effecting a release of the innocent soul. Ti Tsang Wang likewise has free access to the Underworld. When he encounters a truly repentant soul, he approaches the king in whose section the soul is being judged and has the punishment reduced.

Mulien, a pious Buddhist monk, is regularly depicted in scrolls of Hell used by Taoist priests at funeral rites. He descended into Hell in an attempt to save his mother who broke a Buddhist taboo by eating meat. Henry Dore, Keith Stevens, and others give similar accounts of his efforts and her eventual release won by mass prayers and petitions of several monks.[199] Wolfram Eberhard notes that in some traditions, Mulien eventually became Ti Tsang Wang.[200]

A Buddhist monk told me an entirely different account of Mulien's efforts and eventual failure. In his version, Mulien dropped a long rope from Heaven into the Hell court where his mother suffered. As she was climbing, she noticed other souls shinning up behind her. In a selfish attempt to prevent them from sharing her happy escape, she lost her grip and fell back into the torture chamber.

Hsieh Pi An and Fan Wu Chiu (Seventh and Eighth Lords) and Niu Tou and Ma Mien (Cow-head and Horse-face), fixtures in most City God temples, are depicted also in scrolls of Hell. Kuan Yin, likewise, can be seen regularly in scrolls of the first Hell court leading those virtuous ones, who are judged blameless of all sin, across the Golden Bridge to the Western Paradise.

Ti Tsang Wang can be thought of as the personification of the notion of Buddha's compassion for suffering souls.[201] However, some identify him with Chin Ch'iao Chio, a monk who came from India to China during the T'ang Dynasty and who was reputed to have lived an ascetic life, expiring at the age of ninety-nine after assuming the lotus position in preparation for his death, which he foresaw. When his coffin was opened three years later, his body was found preserved in a mummified state.[202]

Today, burial containers of certain holy monks and nuns are likewise opened either because the deceased requested it in a will, or at the instigation of disciples. When a body is discovered to have mummified, the faithful cover the hardened flesh with plaster and gold leaf and enshrine it on an altar. There are many such deified mummies in Southeast Asia and at least three that I viewed on Taiwan. The first was Tz'u Hang, the founder of a Buddhist Academy at the Ching Hsiu Ch'an Yuan in Hsi Chih, Taipei Hsien, and the second was a pious lady enshrined on a family altar outside of Neipu, Pingtung (fig. 115). The third was the monk, Ch'ing Yen Fa Shih (fig. 113), who died in 1970. As requested in his will, he was placed in a crock, covered with spirit money, incense, sandalwood, and lime, and removed six years later. I

➔Figure 109
Yen Lo Wang, king of the fifth court of Hell. Height 36cm.

閻羅王，地獄第五殿的主宰。
像高36公分。

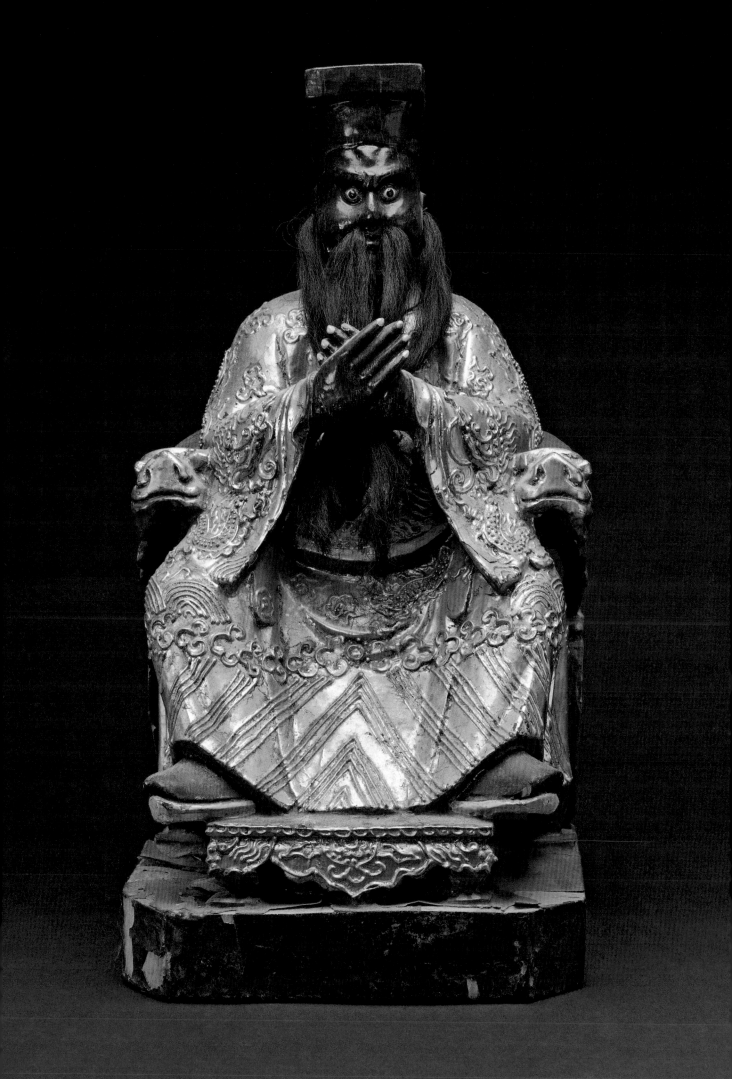

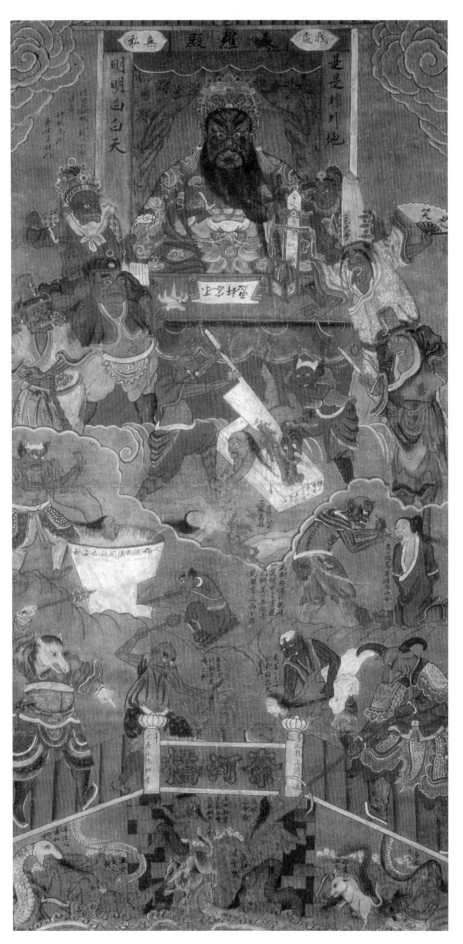

Figure 110
Scroll of the fifth court of Hell. It is one of ten hung by Taoist priests during funeral rites. Yen Lo Wang, flanked by Fan Wu Chiu and Hsieh Pi An, presides over punishments being meted out by Cow Head and Horse Face among others. Size 137 by 68cm. Catalog number E426233, Department of Anthropology, Smithsonian Institution.

地獄第五殿圖。此圖為道教法師在葬禮上所懸掛的十幅地獄圖之一，圖中的　羅王在范無救和謝必安的隨侍下指揮牛頭馬面進行懲處。137 × 68 公分。編號 E426233，史密森尼博物館人類學部門。

→Figure 111
Pao Kung, a Sung Dynasty judge who, some claim, is Yen Lo Wang. Height 27cm.

包公，宋朝判官，一說即為閻羅王。像高27公分。

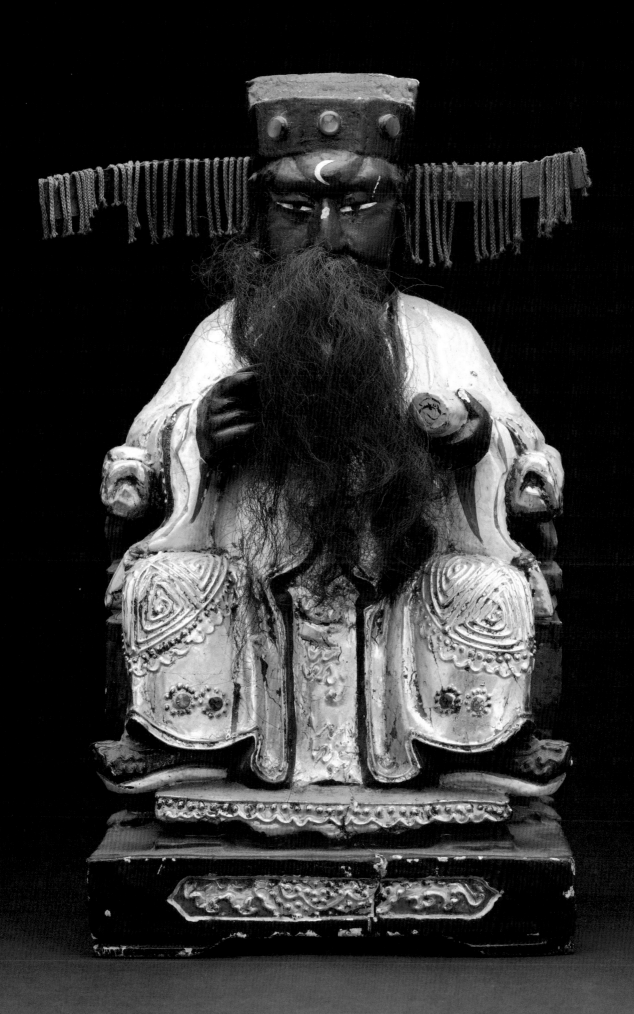

saw him within the first days of removal and was impressed with the state of his mummification. His body was resting on a plain table in a rustic shack on a secluded hillside at San Chang Li, where, for six years, the crock had been kept in storage.

Intense media coverage (fifty press reports within the first several weeks) generated wide curiosity and interest among believers and nonbelievers alike. Ch'ang Ming, a nun at Hai Tsang Szu (Ch'ing Yen's temple while alive) planned to retrieve the body and return it to the temple. The hut where the crock was stored was owned by Hai Tsang Szu but was not conducive to accommodating hordes of expected pilgrims. It was situated on a remote hillside at the end of a long unpaved path inaccessible to vehicular traffic.

The neighbors living in that sparsely populated area opposed Ch'ang Ming and claimed that through divination, Ch'ing Yen made known his desire to remain on the mountainside. They organized a preparatory committee to raise funds for the construction of a temple for Ch'ing Yen at the San Chang Li site.

On July 9, 1979, Ch'ang Ming issued a public statement condemning the preparatory committee. She called on the government to ensure Ch'ing Yen's return to the temple. The government, not wishing to interfere in a purely religious dispute, urged for compromise. Four days later, Ch'ang Ming acted. At 2:30 in the morning, Hai Tsang Szu nuns surprised those guarding the mummified body. A struggle ensued, and three defenders were injured in their failed attempt to prevent the abduction. The following day, the San Chang Li group staged a retaliatory raid on Hai Tsang Szu, but were outnumbered and overpowered by the Hai Tsang Szu staff.

The authorities could no longer ignore such public lawlessness. It presented the police with a novel problem: was this a case of kidnapping or assault? Assault apparently presented fewer procedural headaches for on October 1, 1976, three Hai Tsang Szu nuns were formally brought to court for that offense.

When one dies, the afterlife is much on the minds of the Taiwanese. Elaborate funeral rites are performed, and specific periods of mourning are followed. Because City Gods are responsible for ensuring souls get through the gates to Hell, much of the devotional activities are directed towards them and their temples. So for most communities, there is little incentive to erect impressive edifices specifically dedicated to Ti Tsang Wang.

Ti Tsang Wang is enshrined as the main deity in the secondary hall of Tainan's Tung Yu Tien, one of the best-known temples in southern Taiwan and a favorite of foreign anthropologists, ethnologists, and sociologists because of its ornamentations and age. It was constructed in the second year of the Yung Li reign (1648). With victorious Manchu forces sweeping across China, Ming loyalists, proclaiming allegiance to Emperor Yung Li, maintained for a few decades a small foothold sometimes called the Southern Ming.

The most impressive Ti Tsang Wang temple in the south is Chiayi's Pei Yueh Tien Ti Tsang An. Built in 1697, it was at first a simple structure housing a statue brought by Koxinga loyalists. The structure was renovated many times and completely rebuilt in 1978. It is an impressive five-story pagoda structure flanked by bell towers and approached by wide steps. Each story is trimmed with swallow-tailed roofs supported by bright red pillars. Ambassador and Mrs. Leonard Unger were invited to the opening ceremony on October 25 of that year. As they were unable to attend, my wife, Joan, and I were privileged to represent them and meet the monks and temple committee.

The few other temples to him are in Lukang, Changhua, Yunlin, Kaohsiung, and Hsin Chuang, Taipei *Hsien*. The Ti Tsang An in Chung Kang Li, Hsin Chuang also goes by the name Ta Chung Yeh Miao. Ta Chung Yeh is a euphemism for an "orphaned spirit," one who died without proper funeral rituals necessary for a safe journey to the netherworld. People who die away from home or without relatives to offer incense and spirit money will wander near the place of death, causing trouble. Such spirits must be

→Figure 112
Mulien, a Buddhist monk who visited Hell in a vain attempt to extricate his mother, who sinned by straying from a vegetarian diet by eating meat. Height 33cm.

目蓮，佛教僧侶，曾前往冥界拯救因不吃齋改食肉而入地獄的母親，但終告失敗。像高33公分。

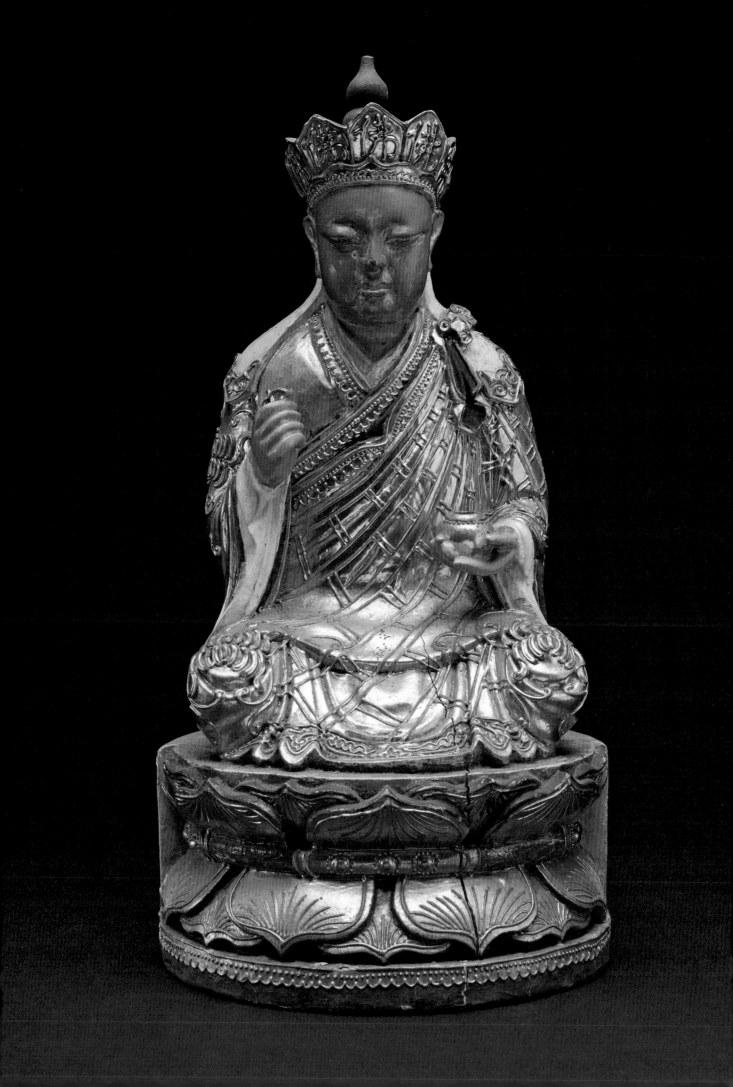

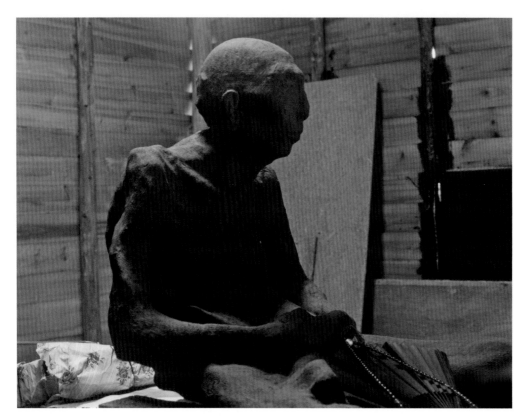

Figure 113
Ch'ing Yen Fa Shih, a Taipei monk, a few days after being removed from the burial crock. Some identify a T'ang Dynasty monk, whose body was naturally mummified, as Ti Tsang Wang. There are several examples of such mummification in Southeast Asia and at least three in Taiwan, including Tz'u Hang, a monk venerated at Ch'ing Shiu Ch'an Yuan in Hsichih, and a monk in Taipei.

清嚴法師，照片拍攝於肉身開缸幾天後。唐朝也曾有如地藏王一般圓寂後肉身不腐的前例。同樣的例子可見於東南亞數處地方，台灣即至少有三例，其中包括供奉於汐止靜修禪院的慈航法師和一位台北的僧人。

placated. Should a farmer turn up a human bone while plowing, for example, he may, in order to appease the unknown spirit, build a miniature temple with the legend "Yu Ying Kung" (The Duke Who Will Respond) inscribed on the lintel. The view taken of these spirits is not uniform throughout Taiwan. Some consider Ta Chung Yeh and Yu Ying Kung to be distinct, while most believe they are the same class of spirits and synonymous with *Hao Hsiung Ti* (Good Brothers). While most veneration is given grudgingly to appease what might otherwise do harm, some seek their assistance in gambling or in escaping the law for a yet undetected crime. It is not uncommon to see these small temples in the countryside near where a stranger may have died in a violent traffic accident.

Like the Chung Kang Li temple, Taipei City's Ti Tsang Wang Miao, a small building located in temple-crowded Wanhua, shares the same address (245 Hsi Ch'ang Street) with Ta Chung Yeh's Chao Hsien Miao. Squeezed between commercial buildings in the middle of Hsi Ch'ang Street and within a few minutes walk from always crowded Lung Shan Szu and the equally popular Tsu Shih Miao, the small shrine is often overlooked. Nevertheless, Ti Tsang Wang Miao, which is among Taipei's oldest, having been built in 1825, has a colorful history. When the Japanese occupation forces arrived, the temple committee, fearful that the property would be confiscated, affiliated itself with the Lung Shan Szu. They reasoned that the alien authorities would not disturb such a prominent and symbolic edifice. When the danger passed, it again became independent.

On the first day of the seventh lunar month, the gates of Hell are opened, and the suffering souls are furloughed for a one month-long journey in the *yang* world. Orphaned souls who have no descendants to worship them wander the world seeking sustenance. Among traditional families on Taiwan, the faithful hang lanterns to light the way for these neglected spirits and prepare dishes of fish, pork, chicken, duck, and vegetables as offerings. A lighted incense stick is placed in each dish, and spirit money and paper clothes are burned to placate these wandering spirits. Special lanterns upon which are written couplets such as: "Praise for the Ghost Festival, relief for all departed souls," are hung.

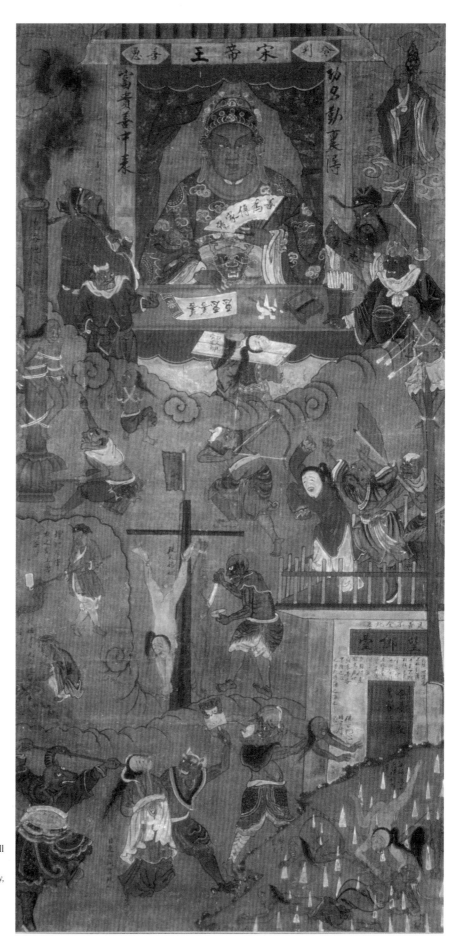

Figure 114
Mulien seen in the upper right hand corner of this Hell
scene. Size 137 by 68cm.
Catalog number E426235, Department of Anthropology,
Smithsonian Institution.

此張地獄圖右上角的僧侶即為目蓮。137×68公分。
編號E426235，史密森尼博物館人類學部門。

Figure 115
A pious mummified lady covered with
gold lead and venerated on a family
altar in Pingtung Hsien.

屏東縣一名虔誠的婦人，其肉身全以金
漆覆蓋，供奉在一個民眾家中神桌上。

On the last day of this ghost month, temples conduct penance ceremonies called Ti Tsang Wang Sessions at which the faithful light incense and burn candles and paper effigies of various gods. Some temples entertain patrons with vegetarian food on this day in order to express appreciation and to exorcise any lingering evil influences that have attached themselves to their benefactors.[203]

Ti Tsang Wang is often depicted wearing the multi-pointed Buddhist crown, holding a staff topped with six rings, and seated on a mythical beast that is endowed with fine-tuned ears, able to hear all that transpires. Because demand for statues of Ti Tsang Wang is not great, one unusual request caught the attention of a reporter for *Central Daily News*. Vice President Hsieh Tung Min so admired a marble statue of T'u Ti Kung by Hualien sculptor Lin Ts'ung Hui that he commissioned him to fashion a five-foot marble statue of Ti Tsang Wang. It was sent to Changhua, where the Vice President had its "eyes opened" during the Dragon Boat Festival.[204]

195. Dore, *Researches into Chinese Superstitions*, Vol. VII, p. 236.
196. Werner, *A Dictionary of Chinese Mythology*, p. 579.
197. Stevens, *Chinese Gods*, p. 182.
198. Ibid., p. 152.
199. Dore, *Researches into Chinese Superstitions*, Vol. VII, p. 242.
200. Eberhard, *Guilt and Sin in Traditional China*, p. 58.
201. Dore, *Researches into Chinese Superstitions*, Vol. VII, p. 236.
202. Werner, *A Dictionary of Chinese Mythology*, p. 499.
203. Chu, *Birthday Listing of Gods*, p. 133.
204. "Ti Tsang Wang Statue," *China Daily News*, May 26, 1976.

GENERAL CHU SHUN

General Chu Shun was a scholar and an official named Huang Tao Chou, who held office during the decline of the Ming and was noted for his incorruptibility and denunciation of members of the emperor's inner circle.

In 1630, he memorialized the emperor three times, accusing the Prime Minister of misdeeds. The Prime Minister's subsequent death was blamed on Huang's incessant attacks, and Huang was demoted as a consequence. Later, Huang asked to be relieved of all duties, but his petition carried an attack on another confidant of the emperor. This again angered the emperor, who stripped him of his titles and demoted him to an ordinary citizen.

Surprisingly, he was soon rehabilitated, only to once again attack a close friend of the emperor. For this, he was banished to a frontier area, but he was forgiven and brought back to the capital after only one year. When Li Tzu Ch'eng betrayed the Ming by opening the Peking gates to the invading armies of the Ch'ing, the emperor committed suicide. Huang fled south, where he formed a militia to resist the Ch'ing. He was defeated, taken prisoner, and executed. Months after his death, Huang appeared to a relative and lamented the fact that while alive, he had served his country poorly. To commemorate the apparition, the villagers built a temple in his honor.

In the mid-eighteenth century, during the reign of Ch'ien Lung, an immigrant from Chuanchou brought a statue of General Chu Shun to Taipei and set up an altar. After a few years, residents, in order to express gratitude for past protection, contributed money to build Chin Te Kung. It was renovated in 1862 and rebuilt in 1921.

At the end of the nineteenth century, a plague struck Taipei. According to old residents, the newly installed Japanese administration lacked an effective policy of preventing the spread of the disease, so the ordinary citizens turned to gods, General Chu Shun among them. Through divination, he prescribed medicine for some and advised others of their immunity.[205]

The pictured here (fig. 116) is a seldom seen example of folk art. Each figure is fashioned from clay, baked, and then covered with paper and painted. I cannot guess at their age. During my years on Taiwan, I never came across artisans earning a living crafting clay figurines of deities. Because the material is inherently unstable and easily deteriorates, I doubt if many examples of this craft still exist.

General Chu Shun is seated in the middle, flanked by two white horses. A soldier carrying the flag of authority heads his entourage. The presence of the Seventh and Eighth Lords, who are usually associated with deities of City God rank, indicates that General Chu Shun has administrative responsibilities in the netherworld.

205. Chu, *Birthday Listing of Gods*, p. 168

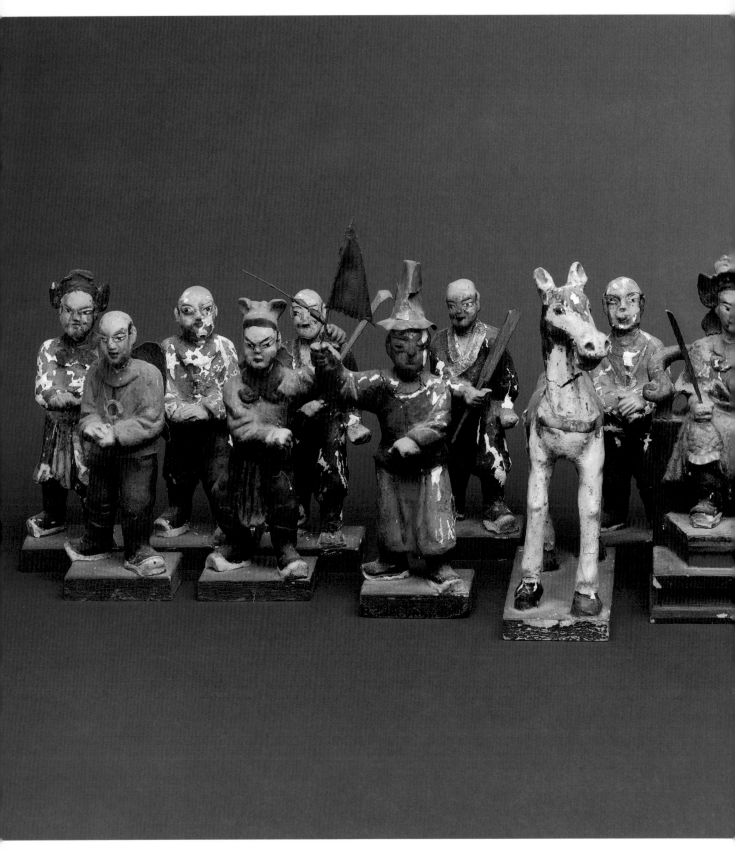

Figure 116
Hand crafted, baked clay figures of General Chu Shun, a minor Ming official and a retinue of soldiers including Fan Wu Chiu and Hsieh Pi An.
Height 31cm (tallest); Height 20cm (shortest).

助順將軍為一名明朝官員，圖中為手工製作、以黏土烘成的助順將軍及其隨扈像，隨扈中還包括范無救與謝必安。
最高 31 公分，最矮 20 公分。

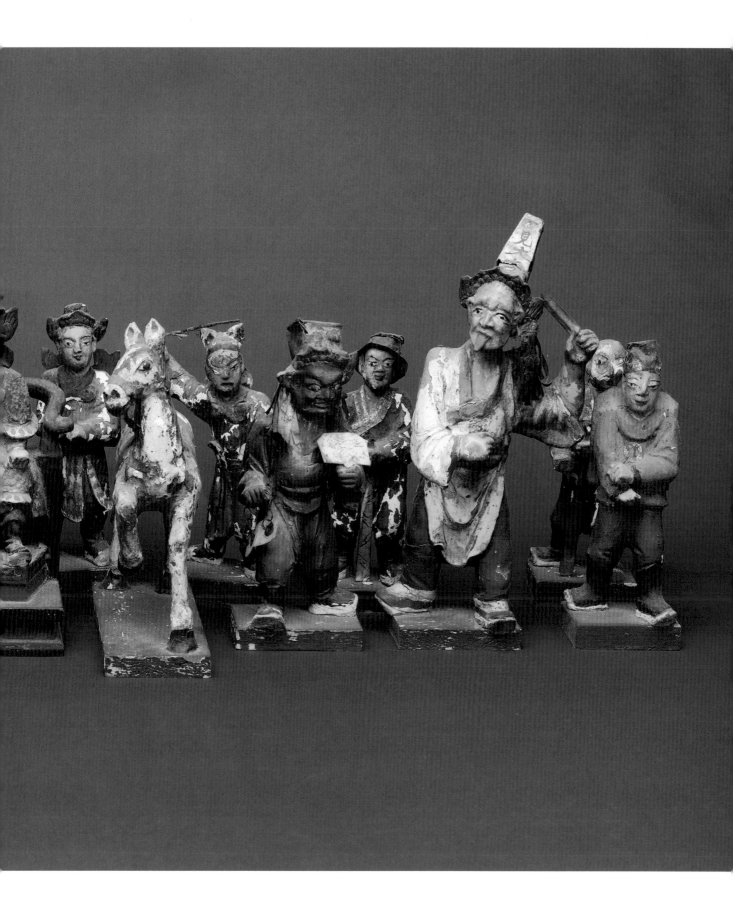

SUN WU K'UNG
(MONKEY)

孫悟空

Sun Wu K'ung (Aware of Vacuity Sun) is known by a variety of names such as Sun Hou Tzu (Sun Monkey), Mei Hou Wang (King of the Beautiful Monkeys), Ch'i Tien Ta Sheng (Great Saint Equal to Heaven), and Pi Ma Wen (Grand Master of the Heavenly Stud — a demeaning title conferred upon him by an exasperated Jade Emperor). In Taiwan, he is commonly referred to as Hou Ch'i Tien (Monkey Equal to Heaven).

The story of Monkey's miraculous birth, mischievous nature, submission by Buddha, detention, release by Kuan Yin, travels to India with T'ang San Tsang (Tripitaka) to collect the sacred texts of Buddhism, return, and subsequent deification as related in *Journey to the West* is known to every Chinese school child. English readers know it from the Arthur Waley translation entitled, *The Adventures of Monkey*.

The novel, which is a fanciful account of Tripitaka's seventh century adventures in securing Buddhist scriptures, books, pictures, and relics, is not only one of China's most loved novels, but an inspiration for artists and an inexhaustible treasure trove for poets and writers.

The novel opens with the miraculous account of Monkey's birth. A huge rock existing since creation itself split open and gave forth a stone ball that, in time, took on a monkey shape and eventually gained life.

He joined with other monkeys and soon became their king. Being of superior intelligence, he sought a status higher than a mere simian. Under the tutelage of an immortal, he gained enlightenment and learned Taoist secrets of transformations and of cloud soaring. While he was away, a powerful demon victimized his monkey kinsmen. He returned to defeat him by tossing hairs plucked from his body at the ogre. Each transformed into a monkey warrior and quickly dispatched the devil.

With an ego puffed up by such an easy victory, he roamed the world making arrogant demands of the mighty that were no match for his power. Long-suffering monarchs, such as the Dragon King, appealed to the Jade Emperor to intervene. Monkey was summoned to Heaven and given the position of Supervisor of the Imperial Stables. Indignant at the appointment to such a lowly position, he returned to earth. Summoned again to Heaven, he was promoted to Guardian of the Imperial Peach Garden. This was more to his liking because the fruit grown there were the peaches of immortality.

He freely indulged himself and for good measure, stole one of Lao Tzu's elixir of immortality gourds and drank himself into a stupor. With Heaven's patience exhausted, a gigantic struggle ensued. After countless rounds, Monkey stumbled and was captured when Erh Lang Shen's Heavenly Dog bit his leg. A frustrated Jade Emperor sought Buddha's help in taming the rascal. Buddha challenged Monkey with a heavenly wager. He would award Monkey the Imperial Throne of Heaven if the ape could jump clear off Buddha's hand. Delighted, he agreed and in an instant, leapt into the air and out of sight. He landed at the end of the earth and urinated on one of what Monkey took to be five

➜Figure 117
Monkey, the mischievous hero of the novel *Journey to the West*, known in English translation as *The Adventures of Monkey*. He is resident in a handful of Taiwan temples. Known for his martial arts skill, he is trusted to ward off evil influences and handle malevolent spirits.
Height 24cm.

英文譯為《猴子歷險記》的《西遊記》小說中的潑猴主角，是台灣大小廟宇中的常客，由於身懷武技，人們相信他能驅逐邪惡，擊退妖魔。像高24公分。

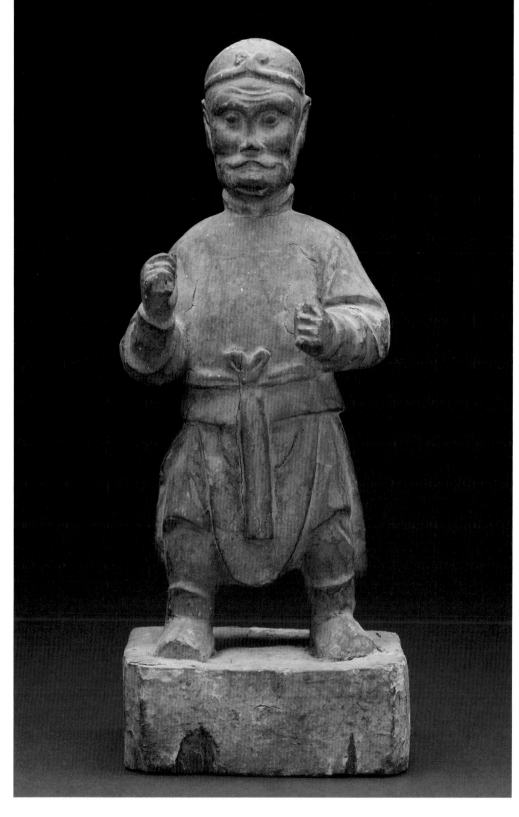

columns. Upon return, Buddha calmly opened his hand and asked Monkey to smell the unmistakable odor on his finger.

Defeated, he was imprisoned for 500 years under a mountain and released only on the request of Kuan Yin, who sought his assistance in protecting the monk, Tripitaka, on his journey to India.

Because he was born of a rock, a stone statue of Monkey caused a stir at the 1976 household furniture exhibition at the Tainan Cultural Hall. A young man from Yun Lin exhibited an eighteen-inch statue resembling a monkey that according to the *Youth Warrior Daily News* (August 4, 1976), he purchased from an aboriginal family in Alishan. Monkey was seated in a pose reminiscent of Rodin's "Thinker." Experts were unable to accurately date the figure, but its weatherbeaten appearance suggested an age in the hundreds of years. The exhibitor was asking 70,000 New Taiwan Dollars for the piece. The paper failed to mention if there were any takers among the crowds of Sun Wu K'ung devotees or the simply curious who came specifically to view the statue.

There is no doubt that Sun Wu K'ung is popular on Taiwan, but there is no accurate account of the number of his temples. Chung Hua Tsao claims there are about ten temples and specifically lists two in Chilung.[206] Lin Heng Tao lists only five temples where Sun Wu K'ung is enshrined as the main god. Nevertheless, statues of him can be found throughout Taiwan either as accompanying gods or on family altars. Liu Wen San writes his popularity is due to his unparalleled martial arts skills. He is trusted to ward off evil influences and handle all sorts of malevolent spirits.[207]

That many hold him in the highest esteem was demonstrated in a letter to the editor denouncing

an article in *Taiwan Daily News*. The letter, signed "Recluse," bitterly condemned the paper for continually referring to the god as "Sun Wu K'ung" (Aware of Vacuity Sun). The proper title, the letter writer angrily wrote, is "Sun Ta Sheng" (Great Saint Sun) and should be used at all times to show proper reverence. "Recluse" wrote that one who is "disrespectable to Buddha, slanders gods, destroys temples, or insults monks will come to a bad end." He advised the editor to "confess and repent his sins in front of a Buddhist statue." The editor replied that no disrespect was intended, and although Sun Wu K'ung undoubtedly was a great and powerful force reputed to be able to transform himself into seventy-two shapes, he was not Buddha. The editor could not resist reminding "Recluse" that Monkey was an orphan, bereft of mother or father and having only a rock as a parent.[208]

The most unusual Monkey statue is enshrined on the main altar of an Earth God temple, Sheng Te Kung, located in the small riverside park outside the Second Water Gate in Wanhua. Shortly after Taiwan was restored to China in 1945, a piece of driftwood resembling Monkey beached in front of the small temple. It was duly enshrined directly in front of the Earth God himself. Later, an adjacent structure was added, which houses additional Monkey statues, but the driftwood remained, accompanying T'u Ti Kung on his altar. Residents of the area believe this driftwood statue is especially effective in curing all kinds of illnesses.[209]

In the mid-1970s, one could not visit the temple without being struck by the incongruous scene. In the middle of a bustling city with high rise, air-conditioned buildings where government and business affairs were being rushed forward with twentieth century speed, here was a bit of rural Taiwan: old men seated on stone benches under shade trees, playing chess or checkers, and with studied slowness, drinking tea and eating cakes purchased for a few cents from hawkers' stalls. Lowering eyes and holding ears to block traffic noise, one could imagine oneself in Matou, Touliu, or any number of other southern towns. Since then, urban development has caught up with this oasis, and an elevated highway ate up the land.

I was a member of only one club in Taipei: The Monkey Club. It was an association with no fixed meeting place, no club dues, no officers, no scheduled meetings, and only one purpose: to enjoy the company of others born in the Year of the Monkey. Five U.S. Information Office staffers, five journalists, two government officials, and an army officer comprised the entire membership. I was the only American. We would meet every now and then over a meal of Chinese or Japanese dishes. After numerous Shaohsing wine toasts, we would gather at Sheng Te Kung and with burning incense sticks in hand, bow to the driftwood Sun Wu K'ung, much to the amazement and amusement of the old men of Wanhua enjoying a late night snack in the tiny adjacent park. Of all my Taiwan contacts, fellow Monkeys are the ones whose friendship I treasure most and with whom I still correspond.

Monkey is usually painted or carved brandishing a wondrous iron rod that can stretch to any length or shrink to the size of a toothpick so that it can be conveniently tucked behind his ear. Around his head is the golden band placed there by Kuan Yin as a condition of his release from captivity. Should Monkey misbehave, the band will contract, causing unbearable pain that forces him to return to more acceptable behavior.

206. Chung, *The Origins of Taiwan's Local Gods*, p. 107.
207. Liu, *The God Statues of Taiwan*, p. 215.
208. "Sun Wu K'ung is not a Buddha," *Taiwan Daily News*, December 27, 1976.
209. Chu, *Birthday Listing of Gods*, p. 145.

➜Figure 118
Sun Wu K'ung (Monkey).
Height 24cm.

孫悟空像，高24公分。

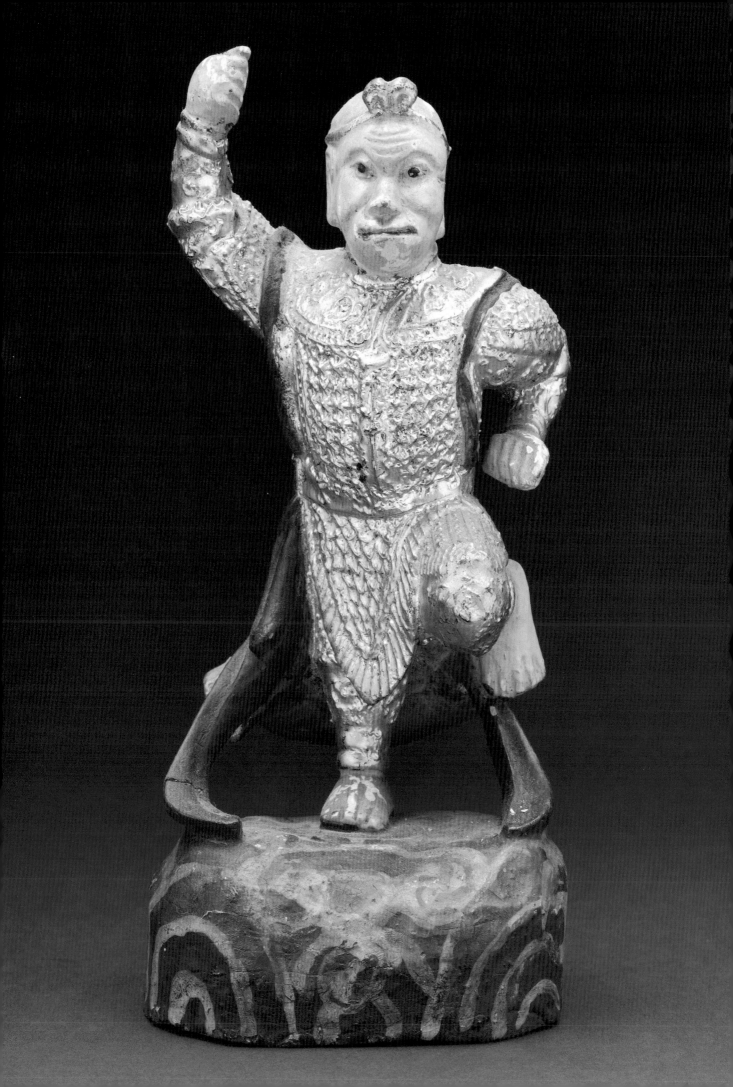

CHU PA CHIEH
(PIG)

猪 八 戒

In a previous existence, Chu Pa Chieh was a minor official in Heaven who, after drinking to excess at the Peach Banquet, abused the Jade Emperor's daughter. An enraged Jade Emperor ordered 2,000 blows with the iron mallet as punishment and banished him to the earth. When his time came to be reincarnated, he mistakenly entered the body of a sow. He emerged half-man, half-swine having the head of a pig and body of a human. His first act, in conformity with his previous perverse ways, was to kill and eat his mother; his next, to devour the rest of the litter.[210] He fled to a mountain retreat, armed himself with an iron rake, and proceeded to rob and eat travelers who passed nearby. Later, at urgings of Kuan Yin, he converted to Buddhism and was ordained a priest.

Pig attached himself to a family named Kao. With the aid of his miraculous nine-pronged muck rake, he turned the man's land into a model farm. In gratitude, Blue Orchid, Kao's third daughter, became betrothed to Pig whose porcine features were not yet evident to them. That soon changed, and the horrified Kao sought unsuccessfully to retrieve his daughter. Luckily, Tang San Tsang (Tripitaka) and Sun Wu K'ung (Monkey) happened on the scene. Monkey rescued Blue Orchid and chased Pig to his cave hideout. Pig's muck rake was no match for Monkey's cudgel. In defeat, the braggart Pig turned humble and kowtowed when he learned Monkey was Tripitaka's disciple. "I was put here by Kuan Yin to await the monk's arrival," he vowed. His oath convinced Monkey of his sincerity. The two who fought as enemies left the field of battle as comrades destined to face many dangers shoulder-to-shoulder, protecting Tripitaka in his pilgrimage to India and return with the precious sutras.

At the successful conclusion of the mission, Tripitaka and Monkey were both elevated to godhood. Pig, for his assistance in propagating Buddhist doctrine, was rewarded by being appointed to the official, but lowly, position of "Cleanser of the Altar." Pig, indignant at not being accorded the same status as his companions, complained to Lord Buddha who patiently explained that his appearance lacked refinement and that his appetite was still too large. Possibly with a trace of wit, Buddha pointed out that there were temples throughout the world at which food offerings were made. As there were sure to be plenty of leftovers, Pig should be able to satisfy his enormous hunger.

There are no temples in Taiwan dedicated to Chu Pa Chieh, and it is unlikely that statues of him could be found on family altars. Nevertheless, he has a following. Statues of him were still being carved in 1978 in at least one shop in Wanhua. When I visited the carver, his storeroom shelves held three finished statues waiting to be collected by customers for whom they were especially made. Those customers were either individual prostitutes or nearby brothels. Although I have never seen him exhibited publicly, a recent traveler to Chiayi has reported finding a statue of Pig at the City God temple. The statue, apparently placed there as a "visiting deity" by a devotee, was carved with a scantily clad woman on his lap.

The affection "ladies of the night" have for Pig undoubtedly has a long tradition in China. One assumes on Taiwan the practice dates from the time cities grew to a size to sustain the profession. By the time of the

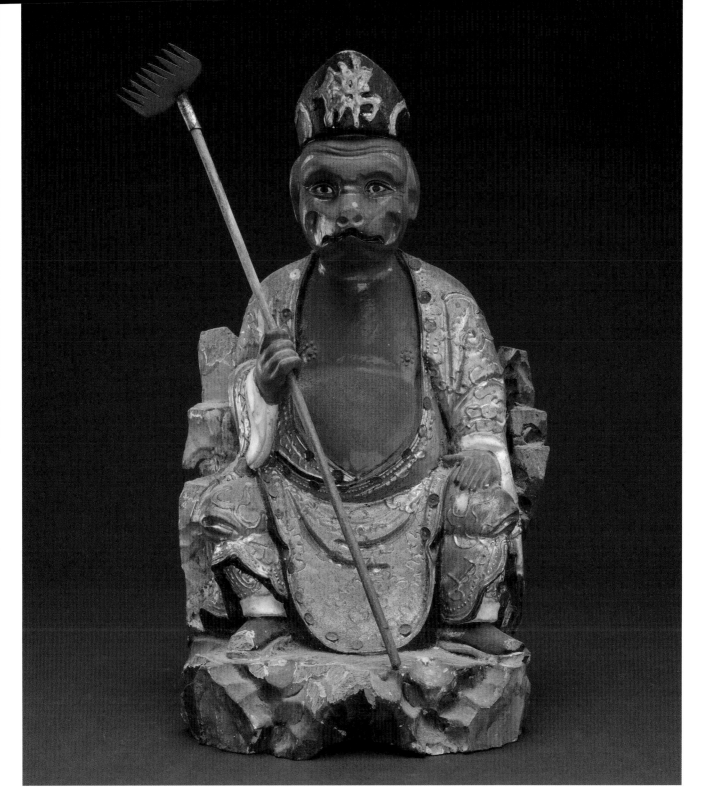

Figure 119
Chu Pa Chieh, who is half man-half pig. Known for his enormous appetite, he is a central figure in *Journey to the West*. Along with Monkey, he served as Tripitaka's bodyguard and guide in the quest for sacred *sutras*.
Height 28cm.

半人半豬的豬八戒，以食慾奇大出名，祂也是《西遊記》的主角之一，和孫悟空同為唐三藏前往西方取經的護衛和嚮導。像高 28 公分。

Japanese occupation, formal prayers accompanied devotion. According to Reverend Gerald Kramer and Mr. George Wu writing in *An Introduction to Taiwanese Folk Religions*, prostitutes in those days invoked Pig with the following petition: "We beseech you to bring us rich guests, foolish as they come, witless as they leave. May we completely fleece them. May they not fear evil or gossip or the scolding of their parents."[211]

He is portrayed with a long snout, large pointed ears, an exposed overhanging belly, and grasping a nine-pronged muck rake.

210. Dore, *Researches into Chinese Superstitions*, Vol. VIII, p. 565.
211. Kramer and Wu, *An Introduction to Taiwanese Folk Religions*, p. 7.

ERH LANG SHEN

According to *The Journey to the West* (*Hsi Yu Chi*), Erh Lang Shen was the nephew of Lao Tzu, the founder of philosophical Taoism. When the numerous misdeeds of Monkey (Sun Wu K'ung) incensed the Jade Emperor to the point of ordering his arrest, Erh Lang joined Lao Tzu, Na Cha, and others to do battle with that mischievous simian warrior. After a protracted and seemingly stalemated battle, Lao Tzu felled Monkey with a toss of his magic ring. Before he could recover, Erh Lang's canine servant, T'ien Kou (Heavenly Dog), was upon him and bit Monkey's leg, causing him to take a second, and for him critical, stumble for he was soon surrounded and seized.[212]

In addition to this mythical tale, Erh Lang has other, more human, biographies. He is claimed to have been Chao Yu, the renowned Sui Dynasty official who, tired of his position, mysteriously vanished. Once during a flood in Szechuan, he was seen riding a white horse through the mist. A temple to him was built at that spot, and a cult grew up around his spirit. When the Mongols were attacking China during the Sung Dynasty, he appeared again to advise the Chinese general on the proper strategy for repelling the attackers. In another version, Erh Lang is the son of Li Ping, the official who developed Szechuan and improved the irrigation system.[213] In Taiwan, he is also known as Ya Yeh, Li Hsing Chun, and Erh Lang Chen Chun. The only record I have found of Taiwan temples or shrines dedicated to him is in Chung Hua Tsao's book on gods worshiped on Taiwan. He refers to a Taichung City temple where he is called Yang Chien *Hsien* Shih and one in Changhua *Hsien* where he is enshrined as Erh Lang Tsun Shen.[214]

V. R. Burkhardt writes of one unusual Peking shrine that is worth noting. A grateful population erected it after Erh Lang was credited with driving off the water dragon, thus saving the city from inundation. In this temple, Erh Lang's dog shares his altar and in the past, was more sought after than his master. Pet lovers sacrificed at it when their dogs were in poor health. The petitioner burned incense and carried the ashes home for the dog to swallow with his next meal. In cases of recovery, ceramic and fur covered animals were contributed as tokens of gratitude.[215]

Heavenly Dog has not always been held in such esteem. In bygone times, he had a reputation for ravishing the souls of children and was considered a cause of sterility. Eclipses were the result of his attempts to eat the moon, a catastrophe averted only by the communal efforts of rural folk, whose noisemaking scared the beast away from his lunar repast.[216]

Erh Lang is portrayed as a young soldier dressed in armor and holding a trident. He has a third eye in the middle of his forehead. The often-mischievous Heavenly Dog, whom he kept in obedient check, accompanies him.

→Figure 120
Erh Lang Shen, who is always accompanied by T'ien Kou (Heavenly Dog), his faithful servant. Together they joined in the celestial battle against Monkey, as recorded in the novel *Journey to the West*.
Height 27cm.

在《西遊記》中，總是有忠僕天狗在旁陪伴的二郎神也加入和孫悟空的對戰。
像高 27 公分。

212. Dore, *Researches into Chinese Superstitions*, Vol. VIII, p. 560.
213. Chu, *Birthday Listing of Gods*, p. 131.
214. Chung, *The Origins of Taiwan's Local Gods*, p. 146.
215. Burkhardt, *Chinese Creeds and Customs*, Vol. I, p. 9.
216. Stevens, *Chinese Gods*, p. 185.

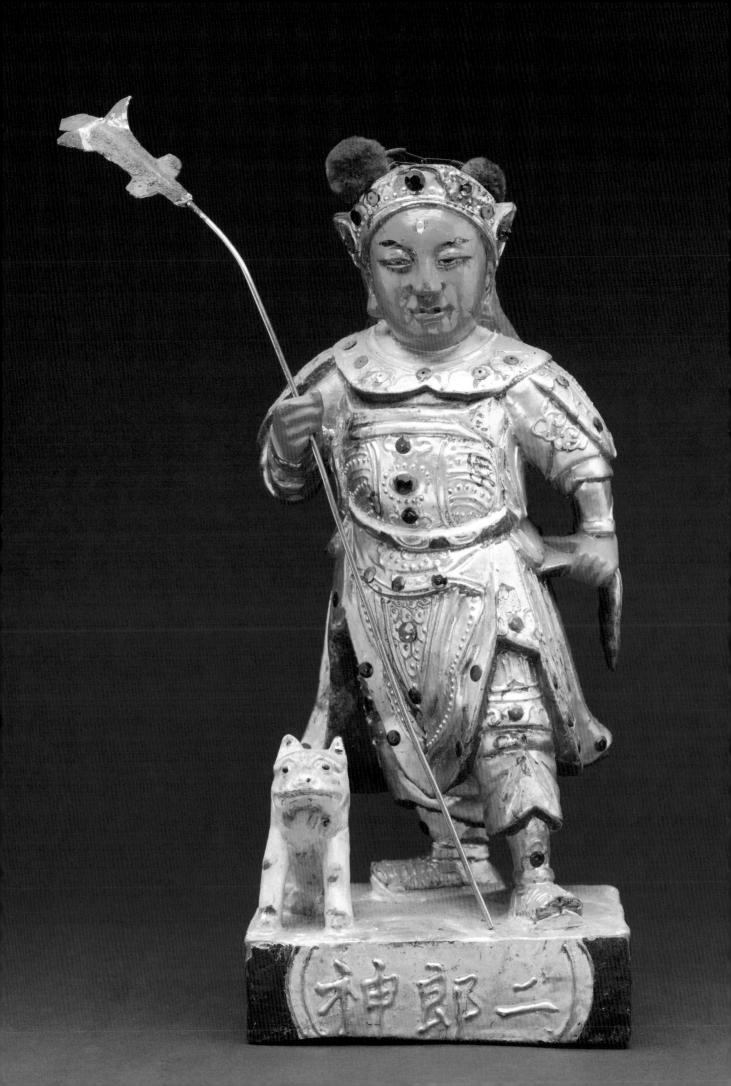

CHI KUNG 濟公

It would be hard to find a more colorful deity than Chi Kung. His supposed exploits were chronicled in *Chi Kung: Living Buddha*, a novel later adapted into a movie.

Surnamed Li, Chi Kung was born in Chekiang during the Sung Dynasty and is said to have been related to an emperor. His parents died when he was eighteen, and after three years of mourning, he entered a monastery. Chi Kung was well-versed in Buddhist doctrines and proficient in conducting rites. As a young monk, he was clever in settling lawsuits, gifted in curing illnesses, and expert in exorcising demons. He was, however, fond of indulging in strong drink and scorned disciplinary rule. To add to his mystique, he posed as an eccentric, which earned him the title "Mad Healer." It is said that the straw fan he clutched in his left hand was equal in magic to the powerful sword wielded by Chang T'ien Shih.

One of his first recorded miracles was the gathering of wood for the Ching Tzu Szu temple that had burned to the ground. He traveled to the Yen *Ling* (mound) where trees, whose wood was suitable for temple construction, grew. Chi Kung merely spread his Buddhist cloak over the area, and trees miraculously fell, moved to the river, and floated to Hangchou at a spot near the burned temple. He reported to his superiors that the wood was collected and waiting. When the astonished monks arrived at the riverbank, they saw six sturdy men, actually spirits, pulling the logs from the water.

He died during the reign of Chia Ting (A.D. 1208-1225). Sometime later, he appeared to monastery monks and complained that he had been forgotten. On Taiwan, he most certainly is not forgotten. Worship of Chi Kung was introduced to the island during the Kuang Hsu reign by soldiers of Li Hung Chang's Huai Army, who rushed to aid locals repel a French attack on Chilung and Tanshui.[217] The Huai Army left, but some of the statues remained in temples scattered throughout Taiwan. Chi Kung is enshrined as the main god in over twenty temples, mainly in Taipei, Nantou, Yunlin, and Chiayi.

In 1978, I visited a former Taipei policeman named Hung, whom I learned had founded a small altar to Chi Kung in his home. He said that he hoped to expand into a large temple to be called Chiao Shih Kung. Money from the sale of two houses he owned was sufficient to begin construction. He said he was banking on support from Chinese in Japan and America to make up the difference. His proposed temple would have rooms for old men whose children failed to fulfill their filial duty. It would be a place where they could live out their last few years with the knowledge that their bones will find a final, appropriate resting place on the temple grounds.

In Mr. Hung's version of the legend, Chi Kung, in a largely unknown previous existence, was the leader of the Lohan but was later reborn into the family of an important government official. Chi Kung was orphaned at sixteen and two years later, entered a monastery where he studied medicine and became a doctor. He was called "Living Buddha" because he could foretell the future. Mr. Hung de-emphasized the supposed inappropriate indulgences of this deity, but he did say that he could safely

→Figure 121
Chi Kung, a gifted monk with a taste for strong drink and an aversion to discipline. His various exploits were chronicled in *Chi Kung: Living Buddha*, a novel later adapted into a movie. Height 39cm.

濟公，嗜喝烈酒，且不喜紀律。《濟公活佛》的小說記載了祂的諸多事蹟，小說後來也改編成了電影。像高39公分。

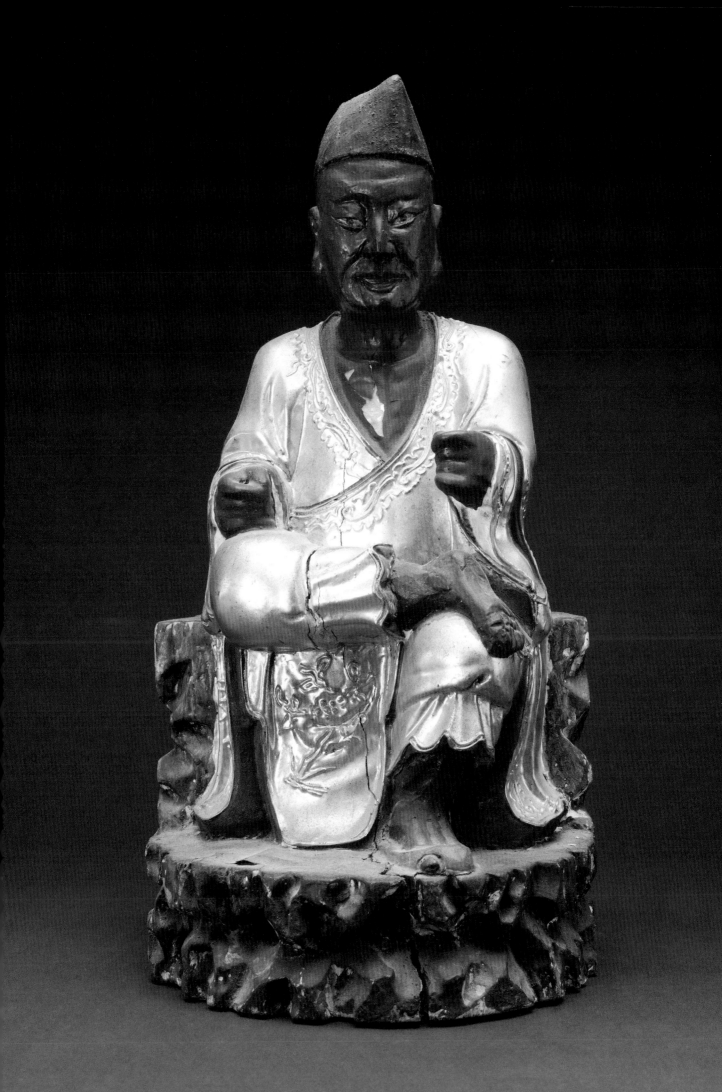

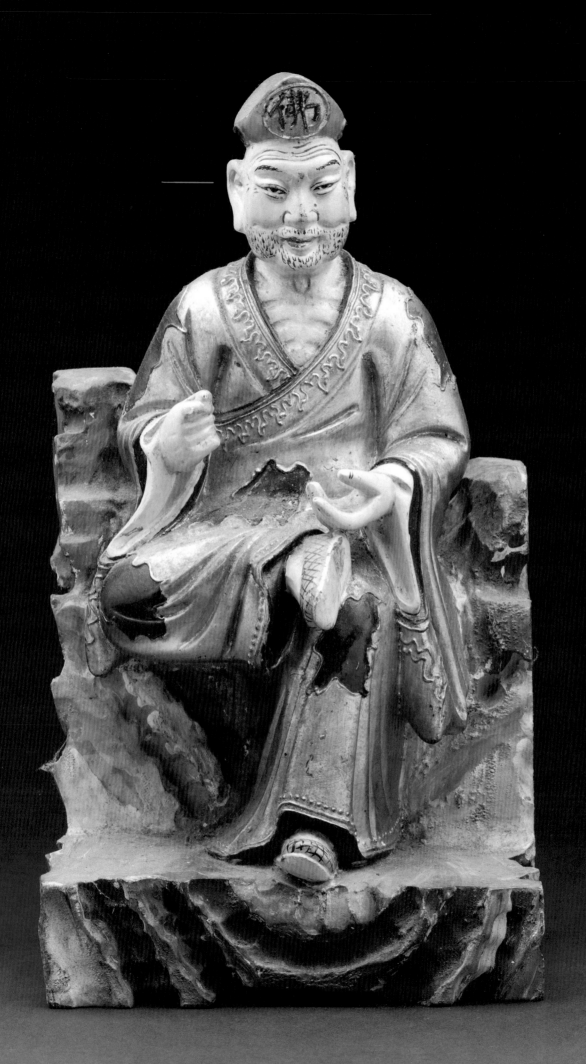

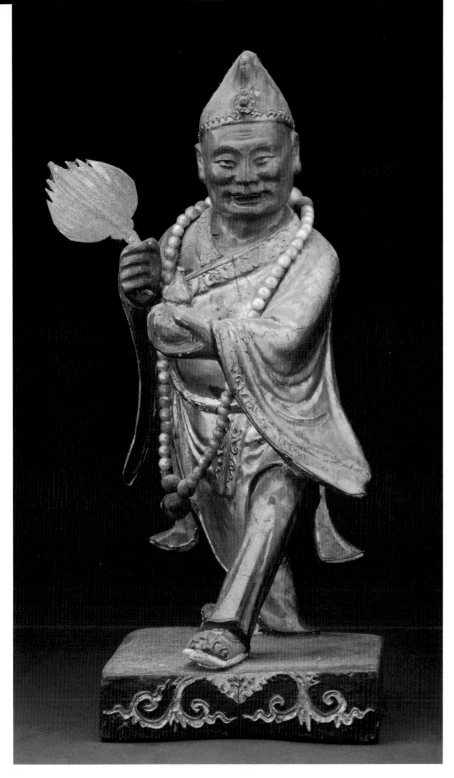

Figure 123
Chi Kung. Height 28cm.

濟公像，高28公分。

←Figure 122. Chi Kung.
Height 27cm.

濟公像，高27公分。

stray from a strictly vegetarian diet and even eat dog meat, because just before he swallowed, the forbidden food miraculously became vegetable.

Chi Kung still retains his bacchanalian reputation as is evident from the boast of another Chi Kung devotee I met by chance in a Taichung temple. Although not a drinker, the man told me that when possessed by Chi Kung's spirit, he could down six bottles of rice wine without apparent effects or even a trace of alcohol on his breath.

Chi Kung's reputation for imbibing was given new life by a movie and a television presentation. They were enormously popular. He was portrayed as a god willing to descend to this clime to assist those in need or solve difficult problems, but he was also a god with a human side. It was emphasized that he "could cultivate the heart, but not the mouth," for he drank to excess from his ever present wine-filled gourd and ate meat whenever he wanted.

In the southern village of Tung Ch'ang Li, just outside of Ch'i Shan in Kaohsiung *Hsien*, there is a five-story tall cement statue of Chi Kung guarding the environs and bringing tourists and pilgrims to this remote area. The statue is on the grounds of Feng Shan Szu, a temple that traces its roots, according to *Central Daily News*, back 200 years when a small bamboo shrine was erected to Kuan Yin. The newspaper compared Chi Kung's effigy with the more famous giant Buddhas at Changhua and Fo Kuang Shan and pronounced Chi Kung their equal.[218] It may be equal in size, but there the similarity ends. Where most Buddhist statues, large or small, present their subjects in solemn and static poses, Chi Kung's statue at Tung Ch'ang Li is animated: his knees are bent, his arms are in a jogging position, and his Buddhist robe is upturned at the hem as if blown by the breeze of motion. He holds his large magic fan in one hand and a wine gourd in the other. Prayer beads hang from his neck. His wide, open face, with a hint of a wine-induced grin, is framed between two large and elongated ears, a Buddhist mark of wisdom.

217. Chu, *Birthday Listing of Gods*, p. 123.
218. "Chi Kung, Living God," *Central Daily News*, December 8, 1978.

TA MO TA SHIH
(BODHIDHARMA)

達摩大師

Bodhidharma is the name by which Ta Mo Ta Shih (also called P'u Ti Ta Mo or simply Ta Mo) is known in Western literature. He is the first patriarch of Chinese Buddhism and generally considered to be the founder of the *Ch'an* (Zen) School.

He arrived in Kuangtung after a three-year journey from India during the early years of Emperor Liang Wu Ti's reign. He worked his way slowly to the capital at Nanking, where he was welcomed by the emperor who begged the monk to impart true enlightenment to him. Bodhidharma's admonition to abandon his throne and embrace the contemplative life disheartened the emperor. Upon failing to move him, Bodhidharma left the capital for Loyang, where he took up residence at the Shao Lin Temple. (An

Figure 124
Bodhidharma, generally considered to be the founder of the *Ch'an* (Zen) School. This damaged statue was carved from a root.
Height 24cm.

菩提達摩一般均認為是禪宗的創始者。
圖中已破損的達摩像是用樹根刻成的。
高 24 公分。

incident in the course of his journey has become a favorite motif for Chinese artists. Lacking a vessel to cross the Yangtse River, he miraculously floated to the opposite bank, supported only by a thin reed.) At the Shao Lin Temple, he is reported to have sat for nine years in the lotus position, staring silently at a wall in a meditative "tour de force."[219]

There are many fanciful stories connected with his nine-year meditation, a time phrase most scholars interpreted as a poetic metaphorical exaggeration for "a long time." One states that after sitting in the lotus position for several years, his legs fell off. Another links his round bulging eyes with the origin of tea. One day, according to the tale, while meditating he fell asleep. To prevent that from happening again, he cut off his eyelids. They fell to the ground, took root, and sprouted as China's first tea plants.[220] To this day, Zen monks in meditation drink tea to stay awake.

Bodhidharma scorned books, the use of images, and the performances of rites. He advocated the concentration of mental energy in order to develop a sense of stillness. Although his principles were never fully adopted, Bodhidharma's disgust for books influenced the later direction of Buddhism by dampening a desire for formal education among monks.

I have never seen a Bodhidharma statue in a temple, and it would appear that few requests, if any, have come to Taiwanese woodcarvers for his image. He is a favorite of the Japanese, and most statues of him one occasionally finds in antique shops are left over from the Japanese occupation. The one pictured here (fig. 124) is one such. It is badly damaged and seems to have been deliberately mutilated in an attempt to prevent recognition. Marks around the mouth and nose clearly indicate chipping, rather than age or erosion, caused the disfigurement. I bought it from a Taipei antique dealer because it is an example of *ch'iao tiao* (ingenious carving).

The Palace Museum cabbage is the most famous *ch'iao tiao*, but there are others − such as the driftwood Monkey statue at Sheng Te Kung in Wanhua − that are less artistic yet nevertheless fascinating. When I lived in Kaohsiung in the late 1960s, a stalagmite was discovered in a southern cave that, after a slight modification, bore a striking resemblance to Kuan Yin. With much solemnity and publicity, the stone was brought to a local temple where it attracted large crowds. This root likewise must have reminded someone of Bodhidharma with arms crossed in meditation. A carver rounded the head, added bugged eyes and facial features, but left the rest of the root untouched. Why it was mutilated, and how it ended up for sale are intriguing mysteries that excite speculation. Bodhidharma, while not often carved, is nevertheless a popular subject for artists. I bought this scroll painting (fig. 125) in 1967 from Chuang Nan Min, a Taichung artist. It is neither an antique, nor a valuable piece. Yet, it is an interesting watercolor example of the genre.

Mr. Chuang kindly dedicated the four-line poem to me that reads as follows:

> Reverent Praise
>
> A famous teacher faced the wall for nine years,
>
> A Supreme but lively Master of great virtue,
>
> Came to China to propagate the true *Dharma*.
>
> And had the ability to expel demons and evil influences for saving the universe.
>
> > Presented to Tang Neng Li
> >
> > Taichung. Chuang Nan Min

219. Dore, *Researches into Chinese Superstitions*, Vol. VII, p. 428.
220. Williams, *Outlines of Chinese Symbolism and Art Motives*, p. 388.

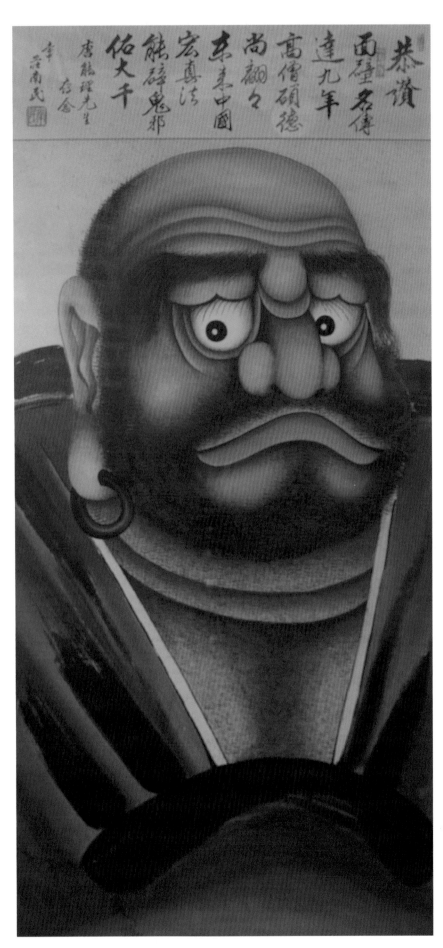

恭讚
面壁名傳
達九年
高僧碩德
尚翻々
東来中國
宏真法
能碎鬼邪
佑大千
唐龍躍先生在念

Figure 125
Watercolor scroll of Bodhidharma with a poem recalling his nine-year meditation.
Size 138 by 67cm.

菩提達摩水彩畫像，附有詩句描述其面壁九年的事蹟。
138 × 67公分

→Figure 126
Attendant deities. Important gods have attendants who flank them on the main altar. Attendants of those with regional responsibilities carry a sword or seal. Others may hold a variety of items such as the *pa kua* (eight trigrams), gourds, fans, flags, and weapons etc.
Height 49cm.

隨侍神明像。主神壇上，大神的身邊經常有隨侍神明在側，負責地方事務者手中拿著劍或印鑑，其他則手持八卦、葫蘆、羽扇、令旗或武器等。高49公分。

ATTENDANT DEITIES

隨侍的神明

Chou Ts'ang and Kuan P'ing can be seen standing next to Kuan Kung in almost every temple where he is honored on an independent altar. Golden Boy and Jade Girl almost always flank statues of Kuan Yin. Thousand Mile Eyes and Efficacious Ears often accompany Matsu, and three pairs assist City Gods: Cow-head and Horse-face, the Civil and Military Judges, and the Seventh and Eighth Lords.

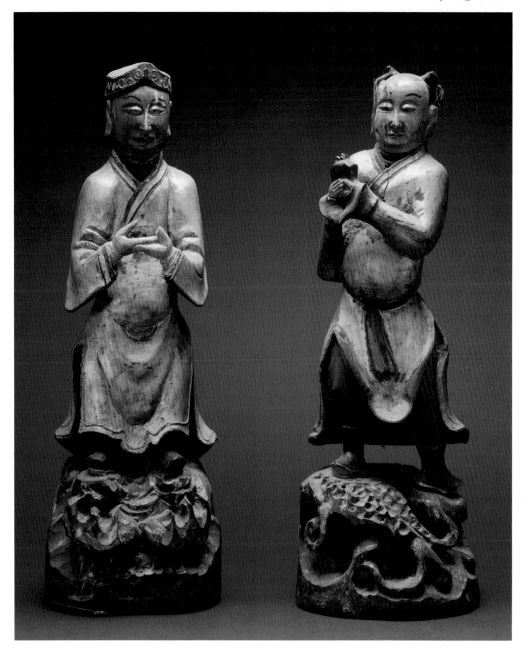

Chien Tung and Yin Tung (Sword Boy and Seal Boy) serve gods who have administrative responsibilities. *Shih nu* (waiting ladies) flank goddesses and stand ready to cool their mistresses with oversized fans. Anonymous servants offering weapons of war or a variety of articles including, among others: gourds, books, writing brushes, scrolls, the *pa kua* (eight trigrams), and flags attend any number of deities.

Temples are not ordinarily erected to honor attendants. Yet Chien Tung Miao (Sword Boy Temple) has stood in Taipei's Sung Shan District since 1947. Several trips to the temple failed to shed any light on why an attendant should be favored with his own place of worship. The temple caretaker said the faithful just accept the fact that the tiny statue of Sword Boy that rests in the center of the main altar is *ling* (efficacious).

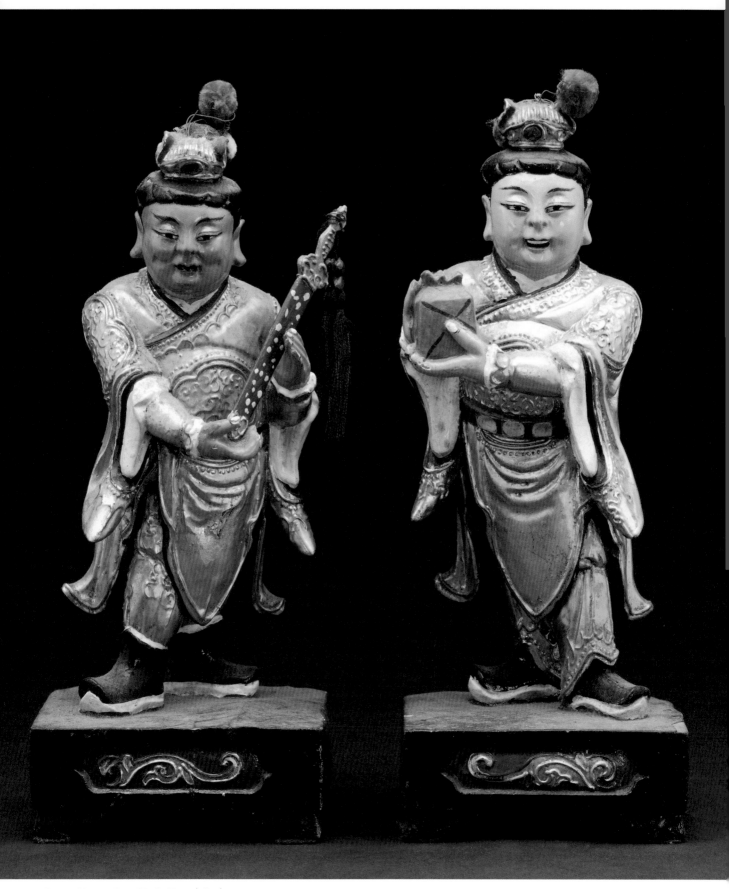

Figure 127. Attendants. Height 23 cm (tallest).

隨侍神明像，最高23公分。

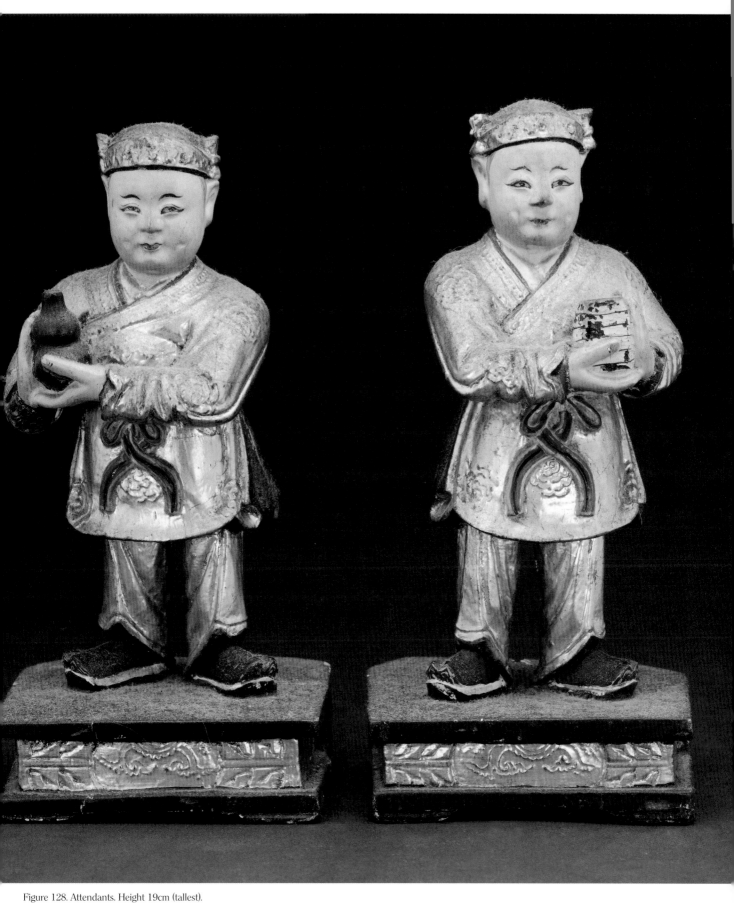

Figure 128. Attendants. Height 19cm (tallest).

隨侍神明像，最高19公分。

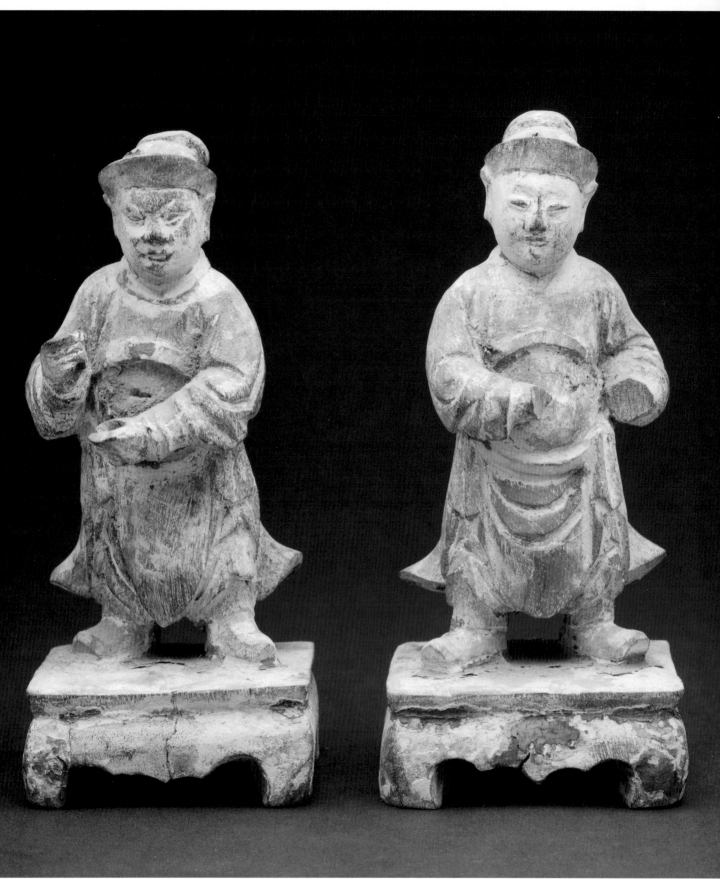

Figure 129. Attendants. Height 15cm (tallest).　　隨侍神明像，最高15公分。

→Figure 130. Female Attendants. Height 25cm.　　女性隨侍神明像，高25公分。

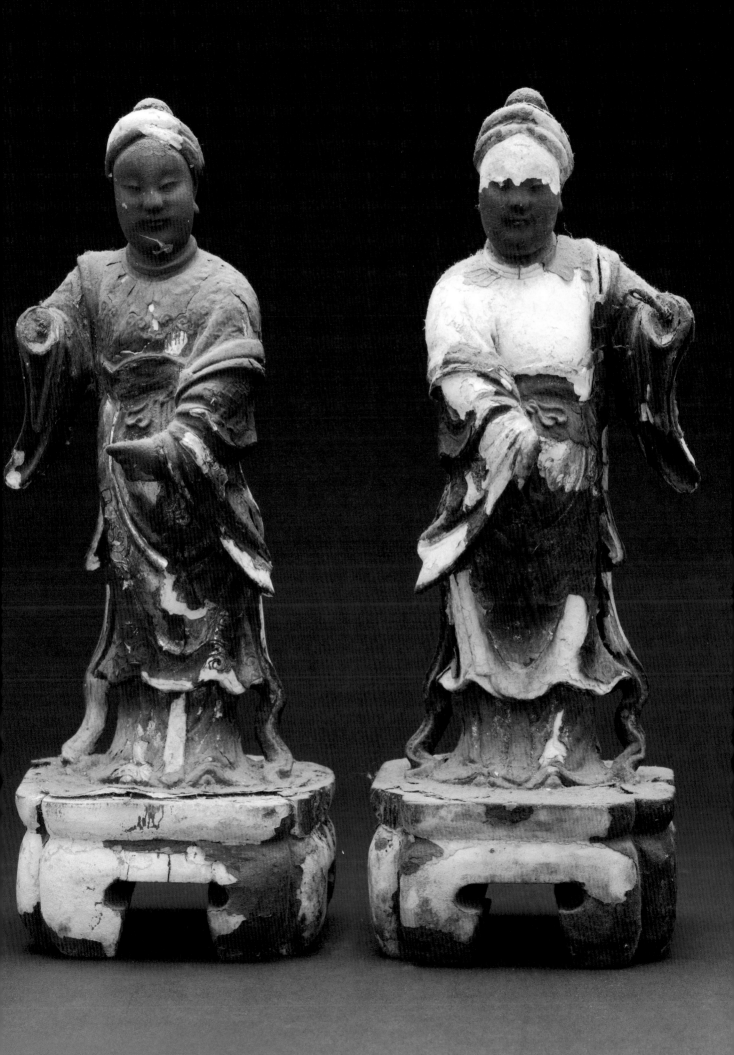

APPENDIX

N.B.: Aspirated words are listed together alphabetically before non-aspirated words.

An Hsi	安溪	Chien T'ung	劍童
An Lu Shan	安祿山	Chien Ti	簡狄
Anhui	安徽	Chih Kung Tsu Shih	志公祖師
Ch'an	禪	Chih Nan Kung	指南宮
Ch'ang Mei Lohan	長眉羅漢	Chih Shan Yen	芝山岩
Ch'ang Ming	常明	Chih Yuan Hsien	姪源先
Ch'ang O	嫦娥	Chilung	基隆
Ch'en Chien Jen	程建人	Chin Ch'iao Chio	金喬覺
Ch'en Chin Jung	陳金絨	Chin Chiang County	晉江
Ch'en Ching Ku	陳靖姑	Chin Hua Lohan	進花羅漢
Ch'en Lai Chang	陳賴章	Chin Kuo Lohan	進果羅漢
Ch'en Lin Hsiang Hui	陳林香惠	Chin Ning Hsiang	金寧鄉
Ch'en Wan Te	陳萬得	Chin Shih Lohan	金獅羅漢
Ch'eng Huang Yeh (City God)	城隍爺	Chin Shih Lohan	進士羅漢
Ch'i Shan	旗山	Chin T'ung	金童
Ch'i T'ien Ta Sheng	齊天大聖	Chin Te Kung	晉德宮
Ch'i Yeh (Seventh Lord)	七爺	Ching Hsiu Ch'an Yuan	靜修禪院
Ch'iao T'ou Hsiang	橋頭鄉	Ching Tzu Szu	淨慈寺
ch'iao tiao	巧彫	Chio Hsiu Kung	覺修宮
Ch'ien Li Yen	千里眼	Chiu Lung Li	九龍里
Ch'ien Lung	乾隆	Chiu T'ien Hsuan Nu	九天玄女
Ch'ien Sui Yeh	千歲爺	Chou Kung	周公
Ch'ih T'ou Fu Jen	池頭夫人	Chou Ts'ang	周倉
Ch'ih Wang Yeh	池王爺	Chou Wang	紂王
Ch'in Kuai	秦檜	Chu Hung Wu	朱洪武
Ch'ing Chi	卿忌	Chu I	朱衣
Ch'ing Shui Tsu Shih Kung	清水祖師公	Chu I Kuei	朱一貴
Ch'ing Yen Fa Shih	清嚴法師	Chu Ko Li	珠格里
Ch'ing Yun Yen	清雲岩	Chu Pa Chieh	朱八戒
Chang En Chu	張恩主	Chu Sheng Kung	註生宮
Chang Fei	張飛	Chu Sheng Niang Niang	註生娘娘
Chang Fu Te	張福德	Chu Shun, General	助順將軍
Chang Hsun	張巡	Chu T'ien Hsiang	竹田鄉
Chang Kung Fa Chu	張公法主	Chu Tung	竹東
Chang Kuo Lao	張果老	Chu Wang Yeh	朱王爺
Chang Lu	張魯	Chu Yuan Shou	朱元壽
Chang Sai Hua	張賽花	Chuanchou	泉州
Chang Sheng Chun	張聖君	Chuang Nan Min	莊南民
Chang Sheng Kung	張聖公	Chung Ch'ing Szu	重慶寺
Chang T'ien Shih	張天師	Chung Ch'iu	中秋
Chang T'ing Tzu	長汀子	Chung Chia Shai	眾甲晒
Chang Tao Ling	張道陵	Chung Ho	中和
Chang Ti	章帝	Chung Hua Tsao	鍾華操
Chang Tzu Fang	張子房	Chung K'uei	鍾馗
Changhua	彰化	Chung Kang Li	中港里
Chao Hsien Miao	昭顯廟	Chung Li Ch'uan	鍾離權
Chao Kung Ming	趙公明	Chung Shan Ch'u (district)	中山區
Chao T'ien Kung	朝天宮	Chung T'an Yuan Shuai	中壇元帥
Chao Yu	趙昱	Dharma	法
Chaochou	潮州	En Chu Kung	恩主公
Chekiang	浙江	Erh Lang Chen Chun	二郎真君
Chen Lan Kung	鎮瀾宮	Erh Lang Shen	二郎神
Chen Nan Ch'a Hang	振南茶行	Erh Lang Tsun Shen	二郎尊神
Chen Wu	真武	Erh Shui	二水
Cheng Ch'eng Kung	鄭成功	Fa Chu Kung	法主公
Chi Kung	濟公	Fa Chu Kung Miao	法主公廟
Chia Ch'ing	嘉慶	Fa Pao	法寶
Chia Ting	嘉定	fa shih	法師
Chiang Ching Kuo	蔣經國	Fa Shih Ch'ing Shen	法師請神啟用法鐘
Chiang Tzu Ya	姜子牙	Ch'i Yung Fa Chung	
chiao	醮	Fan Li	范蠡
Chiao P'ai Ju Chiao	教派儒教	Fan Wang Yeh	范王爺
Chiao Shih Kung	教世宮	Fan Wu Chiu	范無救
Chiayi	嘉義	Fei Po Lohan	飛缽羅漢
chieh yuan	解元	fen shen	分身
Chien Ch'eng	建成	Feng Shan Szu	鳳山寺
Chien Lung	建隆	Feng Shen Yen I	封神演義

Sun Ta Sheng	孫大聖
Sun Wu K'ung	孫悟空
Sung Po Ts'un (village)	松柏村
Sung Shan Ch'u (District)	松山區
Szechwan	四川
Szu Ming Tsao Chun	司命灶君
Szu Sheng Ch'ao T'ien	四聖朝天
T'ai Ch'ing	太清
T'ai Chi	太極
T'ai I Chen Jen	太乙真人
T'ai Shan	泰山
T'ai Tsu	太祖
T'ai Tsung	太宗
T'ai Tzu Yeh	太子爺
T'ai Yang Hsing Chun	太陽星君
T'ai Yin Niang Niang	太陰娘娘
T'ang Hsuan Tsung	唐玄宗
T'ang Neng Li	唐能理
T'ang San Tsang	唐三藏
T'i Ching Lohan	提經羅漢
T'ien Ch'i	天啓
T'ien Fei	天妃
T'ien Hou	天后
T'ien Hou Kung	天后宮
T'ien Kou	天狗
T'ien Shang Sheng Mu	天上聖母
T'ien Sheng Chun	天聖君
T'ien Shih Kung Miao	天師公廟
T'ien T'ai Shan	天台山
T'ien Tu Yuan Shuai	田都元帥
T'u K'u	土庫
T'u Ti Kung	土地公
T'u Ti P'o	土地婆
T'ung An Hsien (district)	同安縣
T'ung Hsin Yuan (garden)	同心園
T'ung Kuan Pass	潼關
Ta Ch'i	大溪
Ta Chung Yeh Miao	大眾爺廟
Ta Mo Ta Shih	達摩大師
Ta Nan Men	大南門
Ta Tao Kung	大道公
Ta Tso	打坐
Ta Tung District	大同區
Tachia	大甲
Tai Chi Hsiung	戴吉雄
Tai T'ien Fu	代天府
Taichung	台中
Tainan Hsien (district)	台南縣
Taiwan Jih Jih Hsin Pao	台灣日日新報
Taiwan Jih Pao	台灣日報
tangki	乩童
Tanshui	淡水
Tao Kuang	道光
Tao Te Ching	道德經
Taoyuan	桃園
Ti Tsang An	地藏庵
Ti Tsang Wang	地藏王
Ti Tsang Wang Miao	地藏王廟
Tien Mu	電母
Tin Hau	天后
To Li Lohan	多利羅漢
To Lo Lohan	多羅羅漢
Touliu	斗六
Ts'ai Shen	財神
Ts'ao T'un Chen	草屯鎮
Ts'ao Ts'ao	曹操
Tsao Chun	灶君
Tsao Yi Ying	曹逸盈
Tsu Shih Miao	祖師廟
Tu Yu Niang	杜玉娘
Tung Ch'ang Li	東昌里
Tung Shih Hsiang	東石鄉
Tung Wang Kung	東王公
Tung Yu Tien	東嶽殿
Tz'u Chi Kung	慈濟宮
Tz'u Hang	慈航
Tzu Mou Ts'un	子茂村
Wan Ying T'an	萬應壇
Wang An Hsien	望安縣
Wang Hsu Ping	王許炳
Wang Yeh	王爺
Wang Yin Kuei	王吟貴
Wei Chin Yi (Lawrence Wei)	魏欽一
Wei Ching Meng (Jimmy Wei)	魏景蒙
Wen Ch'ang Ta Ti	文昌大帝
Wen Ch'uan Ts'un	溫泉村
Wen P'an Kuan	文判官
Wu Ch'ang Street	武昌街
Wu Ch'uan Liu	五權柳
Wu Chen Jen	吳真人
Wu Chieh Hsiang	五結鄉
Wu Chih Shan	五指山
wu fu	五福
Wu Kang	吳剛
Wu Ku Hsien Ti	五穀先帝
Wu Ku Miao	五穀廟
Wu Ku Wang	五穀王
Wu P'an Kuan	武判官
Wu Pen	吳本
Wu Ti	武帝
Wu Wang Yeh	吳王爺
Wu Ying Shen	五營神
Wu Ying T'ou	五營頭
Ya Mu Wang	鴨母王
Ya Yeh	亞爺
yamen	衙門
Yang Chien Hsien Shih	楊戩先師
Yang Kuei Fei	楊貴妃
Yang Kuo Shu	楊國樞
yang world	陽世
Yangtse River	揚子江
Yao Ta Ti	藥大帝
Yao Wang Ta Ti	藥王大帝
Yeh To Lohan	夜多羅漢
Yen Ling (mound)	嚴陵
Yen Lo Wang	閻羅王
Yen P'ing District	延平區
Yen P'ing Pei Road	延平北路
Yin Ming Shih	殷明石
Yin T'ung	印童
ying-yang	陰陽
Yu Ch'ing	玉清
Yu Chu Kung	玉渠宮
Yu Huang Ta Ti (Jade Emperor)	玉皇大帝
Yu Nu	玉女
Yu Ying Kung	有應宮
Yu Yu Shan	岠友山
Yuan Ch'ang Hsien	元長縣
Yuan Shih T'ien Tsun	元始天尊
Yueh Fei	岳飛
Yueh Hsia Lao Kung	月下老公
Yueh Lin Szu	岳林寺
yun chou	雲幃
Yun Kuang Szu	雲光寺
Yung Cheng	雍正
Yung Fu T'ang	永福堂
Yung Li	永曆
Yunlin Hsien	雲林縣

BIBLIOGRAPHY

BOOKS

Albrecht, Ardon and Go Sin-gi. *A Guidebook for Christians on Taiwanese Customs and Superstitions*, 3rd ed. Taipei: published by the authors, 1970.

Burkhardt, V. R. *Chinese Creeds and Customs*. Taipei: Hua Sheng Shu Tien, 1964.

Chamberlain, Jonathan. *Chinese Gods*. Taipei: Imperial Books, 1983.

Chu, Yuan Shou . *Birthday Listing of Gods*. Taipei: Chung Wu , 1975.
朱元壽，《神誕譜》，台北：中午，1975。

Chung, Hua Tsao . *The Origins of Taiwan's Local Gods*. Taipei: Taiwan Sheng Wen Hsien Wei Yuan Hui, 1979.
鍾華操，《台灣地區神明的由來》，台北：台灣省文獻委員會，1979。

Davidson, James W. *The Island of Formosa*. Taipei: Wen Hsing Shu Tien, 1964.

Dore, Henry. *Researches into Chinese Superstitions*. Shanghai: Tsuewei, 1931. Reprint, Taipei: Ch'eng Wen, 1960.

Eberhard, Wolfram. *Guilt and Sin in Traditional China*. Taipei: Rainbow Bridge, 1973.

Gallin, Bernard. *Hsin Hsing, Taiwan: A Chinese Village in Change*. Berkeley: California UP, 1966.

Jordan, David K. *Gods, Ghosts, and Ancestors*. Berkeley: California UP, 1972.

Kramer, Gerald P. and George Wu. *An Introduction to Taiwanese Folk Religions*. Taipei: published by the authors, 1970.

Liao, Yu Wen. *Mythology of Taiwan*. Taipei: Sheng Sheng, 1967.
廖毓文，《台灣神話》，台北：生生，1967。

Lin, Heng Tao. *Taiwan Temple's List*. Taipei: Ch'ing Wen, 1974.
林衡道，《台灣寺廟大全》，台北：青文，1974。

Liu, Liang Yu, ed. *Taiwan's Temples and Ancient Remains*. Taipei: Chung Te Kung Yeh Yen Chiu Fa Chan Chi Chin Hui, 1980.
劉良佑，《台灣寺廟古蹟大觀》，崇德工業研究發展基金會，1980。

Liu, Wen San 劉文三. *The God Statues of Taiwan* 台灣神像藝術. Taipei: Artist, 1981.
劉文三，《台灣神像藝術》，台北：藝術家，1981。

Masuda, Fukutaro . *Taiwan No Shiukyo*. Tokyo: Yokenob, 1939.
增田福太郎，《台灣?宗教》，東京：養賢堂，1939。

Shen, P'ing Shan. *Introduction to Chinese Gods*. Taipei: Hsin Wen Feng, 1979.
沈平山，《中國神明概論》，台北：新文豐，1979。

Shih, Ts'ui Feng . *Consideration of Ancient Things*. Taipei: Shih Pao, 1975.
施翠峰，《思古幽情集》，台北：時報，1975。

Soothill, William Edward and Lewis Hodous. *A Dictionary of Chinese Buddhist Terms*. Kaohsiung: Buddhist Culture Service, 1971.

Stevens, Keith. *Chinese Gods*. London: Collins and Brown, 1997.

Taiwan Provincial Government. "How Much Superstition Harms People," 1977.
台灣省政府，〈迷信害人知多少〉，1977。

Tung, Fang Yuan. *Understanding Taiwan's Folk Beliefs*. Taipei: Yung Wang Wen Hua, 1981.
董芳苑，《台灣民間信仰之認識》，台北：常民文化，1981。

Waley, Arthur. *The Adventures of Monkey*. New York: John Day, 1944.

Watters, Thomas. M.R.A.S. "The Eighteen Lohan of Chinese Buddhist Temples." *Journal of the Royal Asiatic Society*. Shanghai: Kelly and Walsh, 1899.

Wei, Yi-min and Suzanne Coutanceau. *Wine for the Gods*. Taipei: Ching Wen, 1976.

Werner, E.T.C. *A Dictionary of Chinese Mythology*. New York: Julian Press, 1969.

Werner, E.T.C. *Myths and Legends of China*. London: George G. Harrap & Co. Ltd., 1922.

Williams, C.A.S. *Outlines of Chinese Symbolism and Art Motives*, 3rd rev. ed. Shanghai: Kelly and Walsh, 1941.

Wolf, Arthur P., ed. *Religion and Ritual in Chinese Society*. Stanford: Stanford University Press, 1974.

Wu, Ying Tao. *Taiwan's Folk Culture*. Taipei: Ku T'ing, 1969.
吳瀛濤，《台灣民俗》，台北：古亭，1969。

MAGAZINES

Anderson, Mary M., "Kuan Yin: Goddess of Mercy," *Echo*, October 1973: 29-32.

Arts of Asia, November-December 1977, 57 Peking Road, Kowloon, Hong Kong.

"Gods and *Pai Pais*," *Echo*, February 1971: 5.

"Gods and *Pai Pais*," *Echo*, April 1972: 5.

"Gods and *Pai Pais*," *Echo*, April 1973: 5.

"Gods and *Pai Pais*," *Echo*, October 1973: 32.

Huang, Yang Sung, "Ju Ming, Wood Carver," *Echo*, vol. V, no. 9: 15.

Vinecour, Earl, "The Taoist Pope," *Asia Magazine*, 29 March 1981.

Wu, Ping Chung, "Matsu: Goddess of the Sea," *Echo*, January 1971: 14.

TAIWAN NEWSPAPERS

(Article name not available), *Taiwan Daily News* 台灣日報, 20 February 1976.

(Article name not available), *Taiwan Daily News* 台灣日報, 2 March 1976.

(Article name not available), *Taiwan Daily News* 台灣日報, 16 June 1976.

(Article name not available), *Taiwan Daily News* 台灣日報, 18 June 1976.

(Article name not available), *Taiwan Daily News* 台灣日報, 28 August 1976.

"Carving God Statues," *Independence Evening News* 自立晚報, 13 April 1977.

"Carving Today," *Taiwan Daily News* 台灣日報, 8 July 1978.

"Chi Kung, Living God," *Central Daily News* 中央日報, 8 December 1978.

"Commander Li Kuan Chien Dies a Hero," *Central Daily News* 中華日報, 25 October 1979.

"Decline in God Carving Industry," *China Daily News* 中華日報, 2 June 1977.

"Election Oaths before City God," *Taiwan Daily News* 台灣日報, 5 November 1977.

"Giant Statue Moved to Touliu Temple," *China Post*, 9 August 1976.

"God Statues Exhibition," *United Daily News* 聯合報, 2 October 1978.

"High Position May Be Wrong For God," *China Post*, 5 January 1976.

"Honor for the President," *Independence Evening News* 自立晚報, 1 April 1976.

"Increasing Wealth, Source of Belief," *Economic Daily News*, 20 February 1980.

"In the Future God Altars Must Be Registered," *Taiwan Daily News* 台灣日報, 11 August 1978.

"Initial Agreement on Moving T'u Ti Kung Temple," *Taiwan Daily News* 台灣日報, 29 February 1976.

"Li Feng Ming Prays to Agriculture God for Rain," *Taiwan Daily News* 台灣日報, 25 May 1976.

"Main Hall in Province's Largest Temple Destroyed by Fire," *Independence Evening News* 自立晚報, 11 December 1976.

"Matsu, the Sea Goddess Celebrated," *China Post*, 20 April 1979.

"Matsu Sues in Court," *Taiwan Daily News* 台灣日報, 3 May 1978.

"Mi Le Fo and Swallows' Nest," *Taiwan Daily News* 台灣日報, 12 May 1976.

"Offering to the God of Agriculture," *Independence Evening News* 自立晚報, 22 May 1979.

"Pao An Kung Contributes Scholarship Money," *Youth Warrior Daily News* 青年戰士報, 25 February 1977.

"Pao An Kung's Income Used for the Public," *China Daily News* 中華日報, 3 December 1976.

"Poster Exhibition at Pao An Kung," *China Daily News* 中華日報, 14 April 1976.

"President Presents Bronze Kuan Kung Statue," *Youth Warrior Daily News* 青年戰士報, 17 July 1979.

"The Story of Ts'ai Shen," *United Daily News* 聯合報, 5 February 1978.

"Stove God's Birthday Yesterday," *Taiwan Daily News* 台灣日報, 24 September 1979.

"Su Nan Ch'eng Slaughters a Chicken," *United Daily News* 聯合報, 18 November 1977.

"Sun Wu K'ung is not a Buddha," *Taiwan Daily News* 台灣日報, 27 December 1976.

"Tainan Hsien's Nan K'un Shen Temple," *Hsin Sheng Daily News* 新生日報, 3 June 1977.

"Ta Lung Tung District's Pao An Kung," *Ta Hua Wan Pao* 大華晚報, 29 May 1977.

"Tan Shui Tsu Shih Yeh Statue," *United Daily News* 聯合報, 4 April 1977.

"Ti Tsang Wang Statue," *China Daily News* 中華日報, 26 May 1976.

"T'u Ti Kung Temple Problem," *Taiwan Daily News* 台灣日報, 28 February 1976.

"A Vestige of Lu Tung Pin?" *Independence Evening News* 自立晚報, 20 June 1979.

"Worshiping Hsuan T'ien Shang Ti," *Taiwan Daily News* 台灣日報, 2 March 1976.

國家圖書館出版品預行編目資料

台灣的神像：一名美國文物收藏家研究紀事 =
Gods of Taiwan : A Collector's Account /
唐能理（Neal Donnelly）著.
--初版--台北市：藝術家，2006〔民95〕
面21×29公分，參考書目：面

ISBN 986-7034-07-4（平裝）
1.神像 2.民間信仰--台灣

272 95008258

Gods of Taiwan : A Collector's Account
台灣的神像：一名美國文物收藏家研究紀事

Neal Donnelly
唐能理　著

©2006 Neal Donnelly
First published in Taiwan in 2006 by Artist Publishing Co.
6F, No.147, Sec.1, Chongqing S. Rd., Zhongzheng District, Taipei City 100,
Taiwan, R.O.C.
Tel:886-2-23886715 886-2-23719692~3
Fax:886-2-23896655 886-2-23317096

Publisher
He Cheng-kuang

Chief Editor
Wang Ting-mei

Executive Editors
Wang Ya-ling, Hsieh Ju-hsuan

Art Design
Ke Mei-li

Publishing Office
Artist Publishing Co.
6F, No.147, Sec.1, Chongqing S. Rd., Zhongzheng District, Taipei City 100,
Taiwan, R.O.C.

All Rights Reserved. No. part of this publication may be reproduced or
transmitted in any form or by any means, electronic or mechanical, including
photocopy, recording or any other information storage and retrieval system,
without prior permission in writing from the publisher or author.

First Edition

發 行 人　何政廣
主　　編　王庭玫
文字編輯　王雅玲、謝汝萱
美術設計　柯美麗

出 版 者　藝術家出版社
　　　　　台北市重慶南路一段147號6樓
　　　　　TEL:02-23886715
　　　　　FAX:02-23896655
　　　　　郵政劃撥：01044798
　　　　　戶名：藝術家雜誌社

總 經 銷　時報文化出版企業股份有限公司
　　　　　桃園縣龜山鄉萬壽路二段351號
　　　　　TEL：（02）2306-6842

製版印刷　欣佑彩色製版印刷股份有限公司
初　　版　2006年5月

ISBN　986-7034-07-4

法律顧問　蕭雄淋
版權所有，未經許可禁止翻印或轉載
行政院新聞局出版事業登記證局版台業字第1749號